The Interface

The Interface

IBM and
the Transformation
of Corporate Design
1945–1976

John Harwood

A Quadrant Book

 University of Minnesota Press Minneapolis London

QUADRANT

Quadrant, a joint initiative of the University of Minnesota Press and the Institute for Advanced Study at the University of Minnesota, provides support for interdisciplinary scholarship within a new collaborative model of research and publication.

Sponsored by the Quadrant Design, Architecture, and Culture group (advisory board: John Archer, Ritu Bhatt, Marilyn DeLong, Kate Solomonson) and the University of Minnesota's College of Design.

Quadrant is generously funded by the Andrew W. Mellon Foundation.

http://quadrant.umn.edu

This book is supported by a grant from the Graham Foundation for Advanced Studies in the Fine Arts.

Published by the
University of Minnesota Press
111 Third Avenue South, Suite 290
Minneapolis, MN 55401-2520
http://www.upress.umn.edu

Library of Congress Cataloging-in-Publication Data
Harwood, John
The interface : IBM and the transformation of corporate design, 1945–1976 / John Harwood.
p. cm.
Includes bibliographical references and index.
ISBN 978-0-8166-7039-0 (hc : alk. paper)
ISBN 978-0-8166-7452-7 (pb : alk. paper)
1. International Business Machines Corporation—History. 2. Corporations—United States—History. 3. Industrial design. 4. Modern movement (Architecture)—United States. 5. Noyes, Eliot. 6. Rand, Paul, 1914–1996. I. Title.
HD9696.2.U64I2547 2011
338.7'6004097309045—dc23
2011031742

Printed in the United States of America on acid-free paper

The University of Minnesota is an equal-opportunity educator and employer.

18 17 16 15 14 13 12 11
10 9 8 7 6 5 4 3 2 1

On the way from mythology to logistics, thought has lost the element of self-reflection, and today machinery disables men even as it nurtures them.

Theodor Adorno and Max Horkheimer
Dialectic of Enlightenment

Contents

Introduction

The Interface

What remains for some design historian to elucidate some day is the precise chicken–egg
relationship that lies at the heart of . . . [the] uncommon relationship between designer
and corporation on the present US scene, and it has already become difficult to see how
it started. . . . Whatever the answer, the historical fact of Noyes's intervention remains,
and with it, the crucial influence of IBM on the appearance of computers.

Reyner Banham

Figure I.1 The IBM design consultancy: Eliot Noyes, with Paul Rand, George Nelson, Edgar Kaufmann Jr., and Charles Eames, from Hugh B. Johnston, "From Old IBM to New IBM," *Industrial Design* 4, no. 3 (March 1957).

The IBM Design Program

In February 1956, the president of the International Business Machines (IBM) Corporation, Thomas Watson Jr. (1914–93), hired the industrial designer and architect Eliot F. Noyes (1910–77). Given the title "consultant director of design," Noyes was charged with entirely reinventing IBM's corporate image, in parallel with Watson's decision to reorganize IBM's pyramidal managerial hierarchy into a more "horizontal," efficient structure. Noyes thus coordinated the redesign of the entire environment of IBM on a telescoping scale: from stationery and curtains, to products such as typewriters and computers, to laboratory and administration buildings, IBM was literally to become "simply the best in modern design."[1]

That a corporation would bring in a consultant designer or even multiple designers to reform its products, facilities, and even the behavior of its employees was not then a new phenomenon. Perhaps Noyes's most significant predecessor in this regard was Peter Behrens (1868–1940), whose work with the German industrial concern Allgemeine Elektrizitäts Gesellschaft (AEG) in the early twentieth century remains a central episode in the history of modernist design.[2] The parallels between Noyes and Behrens are striking and cannot be ignored. Behrens, like Noyes, worked primarily as an architect and designed buildings, industrial products, and graphics for AEG; Noyes, while he was content to commission graphics from his fellow consultant, Paul Rand, did much the same at IBM.

The Werkbund slogan that "Good Design Is Good Business" meant primarily, according to Noyes's architectural mentor at Harvard University, Walter Gropius (1883–1969), that "goods have become a means of carrying tastefulness and quality among large numbers of people. Not only have they earned themselves a reputation for promoting culture but, which is equally important in business, have considerably increased their pecuniary gain."[3] Good design was also meant to have a certain reformative impact on the functioning of a corporation.

A worker will find that a room well thought out by an artist, which responds to the innate sense of beauty we all possess, will relieve the monotony of the daily task and he will be more willing to join in the common enterprise. If the worker is happy, he will take more pleasure in his duties, and the productivity of the firm will increase.[4]

This corporate design ideology remained more or less intact in the post–World War II era—similar statements can be found in the decrees of Camillo and Adriano Olivetti, in the industrial and graphic design reforms of the Container Corporation of America under Walter Paepke and his consultant designer Herbert Bayer, and in many more instances besides.[5]

However, the design program at IBM introduced an additional and unique claim under the same aegis. Receiving an achievement award in design excellence from Tiffany in

1965, IBM's president and chairman Thomas J. Watson Jr. delivered a lecture—titled, in a conspicuous echo of the Werkbund, "Good Design Is Good Business"[6]—in which he stressed that corporate design was not simply a matter of establishing good taste among the consumer public, nor of simply keeping workers happily productive. It was a matter of management. Unlike AEG, with its industrial and consumer products, IBM's business was the administration of business itself. Whether its products—which were ways of thinking as much as they were office machines—were to be used for military, scientific, administrative, or business purposes, IBM's products and employees concerned themselves primarily with reforming the actual operation of other corporations and organizations ranging in scale from small business enterprises to universities to states. At IBM, the design program was to serve a control function; in harmony with the demand of the computer that all its data be processed in mathematical terms, the design program would seek to establish a material regime by, for, and of the logic of organization.

For this very reason Noyes, as *consultant* director of design, did not go it alone. Rather, he and his colleagues developed an entirely new approach to the problem of designing for the corporation in the post–World War II era. Assembling and directing a team of fellow consultants—including himself, Charles Eames, the graphic designer Paul Rand, the designer and critic George Nelson, and the architecture and design critic and patron Edgar Kaufmann Jr.—and hiring a host of high-profile architects such as Marcel Breuer, Egon Eiermann, Wallace Harrison and Max Abramovitz, Ludwig Mies van der Rohe, Paul Rudolph, and Eero Saarinen for individual commissions, and coordinating these efforts with engineers and designers in IBM's own design department, Noyes *managed,* perhaps more than he *designed,* the "new look" of IBM.

But what was management?[7] What was new about IBM that required such drastic changes in its material organization and appearance, and what was at stake in this transformation? Perhaps surprisingly given his infrequent, sober, taciturn statements on his work, Noyes provides ample insight into these questions. In 1976, reflecting back on his first days working for the corporation, Noyes noted that IBM's appearance was wholly out of step with its rigorous corporate organization.

When I first met IBM the large main company showroom in New York was a sepulchral place, with oak-panelled walls and columns, a deeply coffered painted ceiling, a complex pattern of many types of marble on the floor, oriental rugs on the marble and various models of back IBM accounting machines sitting uneasily on the oriental rugs. These accounting machines, I might add, often had cast iron cabriole legs in the manner, I believe, of Queen Anne furniture. . . . It said IBM about twelve times on the façade. . . . It also said, "World Peace through World Trade" and many other slogans.[8]

The layers of patterns—classical orders, coffering, marble inlays, oriental carpets, and historicist "furniture" of the business machines—all contrasted with one another, producing an incoherent image. Moreover, the vaunted slogans—many of them the products of a

cult of personality previously centered around IBM's president Thomas Watson Sr.—seemed to contradict one another, crowding each other out. As Noyes put it, in devastating terms, "It was design schizophrenia of the worst sort."[9]

But what was the unified subject that Noyes sought to articulate, in order to cure his patient of its fragmented self-image? IBM was not simply a maker of business machines, Noyes reasoned in an interview in 1966; rather, it was in the business of controlling, organizing, and redistributing information in space. This Noyes recognized as a matter of environmental control: "if you get to the very heart of the matter, *what IBM really does is to help man extend his control over his environment. . . .* I think that's the meaning of the company."[10] This was what Noyes called IBM's "corporate character," a quality that unified its various endeavors, from producing business machines to consulting with other companies about how to manage their facilities. As Noyes would emphasize again and again throughout his career, this process of management was one of controlling space.

Here Noyes was on firm ground. The word "management" originally connoted "the working or cultivation of land," and, later, "the maintenance and control of a forest, environment, nature reserve, etc."[11] But with the wholesale transformation of the nature and structure of business interests in the United States at the turn of the twentieth century, management took on yet another spatial dimension. In what has frequently been named by economic historians as the "management revolution," the "invisible hand" of Smith's "market mechanism" had been replaced by a "visible hand," where a well-organized entity termed the "modern business enterprise" increasingly played a central role in "coordinating the activities of the economy and allocating its resources."[12]

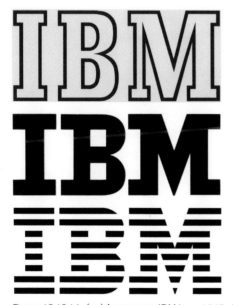

Figures I.2, I.3, I.4 *(top)* Anonymous, IBM logo, 1947; *(middle)* Paul Rand, IBM logo, 1956; *(bottom)* Paul Rand, IBM logo, second design, 1962. Courtesy of IBM Corporate Archives, Somers, New York.

The traditional business firm was a single-unit business enterprise, with a small number of employees engaged in a single economic function from a single office, dealing often with a single product line, in a single geographic area, and owned by an individual or family. In stark contrast, the modern business enterprise was engaged in multiple economic functions over vast distances and controlled by salaried executives presiding over a highly articulated and specialized hierarchy of employees. As Adolf A. Berle and Gardiner C. Means emphasized in their landmark study *The Modern Corporation and Private Property* (1932), the modern business enterprise parsed ownership of the corporation (by individuals and/or shareholders) from managerial control.[13] It is a truism of economic history that by 1917 this new type of firm "had become the dominant business institution in many sectors of the American economy," and that by 1950 it had become the dominant institution in nearly every sector.[14]

Largely missing from such accounts, however, is the specific role that nascent mathematical theories of information and communication, and the machines that were their material and practical embodiment, played in the further development of the interwar corporation from modern business enterprise to multinational corporation. The most admired current histories of corporations in this crucial period tend to deemphasize the role of mathematical and organizational theory in the reformation of the corporation, instead favoring fashionable—and pseudo-scientific or scientistic—theories of corporate "evolution." The best of these histories place heavy emphasis on close attention to corporate routinization, arguing that the most effective way to describe the way that corporations change is to pay close attention to the quotidian practices and procedures that animate a corporation's daily activity.[15] There is much merit in such accounts, given their attention to the specific functions of a corporate body while avoiding the oversimplifications and pop psychology of influential early sociological accounts, such as William H. Whyte's *The Organization Man* (1956).[16] However, these histories introduce or reproduce difficult problems, in that they refuse to state explicitly what the corporation is, seemingly taking for granted the notion that "IBM"—or any other corporation, for that matter—is a stable, fixable entity akin to an individual subject or coherent group subject.

This is, of course, anything but the case. As many scholars have pointed out, the legal theory surrounding the corporation is almost hopelessly fragmented, with competing and mutually contradictory theories—ranging from the storied "concessionist" or "grant" theories identifying the corporation as an "artificial person," to organicist theories based in German historicist thought, to "nexus of contracts" theories[17]—simultaneously operative in the day-to-day legal administration of economic activity. Even more troubling, the efforts of historians to narrate historical change either within individual corporations or in the economy at large has led to a series of mixed metaphors, in which "evolutions," "revolutions," and "developments" in corporate history are presented as though they were equivalencies, and in which the ostensible "natural" and "artificial" components or essences of corporate organizations are in competition with questions of "rights and duties." In this morass, it is difficult to parse out the significance of each theoretical approach and

Figure I.5 IBM punch card. Collection of the author, with thanks to Kevin Stumpf.

even more difficult to select a single theory to which one as a historian ought to commit oneself.

There can therefore be little question of producing a single theory of the corporation through which to analyze the history of a corporation such as IBM. As the philosopher, aesthetician, and pedagogue John Dewey argued in his attempt to address definitively these unsettling questions regarding the ontology of the corporation, one may regard each of these competing theories as an "extensive abstraction" possessing meaning insofar as they describe aspects of the corporation in relation to other phenomena.[18] That is to say, although the multitudinous efforts to pinpoint the modern corporation's essence may be of little value, it is possible to focus one's attention upon the consequences of an organizational form and the theoretical assumptions that are operative within that organization. This is what I pursue here, describing the role that design plays in reformulating many of the basic aspects of the corporation, with consequences for other organizations. Even if the corporation is irreducible to any one thing, to borrow from Marx, it is "a relationship between people mediated by things,"[19] and these people, things, and mediated relations can be described.

IBM, as a developer, manufacturer, and technical liaison for the use of teletechnological equipment—initially time systems, punch-card tabulators, scales, and the like, but later computers, real-time management systems, and Tele-Processing—was a corporation that managed the development of management as a central concept and set of techniques sustaining and renovating the modern business enterprise (i.e., the corporation). In its own words, repeated throughout much of its own promotional literature, IBM was a "business whose business was how other businesses do business." Moreover, its utter dominance of the computer market from the mid-1950s to the late 1970s—which, along with Paul Rand's logotype and color designs, earned it its nickname Big Blue—ensured that whatever IBM produced was installed at the very heart of most modern corporations.

Whether a corporation produced raw materials (e.g., agricultural, mining, and milling concerns), refined industrial products (e.g., construction and manufacturing concerns), or services (e.g., shipping, retail, and professional concerns), or a combination of any or all of these, IBM provided the computer systems and expertise to reorganize it into a business that relied heavily upon the most sophisticated management and logistics techniques available.

Therefore, rather than historicize and theorize IBM's Design Program as one case among many others, or even as a case of exemplary importance (although both are certainly accurate descriptions to a certain extent), this book proposes that IBM's self-articulated corporate character makes it a determining case. By articulating not just how IBM's products would look, but how they would be deployed in space, how they would be designed through coordinated teamwork by literally tens or hundreds of architects, designers, and engineers using both drawing boards and advanced teletechnological equipment, and how end users would interact with this equipment, the design program at IBM elaborated theoretical positions and set standards of practice that quite literally changed the technics of corporate and architectural culture alike. The design program was, in its own right, a work of corporate theory and practice. By understanding it, we may come to understand more about its contemporary corporations that so reshaped the global economy, whether they adopted IBM's specific approaches to corporate practice or not.

The following chapters will treat the specific structure of the landmark program at IBM as articulated by Noyes and his clients in close detail; however, before turning to a brief overview of these questions, it is essential to note one last aspect of the relationship between design and management, in order to understand what the design program's stated aim of achieving something called "design management" might be.

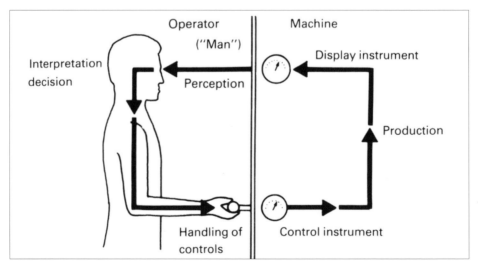

Figure I.6 Etienne Grandjean, diagram of the "man–machine system," from *Fitting the Task to the Man: An Ergonomic Approach,* trans. Harold Oldroyd, 3rd ed. (London: Taylor and Francis, 1980).

Management, although it is a coordinated practice of controlling behavior in space and possesses firm diagrammatic forms and strategies, does not articulate how objects and products are distributed in space in any detailed or descriptive way. As is clear from a cursory examination of any number of textbooks, primers, or handbooks on the subject, management deals with generalities—or at best, it can cope with the situation. In order to develop a consistent and detailed approach to objects and products, management requires another, finer-grained level of articulation that can situate. This discipline is logistics.

Like management, logistics is primarily a spatial discipline; the word is derived not, as one might expect, from the protean *logos,* but rather from the French *loger,* to lodge or house.[20] It is the art of placing each thing (persons/troops, facilities/emplacements, supplies/materiel) in its proper place at its proper time. What is surprising about both management and logistics is that even though they are so directly concerned with spatial organization, their main representational tools are only rarely spatial in any conventional sense. Rather than moving models of weapons/products/people across a model territory, practitioners of management and logistics deploy diagrams—flowcharts, homonculi, regressions, etc.—to model the space and time of the territory under their control. These models are topological, describing only those aspects of the objects represented that are relevant to the logistical process.

Sophisticated logistical systems operate by reducing all objects to be manipulated to numbers. Objects, processes, and even people are literally evaluated, so as to be manipulable through specific algorithms. Whether this remediation is accomplished through ledgers, punch-card machines, or digital computers (or, indeed, all of the above) is only an index to the specific qualities of a logistical system; all logistical systems essentially perform this single, albeit complex, function. Although many such systems predate the 1940s (such as military, transportation, and product-distribution networks[21]), the invention, distribution, and use of the digital computer in the decades immediately following World War II brought logistics into full maturity. For this translation from object to number to take place, there must be a site and apparatus that performs this evaluation, a hinge between the world of things and the world of numbers. This hinge is what I identify throughout this book as the *interface.*

The Interface

Originally coined in the 1880s as a scientific term for the surface along which two adjacent bodies meet, the term "interface" was taken up by the nascent discipline of ergonomics in the late 1940s to describe the site at which the human body interacts with a complex mechanical apparatus.[22] The interface is the crucial but often overlooked element in what ergonomics identifies as the "man–machine system." It is the hyphen between "man" and "machine" that articulates the system as a whole. Whether it is a screen, a keyboard, a sitting surface, a proscenium, or a curtain wall (and it is often all of

these and more), an interface is a complex apparatus that appears as a simple surface. Although it seems to be unitary, it is always fragmentary and complex; although it seems to be two-dimensional, it is always at least three-dimensional and rendered in depth; although it seems to be solid and impermeable, it is always carefully perforated to allow strategically mediated interactions between man and machine.

Describing the design program at IBM in terms of its multiple media or interfaces has several advantages. First of all, it helps to avoid the potential problem of attributing systematic integrity to the program itself—that is, describing all efforts at system-building as systems in a rigorous sense, which is a constant threat to the historian of the information age.[23] The interface is by definition a coordination between two or more agents in a putative system, and by refusing to represent it as a simple relationship between a single subject and a stable set of objects, one avoids the tendency to fix the history of its developments into a single perspective. As Hubert Damisch has argued, "an image constructed in perspective—figurative or other—can be made perfectly coincident, optically speaking, with its object, such that it could be precisely superimposed over it or screen it out perfectly, *but only if it is seen from the fixed point of view of an observer who could take in both of them in one glance.*"[24] Identifying the existence of multiple interfaces, made visible only by considering the situation from multiple points of view, allows me instead to call attention to the very real difficulties that Noyes and his colleagues encountered in developing the design program at IBM systematically, and the program's eventual failure to outlast the lives of its main protagonists, Noyes, Eames, and Rand.

More importantly, though, the interface draws our attention away from (long-lived and insidious) superficialities such as style, and instead toward the way in which these multiple media were intended to relate to one another. For example, rather than trust that asking what a particular building looks like is a self-evident proposition central to architectural history, this book asks how that building was meant to function topologically, as part of a larger technological and economic apparatus. As Jean Baudrillard hypothesizes in his landmark critique of postindustrial society, it is a matter not of objects but of a system of objects. This system eschews means–ends rationality even as it is produced by it:

"functional" in no way qualifies what is adapted to a goal, merely what is adapted to an order or system: functionality is the ability to become integrated into an overall scheme. An object's functionality is the very thing that enables it to transcend its main "function" in the direction of a secondary one, to play a part, to become a combining element, an adjustable item, within a universal system of signs.[25]

To be sure, the object's appearance is of significance—and no corporate design and propaganda machine was as efficient as IBM's in exploiting the visual elegance of its buildings and products—but only insofar as that appearance did not impinge on, and indeed answered directly to, the very real functional and economic demands placed upon architecture by the corporation's various departments.

Analyzing the interface also allows an architectural history to extend its scope beyond the building to the other, related, media that were so crucial to the overall conception of the IBM Design Program: graphics, industrial design, multinational production networks, and exhibition and spectacle design. As I have already suggested, all of these, alongside architecture, were understood by the managers and design consultants at IBM as media not only in an artistic or material sense, but also as means of communication: ways to integrate and organize a vast, far-flung corporate enterprise into a coherent, organic whole.[26] Furthermore, rather than simply mobilize—as many recent histories of corporate design culture have done[27]—archival afflatus such as advertising, corporate ephemera, corporate documents and memoranda, designers' biographies, and so on in the service of explaining buildings or industrial products, treating each of these media as interfaces through which material objects and actions are translated into information and vice versa allows the architectural historian the ability to explain how architecture in turn serves to organize institutions through means well beyond standard approaches to spatial form.[28] As I have already noted, corporations are hardly unitary subjects, and thus it is crucial not to essentialize corporate behavior, interpreting advertising campaigns or product research and development as the product of a single imperative rather than of a fragmentary and incomplete process. As Noyes repeatedly emphasized throughout his corporate consulting career, "a typewriter sits in a room in a building. There *must* be a sense of their relationships in each of these."[29] However, these relationships are anything but secure.

Finally, the recent imperatives to digitize architecture in widely varying areas of architectural culture can only be poorly understood without understanding the history of that digitization itself. Although this book does not treat many of the landmark efforts to create "architecture machines,"[30] it does provide a detailed account of how architects became involved with computation in the very first instance. The genesis of the school of design theory known as "design methods"[31] that sought to reduce design to an internally consistent algorithm for making design decisions based upon a systematic aggregation of numerical data—an ideology strongest at the Hochschule für Gestaltung at Ulm, at several schools in the UK, and at MIT, but with adherents throughout the world from the early 1950s to the present day—can be better understood through paying careful historical attention to the mediatization of architecture and industrial design.

The structure of this book follows the imperative to pay attention to the emergence of this interface-based approach to design and its theoretical reformulation. It moves, as it were, upward and outward in scale, from the articulation of theoretical positions to graphics, industrial design, architecture, planning of multinational installations, and exhibition and spectacle design aimed at an international public.

The first chapter, "Eliot Noyes, Paul Rand, and the Beginnings of the IBM Design Program," begins with a brief genealogy, tracing the theoretical influences that contributed more or less directly to Eliot Noyes's outlook on design. Beginning with Peter Behrens, the leading design consultant to the German industrial concern AEG, and then moving

to Walter Gropius (the Bauhaus director, Harvard professor, and Noyes's teacher and employer), and ending with the theory of industrial design current when Noyes graduated from architecture school, this chapter establishes (1) that Noyes may be seen as a direct descendant of the main currents of German architectural theory of the turn of the twentieth century and of the interwar period; and (2) that Noyes decisively departed from certain aspects of that theory by aggressively asserting the need to extend the designer's purview beyond the industrial product.

The next two sections of the chapter follow Noyes's early career, from his education, to work as the first curator of Industrial Design at the Museum of Modern Art (MoMA) in New York, to his first projects for IBM (done before any formal consultancy was established). This biographical approach is accompanied by critical readings of Noyes's writings and designs, which serves to establish the intellectual and practical background that Noyes brought to the IBM Design Program. Here I explore Noyes's assertions that all design must be organic and that designed objects must be continually and actively redesigned in order to perform effectively.

Finally, this chapter describes the beginnings of the formal design consultancy—its articulated theoretical assumptions, managerial structure, and goals—with particular emphasis on the graphics program under Paul Rand. It provides a detailed analysis of Rand's decisive retheorization of the trademark as the crucial functional element for ensuring corporate cohesion and explains how Rand's approach to systematizing the graphics program for IBM became a paradigmatic approach in other areas of the design program, such as industrial design and architecture.

Chapter 2 offers what is, to my knowledge, the first critical history of architects' and industrial designers' unusual, crucial, and wholly ignored role in the design of computers, from IBM's early digital computers up through the landmark design of the System/360, announced in 1964. It begins with a fundamental rereading of the early history and theory of computers, placing emphasis on the spatial and temporal aspects of the basic concepts and technologies that contributed to the invention of the digital computer. In short, I argue that the computer was and remains a technology that is conceived of in architectural terms, even before John von Neumann articulated what was to become known as the computer's architecture. Building on the rich trove of information in Eliot Noyes's archive, this chapter demonstrates that Noyes and his collaborators at IBM set ground rules for articulating the physical and psychological relationship between people and computers that prevails today. This is the provocative theory—first stated by an unlikely contributor, the critic and curator Edgar Kaufmann Jr.—that the space of computing is to be divided in architectural terms into a "parlor" (i.e., the space that the computer operator inhabits, or interface) and a "coal cellar" (the concealed, distant space in which the machine itself operates). The final section of the chapter describes the architectural and spatial implications of this parlor through an analysis of a curious building designed by Eliot Noyes as the archetypal space for computers—a shed known as the "white room,"

which has become a universal architectural metaphor for computational teletechnologies. The uncanny spatiality of this building became paradigmatic for IBM's architectural program, and my description of it here serves as the basis for the following account of IBM's architecture under the auspices of the design program.

Chapter 3 historicizes and theorizes how Noyes and IBM reconceived the fundamental approach to corporate architecture as a "counterenvironment," an enclosure organized over and against the surrounding, disorganized environment. The corporate counterenvironment, rather than simply being a container for the management systems and computers that became IBM's main business, were instead understood by their designers and users alike as technical. Just as were its graphics and products, IBM architecture was a medium of communication, designed to facilitate connections between installations across the globe. Although IBM, on the advice of Noyes, commissioned buildings from leading architects in the United States and elsewhere, these were most emphatically *not* buildings and campuses meant to be seen as the signature of work of those architects. As the designs of these early buildings strongly suggest, and as IBM's development of a Real Estate and Construction Division (RECD) to oversee the growth of its physical plant through a coherent system of building production and management decisively proves, "simply the best in modern design" meant not glamour but the redesign of architecture itself into a data-processing machine that operated at representational and technical levels.

The next chapter treats IBM's efforts to manage the persistent crises its activities provoked in political and cultural debates. It begins with an account of IBM's failed first attempts at allaying the public's suspicion that the computer and automation in general were sinister forces that threatened Enlightenment values such as individuality and freedom (not to mention labor). Through the intervention of the Eames Office, IBM began a vast, two-decadelong campaign in the late 1950s to naturalize the computer. This campaign was conducted in multimedia barrage, beginning with exhibitions and films, and concluding with the production of overwhelming spectacles meant to convince the public of two seemingly contradictory ideas, each a contradiction in its own right: first, that the computer was a wholly natural tool, capable only of what human beings could command it to do; and second, that the computer was a force that would radically and even magically change the world.

The Eames Office succeeded beyond IBM's wildest expectations through the use of two main strategies. First, it aimed not to explain away such contradictions, but rather to multiply them. In writing and design alike, the designers in the office who worked on the IBM projects—foremost among them Charles Eames, Glen Fleck, and Parke Meeke—collaborated closely with IBM's own researchers, scientists and engineers from the Rand Corporation (located only a few blocks away from the Eames Office in Santa Monica), and leading academics to demonstrate to IBM's managers and the public alike that the computer's purported natural and magical qualities were complementary. Second, the

Eames Office pursued a heuristic design strategy, of placing the exhibition or spectacle viewer in a space that appeared to be free of any formal or overriding regulation, when in fact providing that freedom guaranteed the invisibility of a rigorously conceived and executed pedagogical program. This two-pronged project culminated in a largely forgotten, decadelong project to build an IBM Museum, which would place its visitors inside an invisible computer built at architectural scale with multiple interfaces.

IBM's Design Program gave birth to similar consultancies (although none would be quite so elaborate or enduring) at corporations at several points in the supply chain of industrial production and services. Noyes presided over three of the most significant: Westinghouse Electric (1960–77), Mobil Oil (1964–77), and Pan American Airlines (1969–77). Noyes also began shorter-lived consulting programs at Cummins Engine and Xerox, among others, all the while employing his trademark mixture of in-house design teams and high-profile designers toward the ultimate goal of creating an autonomous and automatic system of design. These simulacra are briefly treated in the conclusion, along with some closing remarks on the degree of success that Noyes and his collaborators achieved in pursuing a redesign of design through the development of the interface and its subsequent impact on architecture and teletechnology alike.

Chapter 1

Eliot Noyes, Paul Rand, and the Beginnings of the IBM Design Program

Particularly in the past fifty years the world has gradually been finding out something that architects have always known—that is—that everything is architecture.

Charles Eames

The Synthesis of Architecture and Industrial Design

In describing the genesis of the IBM Design Program, as Reyner Banham suggests, one is indeed dealing with both chickens and eggs. This "uncommon relationship" was, in the 1940s and early 1950s, still a rapidly changing one, and the establishment of the even more unusual relationship between Eliot Noyes and IBM marked yet another shift. One can do worse than to choose to begin with the chick, as it begins to emerge from its shell.

Eliot Noyes came from a reasonably well-to-do New England family, whose ancestors dated back to the first English settlers of North America, and he grew up steeped in the Puritanical ethos of Massachussetts.[1] Modesty and a rigorous work ethic were the most admired traits in his family; his father, a professor of English literature at Harvard, referred to himself as a "teacher." Noyes graduated from Harvard College in 1932 and immediately enrolled in the Harvard Graduate School of Architecture the following autumn. He clearly showed promise as an architect, and especially as a draftsman, and was awarded the Eugene Dodd Medal for a student project in 1935. However, Noyes found the curriculum, then still largely under the classicizing influence of the École des Beaux-Arts, wholly stultifying. The novel theories of the European avant-gardes had been circulating among the students at Harvard and elsewhere for some time; along with many of his fellow students, he had surreptitiously picked up a copy of Le Corbusier's *Vers une architecture* (by then available in English in Frederick Etchell's 1927 translation *Towards a New Architecture*). He also seems to have begun to read the small number of publications in the United States at the time on architectural modernism; but the curriculum at Harvard contained nothing of the excitement and social import that the architecture of the European avant-gardes and Frank Lloyd Wright stimulated in him and his young colleagues. Frustrated, Noyes left the school, before completing his degree, in 1935. Putting the skills he had acquired in architecture school to use, he joined an archaeological expedition as a renderer and watercolorist, documenting the finds of an excavation at Persepolis. While there, the expedition surveyor taught Noyes to fly gliders over the desert, stimulating a life-long fascination with flight and an eventual expertise as a glider pilot.

When he returned from Persia in 1937, Noyes found the Harvard architectural curriculum entirely transformed. The founder of the Bauhaus, Walter Gropius, had been appointed to the faculty following his flight from Nazi Germany and a brief stint in England, and Gropius had brought modern design and the experimental pedagogy of the Bauhaus to the fore of the curriculum.[2] Stimulated by the new approach, and by his interaction with one of Gropius's key additions to the faculty, his partner and former fellow Bauhäusler Marcel Breuer, Noyes became a star pupil, earning the Alpha Rho Chi Medal and another medal from the American Institute of Architects in 1938 for his efforts. After working as a draftsman in the offices of the venerable Boston firm Coolidge, Shepley, Bulfinch, and Abbott, Noyes entered Gropius and Breuer's studio as a draftsman in their own firm.

Under Gropius and Breuer's tutelage, both at Harvard and in the firm, Noyes certainly absorbed the Bauhaus ethic; however, he also participated in the translation of the ideas of the European avant-garde into the context of New England. As Barry Bergdoll, following H. R. Hitchcock, has convincingly argued, Breuer had already made an effort in Europe to incorporate "vernacular" materials such as fieldstone and timber into his decidedly modernist aesthetic, notably in the Gane Pavilion in Bristol (with F. R. S. Yorke, 1936) and his unrealized design for a ski hotel in Tyrol, Austria (1937).[3] Gropius and Breuer's collaborations in Massachussetts, such as the Gropius House in Lincoln (1937), completed this synthesis. Noyes's own first house design, for the Jackson family in Dover, Massachussets (1940–41),[4] is in much the same vein, perfectly echoing the European modernist admiration for the informal flexibility of American farm houses as expressed eloquently in Siegfried Giedion's influential survey *Space, Time and Architecture.*[5]

Noyes sustained this hybrid approach to design, blending high modernism with traditional techniques, throughout his career. Many years later Noyes, characterizing both his own architecture and that which he had commissioned for IBM, identified himself, paradoxically, as being on the "conservative side of the avant-garde."[6] Yet despite this apparent conservatism, a certain understatedness that has in all likelihood contributed more than any other factor in his work being ignored by architectural historians, Noyes's synthetic approach—both to architectural style and, eventually, to the integration of architecture with industrial design—was a form of radicalism all its own. The motivation for this synthesis was, in all probability, instilled in him during his later years at Harvard.

By the time Gropius arrived in Cambridge, he had long valorized the emerging profession of industrial design as a model for the transformation of the role of the architect in an increasingly industrialized economy and continued to do so well into the 1950s. This sustained interest was, Gropius readily acknowledged, the result of his formative years working in the office of a leading member of the Werkbund and pioneer in corporate design, the German architect Peter Behrens. Gropius appears to have saturated the young Noyes with the ideas he had gleaned while in Behrens's office and with the ethos he had developed as the founding director of the Bauhaus.

Behrens's work as the first true corporate design consultant and the concomitant theories he developed to justify and extend that work are very well documented and analyzed.[7] But it is of the utmost importance to draw out the central tenets of Behrens's theoretical approach if we are to understand how it influenced—via Gropius—Noyes and his contemporaries.

Despite his reputation as one of the first modern industrial designers, Behrens's attitude toward technology was deeply ambivalent, occasionally even hostile. As his foremost biographers, Stanford Anderson and Tilmann Buddensieg, have argued, Behrens was both well versed in and stood in direct opposition to the long tradition of tectonic theory in German architecture and aesthetics. Accepting rather Alois Riegl's concept of *Kunstwollen,* Behrens held that if the industrial product was to attain a status as a defining

element of *Kultur,* it required the intervention of the artist. As he lectured in 1910 (precisely when Gropius was working in his studio),

as the Viennese scholar Riegl has put it, "[Gottfried] Semper's mechanistic view of the nature of the work of art should be replaced by a teleological view in which the work of art is seen as the result of a specific and intentional artistic volition that prevails in the battle against functional purpose, raw materials, and technology." These three last-named factors lose, thereby, the positive role ascribed to them by the so-called Semper theory, and take on instead an inhibiting, negative role: "... *they constitute, as it were, the co-efficient of friction within the overall product.*"[8]

The technological and material basis of the industrial product, Behrens argued, was a drag. It prevented the designer from realizing truth in form, rather than being the material basis for articulating that truth. This theoretical claim is in ready evidence in Behrens's many designs for AEG, perhaps nowhere as clearly as in his famous design of 1910 for a turbine factory in Berlin. The temple-like articulation of the architecture, with its massive piers and pediment inscribed with the firm's logo, is little more than show, meant to glorify the role of industry in leading toward the production of art. As Stanford Anderson and many others have argued, the building is an exercise in atectonic tensions, its outer form at odds with the technologically advanced steel hinges and trusses that hold it up.

In the very same year as Behrens completed this ambivalent masterpiece, however, another approach to the unity of industry and art emerged, from within the confines of Behrens's own office. In the "Program for the Founding of a General House-Building Company with Uniform Artistic Principles" (1910), written as a report to Emil Rathenau, the director of AEG,[9] the young Gropius dreamt of "the happy union between art and technics" that would result when architects and artists acknowledged, as Tilmann Buddensieg has put it, that "the undoubted and unavoidable advantages of technology and the elimination of handcraftsmanship, when coupled with mass production, guaranteed 'an exemplary standard' and 'superior quality.'"[10] It would be several years before Gropius began to steer the Bauhaus in this direction, eliminating handcraft and celebrating the machine as the basis of a modern aesthetic; but nonetheless after 1910 the tide had turned away from the idealism of Behrens and toward that of Gropius. As is well known, Le Corbusier and Amédée Ozenfant's influential theory of the *objet type*— the useful object formed directly from the requirements of its use, such as the wine bottle, the briarwood pipe, etc.—and the *sachlich* theories of various European avant-gardists began to articulate the problem of design as one of deriving the form of an object from its particular functions.

Gropius's initial Rieglian suppositions about the relationship of art to technology were yet further altered in the American context. There Gropius and his followers encountered a nascent, harder-edged theory, one that proposed a more direct relationship between the function of an object and its form. Closer to Semper than to Riegl in its inspiration,

and more directly informed by nearly a century of "functionalist" aesthetic theory (dating back to the writings of Horatio Greenough in the 1820s and 1830s),[11] American theory on industrial design eliminated the need for an artistic interpretation of the form of both the machine and its products almost entirely.

The term "industrial design" first appeared in America in 1919,[12] but usually product designers referred to themselves as "artists in industry."[13] It was not until a generation of young designers—among them Raymond Loewy, Walter Dorwin Teague, Henry Dreyfuss, Norman Bel Geddes, and Egmont Arens—emerged as self-identified industrial designers that the discipline gained legitimacy through their numerous high-profile commissions for products ranging from kitchen appliances to steamships.

In these designers' theoretical writings,[14] every bit as much as in their streamlined designs, the drag of the industrial product was to be alleviated by changing the form of the product itself. At first glance, the theory is similar to Behrens's, right down to the choice of metaphors (friction/drag/flow); however, this transformation was not, as per Behrens, to be effected through the intervention of Art, understood as an ideal form unencumbered by material concerns. Quite the opposite. Drawing heavily upon the metaphors of "experience," "rhythm," and "resistance and conflict" in the aesthetic theory of the American pragmatist philosopher John Dewey,[15] these new industrial designers proposed that the pinnacle of art would be reached when it had assumed the form of the machine, translating that form into a powerful aesthetic experience. Thus images of ball bearings, airplane and ship propellers, animals, eugenically perfect human bodies, and so forth were meant to indicate an already extant functional and aesthetic ideal state that other products had not yet achieved.

Perhaps the pinnacle of this new "machine aesthetic" was the exhibition, held at MoMA in 1934, *Machine Art* (Figure 1.1). Curated by the young architect Philip Johnson and Alfred Barr Jr., the MoMA show valorized these industrially produced objects as works of art in their own right (albeit carefully described throughout the exhibition and its catalog as a special category of art, "machine art"). As Barr wrote in his forward,

a knowledge of function may be of considerable importance in the visual enjoyment of machine art. . . . Mechanical function and utilitarian function—"how it works" and "what it does"—are distinct problems, the former requiring in many cases a certain understanding of mechanics, the latter, of practical use. Whoever understands the dynamics or pitch in propeller blades or the distribution of forces in a ball bearing so that he can participate imaginatively in the action of mechanical functions is likely to find that this knowledge enhances the beauty of the objects.[16]

Thus the door was opened for a new kind of expert, the designer with sophisticated knowledge of mechanical processes. Yet the exhibition also opened the museum to the corporations that had produced the hundreds of objects on display: Alcoa, U.S. Steel, Bingham Stamping and Tool, America Sheet and Tin Plating Company, and American

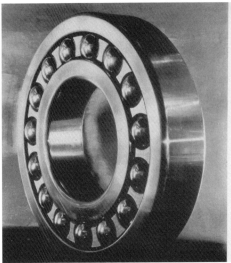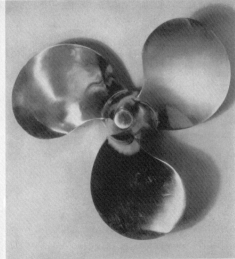

Figure 1.1 SKF Industries self-aligning ball bearing and Alcoa outboard propeller, from the Museum of Modern Art, *Machine Art,* curated by Alfred Barr Jr. and Philip Johnson, 1934. Courtesy of the Museum of Modern Art, New York.

Radiator, among others, were listed on the walls in the gallery, just as individual artists might have been for an exhibition of paintings.

Awash in this heady theory, Gropius continued to emphasize the need for a new kind of artist-technician to respond to the increasingly important role of industry in architecture and product design. In summing up the development of his views from the 1920s to the 1950s, Gropius prophesied that "the contemporary architect" would fulfill the "historical mission" of architecture: "the complete co-ordination of all efforts in building up man's physical environment."[17] In announcing his agenda for transforming the curriculum of the Harvard Graduate School of Architecture in 1937, he demanded that the architect be trained to coordinate the application of various forms of scientific and technical knowledge; no longer a specialist, the architect would be a kind of professional visionary.

Good architecture should be a projection of life itself and that implies an intimate knowledge of biological, social, technical and artistic problems. But then—even that is not enough. To make a unity out of all these different branches of human activity, a strong character is required and that is where the means of education partly come to an end. Still, it should be our highest aim to produce this type of men who are able to visualize an entity rather than let themselves get absorbed too early into the narrow channels of specialization. Our century has produced the expert type in millions; let us make way now for the men of vision.[18]

Noyes, who remained unrestricted by the "narrow channels of specialization" throughout his career, seems to have embodied Gropius's call for a new kind of architect—and, moreover, he was one who could grasp the dynamics of the modern industrial corporation with a thoroughness and familiarity that continued to elude the older European.

Eliot Noyes and "Organic Design," 1940

Noyes was the beneficiary of Gropius's newfound influence upon the American scene when he was appointed as the first curator of Industrial Design at MoMA in 1940.[19] It was in this position that Noyes made his first important efforts at articulating the design of the liminal space between human beings and machines. Just as importantly, it was also his first opportunity to collaborate with two designers, Eero Saarinen and Charles Eames, and with the design editor of *New Directions,* the architectural critic and patron Edgar Kaufmann Jr., all of whom would become lifelong friends and allies in a joint effort to redefine corporations through design over the ensuing three decades. Noyes's first exhibition, the now-famous competition *Organic Design in Home Furnishings,* of the following year (Figure 1.2),[20] fittingly served as his point of entry into, and a kind of prospectus for, the remainder of his career in architecture and industrial design. On the inside cover of the intensely polemical catalog documenting the results of the exhibition, Noyes set the terms of the competition with his definition of "organic design" by drawing an explicit connection between the quality of being "organic" and the "harmonious organization" of disparate parts in space.

A design may be called organic when there is an harmonious organization of the parts within the whole, according to structure, material, and purpose. Within this definition there can be no vain ornamentation or superfluity, but the part of beauty is none the less great—in ideal choice of material, in visual refinement, and in the rational elegance of things intended for use.[21]

This last statement is telling, since the competition was as much a business deal as a museum exhibit; following Kaufmann's plan for *Organic Design* and the annual exhibitions in a similar vein that would—Kaufmann hoped—follow, each of the winning designers was awarded a production deal with a large-scale manufacturer and a distribution contract with a major American department store.[22] However, the concluding phrase—"rational elegance of things intended for use"—also carries within it an implied dynamic relationship between the industrially produced object and its subject (the user). The "purpose" of the objects exhibited in *Organic Design* was not simply to be sold, but also to integrate themselves into a productive whole, a domestic space that includes in it furniture and the human beings who use that furniture. As John Hay Whitney put it at a luncheon in June 1941 honoring the winners of the competition,

There was a time in our Puritan background when to want to be comfortable, to care about, even to know about, the beauty of one's surroundings was considered soft if not sinful; but today's sociologists, psychologists, and those engaged in the physical as well as the social sciences agree that efficiency and happiness result from an environment which is both comfortable and beautiful.[23]

Noyes, as a product of this selfsame Puritan ethic, sought to redefine comfort on a scientific basis—it was not indulgence, but necessity. Thus Noyes stressed in *Organic*

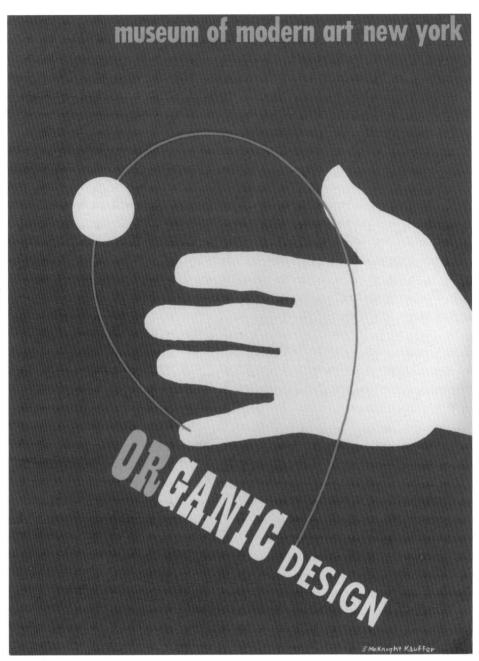

Figure 1.2 Eliot Noyes, *Organic Design in Home Furnishings* (New York: Museum of Modern Art, 1941). Cover design by Edward McKnight Kauffer.

Design not only the role of the machine in design and production, but also its instrumental and metonymic power as an industrial object: the ability of the machine, as part, to enrich society, the whole. Also on the inside cover, alongside his own definition of organic design, Noyes included two quotations from Lewis Mumford:

Our capacity to go beyond the machine rests in our power to assimilate the machine. Until we have absorbed the lessons of objectivity, impersonality, neutrality, the lessons of the mechanical realm, we cannot go further in our development toward the more richly organic, the more profoundly human.

The economic: the objective: and finally the integration of these principles in a new conception of the organic—these are the marks, already discernible, of our assimilation of the machine not merely as an instrument of action but as a valuable mode of life.[24]

Here was the central problem of design, as Noyes saw it in 1940. The chair and the living room were points of interface between the human and the machine. The success of that interaction hinged on the development of a newly organic—that is, newly organized—relationship between human being and machine. Built into Noyes's and Mumford's equation is a process of effacing the boundary between human being and machine, as both subject and object comfortably inhabit and identify themselves with one another. Mumford's emancipatory tropes of "assimilation," "absorption," and "integration" point toward a new "mode of life" in which the relationship between human beings and machines transcends the simple performance of work.

Both of the above quotations are taken from the seventh chapter—"The Assimilation of the Machine"—of *Technics and Civilization* (1934), in which Mumford articulates a theory of a newly emerging, and inherently complex, mechanical and informational environment built up out of machines and their effects. The inherent complexity of this mechanical environment, according to Mumford, threatens to prevent the human being from effective assimilation and integration.

We need to guard ourselves against the fatigue of dealing with too many objects or being stimulated unnecessarily by their presence, as we perform the numerous offices they impose. Hence a simplification of the externals of the mechanical world is almost a prerequisite for dealing with its internal complications. To reduce the constant succession of stimuli, the environment itself must be made as neutral as possible.[25]

It is thus the role of the designer to effect this "simplification," in effect to generate a "neutral" environment at the level of the outside ("the externals") of the machine. That is, Mumford proposes an apparently paradoxical operation: in order to effectively manage the complexity of the mechanical environment and thus organically integrate themselves with machines, human beings must first cover over that complexity with a layer of representations that will mediate the dynamic exchanges between them and machines. This

process of covering over and mediation, as much a matter of language as it is of space or environment, is precisely the act of design in a specific mode that would eventually become known as ergonomics. The identification of design—whether graphic, industrial, or architectural—with this process is thus the explicit goal of Organic Design, and it is in the objects and methods produced by the exhibition that the stakes of this reorientation of design began to become clear.

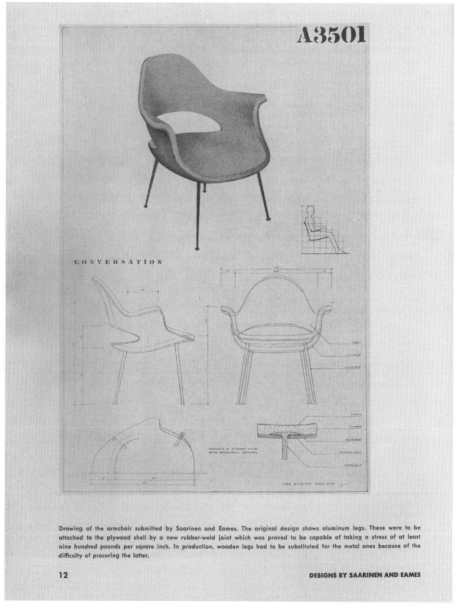

Figure 1.3 Charles Eames and Eero Saarinen, "Conversation" chair, 1940. *(above)* competition entry; *(facing)* construction. From Noyes, *Organic Design in Home Furnishings.* Courtesy of the Museum of Modern Art, New York.

Noyes defined design, albeit implicitly, as a matter of teamwork. The exhibition was itself a collaboration between museum, designers, and corporations, and all of the winners of the competition, with the exception of textile designers, were teams of two or more designers.[26] Significantly, the overwhelming winner of the competition was the team of Eero Saarinen and Charles Eames, two young architects who had met while teaching at the Cranbrook Academy, and with whom Noyes was to collaborate frequently over the

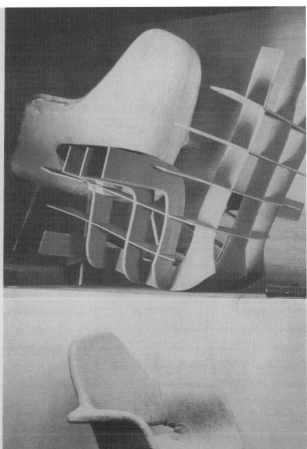

The chair was made first of plaster on wire mesh reinforcing. In this way it was carefully molded to give maximum support and comfort to the body. Adjustments were made by fracturing the plaster shell and re-setting it correctly. In order to record the concave form thus obtained, a light crate of strips of masonite was made. These strips followed the contours, and when assembled as in the photograph, recorded the modulations of form inside the chair.

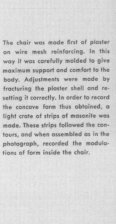

From the crate, which defined the form, a cast iron mold was made, and the wood shell of the final chair was glued up in this mold by the Haskelite Corporation. Shells were then trimmed, fitted with rubber, finished, and upholstered by the Heywood-Wakefield Company. A special patented joint holds the wood legs firmly to the shell whether there is expansion or contraction of the wood. The finished armchair, covered in a fabric by Marli Ehrman, is shown at right.

DESIGNS BY SAARINEN AND EAMES Very good
Should be in taupe material as exhibited 13
$75

course of the ensuing decades. The pair took the two most important categories—living room and chair design (Figure 1.3)—with their innovative reformulation of the entire problem of designing a chair "as a problem of making a three dimensional form to fit the human body."[27] This they achieved by developing a method of "anthropomorphic-ally" bending plywood; in its preliminary report, the judges praised the two designers, "whose submissions matched a reasonable and intelligent structural idea with a brilliant aesthetic expression."[28] This *aesthetic* feat, which related the human body to the chair in an entirely new way as the meeting of two identically shaped surfaces, proved to be what Bloomingdale's would label in its catalog as "revolutionary";[29] it was only *after* Noyes and the jury had decided on the winning entries that Noyes elected to name the exhibi-tion—thereunto known blandly as the "Industrial Design Competition"—*Organic Design*.

In a brief essay on "Chair Construction" in the catalog, Noyes described a trend toward lighter furniture through the rational application of structural principles. The traditional armchair, built by hand and a "gargantua" weighing as much as forty-five pounds, was gradually being superseded by chairs built out of less material and designed to be mass-produced by machines. To illustrate the point, Noyes included just such an armchair in the exhibition, haphazardly torn apart and locked in a steel cage in front of a photo of King Kong and identified by a large sign reading: "*Cathedra Gargantua,* genus Americanus. Weight when fully matured, 60 pounds. Habitat, the American Home. Devours little children, pencils, fountain pens, bracelets, clips, earrings, scissors, hairpins and other small flora and fauna of the domestic jungle. Is rapidly becoming extinct."[30] The humor-ous but critical point was clear: the problem with such chairs was not just their size but also their depth. The chair, Noyes implied, needed no depth, but only a structure and a functional surface. By applying modern structural principles, such as that of the S-curve spring, and by forming the chair out of more rigid materials that would nonetheless accommodate the human body, designers could produce chairs of "extreme elegance" along rational lines. According to Noyes, Saarinen and Eames had developed "the most advanced of all these systems," in which "the principle . . . is that of continuous contact and support."[31]

In this respect, Noyes's theory of chair design most probably arose out of the lessons of his teacher and friend Breuer. While not a prolific or very gifted writer, Breuer had already presented a theoretical manifesto on chair design in graphic form in his "ein bauhaus-film, fünf jahre lang" (1926). The poster Breuer designed—although he claimed its "author" was "life" itself—showed a film strip framing photographs of six chair de-signs, each set unoccupied against a white backdrop, and each marked with a date, clearly demonstrating a historical progression in which the chairs became progressively lighter and more flexible in structure. The first was his "African" chair of 1921, designed with Gunta Stötzl; the second, third, and fourth his slatted and woven chairs, dating from 1921 to 1924; the fifth was perhaps his most famous design, the "Wassily" chair (named after his fellow Bauhausmeister, Wassily Kandinsky) of 1925, in which the tubu-lar metal structure suspended the taut leather surfaces of the chair. The sixth design,

however, marked "19??," showed only the figure of a seated woman suspended in thin air. A brief caption noted that "It gets better and better every year. In the future, we will sit upon an elastic column of air." This sixth "chair," which preceded the development of ergonomics by nearly twenty years, provided a powerful image of the limit case of comfort. If design is oriented wholly around the function of conforming to the human body, then the object itself—its aesthetic quality—disappears. Design becomes almost unexperienced, an anaesthetic, wholly composed of a technology concealed behind an occluding surface.

Thus the double appeal of the approach taken by Eames and Saarinen to the problem of chair design, which was not only one of surface, but also one of the realization of the most efficient surface through the application of structural principles and new production techniques.[32] If the interface between human being and chair was to be efficiently resolved, the problem would have to be understood as a harmonization of structure with surface. The point is illustrated by a full-page reproduction of a competition drawing by Saarinen and Eames of the "Conversation" chair (Figure 1.3), which includes an elevation, drawn on a grid, of a human figure and the continuous lines of contact with the chair.[33] The integration of human being and sitting machine, "carefully molded to give maximum comfort and support to the body" through the design of chairs with "complicated compound curves," was represented as seamless, though it was hardly effortless, or even cheap.[34] As Noyes wrote of Eames's chair designs, "joints are handled with the same precision that one finds in the aircraft industry, where there can be no approximations in the way a wing fitting attaches to a fuselage."[35]

Eames, too, was quick to point out the proximity of his designs to those for military applications. As he wrote in a review of the exhibition, the techniques that he and Saarinen had used were "not long out of the laboratory stage . . . they were being used primarily in defense construction. . . . [This] insured their growth and promised great possibilities when the war needs let up."[36] The proximity of their own methods of research and analysis to those used by the military remained a point of pride for both Noyes and Eames in the years to come, especially in their work for IBM.[37]

The technical adroitness of the Saarinen and Eames designs naturally appealed to Noyes, insofar as they literalized and realized his call for the integration of the human body with the machine. However, the Saarinen–Eames collaboration had yet another product beyond the four sitting-machines they designed for the competition: a method of design that seemed to embody precisely the ideals of organicity demanded by Noyes and Mumford. As part of their interest in working "simultaneously with factory technicians and many experimental sitters"[38] to develop forms that would fit the human body, Eames and Saarinen sought to apply a scientific approach. In describing his involvement in the competition many years later, Eames disclosed the "secret" of successful design:

This is the trick, I give it to you, you can use it. We looked at the program and divided it into the essential elements, which turned out to be thirty-odd. And we proceeded methodically to make

100 studies of each element. At the end of the hundred studies we tried to get the solution for that element that suited the thing best, and then set that up as a standard below which we could not fall in the final scheme. Then we proceeded to break down all logical combinations of these elements, trying not to erode the quality that we had gained in the best of the hundred single elements; and then we took those elements and began to search for the logical combinations of combinations, and several of such stages before we even began to consider a plan.. . .

It went on, it was sort of a brutal thing, and at the end of this period . . . we were in the second stage. Now you have to start; but what do you do? We reorganized all elements. But this time, with a little more experience, chose the elements in a different way (we still had about 26, 28, or 30) and proceeded: we made 100 studies of every element; we took every logical group of elements and studied these together . . . and we went right on down the procedure. And at the end of that time, before the 2nd competition drawings went in, we really wept, it looked so idiotically simple we thought we'd sort of blown the whole bit. And won the competition. This is the secret and you can apply it.[39]

The production of an organically designed object is thus a fundamentally systematic or methodical process of reduction and simplification. That is, it is a design "logic," in which "elements" are combined in an experimental fashion in an effort to arrive at a solution that satisfies a series of predetermined conditions (the program): comfort, appearance, ease of manufacture, etc. The process is akin to the mathematical technique of solving a problem through brute force (thus Eames's description of it as "brutal"), that is, through iterative repetition and recombination. Each successive combination of elements must be tested against the a priori conditions and rejected until the only possible outcomes remain. The apparent simplicity of the result—the ergonomically sound, or biomorphic, "Conversation" chair—is revealed through Eames's explication of his and Saarinen's "secret" logic to be in fact only one possible, though ostensibly the most correct, outcome of an exponentially more complex process. After all, as Eames wrote in 1958, furniture was really "architecture in miniature . . . a human-scale proving ground for directions in which [architects] have faith."[40] (This faith, of course, was faith in a utilitarian tautology roundly critiqued in the same year as Eames's theorization of "architecture in miniature" by the philosopher Hannah Arendt as a "chain whose very end can serve again as a means in some other context." Paraphrasing Lessing, she asked: "And what is the use of use?"[41])

In the two years following the opening of the exhibition, Noyes worked tirelessly alongside Eames, Saarinen, and the other winning designers to arrange for the efficient mass production of organic furniture.[42] While this labor cemented their relationship and provided them all with their most extensive training to date in the exigencies of mass-produced industrial design, their project was eventually brought to a close by the entry of the United States into World War II. Only a small fraction of the exhibited furniture ever made it to mass production. Saarinen and Eames amicably ended their formal partnership, as Saarinen left Cranbrook to take up a position as chief of the Special Exhibits

Division in the Office of Strategic Services (OSS) in Washington, D.C., and Eames and his wife Ray moved to Los Angeles and formed their own design partnership. Each, in their own way, continued to pursue the design problems formulated so lucidly by Noyes in the *Organic Design* competition.

Saarinen had been recruited by the head of the OSS, William J. Donovan, to help a massive team of designers and theorists of design—which, at one time or another, included Raymond Loewy, Walter Dorwin Teague, Henry Dreyfuss, Norman Bel Geddes, Buckminster Fuller, Louis Kahn, Bertrand Goldberg, Lewis Mumford, Lee Simonson, Walt Disney, Oliver Lundquist, Donal McLaughlin, Jo Mielziner, Edna Andrade, Dan Kiley, Benjamin Thompson, Georg Olden, and many more—work out innovative new systems of presenting complicated and overwhelming amounts of information through visual means.[43] The end product of their research, the multimedia system known as the "war room," became a paradigmatic form of military-industrial representation in the post–World War II era.

Figure 1.4 Charles and Ray Eames, plywood leg splint, 1941. Copyright 2011 Eames Office, LLC (eamesoffice.com).

The Eameses, meanwhile, struggling to get their design practice up and running in a wartime economy that precluded the mass production of any products not geared toward the war effort, continued to develop the organicist design logic Charles Eames had formulated in his partnership with Saarinen. After a conversation with Dr. Wendell Scott, a friend of Charles's from St. Louis who was stationed in San Diego as part of the Army Medical Corps, they learned that the army's regulation metal leg splints were in fact doing more harm than good to wounded soldiers. Calculating that the problem was due to the rigid linear geometry of the splints, they designed a single-piece molded-plywood splint that conformed to the curved form of the average human leg (that leg was actually Charles Eames's own; Figure 1.4),[44] and the symmetrical holes necessary to relieve the stress of the bent plywood provided space to thread bandages and dressings around the wounded leg. The splint, reduced from its previously fragmented form into a single set of compound curves, was a fitting end product of the "secret" method that Charles Eames had outlined.[45]

Redesign

Noyes's career at MoMA was also interrupted—though one might also say accelerated—by the entry of the United States into World War II. While working at the Pentagon, Noyes's neighbor down the hall was Thomas J. Watson Jr., a reconnaissance pilot and future president, CEO, and chairman of IBM. The two became lifelong friends through their mutual fascination with flight: Noyes gave Watson lessons on how to fly gliders, and Watson invited Noyes and his wife Molly to family dinner parties and on plane trips.[46]

After the war, Noyes returned to New York and began to work in the office of Norman Bel Geddes, the noted industrial designer. Possibly through Noyes's friendship with Watson Jr.—although both would later claim that it was serendipity—the Bel Geddes office won a commission to redesign IBM's line of office machines. After Bel Geddes closed his office in 1947, Noyes struck out on his own, taking the contract for IBM's typewriter designs with him. It was then that Noyes redesigned the IBM 562 typewriter, transforming it into the sleeker "Executary" Model A electric typewriter. (Figure 1.5)

In developing the new look and function of the Model A, Noyes worked closely with IBM design engineers for the first time, developing what would be a long-standing relation-ship. Noyes recalled later in a brief essay on the design that the IBM engineers "never allowed a handle or hinge or a lever to be put into a production drawing without my having helped to shape it and relate it to the composition as a whole."[47] Over the course of a full year, Noyes traveled back and forth between New York and Poughkeepsie, where the IBM design offices were located in the stables of the recently acquired Kenyon Estate. The estate, an old manor house sitting on a hill above the IBM factory in Poughkeepsie, was in these years the site of IBM's most advanced engineering and design research, and there can be little doubt that these trips to the Hudson Valley to work on typewriter

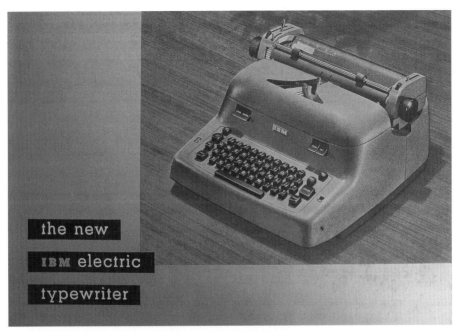

Figure 1.5 Advertisement for IBM Model A electric typewriter, designed by Eliot Noyes and the IBM Design Department, 1949. Courtesy IBM Corporate Archives, Somers, New York.

design also constituted Noyes's first exposure to the new electronics technologies that IBM had developed during the war, first and foremost among them being the Selective Sequence Electronic Calculator (SSEC)—IBM's first fully digital stored-program computer, which was being developed and built specifically to aid in the design of the hydrogen bomb.

The designers reconsidered the typewriter from the ground up, redesigning everything from the paper-feed mechanisms to the keys to the casing, in order to produce a completely new machine. As the engineers presented him with mechanical innovations such as the speed-leveled electronic keyboard,[48] Noyes worked in clay and plaster, carefully modeling each piece before it was produced in aluminum, and from there rendered into production drawings. In keeping with its long-standing practice in product research and development, however, IBM had another team of engineers working on an alternative design for precisely the same model. This competitor, which Noyes described as "very much like other existing typewriters produced by other companies," was preferred by a number of IBM managers. Noyes accordingly marshaled evidence of the superiority of his team's design.

We ended up with only one screw head showing on the end of each carriage cover and I believe that even this might have been eliminated if we had had a little more time. Among the innovations on this model . . . were the key plate covering the hole between keys, the covers on the ends of the carriage, and the simple unified form of the machine as a whole, which was in contrast to the busy multiple parts of other machines available at that time. . . . We produced a

line of five or six tones ranging through the lighter office colors to make the machine compatible with wood or painted office interiors.[49]

Several issues were thus at stake, each of them recalling the criteria elucidated years earlier in the *Organic Design* competition. Beyond refinements to the typewriter's multiple mechanisms, the Noyes team's design offered a simplification and rearticulation of the exterior of the machine. Evidence of the machine's inner workings was systematically erased from its surface ("only one screw head showing"), gaps and holes were closed, and the complicated machine was enclosed by a single die-cast metal volume. This served not only to bring the various "busy multiple parts" of the machine into a coherent organic "whole," but also to coordinate the machine with its surrounding space: the office interior. The typewriter should be considered, Noyes argued, as an organ of the office, metonymically underscoring the productive unity of the workspace.

The controversy over which typewriter to produce was eventually resolved as were all controversies within IBM under the chairmanship of Thomas Watson Sr.: by Watson himself. With Watson's advocacy of his team's design, Noyes achieved his first access to the very top of management at IBM. There can be little doubt that his friendship with Watson's son and heir apparent helped his case; Watson Jr. and Noyes had begun discussing the role of industrial design at IBM as early as 1947.[50] All of Noyes's arguments regarding organic design aside, the members of IBM management who counted were favorably disposed toward the young designer's view that IBM products should appeal to the consumer as new and exciting from the beginning. As Noyes put it: "It took the perceptive eye of Mr. T.J. Watson, Sr. to rule in favor of this advanced look."[51] The design was thus awarded to the Bel Geddes office, and following IBM practice the Bel Geddes and Noyes sold their joint patent for the Executary Model A design to the company for one dollar (in exchange for a handsome consultancy fee and continuing contracts) when the typewriter went into production in 1949.[52]

After the closure of the Bel Geddes office in 1947, Noyes remained in New York, attached his office to that of his former teacher, Marcel Breuer,[53] and brought his carefully cultivated relationship to the upper reaches of IBM with him. Though the decision to produce Noyes's typewriter design may have been more due to its newfangled appearance than to Noyes's theories about organic design, the Watsons did in fact have serious interest in office design and sponsored experiments in redesigning IBM's own offices with an eye toward economy and efficiency. In 1948, Watson Sr. commissioned a "study of possible advantages to IBM in the use of a chair-desk unit instead of the standard desk and chair" from the Noyes office that, though it produced no positive results, nonetheless demonstrates IBM's growing interest in redefining the dynamics of the workplace.[54] Commissions such as these from IBM eventually allowed Noyes to detach his office from Breuer's and establish an independent practice in New Canaan, Connecticut, in 1950; they also allowed Noyes a view into the rapid technological change taking place in the laboratories and offices of IBM.

Meanwhile, Noyes took further steps in elaborating upon the organic design polemic he had first articulated in the MoMA exhibition. While continuing to work on IBM design projects, Noyes also accepted a dual position as associate professor and critic of architecture and curator of special exhibitions at Yale University in late 1948. Noyes had been at that point engaged in a sustained critique of streamlining in industrial design, mounted primarily through a nearly regular column, titled "The Shape of Things," he wrote for *Consumer Reports* magazine from 1947 to mid-1949.[55] Published by Consumers Union, a nonprofit research and advocacy organization founded in 1936 to improve the quality and safety of American-made goods by collecting statistical data on their performance and publishing articles evaluating their visual appeal, *Consumer Reports* had by the early post–World War II period become a powerful force in shaping public buying habits. The first two articles of the series poked fun at designers who had, in his view, clearly not made any substantial effort to design the functional mechanism and had instead simply covered over an "obsolete" appliance with "styling."[56]

In April 1949, Noyes culminated his attack on streamlining when he unveiled his first and only exhibition at Yale, titled *Modern Design: The Search for Appropriate Form* (Figure 1.6). As Noyes stated at the symposium opening the exhibition, "what is necessary for a jet fighter is certainly superficial, and the height of trickery, in a kitchen mixer."[57] The unequivocal tone of the pronouncement, however, concealed his deeper ambivalence toward the ethic and aesthetic of streamlining, which was nonetheless evident in both his further descriptions of the exhibition and in the very objects he selected for the show.

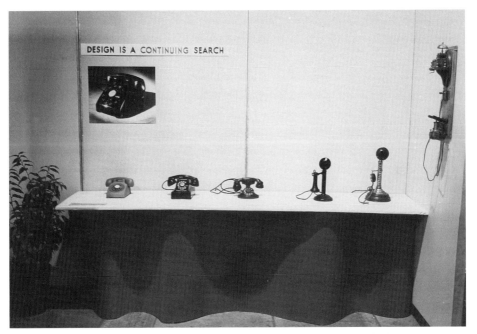

Figure 1.6 Eliot Noyes, curator, *Modern Design: The Search for Appropriate Form,* Yale University, 1949. View of telephone display, "Design Is a Continuing Search." Courtesy of the Eliot Noyes Archive, Norwalk, Connecticut.

Upon entering the gallery, the visitor was greeted with a curious display of quotidian tools laid out on a tabletop and suspended on strings from a wooden armature overhead. Labeled "Appropriate Form Often Develops Naturally," this first display presented a visual argument for an evolutionary understanding of technology. As Noyes wrote in his column regarding this portion of the exhibit:

There is no doubting the clean good looks of a casting rod, a tennis racquet, a plumb-bob, drafting instruments, an axe, golf clubs, and so forth. Through requirements of use, each has developed direct, handsome, and appropriate form—though little or no conscious aesthetic intention went into their shaping. In them, materials are used for their own good qualities; their design serves no fashion or fad.[58]

Noyes's use of the passive tense here is of the utmost importance (e.g., "each has developed"); as he stresses, these objects evolved their form through the natural process of their use, without the intervention of "aesthetic intention." The argument was, as we have seen, far from original. Like his predecessors, Noyes inserted a caveat, positing a kind of present-day historical caesura within the development of technology, into which the designer would step.

Other more complex objects, toasters and automobiles, for example, are often less satisfactory in design. Their form has not evolved simply and easily from the requirements of use. In their making, many materials have to be combined and many factors considered. Someone—a designer, or a person functioning as a designer—has to coordinate diverse elements and find an appropriate expression for them which takes account of the object's components and purpose. That, at least, should be the objective—an objective which lends no sanction to the addition of meaningless doodles and speedwhiskers.[59]

The remainder of *Modern Design* was devoted to documenting this necessary intervention in the devolved world of "complex objects." A sequence of exhibits—a series of cartoons by the Hungarian-born emigré (and friend of Marcel Breuer) Saul Steinberg parodying the fakery of streamlining; a sequence of telephones showing the progressive simplification of their design; a series of "before and after" displays showing how the intervention of the designer simplified the complex object (e.g., a tape dispenser, a vacuum cleaner); a set of tools for the exhibition-goer to handle; and last, "A Room of Well-Designed Objects" (i.e., housewares)—forcefully made the case that the designer's primary objective was to ameliorate the hostile and threatening complexity of the machine by encapsulating it in a smooth and elegant enclosure.

Noyes's critique of streamlining, then, was not absolute, but a matter of degree. Streamlining was simply not radical enough; it did not sufficiently arrange the organs of product and body into a harmonious whole. The final section of the exhibition, "A Room of Well-Designed Objects," underscored this emphasis on the user's body by providing an enclosed space furnished with Saarinen and Eames chairs, and tables and desks on which a

litany of "well-designed" household objects from lamps and radios to tableware were arrayed. Here, in true domestic comfort, the viewer would find a home in which her tools were suited to her body to an unprecedented degree. His point made, Noyes left his positions at Yale a year later, passing it on to the former Bauhäusler Josef Albers, and returned to full-time private practice with Breuer, now in New Canaan, where his office would remain until his death in 1977.

With interventions such as these, the ground had been prepared for further work with IBM. At stake was the very transition staged in the *Modern Design* exhibition—that from product to architecture. In January 1952, Watson Jr. made a cautious first move in what would become a massive program to overhaul IBM's corporate environment. He sent a letter to Noyes asking him to remodel a conference room on the sixteenth floor of IBM World Headquarters.[60] Noyes obliged by reconfiguring the corner room into an office befitting the president of a major electronics corporation; while there was nothing particularly radical about Noyes's design, it did—at least provisionally—provide a model for integrating IBM's products into its architecture at a literal and symbolic level.

The furniture was taken from Knoll Associates' brand-new 1952 line of office furniture: four types of chairs, two "executive" desks (one for Watson's secretary Mr. Post), and storage cabinets, providing IBM with its "first slice of color and light."[61] Of particular interest, however, was the way in which Noyes responded to Watson's request for display areas. Two low-slung walnut cabinets with sliding doors, one in the secretary's office and waiting room and the other behind Watson's desk, were built into the walls to house IBM "electronic components." An IBM World Clock sat on Watson's desk, and a closet in Watson's private entrance housed easels that could be pulled out quickly and easily for presentations. Watson, seated or standing at his desk, was to be framed by the accoutrements of IBM technology and management, as his guests or employees lounged in crisp modern couches and armchairs.

IBM Graphics: Communications and Design Logic

In the same years that he was redesigning his office on Madison Avenue, Thomas Watson Jr., about to assume his role as CEO and chairman of the board of IBM after the retirement of his father, Thomas Watson Sr., made a series of momentous decisions regarding the future of IBM.[62] Following an emerging trend in management—reflected most famously in the reorganization strategies of General Electric and the U.S. government under Eisenhower—Watson determined to abandon IBM's outdated pyramidal managerial hierarchy in favor of a more efficient, horizontal structure. When he was appointed president of the corporation by his father in 1950, he began considering reshuffling IBM's various activities into a series of more or less autonomous divisions, coordinated by a new corporate managerial staff. This process culminated in 1956, when Watson called together all of IBM's top executives at Williamsburg, Virginia, and issued a decree stating that none

would leave the conference until an entirely new, fully articulated managerial structure had been invented for the corporation.

As he wrote in his memoirs, the young Watson "picked Williamsburg because it is a historic place and this meeting was meant to be a kind of constitutional convention for the new IBM."[63] Sweeping away most of the paternalism and evangelism of his father's company—biographers of both father and son report company song books thrown out and oil portraits removed from executive offices[64]—Watson aimed to replace the IBM cult of personality with a modern management system. With characteristic hyperbole he later wrote, "What we created was not so much a reorganization as the first top-to-bottom *organization* IBM ever had."[65] The design of the management system, articulated by Watson's hand-picked "organizational architect," the recent business school graduate Dick Bullen,[66] was based upon two metaphors. The first was familiar: IBM would consider itself as a body, with its various product divisions serving as its "arms and legs," and at the "head" would be a six-man corporate management committee led by Watson and staffed with IBM's top executives (including Watson's brother, Arthur K. "Dick" Watson, and future IBM president T. Vincent Learson), each member responsible for a particular organ of the corporate body. Running from the head down into the body would be a newly organized corporate staff, "a kind of nervous system" for the "adolescent company."[67] The second metaphor, broadly accepted in management circles but not often openly discussed, was that a corporation should identify itself as an army. The "staff-and-line" structure of the more autonomous and horizontal management system was, as Watson freely admitted, based "on military organizations going back to the Prussian army in Napoleonic times."[68] This double metaphor would, it was hoped, give birth to an organic discipline, in which IBM's various organs could operate harmoniously and automatically.

In the same years, Watson made a commitment to move the bulk of IBM's massive resources into the research, development, and marketing of computers. Watson Sr. had always considered IBM's work in computers before and during World War II largely a matter of prestige rather than of business. The production of computers had been a means to preserve working relationships with both universities and the U.S. government, bringing in increasingly large amounts of money in the way of research grants but relatively little sales revenue. Watson Jr. saw things differently. In order to win and maintain the numerous newly emerging and lucrative contracts from the U.S. military, with an eye to a prospective market for computers in the world of corporate business, and in competitive response to recent successes of the Remington Rand UNIVAC computer in the business market, Watson determined that IBM should, by the end of the 1950s, corner the entire computer market.

These two fundamental shifts in the structure and orientation of IBM were accompanied by a third change: Watson determined that IBM should adopt a new look. Following a pair of chance encounters with the sleek modern design of Olivetti's Manhattan showroom and advertisements in 1954,[69] Watson summoned Noyes and, through Noyes, the

graphic designer Paul Rand—to whom Noyes had probably been introduced by Kaufmann, who had worked extensively with Rand in the 1940s in his capacity as editor of *New Directions*—along with several IBM engineers and managers to his family's vacation home at Buck Hill Falls in the Pocono Mountains. On a table, alongside photographs of the newly unveiled Olivetti showroom on Fifth Avenue in Manhattan, designed by BBPR in 1953 (Figure 1.7),[70] Watson laid out a series of Olivetti ads and brochures he had been given by a manager from IBM Netherlands. He then insisted that IBM's products and sales apparatus needed a makeover. As he recalled in his memoirs, "the Olivetti material was filled with color and excitement and fit together like a beautiful picture puzzle. Ours looked like directions on how to make bicarbonate of soda."[71]

After the meeting, Watson commissioned Rand to study IBM's printed material (e.g., Plate 1) and to make specific recommendations. In a report submitted to Watson in early 1955, predating the Williamsburg meeting, Rand offered a scathing critique of the appearance of everything from advertising to stationery:

The examination has of necessity been cursory but it is believed that a number of significant features can be noted. Of all these perhaps the most critical is the absence of a *family resemblance*. There are, to be sure, a number of well designed advertisements and house organs, but they are isolated pieces. . . . Typographic style is inconsistent even within individual campaigns;

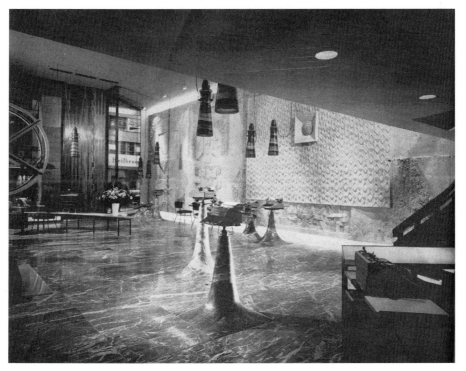

Figure 1.7 Belgiojoso, Peressutti, and Rogers (BBPR), Olivetti showroom, 580 Fifth Avenue, New York, 1953. View of typewriter displays.

the IBM trademark is not sufficiently distinctive to be exploited with maximum effectiveness; and with a few exceptions, pictorial execution and layout incline to the commonplace. The fact that IBM's printed pieces bear little family resemblance to one another makes it difficult satisfactorily to establish a "company personality."[72]

Such criticisms, to a company that had previously and forcefully identified itself as just such a "family," with a rigorous dress code and cohesive corporate culture, would have wounded any IBMer deeply, and surely struck home with Watson Jr. Rand also made more specific criticisms, taking particular aim at the ads for IBM's Data Processing Services arm: "The . . . ads are cluttered with text; this not only diminishes the pictorial impact but actually discourages reading. They are conceived and executed without imagination. It can even be argued that from a graphic standpoint some are in bad taste."[73] The ads used numerous, uncoordinated typefaces and often obscured pictures with text to confusing effect. By contrast, Rand claimed, IBM's ads for electric typewriters were "distinguished pieces of advertising." The scattershot appearance of IBM's printed material, Rand made plain, rendered it impossible for the "average buyer" to identify IBM as a coherent and concrete entity: "The layouts and presentation of Electric Typewriter and certain Data Processing ads are so different it is difficult to recognize them as representative of the same company."[74] The only means to achieving a "family resemblance" would be to fix "standards of quality" for graphic design throughout the corporation and to "integrate" the design efforts of the company under centralized control.

After demonstrating what he meant by effective advertising—which, in the main, involved showing IBM his own magazine advertisement designs for other companies—Rand proposed a "first step." The IBM logo, in use since 1947 (Figure I.2), would need to be redesigned. As he wrote in the penultimate section of his report on "The Trademark":

IBM's present mark is basically a good one both visually and verbally. It is simple, direct and euphonious. However it is believed that the mark could be considerably improved. . . . The style of letter—Beton Extra Bold—is a rather commonplace one. Furthermore the form of the letters lacks precision and definition. For a company such as IBM this is obviously undesirable. If the redesigning of the IBM trademark is undertaken the first step is clearly to reform the letters themselves. Furthermore some graphic feature, when possible, might be added to give the mark even more distinction and to increase its flexibility.[75]

The logo therefore had to "express dignity, authority, efficiency and modernity."[76] Underscoring his point about the importance of continuity, or "family resemblance," Rand thus proposed that "any change in IBM's mark must not be so drastic as to negate the identifying and symbolic value of the present mark (nor the time and money expended on developing it)."[77]

In analyzing IBM's logo, Rand did not ignore the substance to which it would need to lend its authority and clarity. Much as Noyes had insisted upon concealing the inner

workings of the typewriters he had designed for the corporation in order to present a clearer image of the idea of typewriting, Rand made it clear that the logo had a similarly counterintuitive relationship to its putative referents, IBM's products. Because "IBM's products are too complex to be understood by the average buyer," he argued, "[the buyer] must rely on IBM's reputable name."[78] The corporate name would be a symbol assuring the customer of the technological sophistication and reliability of its products. Yet how could so few letters do so much?

Rand answered this question unequivocally near the outset of one of his many later explications of the function and proper use of the IBM logo. According to the policy laid out in the *IBM Design Guidelines,* Rand reaches back to the etymological roots of the terms "logo" and "logotype" in the Greek word *logos.*[79] Exploiting the protean nature of the Greek source of the term—*logos* may be translated alternatively as "word," "speech," "concept," "reason," or "logic"—Rand emphasizes the diffuse metaphorical power invested in a trademark. A proper logo design, Rand suggests, may only emerge out of a proper understanding of its function—furthermore, a function that has only recently been established. The logo, as the etymology of the term suggests, derives its symbolic power not from a specification of meaning, but rather through its very emptiness of meaning—a capability to apply itself to any number of objects and in so doing, to name and organize them. It is, perforce, multivalent. Furthermore, the metaphorical and economic power that it possesses was, until World War II, not well understood and had uncertain legal standing.[80] The introduction to the *IBM Trademark Manual,* designed by Rand and published just as he produced the first design guidelines manuals, began by quoting at length from the U.S. Supreme Court decision in the precedent-setting trademark case *Mishawaka Rubber & Woolen Manufacturing Company v. S.S. Kresge Company* of 1942:

The protection of trademarks is the law's recognition of the psychological function of symbols. If it is true that we live by symbols, it is no less true that we purchase goods by them. A trademark is a merchandising short-cut which induces a purchaser to select what he wants. The owner of a mark exploits this human propensity by making every effort to impregnate the atmosphere of the market with the drawing power of a congenial symbol. Whatever the means employed, the aim is the same—to convey through the mark in the minds of potential customers, the desirability of the commodity upon which it appears. Once this is attained, the trademark owner has something of value. If another poaches upon the commercial magnetism of the symbol he has created, the owner can obtain legal redress.[81]

The post–World War II corporate logo is thus, quite plainly, a metaphor—specifically, a metonym. However, it is a special kind of metonym, since it is a part that does not originally belong to the body of objects to which it lends meaning, but is nonetheless an indispensable organ within the whole that it engenders. The logo, by virtue not only of its design but of its legal status, became the red (or perhaps Pantone 2718, the blue color that Rand mixed in 1956 that earned IBM its nickname Big Blue[82]) thread running

through the entirety of IBM's visual environment, stitching diverse objects together into a coherent pattern. This is made plain in the *IBM Trademark Manual,* which quotes again from the same Supreme Court case:

An abstract right in a symbol has no existence, but the symbol must be considered in association with the article it identifies. In this sense a trademark differs from a patent or copyright. The latter exists the instant either is issued or entered. The patentee or author, without use, remains the real or true owner.... Patent rights and copyright rest upon the view that the results of the original labor of the inventor and the author ought as a matter alike of justice and public policy to be secured against piracy, *while as regards the proprietor of a trademark, the question of originality does not arise so long as the mark is sufficiently distinctive really to identify his goods and for the purpose of registration* to satisfy the Trade-Mark Act.[83]

The logo itself does not function as logo until it is firmly attached—physically and conceptually—to a particular, proprietary object or set of objects. While it may be said to exist without such an object, a logo does not attain its status as a symbol or value—that is, it does not have currency—until the system of objects to which it is affixed gives it meaning. As Rand put it, less legalistically, "It is only by association with a product, a service, a business, or a corporation that a logo takes on any real meaning. It derives its meaning and usefulness from the quality of that which it symbolizes."[84] It can neither pretend to being property nor serve as the vehicle of an "abstract right" until it is attached to a material referent.

Following this logic, one must conclude that in its originary moment, the design of a logo is a design of a second, representational order that, in a legal and instrumental sense, assumes its role in articulating the symbolic function of the primary object. After this originary moment, in which the logo is applied to the objects in question, it is clear that the logo's power exists in establishing a pattern that replicates itself. Like another ubiquitous form of inconvertible value, money, it is an object that adheres to other objects and manufactures a topological equivalence; much as money grants objects exchange value through its putative status as both a universal "medium of exchange" and guarantor of absolute value, the logo grants objects identity with one another.[85] However, the logo differs from money or other traditional media of capital insofar as it does not identify the state, but rather the individual owner of the mark, and is not (immediately) exchangeable with another logo. In this sense, the logo is the most fundamental act of *de-sign-ation* at the beginning of the design program, a marking out that engenders a conceptual and spatial separation from that which does not bear it. This designing/designating capacity is, moreover, entirely contingent upon the quality or qualities of the logo's form, its design; this is borne out in the history of the development of the IBM logo and its graphics program more broadly conceived.

With the redesign of the IBM logo, Rand embarked upon a new phase of his career. He became a prolific designer of corporate logos and a much sought after consultant in

corporate image-making in general. Although he remained a recognizable name in the field of graphic design (through his writings as much as by the iconic quality of his designs), by the mid-1950s he was no longer the celebrated artist who proudly signed his bold collages, photograms, and layouts for magazine covers, such as those he did for *Direction* or as works of art in their own right. As Rand famously observed, "a trademark is the signature of a company as opposed to the signature of an individual."[86] The corporate logo will not admit of a human signature, because it is a signature in its own right; and Rand, it seems, went from signing designs to designing signatures.

The new logo (seen in context in Plate 2) was a dramatically simple reworking of the previous Beton Extra Bold typeface: the serifs were made more substantial, the "I" and the "M" made nearly symmetrical (Rand gave the "M" slightly longer serifs on the right-hand side to lend the logo a sense of dynamism), the loops of the "B" rounded into circular arcs. And, as Rand pointed out in his report-cum-design pitch, "it is also practical. The entire mark is composed of circles, squares and triangles and can therefore be easily duplicated."[87] The sharper, more dramatic dip in the "M" broke the line established by the bottoms of the other letters, lending a dynamism and emphasis to its referent: machines; but when the entire logo was combined with a heavy underscore composed of a double-square rectangle, the logo became "an architectural or geometric form . . . simple, stable and dignified."[88]

Rand concluded his report with a series of policy proposals that would ostensibly, along with the use of the new logo, resolve IBM's "family resemblance" problem through the creation of a "comprehensive and integrated design program for IBM with respect to its printed material."[89] He proposed hiring a "single consultant director to coordinate all graphic output and to work in collaboration with the overall director of IBM's design program." These consultant directors—who would, of course, by 1956 be Rand and Noyes respectively—would then oversee art directors and design staffs appointed to each major IBM division, holding weekly meetings and issuing "periodical critiques of all promotional material." Finally, "IBM might also consider the production of its own advertising in the manner of CBS, Look Magazine, Olivetti, Mutual Broadcasting and NBC."[90]

Noyes, for his part, was ready for the meeting in Buck Hill Falls. He brought with him a reel of film that would eventually convince Watson not only of the value of Rand's later report, but of the fundamental, constitutive role that design would have to play in IBM's future. The film was Charles and Ray Eames's *A Communications Primer* (1953; Plates 3 and 4). An adaptation of Warren Weaver's popularizing introduction to Claude Shannon's *The Mathematical Theory of Communication* (1949), the film presented the basic tenets of communications and information theory to a lay audience. Using an innovative combination of animation, live action, and still photography, the Eameses illustrated, for example, the axiom that "the English language is about 50% redundant" by removing letters from common phrases and demonstrating that they remained legible. While overall the tone of the film was characterized by the Eameses' perpetual whimsy, it

remained rigorously faithful to the spirit (if not always the letter[91]) of the original text. Most striking—and most relevant to Watson's concerns about corporate organization and "personality"—were the portions of the film devoted to the mechanics of communication as described by Shannon.

Central to both Weaver's and the Eameses' account of communications theory was a diagram symbolically devised by Weaver to represent a communications system (Plate 3). As Weaver described his diagram:

The *information source* selects a desired *message* out of a set of possible messages. . . . The selected message may consist of written or spoken words, or of pictures, music, etc.

The *transmitter* changes this *message* into the *signal* which is actually sent over the *communication channel* from the transmitter to the *receiver*. In the case of telephony, the channel is a wire, the signal a varying electrical current on this wire; the transmitter is the set of devices (telephone transmitter, etc.) which change the sound pressure of the voice into the varying electrical current. In telegraphy, the transmitter codes written words into sequences of interrupted currents of varying lengths (dots, dashes, spaces). In oral speech, the information source is the brain, the transmitter is the voice mechanism producing the varying sound pressure (the signal) which is transmitted through the air (the channel). In radio, the channel is simply space (or the aether, if any one still prefers that antiquated and misleading word), and the signal is the electromagnetic wave which is transmitted.

The *receiver* is a sort of inverse transmitter, changing the transmitted signal back into a message, and handing this message on to the destination. When I talk to you, my brain is the information source, yours the destination; my vocal system is the transmitter, and your ear and the associated eighth nerve is the receiver.

In the process of being transmitted, it is unfortunately characteristic that certain things are added to the signal which were not intended by the information source. These unwanted additions . . . are called *noise*.[92]

A Communications Primer took up this description almost word for word, frequently quoting short bits of Weaver's text; however, it also sought to remedy the tendency toward abstraction of which even so colorful a writer as Weaver was frequently guilty. The Eameses' method for achieving this feat was a double homology. Communications, the film explains, does not simply lie at the heart of all cultural production, it *is* cultural production. Music, art, management, war—all of these were henceforth to be considered as communicative acts. Upon this first homology the Eameses artfully superimposed a second: communications and design were self-same. The film armed information theory to infiltrate design precisely by playacting its disarmament. Combining live-action footage with still photography and animation, it playfully demonstrated the basic concepts of information theory, such as coding and transmission, by careful juxtaposition and overlapping of abstract

shapes ("symbols" or "bits") and photographic images of people, and demonstrating how people "naturally" use machines to create and transmit "messages" (Plate 4). The abstractions of mathematics were mapped directly onto the ostensibly concrete form of the human body, all set to a whimsical score by Elmer Bernstein and Charles Eames's own soothing narration.

The Eameses' approach to communications science as a new foundational metaphor for design did not supplant their earlier reliance on organic or biological metaphors; rather, it augmented the earlier metaphor, transforming the biological referent from a simple, determinate form into something more closely resembling the feedback loops described by the emerging science of cybernetics. At stake in conceiving design as communication was the question of control—over form, over process, and, most impor-tant, over people—that, if answered, would bring people and machines into harmony with their environment. One of Charles Eames's touchstones in this regard was Norbert Wiener's self-popularizing treatise *The Human Use of Human Beings* (1950), which, Wiener claimed, heralded the coming of an exciting (if also threatening) technological management of living things at both social and individual levels. "We now come," Wiener wrote in the conclusion to his tract, "to another class of machines which possess some very sinister possibilities . . . the machine made in [man's] own image": the computer.[93] By taking hold of the wheel, Eames extrapolated, designers could henceforth self-consciously direct the process of evolution, preserving order in the face of disorder, "fit" in the face of disharmony. However, Eames admitted willingly and repeatedly, this omelet could not be made without breaking some eggs: many of the supposed truths under-pinning architectural thought would have to be discarded.[94]

The glorious futurology glossed by *A Communications Primer* was hardly lost on Wat-son, already a devout Keynesian deeply invested in the rational and centralized manage-ment of the future.[95] The film held out the promise of a world in which "messages"—and the ordered, negentropic entities they sustained—could overcome the "noise" of the marketplace, provided that said messages were properly selected, coded, and disseminated. It was this promise that motivated Watson to endorse a series of tenta-tive, provisional changes to IBM's aesthetic presence—small but significant steps that would lead eventually to the formation of the IBM Design Program similar to that sug-gested by Rand's report. One of Watson's first moves, made in the wake of his initial design meeting with Noyes and Rand, was to hire Noyes to redesign the IBM lobby and showroom on the ground floor of the corporate headquarters in Manhattan, on the cor-ner of Fifty-Seventh Street and Madison Avenue, finished in November 1954. Noyes, it appears, had already designed a room on an upper floor to house the first IBM 701,[96] and this new space was to be unveiled at the premiere of the IBM 702 computer. The announcement of this new machine, IBM's first computer designed exclusively for busi-ness needs, prophetically signaled IBM's dominance of the market for the next thirty-five years.[97] Watson described the appearance of the original lobby in his autobiography:

Dad [Thomas Watson Sr.] had decorated it to suit his taste, and it was like the first-class salon on an ocean liner. It had the Oriental rugs he loved and black marble pillars trimmed with gold leaf. Lining the walls were punch-card machines and time clocks on display, cordoned off by velvet ropes hooked to burnished brass posts.[98]

Noyes completely redecorated (Plate 5). The new floor was white, the walls painted red, the marble pillars covered over with smooth panels, and small silver signs reading "IBM 702" (or, in the later photo shown, "705") in a sans-serif font set on the walls. Perhaps the most significant change was the way in which the computers were displayed. As Watson Jr. relates:

The Data Processing Center generated enormous excitement. Like the SSEC and the 701 that had preceded it in the window, the 702 was actually a working machine. Customers who wanted to rent computer time would simply bring their data in, and we kept the computer running around the clock. If you went by on Madison Avenue in the middle of the night you would see it behind the big plate-glass windows, tended by well-dressed technicians in its brightly lit room.[99]

Noyes's redecoration was not only an interior design, but also an exhibition staged in a shop window. Noyes and IBM were concerned at the outset with projecting an image of IBM as a provider of an essentially modern service: the handling of information. Interestingly, this was achieved by a "theatrically" staged transparency that allowed a glimpse into an interior space—from outside to inside—that offered "the first graphic statement of IBM's integrated design policy."[100] This interior was specially designed to highlight the sound relationship between the computer and its operators, processes that occurred in a space entirely independent of the external environment: "brightly lit," "in the middle of the night," "around the clock." Crowds gathered on the street to gaze at the unfamiliar, antiseptic drama of the computer.

The Consultancy: Design Management and the *IBM Design Guidelines*

Following the popular success of this design (and IBM's early financial successes in marketing computers), Watson offered Noyes a job as the director of design at IBM in February 1956, shortly before he assumed his role as CEO and chairman of the board. Noyes turned him down, saying: "I'll work with you, not for you. The only way I can do this job right is to have full access to top management."[101] Watson was convinced, and Noyes thus accepted a position as consultant director of design, pledging a major portion of his time—in contracts and anecdotes it was stipulated alternately as "one third" or "one half"[102]—to IBM while retaining his own private practice. By remaining outside of the corporation, and thus outside of its hierarchies and autonomous divisions, Noyes considered himself better able to transform IBM on a structural level by linking its products, spaces, and managerial processes through design. He later recalled the four main conditions of his agreement with IBM:

First, a title. I became Consultant Director of Design. Second, contact for reporting purposes with the top management of the company. Design must be a function of management, attentive to but not controlled by sales or engineering departments, or any divisional echelons. The program was put under the Director of Communication, a corporate staff office, for coordinating purposes. Third, an announcement within the company to establish my right to work freely on these problems, and to state partially the goals of the program. Fourth, an operating budget—not for design but for administering the program.[103]

From this ambiguous position as an administrator outside of the corporation proper, he was to coordinate the redesign of the entire environment of IBM on a telescoping scale—from stationery and curtains, to products such as typewriters and computers, to laboratory and administration buildings.

According to both Watson and Noyes, both taking their cue from Eames, redesigning the look of IBM was essential to the way it functioned. As Watson related in a 1963 lecture at Columbia University—significantly titled "The New Environment"—on the various techniques IBM used to restructure its management system and employee policies during the period:

With all of these innovations we have introduced in company communication, the principal lesson we have learned, I believe, is that you must make use of a number of pipelines, upward as well as downward. Parallel communication paths may seem unnecessary to some. But we have found that any single path can be only partly successful, that certain information flows better over some paths than others, and that all employees do not react in the same way to a given medium. Management must have a wide selection of communication means at its disposal.[104]

Taking up the homological theory of *A Communications Primer,* Watson considered design to be one such "parallel communication path." It was to be integrated into the dynamics of management so thoroughly that it could literally be considered a defining characteristic: management, as a process of communication, was to be inseparable from its environment.

Watson appointed an IBM sales executive, Gordon Smith, to the newly created position of director of communications, who, in addition to coordinating the efforts of Noyes's office and those of IBM's own in-house Design Department, would also be in charge of advancing the program throughout the corporation. The process of communication and management through design was made redundant, as information flowed along "parallel communication paths."

This program, Watson, Noyes, and Smith recognized, could not be applied from the top down. "The way to make it effective," Smith explained in an interview with Noyes in *Industrial Design* in 1957, "is not to send down a weighty memo from above, but to kindle spontaneous enthusiasm with a succession of good works." Noyes finished his thought:

And this will happen only when good design—the awareness of it and the desire for it—*begins to come out through their own skins.* That is why this is not an outside movement. We are trying to start one within the company, using a variety of stimuli.[105]

Teamwork and horizontality thus not only characterized the ideal management network, they characterized the intentions of the design program as well: design was a means of re-forming the corporate body, literally at the level of the individual member, from the inside out. Emerging from under the gray flannel suit, the design signal—communicating the organized unity of the corporate body, its spaces, and its machines—was to be borne along "parallel communication paths" with ultimate redundancy by the "awareness" and "desire" of every IBM engineer, salesperson, and manager.

This program of action had significant consequences for the mode of design authorship at IBM (and in the countless corporations in which similar programs were instituted, whether by Noyes or other designers). Unlike many contemporary American firms that combined architectural practice with industrial design and graphics—such as SOM (formerly Skidmore, Owings & Merrill),[106] Caudill Rowlett Scott (CRS),[107] and Walter Dorwin Teague and Associates—Eliot Noyes and Associates did not attempt to remake itself into a large-scale corporation in its own right. Instead, taking a cue from Harold Van Doren's 1940 treatise *Industrial Design: A Practical Guide,* Noyes sought to extend what Van Doren called the designer's "sphere of influence" over as many relevant aspects of IBM as possible. The (small) design firm could overlap with the corporation, becoming immanent to the corporation rather than becoming part of it.

At his best, the designer is an animator, a builder of enthusiasm in others. . . . He knows how to work with others, meeting executives on an equal footing and still gaining the confidence of the man on the bench.

He brings to his client a broader design point of view than a man can have when burdened with the responsibilities of everyday operation. He fully acknowledges the superior technical knowledge of the men in the client's organization. He cannot and does not presume, of course, to tell them how to do things which they have learned through years of research and experience.[108]

Pithily, Van Doren quickly reduced this principle to an aphorism: "Industrial designers who take their work seriously cannot afford to play the prima donna."[109]

Although he never offered such a cogent and systematic theory of the relationship, Noyes still had a gift for articulating it, and he echoed Van Doren in precise terms.

[Design] often illuminates the nature of the company to itself and stimulates fresh internal courses of action. . . . The processes of sound industrial design touch the phases of product planning, ergonomics, engineering, economics, manufacturing, aesthetics, and marketing, and so must be an integral part of a company's product development processes. . . . For such a role [the design

consultant] must be some combination of designer, philosopher, historian, educator, lecturer, and business man.[110]

To those unfamiliar with the unusual self-image of the corporate design consultant, this description may smack of pride; however, Noyes and his fellow industrial designers, humble in almost all cases, saw it quite the other way round. The idea was to serve as a medium to the corporation, a way of rendering it material, providing it with a character that could pervade the entire organization.

This new kind of teamwork did not appear spontaneously. Noyes and Rand began their consultancy with a handful of graphics, industrial design, and architectural commissions, but just as importantly, they visited nearly every IBM office, factory, and laboratory in the United States and Europe in the four years following their appointment as design consultants.[111] What they found was haphazard, disorganized, and isolated teams of designers, many of them amateurs, constantly improvising responses to design problems without any oversight from corporate management or development engineers. At the suggestion of Rand, IBM vice president and career-long apologist for the IBM Design Program Dean R. McKay appointed Marion Swannie, a former IBM amateur designer herself who had originally worked in sales and advertising, to accompany Noyes and Rand and to serve as the head of a new Design and Display Department within the Corporate Division.[112] From her vantage point, liaising between the consultants and IBMers, there was often initial enthusiasm for the program, but then disappointing results; often, there was even resistance. She recalled "a guy in Poughkeepsie who drew a little Indian character called Ogiwambi on plant posters," and that Rand referred to many of the IBM designers and managers as "Philistines."[113] Noyes, Rand, and Swannie concluded from their visits that IBM design would need to be more centralized, and they established a staff of designers under Swannie's supervision in New York to produce the majority of the necessary graphics in conjunction with Rand, who worked from his house in nearby Harrison, New York, and later in Weston, Connecticut. Rand would host design critiques at his home or at a nearby diner.

Despite these efforts, and despite the existence of several talented designers within the company,[114] the quality of the corporation's design production remained erratic. In addition to laying out the corporation's stationery and designing packaging, Rand was often forced to redesign posters and ads himself. It was clear that the authorship of the graphic design program would have to be an agent other than Rand. This agent needed to be ubiquitous, authoritative, and objective, not an individual designer but a system of rules around which all designers could rally: a pattern book, but also an ideological center to a vast and far-flung enterprise. This need, in time, generated what became known as *The IBM Design Guide.*

The first *IBM Design Guide* (Figure 1.8), dealing primarily with graphics, was, in comparison with the stated goals of the design program, rather modest in its ambition and primitive in its means. Even though Noyes and his team had been coordinating the

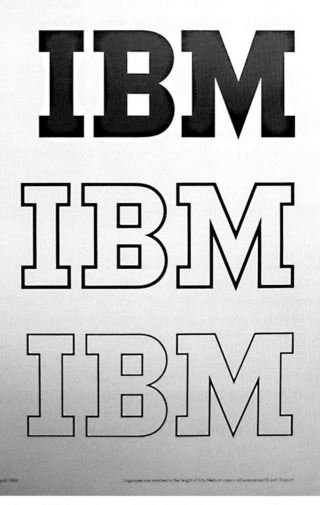

Figure 1.8 Paul Rand, Marion Swannie, and IBM Design Center, *IBM Design Guide,* logotype page, April 1965. Collection of the author, with thanks to James LaDue.

new look of IBM in all media since 1956, it was issued to every division and department in the corporation only four years later, in July 1960, with a cover letter from McKay introducing many employees to a still unfamiliar program.[115]

The guidelines cautioned that the "use of the logo with any other non-IBM identity (even when 100 percent owned by IBM) should be very limited," and that, if IBM's name had to be mentioned as the owner of said company for legal reasons, the logo should not be used at all (appearing instead in a standard typeface like Bodoni).[116] On the printed page itself, Rand made clear, the logo was to be distant from any other text, especially from product names or advertising copy, to preserve the idea that the logo "speaks for the breadth and capabilities of the entire company" rather than for a single product, service, or concept. Further, Rand stressed that overambitious attempts at graphic design risked endangering the entire program: "Multiple versions of a logo, like multiple versions of a signature, confuse its meaning and dilute its power. Don't alter the IBM logo . . . even in humor."[117]

Rand continued to teach graphic design to IBMers in New York until at least 1965, but he gradually scaled back his and Noyes's ambitions for the graphic design program. For instance, the adoption of City Medium as a signature font style for IBM did not last long; according to Rand, "because of widespread distribution and exposure, the typeface was quickly taken up by others" and thus "no longer served its original function."[118] Rand thus concluded that "a distinctive, *all purpose* typeface [was] impractical"; instead, he replaced City Medium with a new, specially designed typeface derived from his redesigned Beton Extra Bold face and stipulated that it only be used in special circumstances, such as for manual covers: "unless there is sufficient time, money and talent available to do a proper job of designing graphic material, the information should be issued in simple typewritten form, which always looks decent."[119]

Where IBM's own designers could not be trusted to develop their own graphics for applications that would need to be used throughout the corporation, Rand simply did the design himself. From 1956 to the early 1990s, he remained responsible for designing much of IBM's stationery, packaging for computer parts and accessories (Figure 1.9), and nameplates for IBM's diverse array of office machines.

In addition to giving detailed instructions on the design and use of various graphics, thus establishing the means by which the IBM signature would assert its organizational power, the 1960 *Design Guide* sought to develop other means for easing communication throughout the corporation. One method was to assign a color to each division of IBM—Corporate would be beige, Data Processing blue, Data Systems grey, Advanced Systems Development red, etc.—that would identify it in "letterheads . . . architecture, packaging, interiors, displays, printed material, advertisements, etc." While it was "not mandatory," especially since "flexibility" was the watchword of the guide, these colors were to be used whenever "appropriate."[120] The color code would provide readers inside IBM with a

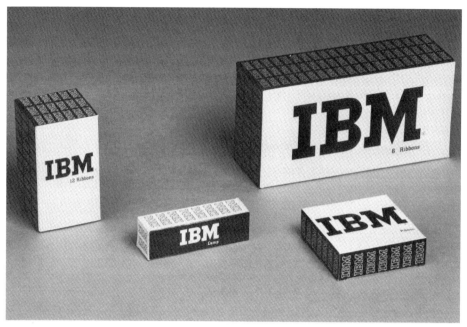

Figure 1.9 Paul Rand, IBM packaging samples, ca. 1960. Courtesy of IBM Corporate Archives, Somers, New York

"quick flag."[121] With each of these colors, ad hoc designers using the guide were encouraged to use dark grey, which, Rand asserted, would relate "them to the corporate identity. It is neutral and dignified, does not conflict with any of the divisional colors—on the contrary, makes the other divisional colors come to life. The Corporate color is this same gray, combined with beige or light tan."[122]

Rand continued to experiment with all aspects of the graphics program, even daring, in 1962, to break his own rule against altering the logo. Never one to abandon the recognizability of a trademark (which would deprive it of its organizational and value-producing power), Rand used his first redesign of the company's logo in 1955 as the basis for its further elaboration.

As the design program gathered momentum in the early 1960s, and as the first coherent sets of design guidelines were established in graphics and industrial design, Rand redesigned the logo once again into the now familiar eight-striped "IBM" that remains the corporation's signature today (Figure I.4). In this later design, the marks that form the logo are reorganized entirely, corresponding not in the first place to the a priori forms of the letters in their specificity as individual members of a typographical system known as a font, but rather to a geometry that traverses the set of letters in the form of horizontal lines. Rand claimed little or no representational intent in his redesign, asserting that the horizontal lines simply helped to overcome the awkwardness of the differing widths of the three letters, creating a visual "rhythm" while keeping the initial form of the logo

consistent. However, he did concede his original inspiration (one perhaps born of his frustrations in implementing the design program in the previous four years): since IBM and its logo were a "symbol of authority," he decided to give the logo a "legal sense, like scan lines on a bank note."[123] These "scan lines," used on signature forms to deter counterfeiting, quite literally underscored Rand's understanding of a logo as "the signature of a company." In a kind of metaphorical pun, Rand transformed the signature of a corporation, an entity comparable to an individual only in a legal sense,[124] into a legal form. However, an important caveat is necessary, one that Rand, being accustomed to his status as an individual author at the same time as he upset this state of affairs, quite naturally did not make: the striped logo did not serve as a field on to which some individual entity would sign its name; instead, *the field became the signature itself.* This transformation answered to the very nature of IBM's business, as a business that managed other businesses through information technology and management consulting.

As a logo is by its very nature multivalent, it is often pregnant with other suggestive formal tropes. The IBM logo's horizontal lines are set apart at regular vertical intervals like the alternating crests and valleys of a communications signal; the discrete quality of the lines even within a single register evokes the dashes and spaces of telegraphy (save for the dots). As Rand later complained, the design was almost too successful in its literal evocation of the aesthetics of communication: "Every logo that some designers do has stripes . . . stripes have become symbolic of the latest in technology."[125] Nonetheless, the pattern that the alternating stripes and open spaces established echoed the two states of Boolean logic that formed the basis of computing technology, and the insistent repetition of the marks evoked the redundancy that is the fundamental structure of communication as formulated by Shannon and Weaver. The logo thus partook of what Rand had long called "the magical, almost hypnotic effects of repetition . . . the thrilling spectacle of marching soldiers, all in the same dress, same step, and same attitude."[126]

Thus the logo, along with the graphics program as a whole, was a call to order. It related to one another not only the various objects produced by the corporation, but also the bodies of its corporate employees. In this sense, it is of equal importance that the form of the logo is constructed as much by the marks themselves as it is by the gaps between the marks, which are of the same quality as the space around the marks. The logo is formed and forms the empty space around it, prompting a visual oscillation between logo and its referent—an environmental tension characterized by a strategic occupation of space, in which the signature mark of IBM serves to control its surroundings but is nonetheless brought into a rigid form by them. In short, one could say that the gaps and surrounds are composed of space, whereas the marks themselves correspond to an idea of placement. Thus, built into Rand's striped IBM logo is a structural consonance with the phenomenon of IBM as a multinational corporation. It is an apparatus and an installation or emplacement *(Gestell),* its marks coming into presence in a specific place, in a wider space or territory, placing in order the space surrounding it. (This phenomenon will be treated in greater detail in the discussion of IBM's architecture in chapter 3 below.)

Thus Rand stipulated that, in almost every case, the logo be placed at a distance of at least the logo's own height from the nearest text; this ensured that the logo ordered and visually dominated any subordinate text or graphic.[127] In a later iteration of the logo, designed for the IBM Annual Report in 1974 and subsequently used in numerous packaging designs, Rand tilted the logo at thirty-seven degrees and allowed the marks of the logo to wrap around the edges of the binding or box. This gave a sense of extension into space even as it figured the process of encompassing an ever-wider territory.

In the event, Rand's striped IBM logo was not employed until 1970, and it was used alternatively with the original Rand logo until 1972, when previous objections by IBM executives that it evoked an image of incarceration were dismissed in the face of the design's evident symbolic richness.[128] In that year, he also designed an additional version of the striped logo with thirteen stripes, which heightened the visual impression of vibration, speed, and redundancy.

In conjunction with the imperative to standardize graphics through the organ of the *Design Guide* and oversight by the director of communications (now Dean R. McKay),[129] Rand trained a group of designers to offer a "graphic arts education program" at IBM offices and production facilities in Poughkeepsie, Kingston, and New York.[130] According to Rand, these received "exceedingly favorable comments" from IBM employees; "constantly noted, however, were comments that those of the managerial level above them need to be informed that this is the company's wish and that personal objectives of the various locations should not be uppermost in their minds."[131] This was not the only evidence of a stubborn resistance to, or simple ignorance of, the goals of the design program within IBM.

As late as 1965, chaos in corporate design was still evident. It was still necessary for Noyes, Swannie, and other members of the American arm of the corporation to travel abroad to ensure regularity of the designs (Figure 1.10). Despite these efforts, a communications manager from IBM Netherlands named W. J. van Hoek could submit a report to Swannie, Noyes, Rand, and IBM World Trade executives on "Communications Design in Europe" that pointed out widely divergent design practices, from the details of industrial design and graphics to the basic organization of design departments. According to van Hoek, oversight by the consultants, limited by distance to yearly visits by Rand, Noyes, and a display designer for IBM World Trade named J. A. Healion, was "absolutely insufficient. These visits are too short, people hardly get to know each other, and there often is a communication and language problem."[132] A new, more aggressive means of coordinating the efforts of so many thousands of designers was needed.

As heated internal debates erupted in the 1960s among executives and engineers alike over the best means of maintaining IBM's growing dominance over the computer market, the various design departments underwent dramatic turmoil. Just as IBM executives realized that continuing to produce six wholly incompatible product lines would eventually lead to massive problems in terms of manufacturing and sales, major shortcomings

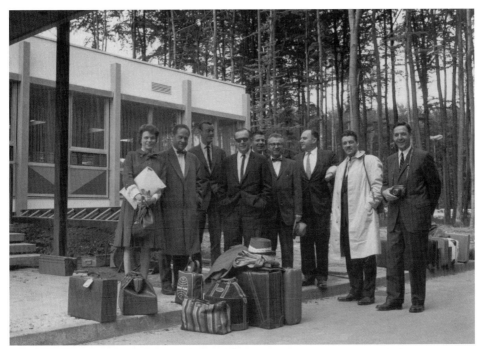

Figure 1.10 Marion Swannie (far left) and Eliot Noyes (second from left) visiting IBM Böblingen, Germany, 1961. Courtesy of IBM Corporate Archives, Somers, New York.

in industrial design were everywhere evident: inconsistencies in dimensions, materials, and even graphics standards between designers at various IBM installations working on the same products; widely disparate organizational charts, in which engineers or industrial designers in different departments held varying degrees of authority relative to one another; and, most important, insufficient transparency in terms of that key concept underpinning the entire design effort—communication. In the years between 1961 and 1964, IBM management decided to stake its entire future on the success of a new integrated, intermachine-compatible line of computers—known to IBM engineers then as the "NPL" (standing, in an indication of the confusion inside the company, for both "New Programming Language" and "New Product Line"), but soon to be known the world over as System/ 360. Memos flew between Noyes, his fellow consultants, and IBM industrial designers, all offering solutions to the problems at hand and frequently bickering over territorial matters.[133] In some cases, the industrial designers sought to subsume other specialists into their own departments, and in others arguments between the industrial designers and the hardware engineers broke out, with various managers attempting to keep the peace.[134]

As under Watson Sr., IBM's policy of competition between engineers working on the same project remained critical to IBM's success; however, the competitive atmosphere that IBM had long fostered was becoming self-defeating. Work on designing System/ 360 demanded a new model. As then director of research at the Thomas J. Watson Jr. IBM Research Laboratory in Yorktown Heights, Emerson W. Pugh, described it in one

of his many histories of the period: "Competition was no longer 'blind.' Now information on engineering plans, assignments, and requirements was broadly available [within the corporation]. Individual engineers could readily learn what approaches were being tried and what opportunities there might be for improvement."[135] This new policy, combined with a renewed emphasis on the autonomy of various departments under the direction of strong leaders, allowed IBM to achieve the remarkable commercial, technological, and aesthetic success of System/360.[136]

The design departments underwent a similar change in policy and management structure. As the debates reached a fever pitch in the boiler room days of early 1964 (IBM was about to announce the System/360 to the public in April), McKay sprung into action. He created a new Design Center, to be located in Poughkeepsie and headed by the IBM industrial designer Walter Furlani, that would spearhead "an overall program in support of the objectives of the IBM Design Program" and produce a single set of guidelines for industrial design (Figure 1.11). As a memo sent to "All Laboratory Managers" declared, "Mr. Furlani will coordinate the work of outside consultants and provide guidance to laboratory personnel whose work falls within the range of his new responsibilities. All matters regarding aesthetic design are to be brought to his attention for concurrence prior to implementation. This includes Graphics design, exhibits, building interiors, and photography, as well as industrial design."[137] Every design save for architectural structures, in short, would now pass across Furlani's desk, and Furlani himself would be vested with the power not only to enforce the will of the consultant director (Noyes) within the corporation, but also to resolve organizational or design disputes. With this recentralization, IBM ensured that its industrial designers would endow its new line of universally compatible machines with an appropriately unified aesthetic.

Figure 1.11 Page from IBM Design Department, Poughkeepsie, *IBM Industrial Design Practices—General Design Guidelines* (28 February 1972). Collection of the author, with thanks to James LaDue. Reprinted with permission.

It was out of the integrated Design Center, which responded to the new imperative of compatibility, that a set of guidelines for computers and their peripherals at last emerged. As the introduction to the *IBM Industrial Design Practices—General Design Guidelines* stated:

The IBM product line consists of many products used separately, or, more often, in virtually unlimited system combinations. This constant intermix of our products requires two levels of design guidelines—conceptual and detail—to ensure a consistent design statement across the product line.

Conceptual guidelines reflect our basic design attitude toward the product line as a whole and relate all units of the line to each other. These guidelines are broad enough to permit many possible design solutions.

Detail guidelines summarize the currently agreed-to solutions which implement the conceptual guidelines into the design of our individual products.[138]

The guidelines provided thus mimicked the ascendant form of management within the corporation: an open, organic model, in which the designers at work in one part of the corporation could be seen and responded to by others elsewhere. With a guiding conceptual rubric in place, designers could collaborate on meshing their detailed designs into a coherent whole. However, this was hardly a one-way process, with technological demands wholly determining the designers' response; the designers, from Paul Rand to the often anonymous engineering teams working in various IBM industrial design departments, demonstrated the value of conceptual unity and organization through their struggle to coordinate their efforts.

Initially, the applicability of the guidelines to IBM's products and spaces appear to have been contingent upon the scale of the project in question. Graphic design techniques could be prescribed to the smallest serif and layout modules; computers and other office machines were less tautly defined, but patterns were, in time, provided for all manner of details. For architecture, in keeping with Watson's and Noyes's shared dictum that IBM should be "simply the best in modern design," no pattern book was produced at all for some time. Management, and later a separate Real Estate and Construction Division solely devoted to the development and production of IBM's facilities, established in 1962, eventually provided guidelines in terms of building modules, lighting standards, and even a series of more-or-less flexible rules about art installations.[139] In all facets of IBM's ever-growing design program, a period of experimentation presided over and even dominated by Noyes and his fellow leading consultants preceded a reorganization around a consolidated organizational structure and a more diffuse mode of design authorship. The chapters that follow trace this process in a staggered, overlapping chronological order, mirroring this process of experiment, organization, and finally, reconsideration.

Chapter 2

The Architecture of
the Computer

... the machine that replaces your secretary and sets her free for full-time pre-marital sex
will probably look less like a battery hen-house full of war-surplus W/T equipment than
a tastefully two-toned filing cabinet with cooling louvres, discreetly wired to what appears
to be a typewriter with ideas above its station.

Reyner Banham

... the typewriter is not really a machine in the strict sense of machine technology, but is
an "intermediate" thing, between a tool and a machine, a mechanism. ... This "machine,"
operated in the closest vicinity to the word, is in use; it imposes its own use. Even if we do
not actually operate this machine, it demands that we regard it if only to renounce and
avoid it. This situation is constantly repeated everywhere, in all relations of modern man to
technology. Technology is entrenched in our history.

Martin Heidegger

Computers and the New Vision

It is a truism in the history of science and technology that the computer, like any technology, was invented at multiple times and in many places, by any number of different people; accordingly, the contemporary historian of science and technology has any number of methodological responses to this problem immediately to hand.[1] Yet the computer presents a special problem to both designer and design historian, for two complex but interrelated reasons. The first is that it is impossible to pinpoint exactly who designed a given computer. An industrial product of immense technological complexity, a computer is the result of the combined efforts of many different kinds of designs and designers: mathematicians, who articulate the computer's logical form; engineers of various types, who transpose that logical form into material, develop the mechanisms that grant it its memory and ability to communicate its functioning to other machines and operators, and much else besides; and technicians—whether machine or human—who assemble the vast array of components into a functional apparatus on the factory floor and wherever the computer is to be used.

Most of these aspects of computer design are not treated here. They are treated extremely thoroughly elsewhere, in the literature on the history of science and technology and in technical manuals, by historians and engineers with much greater expertise in such matters than I could possibly possess.[2] Rather, this chapter seeks to discuss the contributions to the design of computers made by industrial designers, which has thus far gone undiscussed in any detail by design historians.[3]

It is not hard to see why historians have avoided such a difficult problem. Eliot Noyes, Paul Rand, and the IBM industrial design engineers with whom they collaborated did not participate directly in the design or engineering of the form or structure of the CPU or the computer's other mechanical and electronic parts, nor did they participate actively in the academic research then being conducted into human physiology or the psychology of behavior and perception (the cognitive sciences) by ergonomists. Industrial designers did not make substantial contributions to the design of software (notwithstanding a handful of notable exceptions).[4] They were misunderstood by their colleagues in other departments within the corporation, who saw them as concerned only with "the height of a reading board, the knee space necessary, the diameter of a knob,"[5] or with the banalities of advertising and so forth. In the rapidly changing world of computer design, the role of the industrial designer in the process of designing computers became at one point so vague even to IBM management that the company considered merging the Industrial Design Department with the Human Factors Department, an episode that will be discussed in some detail below.

If industrial designers could not participate in any of these putatively essential aspects of computer design and manufacture, then what was their function? The answer is at once remarkably abstract and, in view of the evidence, tangibly concrete. Industrial de-

signers designed and engineered the apparatus character of the man–machine system of the computer: the functional and spatial relation of the machine to its users and to its surrounding environment. Another way of saying this is that in the design of computers, industrial designers played the part of engineers, but engineers of a very special kind, occupying a liminal area of expertise situated somewhere between that of the electrical engineer, the computer scientist, the human factors engineer (ergonomist), and, perplexingly, the architect. Noyes and his fellow design engineers coordinated the raw data generated by the human sciences (psychology, psychiatry, human factors engineering, medicine, etc.), information sciences (information and communications theory, cybernetics, game theory, systems theory, simulation), and the technical engineering of electronics into a representational system capable of organizing and suspending the human being and the automatic, autonomous object called the computer into an organic and productive whole—a semiautomatic system. All of this work was poured into the production of an approach to the design of what Noyes and his colleagues at IBM called the externals of the machine—its interface.

In 1966, when he was asked by Reyner Banham in a television interview how he maintained visual and experiential consistency among the various IBM machines, Noyes answered amusingly,

Well, it's first of all I think a general philosophy of design, let's say it's non-decorative, it's pretty straightforward and functional and it's kind of producing order to make sure that there is order, but the devices by which I keep order going here is, for example, a consistent approach to form and a consistent approach to detailing, and a consistent approach to colour and these to some extent can be codified and I enlist the collaboration and co-operation of industrial design managers of each location within IBM to become a sort of an informal committee. In fact I've often called it the Lavender Hill Mob of IBM because it's absolutely illegal, there's nothing in their table of organisation that says such people should talk to each other, or even know each other, because they're in different divisions, each one of which has its own responsibility, but we do need and we do have our parties and we do agree about our standards and nobody can make any . . . design innovation or change without our general agreement, and in case of dispute I'm the referee.[6]

This group of bumbling crooks—Noyes refers to the Oscar-winning bank heist comedy *The Lavender Hill Mob* (1951)—worked across the clearly defined organizational units of the corporation,[7] bringing their individual data into alignment with each other, critiquing and correcting those data, and eventually codifying that harmony in the form of the *IBM Design Guidelines*. By virtue of this transorganizational position, the industrial designers at IBM, then, did not just design the way that the computer looked, but also determined its fundamental character as a single system, and in so doing, redesigned the workings of the individual departments of the corporation itself. Any account of the design of the computer must therefore take into account the nature of this role and seek to explain the precise techniques—at both formal and organizational levels—by which they fulfilled it.

Further complicating matters, there is a second reason why the design of the computer is a difficult subject for the designer and historian alike, and this is the simple fact that—because the computer is capable of reproducing formal logic and is always and everywhere in dialogue with a vast number of different people, of varying types discussed below—the computer is a subject as much as it is an object. This is, of course, a problem for the designer or historian of any given technological object, insofar as that object is both the product and the artifact of use. As we have seen in the preceding discussion of organic design, Noyes and his colleagues were acutely aware of the problems that this state of affairs presented, forcing the designer and historian to accept a contradictory status: as the maker, form-giver, or author of the object, and as the passive medium through which objects change themselves through an intensive program of use (viz. Noyes's and others' narratives of the "evolution" of objects toward a perfect form).

Yet with respect to the computer, the uncanniness of the authorship of the object is even more profound than that described by Marx in his theory of commodity fetishism, with the hopeless confusion between use and exchange values that animates it.[8] To be sure, as an automatic "thinking machine" the digital computer is the reification, in the most literal terms imaginable, of Marx's prototypical *Warenform,* the table, that so famously "stands on its head, and evolves out of its wooden brain *[Gehirn]* grotesque ideas, far more wonderful than if it were to begin dancing of its own free will."[9] Yet the computer is a table in another sense, not fully articulated in Marx's analysis. The computer is a *tabula,* an ordered form of knowledge, that, to follow Foucault and others,[10] both speaks and writes itself. The computer, like the corporation, is a form of discourse every bit as much as it is a machine or a commodity and as such has profound implications for the self-image of the human being who uses it.[11] But the form of the computer, unlike the wooden table, does not just distort social relations by virtue of its position on the stage of the market (although it certainly does do this). Making cautious use of one of the more puzzling metaphors of the twentieth century, we might say along with one of the computer's many inventors, the mathematician John von Neumann, that the computer distinguishes itself from any other object because it has an architecture.

Before turning to my attempt to articulate what the implications of the claim that the computer possesses an architecture might be, it bears noting precisely from where the uncanny and confounding idea that the computer thinks comes. The very vocabulary of metaphors with which we speak of the computer derives from sources that generate ideological misconceptions of, as Noyes would put it, the relationship between human beings and their equipment.

A "computer" was once a human being.[12] Strictly speaking, anyone who "computed"—that is, manipulated numbers according to mathematical rules—was a computer. Such biological computers were analog versions of the familiar digital computers of today, wholly modular (imagine vast arrays of actuaries calculating the terms and payments of insurance policies, or the mathematicians put to work in the discrete, and discreet,

hives of the Manhattan Project) and mechanical, even when not operating machines. They were adjuncts of the tables and arithmetic that constituted the modern administration of business. One of the founding theoretical texts of computer science, the British mathematician Alan Turing's "On Computable Numbers, with an Application to the *Entscheidungsproblem*" (1935), takes the slippage between embodied human thought[13] and discrete formal logic—a slippage engendered through the material practice of people behaving as computers—as both its basic assumption and its incredibly powerful conclusion. In seeking to prove a solution to the hanging theorem by Kurt Gödel named in the title of his paper, Turing described what he called a "universal machine," an imaginary device that could solve almost any mathematical problem by breaking down complex operations into a series of single, definite steps. "The operation actually performed is determined . . . by the state of mind of the [human] computer and the observed symbols. In particular, they determine the state of mind of the computer after the operation is carried out. . . . We may now construct a machine to do the work of the computer."[14] In other words, given that the mathematical work of computation (performed by a person or people) is wholly reducible to a string of operations reproducible by the machine, the person or people assembled to do that work may be replaced by a machine. Turing's "universal machine" thesis eventually became just such an actual machine, the very first digital computer—named a Bombe for the ominous ticking noise its mechanical components made—that he helped to design and operate at Bletchley Park during World War II, in the famous and extremely successful bid to decode the German Enigma encryption system. A later, more fully realized digital computer, Colossus, was developed to crack yet another German encryption system.

After the war, he happily continued theorizing new machines for all purposes, including designing weapons, but his work took a dramatic turn when he gleefully declared his intent to construct a machinic equivalent of a "mediocre" human brain. Toward the end of his short life, he turned the point of his formal logic away from mathematics and toward life itself, proposing to explain the puzzling diversity of life from a nearly homogeneous set of elements through a set of computational simulations.[15] In 1950, Turing wrote a landmark paper for the development of the nascent discipline of artificial intelligence (AI)—published, significantly, in the philosophy journal *Mind*—that solidified his claim to the identity of mechanical computation and thought.[16]

This homology, built on the assumption that any phenomenon can (and should) be reproduced as information, is a deeply problematic one. My criticism here of Turing's homology between mechanical computation and thought (or "intelligence," in Turing's terms) is not made on philosophical grounds, nor does it proceed from any of the famous "nine objections" to Turing's thesis that Turing himself codified in his own article.[17] Instead, it proceeds from the fact that there are two fundamental assumptions made at the beginning of Turing's analysis that are left unarticulated by both Turing and his many interlocutors, during and following his lifetime. The first assumption—absolutely necessary to Turing's argument—is that thought exists independently of any mediation. This is what makes it

possible for Turing to claim that thought can be produced by any properly arranged apparatus, whether biological or mechanical; thought is simply such a logical arrangement. Whether or not this is the case is not the issue; the problem is that the design of the Turing test blatantly contradicts the basic terms of his argument.

In the test, a human being is placed at a computer terminal and prompted to enter questions. The questions are answered by two subjects, one another human being and the other a computer, both of whom are concealed in another room, with the order in which each interlocutor answers determined randomly. If the subject asking the questions is unable to tell the difference between its two interlocutors, then the machine, Turing claims, may be called "intelligent." This seems reasonable enough, until one considers that the entire experiment depends in the first and last instances on the questioning human being to translate its thought and the thought of its interlocutors through a machine. Even the structure of the entire experiment is unclear, insofar as it is ostensibly the machine that is being tested for intelligence, but the subject of the experiment upon which the result ultimately hinges is the judge, the human subject asking the questions. Thus, one may see (1) that the entire question of "machine intelligence" is thus one of the mediation between the human being and the machine in question by language rendered on a printer or display; (2) that the placement of each subject concealed at a distance from the others is essential to the experiment; and (3) leading to my second objection to Turing's thesis, that the material apparatus of the test is, on either side of the screen, not computer *or* human being, but computer *and* human being—in short, a man–machine system, coordinated by an interface.

In a long-forgotten book on the relation of the computer to the philosophy of mind, Mortimer Taube demonstrates the ludicrous but foundational tautology of the assumption made in Turing's original paper, his later writings on machine intelligence, and in nearly all of the subsequent literature on computers as thinking machines.

If a machine is to simulate the behavior of a human brain, the designer of the machine must have a good notion of the behavior which is being simulated. . . . It is unfortunately true that much of the theoretical and experimental work in this field has neglected this requirement and consequently has found itself mired in the classical vicious circle: (1) A machine is proposed or constructed to simulate the human brain which is not described. (2) The characteristics of the machine which are carefully described are then stated to be analogous to the characteristics of the brain. (3) It is then "discovered" that the machine behaves like a brain. The circularity consists in "discovering" what has already been posited.[18]

Another way of saying this is that Turing, despite his stated goal of demonstrating the identity of human being and computer, insists on their separation into individual entities. He does not, in effect, answer the more interesting questions posed by the thought experiment of the "imitation game": How does thought change when it is produced by the integration of human beings with machines? What happens when we remediate and conceal aspects of our thinking from ourselves?

Turing seemed to worry little, if at all, about the significance of his hypothesis that human thought was reducible to mechanical calculation. However, his exact contemporary on the other side of the Baltic, Konrad Zuse, the Berlin eccentric who designed and built the first digital calculator before World War II, claimed serious misgivings. "Since programs, like numbers," he wrote,

are built from series of bits, it was only a matter of course that programs be stored as well. With that it was possible to make conditional jumps, as we say today, and to convert addresses. From the point of view of schematics, there are several solutions for it. They all rest on a common thought: the feedback of the result of the calculation on the process and on the configuration of the program itself. Symbolically, one can envision that through a single wire. I was, frankly, nervous about taking that step. As long as that wire has not been laid, computers can easily be overseen and controlled in their possibilities and effects. But once unrestricted program processing becomes a possibility, it is difficult to recognize the point at which one could say: up to this point, but no further.[19]

To Zuse, the stored-program computer was nothing more and yet so much more than a typewriter with a feedback loop: it was a machine that could alter itself and thus gain a new form of autonomy, out of sight of its putative user.

It is the space and time through which this feedback loop is passing that is the cause of all of this subjective uncertainty. To attempt an answer to the philosophical and ethical conundrums that follow upon the invention and construction of computers and their networks, one must first understand these spatial and temporal aspects of computing, and it is these that are the object of the industrial design (and, by extension, the architecture) of the computer. What follows in this chapter is an effort to restore what has for the most part been left out of the history of computing—the attempt to articulate the physical, visual, and spatial aspects of the computer—thus complementing more routine narratives regarding what (or who) the computer is and how it has developed over the ensuing seventy-odd years.[20]

The conspicuous absence of these aspects in Turing's own work is made apparent by the fact that Turing's paper alone was not enough to transform the "universal machine" into a functioning machine. The hypothetical construction that he laid out in his description of the new "mechanical computer," of a punched-paper tape read and written by a mechanical arm, was only an abstract fantasy. The mechanical computer as a technological possibility required a translation of formal logic into structure—this was accomplished by the American mathematician Claude Shannon's doctoral dissertation, "A Symbolic Analysis of Relay and Switching Circuits," republished in *Transactions of the American Institute of Electrical Engineers* in 1938. Shannon demonstrated that a series of telegraph relays could be used to represent, and perform the functions of, the whole of Boolean logic. The "on–off" switches of telegraph relays could function, following Shannon, as representations of the ones and zeroes of binary mathematics. Further, each change

in the system would precipitate changes in the other relays, allowing, depending on how one set up the network of relays, manipulations of the binary digits to replicate simple arithmetic such as addition and subtraction; and through the accretion of such simple operations one could also reproduce complex operations such as derivation and integration. This hypothesis became the operative principle underlying early computer processors and memories, and before the advent of the microchip, these changing states could still be seen by the naked eye as a series of magnetic loops changing state in a rigidly fixed modular grid, as stacks of magnetic disks rotating in cabinets, or as a stack of punched cards.

Colossus, Turing's first machine, was built at architectural scale. Containing over 2,400 vacuum tubes (the "miniaturized" realization of Shannon's metaphorical telegraph relays), it took up the better part of a building at Bletchley Park. The computer was in itself a space to be inhabited, an apparatus organizing scores of cryptographers and female attendants into a coordinated effort that corresponded precisely to its mechanical structure. Although the origins of the term are quite unclear,[21] it is certain that the later "mainframe" computers built by IBM and its many competitors were so called because of their immense scale, occupying bays in computer rooms that served as de facto walls. Despite the rapid miniaturization of computers through the use of transistors and then microchips, this architectural quality, as we shall see, remains an essential part of the computer as a technological and aesthetic object. As recently as 1983, two computer scientists were allowed to visit the underground North American Air Defense Command (NORAD) site in North Bay, Ontario, which housed one of the last functional Semi-Automatic Ground Environment (SAGE) air-defense computers (discussed at greater length in the next chapter). On leaving, one remarked to the other, "Do you realize that we walked inside a computer? There is no way you can do that with a computer built today." At the time, the second scientist "absolutely agreed"; but "three months later to the day, [he] stood inside a Cray I [supercomputer] and felt the cool air blow up around [him]."[22] Computer miniaturization always antedates the computer's articulation as an architectural structure, often at massive scale. Even in today's environment of "integrated" digital handheld devices such as the iPhone, the actual computer "networks" that allow the devices to work are buildings of monumental scale, such as Google's Data Center in The Dalles, Oregon, of 2005, which is composed of three 68,680-square-foot buildings.[23]

The cryptography that Colossus was programmed to decipher was anything but a hermetic exercise in symbolic manipulation.[24] The German messages pertained to troop movements and the routes of patrolling U-boats in the Atlantic. Decoded in proper time—that is, if the coded messages passed from circuit to circuit within Colossus at sufficient speed—these formerly secret messages allowed Allied commanders to adjust their own strategies as if they could both survey the entirety of the territory occupied by the German army and navy at once and see the enemy's future movements. That is, the digital computer was at once a mathematics machine and a new way of seeing and foreseeing. Whether engaged in the high-stakes task of decoding enemy transmissions in wartime or producing seemingly banal sales reports, it controlled information in wider fields of

space and time than were previously possible. As a journalist observer noted on a visit with executives to a Westinghouse telecomputer installation (in a building specially designed for it, incidentally, by Eliot Noyes), "as the lights dimmed, the screen lit up with current reports from many of the company's important divisions—news of gross sales, orders, profitability, inventory levels, manufacturing costs, and various measures of performance based on such data. When the officers asked the remote-inquiry device for additional information or calculations, distant computers shot back the answers in seconds."[25]

World War II brought similar computational advances in numerous fields beyond cryptography, and they addressed, without exception, the problem of visuality in space-time. Perhaps the most significant of these were the top-secret American development of the Norden bombsight and antiaircraft targeting calculators, both of which exploited the new mathematics of feedback in order to improve the predictive capability of bombardiers and gunners—and thus, it was hoped, their ability to hit moving enemy targets. The mathematical formulas and technological experiments developed in both enterprises, in each case, were deeply marked by the insights of the mathematician Norbert Wiener, who would later synthesize his discoveries into the new applied science of cybernetics. Wiener popularized this new feedback-centered discipline in a book of his own, shockingly titled *The Human Use of Human Beings,* which appeared in 1950. Born as it was out of the need to "shoot the missile, not at the target, but in such a way that missile and target may come together in space at some time in the future," the synthetic science of cybernetics would provide important technical and temporal revisions of biology and psychology. Cybernetics, as a putative means of inserting an agent—the term derives from the Greek *kybernetes,* "steersman," "governor"—into a temporal wedge between present and future through a hyperrapid stocktaking of the past and the application of the "laws" of probability, promised eugenic control over any kind of organic system of relations.[26] Indeed, cybernetics held out the possibility of exercising direct control over evolution itself. From the vantage point of cybernetics, the computer could be understood as an entirely new phenomenon—even a form of "life." This life, far from being a matter of the abstract "intelligence" theorized by Turing, emerged from the computer's capacity to produce representations. Thus we may read Wiener's ominous aphorism—"We now come to a class of machines which possess a remarkable quality . . . a machine made in man's own image"[27]—as a statement not of ontology but of technique. Its means and end are to reproduce images of the human, and this is why one must sidestep the debates over "mind" and "brain" in computing in order to avoid slipping into the vortex of homologies that surround the computer.[28]

Early Computer "Architectures"

IBM entered the field of computing early on, and, in a sense, by the time it formally entered the business computing market in the early 1950s, it had already been there for years. Along with Turing's, Shannon's, and von Neumann's theoretical and practical work in

designing early computers, the mechanisms of IBM's accounting machines—based as they were on Herman Hollerith's patents for punched-card tabulators—constituted the material and technical basis of the development of analog and digital computers. By the mid-1930s it was already sponsoring research into the possibilities of new kinds of electromechanical computation, which seemed a natural outgrowth of its business in punched-card systems. From 1937 to 1944, in conjunction with Harvard University's Howard Aiken, IBM designed and built what was considered by many to be the world's first digital computer, the Harvard Mark I. Making use of extensive funding from the federal government as part of the war effort, IBM proceeded from this landmark achievement directly to a new project, the SSEC, a stored-program digital computer that was finished in 1947. This computer was built for a single and singular purpose, to run simulations for the designers of the hydrogen bomb. Occupying approximately 1,500 square feet at IBM World Headquarters on Madison Avenue in Manhattan, it was unveiled to the public with much fanfare in 1948. Beyond its role in more or less permanently cementing an already solid relationship between IBM and the federal government and U.S. military, the SSEC also represented an especially important step for its designers: a patent for digital computers including a claim covering the concept and structure of stored programs.[29] Moreover, the SSEC's evident capacity to simulate events as complex as an atomic explosion piqued the interest of a much broader scientific and business community. Its predictive power, and its ability to position previously unpredictable future events in space, foreshadowed a revolution in management and logistics—that is, the control of people, behavior, and objects in both time and space. Watson Sr., in typical grandstanding fashion, had a plaque engraved on the SSEC that read: "This machine will assist the scientist in institutions of learning, in government, and in industry to explore the consequences of man's thought to the outermost reaches of time, space, and physical conditions."[30]

Despite these initial successes, at this early stage Watson did not see a wide market for the application of electronic data processing (EDP). IBM nonetheless established, in 1949, an Applied Science Group, headed by Cuthbert Hurd,[31] and began hiring PhDs in an effort to build a formidable research and development program in computer technology. The motive was obvious enough: by supplying the federal government with its computational needs, from managing census data and payrolls to calculating rocket trajectories and simulating the mechanics of atomic explosions, IBM could not only defray its research and development expenses and win increasingly lucrative contracts from the federal government, it would also gain control over a number of potentially valuable patents and a reputation as a leader in scientific, technological, and industrial development.[32]

By 1950, many inside the corporation—including, most notably, Watson Jr.—were encouraged to try to translate the strides that IBM had made in scientific computing into its own field of expertise: "unit record" applications (actuarial and administrative machines). Especially following the early successes of Remington Rand (later Sperry Rand) in marketing the UNIVAC I to business users, many scientists and executives within IBM saw a clear opportunity to apply the scientific and military machine to businesses.

However, the skeptics within IBM had Watson Sr.'s ear: "They . . . told me that, in their opinion, general purpose computers had nothing whatsoever to do with IBM or IBM's main line of equipment and profitability, IBM's customers or the problems those customers wished to solve."[33]

The high costs and risks associated with designing and manufacturing new computers intended for scientific, military, and business uses, then in their earliest stages of development, nearly convinced Watson Sr. to discontinue IBM's involvement in computers for good. But Watson Jr. succeeded in pushing the project through to completion through a bit of gentle internal subterfuge. He named the project "the Defense Calculator" because it "helped to ease some of the internal IBM opposition to it since it could be viewed as a special project (like the bombsights, rifles, and supercharged impellers that IBM had built for the US Army during World War II) that was not intended to threaten IBM's main product line."[34] The "Defense Calculator," later named the IBM 701 (Figure 2.1), was the first computer to be manufactured on a "multiple, identical, assembly line basis," and it was designed to a scale small enough so that it "did not have to be built, or rebuilt, in the customer's computer room." In fact, its compact design, which eliminated superfluous wiring by using pluggable logic circuitry, allowed it to be "packaged in boxes in such fashion that any box would fit in a standard size elevator and go through a standard size door and fit on a standard size dolly."[35] In short, the 701 marked the transformation

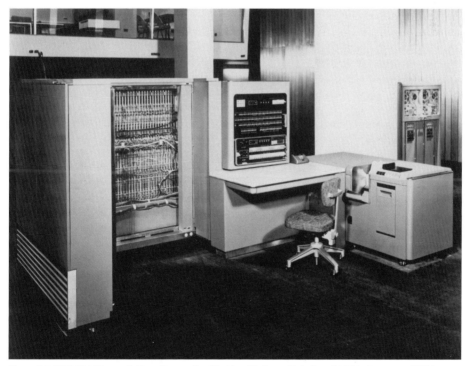

Figure 2.1 IBM 701 Electronic Data Processing Machine "Defense Calculator," 1952. Courtesy of IBM Corporate Archives, Somers, New York.

of the computer from a scientific apparatus produced at the scale of architecture to a modular appliance at the scale of furniture;[36] the design of the 701 lent the computer the potential status of a mass-produced industrial object or commodity like any other, albeit more expensive and less understood than most.

The risk taken on the IBM 701 reestablished IBM at the head of the pack of companies scrambling to dominate the small but rapidly growing computer market by outselling its main rival, the UNIVAC I, and has since become a key piece of twentieth-century business lore. The success of the 701, which was bought not only by governments and universities but also by businesses, encouraged IBM to develop software specifically aimed at business applications. Through IBM engineers' and salesmen's close relationship to their clients, and their aptitude in rapidly creating software for different applications, "the types of uses and users quickly multiplied, and included programs to assemble financial data and prepare quarterly financial reports (Monsanto Chemical), statistical analysis of seismic and well logging data for oil companies, analysis of returns during the 1956 presidential election, actuarial reports, and payrolls."[37] The military contractor Lockheed selected the 701 over the UNIVAC after concluding that the former was more flexible, able to handle "both our scientific and our business work loads."[38]

This work paid major dividends, as the demand for business computers grew steadily over the next two years. IBM responded by designing a "small" computer, more affordable than the 701. Announced in early 1953, and delivered the following year, the IBM 650 (Figure 2.2) was both an important technological innovation—with its magnetic drum memory, which earned IBM several patents—and a second, enormous commercial success. It became an industry standard for several years and the template for all subsequent IBM commercial computers up until the development of System/360.

At the same time as it announced the 650, however, IBM was also at work on a large-scale computer system aimed specifically at the powerful businesses that had purchased the 701. A kind of sequel to the 701, the new computer was named the 702 (Figure 2.3) and was announced in 1953, marking IBM's decisive shift into computing as its primary field of activity. As we have seen, it was at this moment—the arrival of the IBM 702—that Watson Jr. ascended to the apex of IBM's corporate hierarchy and that Noyes arrived on the scene at IBM as a major force with his dramatic redesign of the showroom at IBM Corporate Headquarters in New York (Plate 5) to house the new 702. Less than two years later, in February 1956, Noyes was appointed consultant director of design and began the task of redesigning the corporation from the ground up; as an industrial designer, his first instinct was to address the problem of designing the future bread and butter of IBM's business, the machines themselves.

When Noyes began to redesign IBM's tabulators, however, he did not write upon a tabula rasa. IBM's previous machines, both its computers and its other office machines (which still constituted the bulk of IBM sales, and thus its profits), were not undesigned. As a

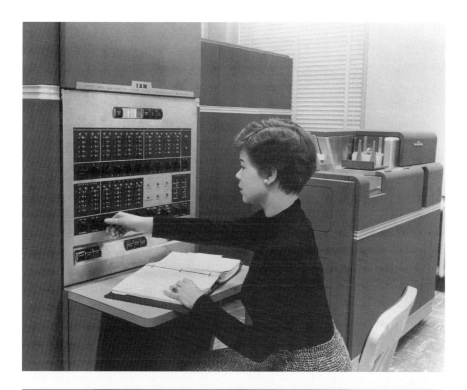

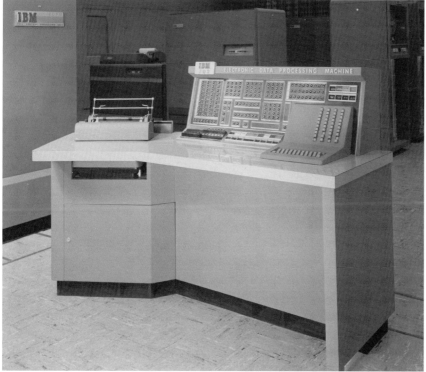

Figure 2.2 IBM 650, 1954. Courtesy of IBM Corporate Archives, Somers, New York.

Figure 2.3 IBM 702, 1954. Main operator's control interface. Courtesy of IBM Corporate Archives, Somers, New York.

catalog of IBM products offered at the 1939 New York World's Fair attests, the company's wide range of time systems, punched-card accounting machines, scales, and typewriters were all becoming loosely united by what one might describe as an understated Art Deco aesthetic (Figure 2.4). Some of the pieces retained anachronistic references to nineteenth-century furniture, and several were simply bolted to items of standard furniture, such as the Electric Alphabetical Printing Punch, with its spindly cabriole legs. Noyes called them "Queen Anne furniture."[39] But by 1939 these were giving way to sleeker enclosures like that of the Type 285 Numerical Electric Accounting Machine.

As we have seen, Noyes himself had been contracted to redesign IBM's typewriters well before he was appointed consultant director of design, but IBM had also retained other individuals and firms to design its products earlier than 1947. In fact, IBM had retained a pair of industrial design firms—George Kress and Sundberg-Ferar[40]—since 1943, when they won a competition for the design of its new 407 punched-card accounting machine. Kress became almost an in-house employee of IBM, designing the housings for an entire new line of Art Deco-ish accounting machines and establishing the company's first attempt at a comprehensive design program.

Kress's few pronouncements in the design press were bland enough, stressing function and aesthetic appeal; the only bold proclamations he made were in regard to the

Figure 2.4 IBM International 50 equipment and Electric Alphabetical Printing Punch, 1939. Courtesy of IBM Corporate Archives, Somers, New York.

importance of teamwork and an early emphasis on "human engineering," or what would soon be widely known as ergonomics: "A satisfactory design solution, with the least amount of extra cost, is achieved only when I.D. works with the other people developing the machine, the engineers and new-product men [i.e., salesmen], *right from the beginning*."[41] The IBM industrial design program was small, but it claimed already to be "concerned with the development of the fundamental shapes of the machines, with their external appearance, with the mechanical detailing of their exterior members, and with their human engineering, the operator-machine relationship."[42] This latter relationship was under strain in the context of the new computing apparatuses, since the previously separate machines of the tabulating apparatus—IBM's unit record equipment: card punches, card readers, card sorters—were now no longer overseen solely by a human organization, but rather integrated and controlled by and from a central logic circuit. The place of the human being in this new apparatus was thus put in question.

Kress and Sundberg-Ferar did indeed make crucial first steps in articulating the "fundamental shapes" of these new machines. As a plan of the installation of the first IBM 704, 705, and 650 systems in the Data Processing Center at IBM World Headquarters on Madison Avenue in 1954–55 shows (Figure 2.5), the apparatus was arranged in space in an orthogonal and modular fashion that became a convention of computing installations for years to come. The vast network of vacuum tubes that constituted the

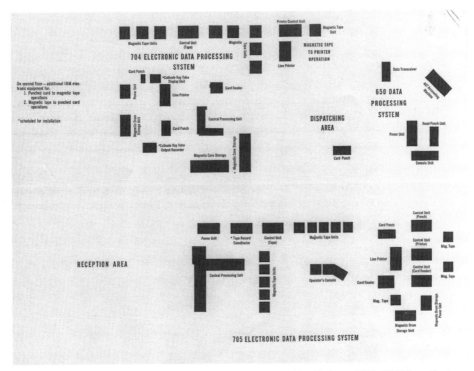

Figure 2.5 IBM Data Processing Center, IBM World Headquarters, New York, ca. 1954–55. Schematic plan of computer installations. Courtesy of IBM Corporate Archives, Somers, New York.

CPU was broken down into several individual, freestanding volumes linked together by wiring concealed underneath a raised floor and behind walls, demonstrating the iterative form of the logic circuit. The mechanical elements of previous IBM machines were translated into a new context and united into a perceived whole by a consistent approach to the casing surrounding each module in the apparatus. At the center of the sprawling machine was an input/output (I/O) unit (identified as the "operator's console"), basically a desk with a typewriter keyboard with a few additional dials and switches, from which the computer's operation would be controlled. Although the operation of the computer still required several human adjuncts, especially to monitor various memory units such as tape drives and replace easily burnt-out vacuum tubes, Kress and the IBM engineers clearly made an effort to centralize and simplify the interface between human operator and machine through the design and position of the I/O device.

Despite these innovations in the industrial design of computing, when Noyes was asked to redesign the showroom for the new IBM 702 in 1954, he considered the Kress and Sundberg-Ferar designs to be "scattered and intricate"; he felt the need to "bind" the various parts of the computer together using a dramatic red wall and white floor, with special lighting effects to make "the wall radiate and the floor dazzle even when [it was] bright outside."[43] The lighting and color that Noyes applied emphasized, in analogical fashion, the new spatiality and temporality of computing—an environment indifferent to its surroundings and unhindered by the limited endurance of its interchangeable human attendants. The radiation and dazzling, however, also seem to introduce a basic instability in the taxonomy separating the industrial object from architecture. It was this architectural approach to the design of the computer that Noyes used to define the initial parameters of the IBM program in industrial design.

"Parlor and Coal Cellar": The Ergonomics of the Computer

When the design program was officially established in 1956, Kress was pushed out, and Noyes assumed control. No longer limited to designing the showrooms for the machines, Noyes aggressively engaged with the problem of designing the entirely new machines just then emerging from IBM's various engineering departments. Noyes worked with Sundberg-Ferar on numerous designs: most notably, the successors to the 701 and 702, the more powerful 704 and 705. From his first experiments in this direction, it is clear that Noyes initially approached the design of the computer as a problem not of industrial design but of architecture. In his previous industrial designs, such as his redesign of the IBM electric typewriter, he concerned himself with the operation of the mechanism as a means to discover how it could best be concealed; as we have seen, this concealment was then intended to be harmonized with its putative architectural surroundings as an organic part of a greater whole. Computers, however, with their vastly different scale, and taking into account their incorporation of the typewriter/printer as an I/O device, required an extrapolation of this principle. In order to banish the "scattered" impression

that these machines left upon their users, the I/O devices needed to be related visually to the CPU and storage apparatuses of which they were but parts. Noyes, in keeping with his general tendency toward an organic and transparent design solution, initially sought to accomplish this feat through the same tactics that he had used in his design of the computer showroom itself; as he stated later in his career, "Take the central processing unit of the 705, for example. It was entirely covered over with gray panels, and we began stripping off the panels, and the more we stripped the more beautiful it became, and there were blues and oranges and wonderful reds. And we ended up exposing the entire thing under glass, and *apart from this coat of many colors,* this revealed the machine's true character" (Figure 2.6).[44] Thus, Noyes attempted to establish a visual and spatial relationship—an aesthetic relationship—between the user and the computer by removing the opaque panels and offering the user a view (through a glass window) into the machine's innards. Yet it is essential to note Noyes's acknowledgment that no matter how much he and Sundberg-Ferar may have succeeded in exposing the machine's inner character through this mechanical striptease, it nonetheless remained cloaked in an essential mystery—it retained its "coat of many colors," which still concealed the inner workings of the machine.

As it happened, the experiment begun with the 705 design was hardly complete by the time the production schedule demanded that it be finished, and IBM's relatively crude manufacturing capabilities placed severe limits on its ability to produce a wholly new design on short notice, limiting innovation to the housing of the computer to a series of sliding

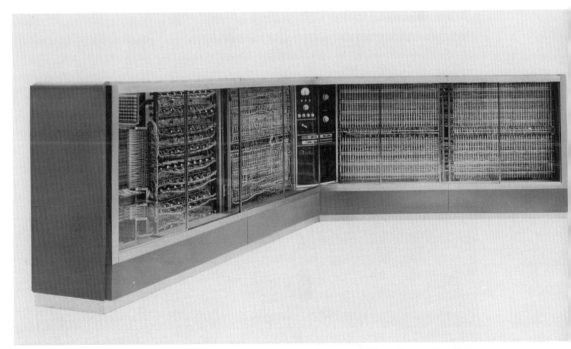

Figure 2.6 IBM 705 III, 1954. Central processing unit. Courtesy of IBM Corporate Archives, Somers, New York.

glass doors on the rear of the unit; in any event, the experiment had only been done on the CPU, with which few users ever interacted, concealed as it was away from the operator's area. But, as with his early redesign of the IBM electric typewriter, Noyes's true innovations in the industrial design of the computer went hand in hand with the development of new technology.

Announced in September 1956, the IBM 305 RAMAC (Figure 2.7)—an acronym for "Random Access Memory Automatic Computer"—revolutionized EDP by providing a wholly new technology for storing data.[45] Previously, the only means of storing data had been tape drives and expensive CRTs (which IBM did not use); with such devices, data were stored along a single line, and to retrieve a piece of data, the machine would have to scan through all the data between where it was at the moment and the desired point. In stark contrast, the new 305 included the IBM 350 disk drive unit, which stored and retrieved data from a revolving stack of fifty disks two feet in diameter. Magnetic heads on the end of mechanical arms could be inserted into the whirling column of disks, cushioned by a blast of compressed air that prevented the heads from damaging the disks, and retrieve any piece of information, no matter when or where it was stored, in a fraction of a second. This data retrieval system, approximately two hundred times faster than competing tape drive systems, allowed modestly sized businesses to possess computing power sufficient to process data in "real time."[46]

Just as he had with the 705, Noyes insisted that it was the designer's task to ensure the visual cohesiveness of the entire computing apparatus. Drawing upon a familiar trope,

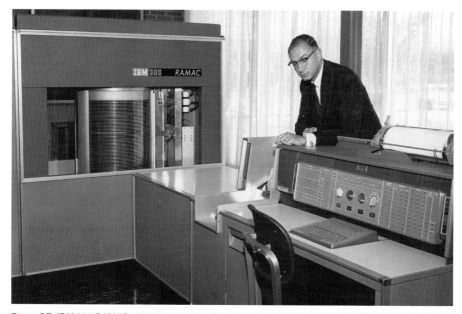

Figure 2.7 IBM 305 RAMAC with 350 magnetic disk drive unit, 1956. Courtesy of IBM Corporate Archives, Somers, New York.

the identification of the stored-program concept as the "von Neumann architecture," Noyes's design sought to reveal this architectural "character" by designing the housing of the machine as a house. The RAMAC machines, he stated in an interview, "should not be like a ranch house. They should be like a Mies house. They should have that much integrity and joy."[47] In this dramatic and pregnant analogy, Noyes made a double declaration. On the one hand, the casing of the computer would no longer be made of haphazard load-bearing walls, but rather the sheer glass surfaces of the Farnsworth house, on which the intimate interior of domestic space and the surrounding landscape would be collapsed onto one another at the level of the computer's outer skin. On the other, the Miesian quality of the redesigned computer lay in its articulation according to rigidly modular principles. The computer could not be "scattered," or sprawling like a ranch house; rather, its complex nature as an apparatus had to be pulled into a coherent whole, enclosed and complete in and of itself. Rather than consider each unit of the computer apparatus as an object in its own right, the real site of the industrial designer's intervention would be the space into which the computer apparatus was situated. In this respect—and keeping in mind the direction in which Noyes's architectural designs moved in these years, especially in his own house, which condensed the sprawling binuclear house into a single volume behind stark fieldstone and recessed glass walls[48]—Noyes's analogy alludes at one and the same time to Mies's courtyard houses, in which the domestic space of the house encloses and domesticates a portion of the territory in which it is placed.

In this dual manner, Noyes (and Sundberg-Ferar, who continued as consultant designers to IBM through the design of the RAMAC and were then dismissed) responded to the problem of designing the externals of the RAMAC by dramatizing the wondrous workings of this new machine. Noyes opened up the usual casing around the whirling drum memory unit, exposing the computer's "coat of many colors"—colored coated wires, plastic and metal connectors, and various other computer parts. Installed now behind glass, whirling in a little white room inside its larger casing, the magnetic disks of the computer confronted its operator directly. The design immediately calls to mind Noyes's redesign of the IBM 702 showroom in Manhattan, where he had erased fussy details and curtains and instead allowed a seemingly direct, and wholly theatrical, view into a previously concealed space.

This architectural approach seemed a grand idea, and the emerging professional press in industrial design praised the design to the skies. Noyes and Sundberg-Ferar received a medallion in 1957 from the Industrial Designers Institute "for imparting a *distinguished architectural quality* which integrates with contemporary office design."[49] However, the rest of the design of the RAMAC was uninspired, and even lacking in some respects. It appears Noyes only concerned himself with the disk drive, and—whether due to time pressure, lack of sufficient expertise, or lack of experience—was content to leave the rest to Sundberg-Ferar's conventional solutions. The means of integrating the console into the larger volume of the computer was left unresolved as well; Noyes's design

abandoned the more flexible arrangement that had prevailed in the 701 and 702 designs, instead attaching the I/O unit to the main body of the computer at a right angle. This meant that the main visual emphasis of the design, the glass-enclosed disk, was partly in the operator's field of vision, but off to one side, bifurcating the user's attention. And, beyond the praise of design critics, Noyes can hardly have been pleased with the associations conjured in the minds of users; apparently many observers noted that "both in appearance and in operation the 350 RAMAC disk drive resembled a jukebox."[50]

Nonetheless, Noyes used this "coat of many colors" technique again with the 7320 magnetic drum memory unit for the IBM 7090 series of computers, which were designed in 1958 and delivered in 1959. The design of the 7320 was, arguably, even more theatrical than that of the RAMAC, since the memory unit was freestanding, rather than integrated into the design of the I/O unit, and had no controls of its own. It was designed to be a modular storage unit for very large computers. Each 7320 could store slightly more than a million characters, but CPUs large enough to use such capacity generally required several. Here the "Mies house" was rendered as a miniature skyscraper; the bright multicolored wires and whirling drums, when installed, would be positioned in rows, further amplifying the magical effect of the automata through repetition.

Thus, by the time he had completed his first computer designs, Noyes had already discovered, through a kind of heuristic exercise, some of the fundamental problems of the ergonomics of the computer. To troubleshoot these problems, in 1957 he deployed his fellow consultants to various important sectors of IBM, in hopes of assembling a coherent program for computer design. George Nelson was assigned to consult with IBM engineers on the design of Semi-Automatic Business Research Environment (SABRE), a project for American Airlines that would allow for real-time management of reservations and scheduling using a combination of digital and analog computers.[51] From Eames, Noyes commissioned a sequel to *A Communications Primer,* to be called *An Introduction to Feedback,* that would elucidate the main tenets of cybernetics and articulate their role in the design process (discussed in chapter 4). In the event, Nelson's involvement with IBM soon ended due to a contractual dispute with Herman Miller,[52] and Eames was sidetracked from completing the film by a project with Nelson for the United States Information Agency (USIA) in Moscow (the multiscreen projection *Glimpses of the U.S.A.*), a visit to India, and the commission to design the IBM exhibition *Mathematica.*[53]

Edgar Kaufmann Jr., however, remained available, and it was his contribution that brought the matter of machine design into sharp focus. He began consulting in early 1957. Noyes supplied him with drawings, photographs, and material samples of recent IBM designs, including the 702, 704, and RAMAC. In a letter to Noyes of 13 June of that year, written after additional research (one might almost say industrial espionage) during a visit to the General Electric Computer Center in Rockefeller Center, Kaufmann offered a sketch critique of the IBM designs, which formed the beginnings of what would become

the *IBM Design Guidelines* for industrial design.[54] Kaufmann's comments were divided into two columns, one offering his "Impressions" and marked by numbers, and a second his corresponding "Hunches" regarding how IBM computers should be designed in the future, marked by letters. The letter is so important to the IBM Design Program that it is worth quoting in full but, due to its staccato structure, one piece at a time.

I. Electronic computers have a specific visual character based on the massively complex assembly of very small parts, whose colors and textures are surprisingly "natural" and appealing, not mechanistic. (This generalization is not seriously affected by transistors, printed circuits, etc., nor by the special forms of reels, console keyboards, etc.) Their character nowhere affects their cabinets, tho' you have opened these to reveal it every so often.

This impression is obviously formulated in reference to Noyes's designs for the 705 and for the RAMAC, with Kaufmann objecting to its emphasis on the mechanical operation of storage retrieval rather than on the general nonmechanical (i.e., nonmoving) character of the "electronic computer," its moving adjuncts and I/O devices notwithstanding. Even more interesting, though, is the basic conceptual division that Kaufmann identified between the machine itself and its container, a distinction that is fundamental and consistent throughout the entire history of the industrial design of computers. The actual computer, at first a "massively complex assembly of very small parts," and "natural" rather than "mechanistic," cannot function on its own. Like a collection of organs, it requires a skin or membrane to protect it. For numerous reasons, from electrostatic sensitivity to the need for an interface with its operator, the computer cannot be allowed simply to sit on a desk or the floor, exposed entirely to the surrounding environment; it needs rather a doubly protective enclosure. On the one hand, the enclosure protects the machine from environmental interference; on the other, the enclosure must be in some sense "porous" (a word that Kaufmann himself used, see below), allowing for a select set of representational transactions between the user and the machine. This latter point is of the utmost importance, since it identifies the "skin" or "cabinet" of the computer as the precondition for its functionality.

This skin thus became an essential part of the machine itself despite a quasi-paradoxical but essential difference from the parts that perform the mechanical aspect of the computational process, raising the difficult design problem of how to integrate these two machines—computer and cabinet—into a functional, organic whole. In the corresponding hunch, Kaufmann made a key conceptual correction to Noyes's early architectural approach. Noyes's architectural instinct toward revealing the machine's "character" was correct, but opening the machine to view was not the solution:

A. Design should feature the inherent character of computers more and more. You have pretty much decided this already, and are continuing to think of color (inside the cabinets) as a means to this end. I believe this should be carefully considered. Color so used might easily sap the vitality of the natural textures and impose a merely picturesque effect on an installation. Another impedi-

ment (no pun intended) to the natural character lies in the massive bases beneath the units, themselves so feathery and mobile.

Kaufmann's first hunches are—beyond his injunction to "feature the inherent character of computers more and more" and his yet unqualified association of computers with "feather-[iness] and mobil[ity]"—skeptical and negative. A design that showcased the computer's "inherent character," Kaufmann seemed to suggest, was not equivalent to a window looking into the computer. Rather, the colorful world of the computer's innards was "merely picturesque" and did not keep in view the overall composition of the "installation." (Color, in any case, was hardly Noyes's strong suit; he preferred rather to augment the "natural quality" of a material through the use of lacquers or stains.[55])

His next impression and hunch, however, demonstrate that Noyes's architectural approach to the design of computers was not entirely off-base:

II. Cabinets can be made by a number of processes other than those now used (stressed skin, frame and panel, etc.).
B. Cabinets could be gradually swung around toward the intrinsic character, at least *analogically. That is, not designed to imitate the guts, but in better harmony with them.* Lighter, more articulated, of less mechanistic-seeming materials (textures as well as colors). Bases could be lighter, higher, even faked if need be, to avoid that squashed-down look, and if possible semi-transparent (perforated, constructivist, overhead wiring and cooling).[56]

The relationship between computer, cabinet, and operator required the deployment not of a trope of transparency, but rather a strategic analogy. Simply put, Kaufmann here reset the terms of the design problem not as a matter of what the computer is, but of what the computer is like. Following on his initial assumption of the computer's natural, nonmechanical (visual and functional) character, the cabinet would need to express— through a quasi-architectural system of "stressed skin" or "frame and panel" structural techniques—the logical processes going on behind it on a formal level. Kaufmann associated the functioning of a logic machine not with the literal and banal "guts" that make it work, but rather with the purer elegance of an architect's mathematics: geometry. Kaufmann's suggestion for a "perforated, constructivist" approach to designing the base and housings for the computer's requisite services—tubes for coolants, electrical and connecting wires—was never taken up, for reasons that will become clear; however, the suggestion nonetheless places emphasis on the stark contrast he wished to engender between what he considered the "guts" and the remainder of the apparatus that surrounded it.

Noyes solved the problem of the bases via similar means, exploiting the logic of architectural curtain-wall construction. Future IBM designs, as we shall see, aimed to preserve the impression of lightness and mobility through dark-colored bases recessed behind the brightly enameled metal skin of the cabinets. Especially when set in the usually white

rooms devoted to computers, the computers appeared to float above the modular grid of the floor tiles—in much the same way as the tower of SOM's Lever House skyscraper in Manhattan, where the structural columns are pulled inward, away from the outer curtain wall, giving the primary volumes the illusion of hovering weightlessly in space.

Referring to Noyes's design for an IBM Presentation Center in Washington, D.C., finished in 1957 and redesigned in 1968 by the Eames Office,[57] Kaufmann went on to emphasize that this process of analogy must ground itself in the "inherent drama" of computing:

III. Users of computers are immensely proud of a new dimension in their world: inherent drama is part of computers, and as little likely to fade with time as the drama of airplanes. The Washington installation points out this advantage through color, a good initial step.
C. Dramatize consoles and keyboards to the fullest (movement and color included); keep the rest in the "grandfather's gold watch" technique unless you are ready for the "parlor–coal cellar" division, which can be used to the same effect.

Kaufmann's "drama" is the careful, double operation of concealment and revealing that is at the heart of ergonomic design logic. The operation of revealing, moreover, is multiple and inherent in the act of concealment: the points of interaction with the human being ("consoles and keyboards"), those parts of the interface that break through the membrane between CPU and human being, should in some way translate and amplify the electronic activity within for the "user" outside; however, as the "grandfather's gold watch" metaphor suggests, there should also be methods of concealing—like the hinged cover on a pocket watch—that the operator may open selectively to gain a privileged but nonetheless mediated and strictly temporary view into the machine's inner workings.

The as yet unready "parlor–coal cellar" division to which Kaufmann refers, which Noyes and the IBM industrial designers had also referred to as "the furnace approach to the design of a computer,"[58] is perhaps Kaufmann's most important contribution to the theory of ergonomically sound computer design. In short, it is the idea that the most efficient, safe, and "dramatic" way to operate a computer is by segregating the vast majority of it not only visually but also spatially from its users: "only components used by the staff are exposed on a main floor and all others are buried in the cellar or in a back room."[59] By and large, as Kaufmann suggested at the outset, the problem of designing the externals of the computer was one of how to seal off or conceal the machine's inner workings.[60]

Kaufmann's last two pairs of impressions and hunches seem at first glance to be only elaborations of the "parlor–coal cellar" theme; however, they describe two crucial aspects of the design of the computer that he felt Noyes needed to address.

IV. Computer operators are keyboard conscious, and want to keep an eye on one or two other revealing movements (at the reels, e.g.).

D. Mask all but the most revealing movements that operators *must* see. Mask these much more than now.

Per Kaufmann, any of the computer's mechanical operations—that is, its moving parts—located away from the I/O unit had to be kept to a minimum, lest they distract the computer operator; these, Kaufmann did not suggest, but rather commanded, should be hidden from view behind a "mask." However, the movements that were part of the I/O unit should be clarified and dramatized to the greatest extent possible. Even a casual review of computing history—particularly of the history of I/O devices—demonstrates that this basic principle of division and concentration of attention remains a bedrock of computer design even today. (For instance, on my Macintosh laptop, the only elements visible from my seated position are the screen, the keyboard, and the trackpad.) Kaufmann appears to have been the first to articulate it in the terms of industrial design theory, and his pronouncements predate by several years even the most visionary statements by the computer scientists, psychologists, and engineers regularly credited with the idea (e.g., Ivan Sutherland or J. C. R. Licklider).[61]

Keeping in mind IBM's penchant for economy, Kaufmann's last suggestion pointed to an as-yet-unrealized but coming era of rapid industrial production of computers.

V. Computer salesmen are consistency minded, thinking older style cabinets shouldn't be obsoleted until replacements are ready for delivery.
E. The "parlor–coal cellar" division would minimize the dangers of incongruent design as the models change.

The former statement is oddly insightful, showing Kaufmann's instinctive understanding of the sales culture at IBM—one sold out one's product before producing another, different one. There was to be no putting a new skin (the cabinet) on an old machine, either; the new product would come with a completely coherent aesthetic, and the "parlor–coal cellar" principle would ensure that if supplementary equipment became necessary, it could be easily connected to the owner's current system in a discreet location. These last two hunches were eventually to become a guiding principle, as IBM design engineers worked to create a set of nearly uniform enclosures that could accommodate nearly any machine. In this way, the only site of potentially complex design would be the handful of interfaces for any given model, and norms could be established for every other aspect of not only the computer enclosures, but the architectural design of the client's computer room as well.

Kaufmann's provisional hunches had the effect he desired: they prompted Noyes to a wholesale reconsideration of his fundamental assumptions pertaining to the design of computers. While he continued to consult with Noyes and IBM designers on a casual basis in the ensuing years,[62] Kaufmann's memo and notes to Noyes remained his most significant contribution to the design of the company's business machines. They pro-

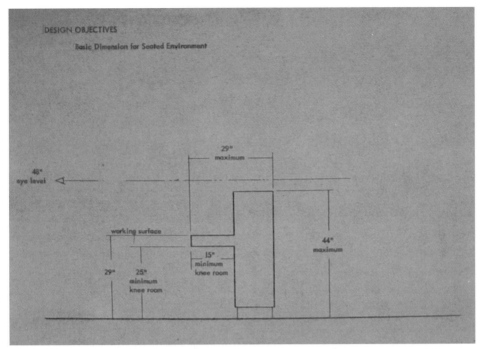

Figure 2.8 Diagram from draft of *IBM Design Guidelines* for industrial design, 1959. Courtesy of the Eliot Noyes Archive, Norwalk, Connecticut.

vided the spur to produce a first draft of *IBM Design Guidelines* for industrial design in late 1959 (Figure 2.8). Finished roughly at the same time as Rand was finishing work on the graphics manual, it was drafted by an IBM Poughkeepsie design engineer, J. W. Stringer, for Walter Furlani (then head of the Industrial Design Department at Endicott, later at Poughkeepsie) and based upon the results of a daylong meeting on the subject in September 1959.[63] The draft guidelines were simple and relatively unambitious, confined in the main to the application of conventional dimensions from architectural graphic standards manuals—the minimum height of a table top, the maximum height of a machine casing that the average man could see over, and so forth—and the draft drawings were especially crude, but there were some efforts at a more sophisticated standardization of the machines' "appearance capability." Different functional elements of the machines' surfaces—that is, areas for different types of control panels—were set off visually from their surrounding surfaces by recessed "feature strips." And, perhaps more significantly, the manual proposed a "Master Color Program," in which various media—for example, vinyl paints, plastics, and printing inks—would be coordinated to a set of "master color specs" rather than approximated by the use of color chips.

The draft version of the manual was, apparently, never fully reviewed or published.[64] Nevertheless, some of the operative assumptions outlined in the manual clearly influenced the Advanced Systems Development Division's designs for the next generation of IBM computers, the 1400 series, which appeared on the market at the end of 1959 (Plate 6).

The first of IBM's computers to take full advantage of transistor technology, the 1401 was, according to one IBM engineer and executive, "the Model-T Ford of the computer industry,"[65] because it was mass-produced at an unprecedented scale—over twelve thousand of them were built.

Noyes and IBM's industrial designers applied some of the lessons learned from Kaufmann's research to the 1401. The transistorized workings allowed more flexibility in the design of the casing and the integration of the necessary peripherals; as a result, the 1401 took on a sleeker, more lightweight look. The keyboard was eliminated, and both the punched-card input device and the printer were freestanding, allowing the user to adjust the configuration to her needs. Since the memory units for the 1401 and its "family member" 1410 were primarily tape drives, the problem of exposing too many features of the interior of the computer was avoided entirely. As the model proved increasingly popular, Noyes surmounted his usual uneasiness as regarded color and worked out a coherent color system for the casings. Thus, instead of dramatizing the inner workings of the computer, the surface of the machine and the user environment or operator environment became the crux of the design. As a promotional pamphlet for the 1400 series called *IBM: Color for Computers* put it, customers could now purchase the machines in "Flame Red, Sun Yellow or Sky Blue," in addition to "Deep Charcoal and Light Gray":

After years of study, IBM Industrial Designers have developed a color system that considers the individual data processing unit *as well as its relationship to the total configuration of which it may be part.* This is a color system that collectively blends the color arrangement of each machine into a *harmonious, systematic, unified whole. . . .*

See a purposely planned atmosphere reflecting human as well as machine engineering.[66]

In order to ensure this process of unification of machine with environment, "the guidelines visually unify the products in a systems intermix. To strengthen this color unity, only one optional color [was] used per customer system."[67] The impression of organic unity that had thus far eluded Noyes and his fellow designers in their computer designs was thus achieved by surrounding the machine with panels at the level of what Mumford had called "the externals," rather than by opening up the interior of the machine. In this sense, the "typewriter with ideas above its station" became much more like Noyes's original typewriter designs. The discrete, individual object was connected metonymically to its surroundings precisely through a visual emphasis on its discreteness and appeal to the human body.

This approach to color and enclosure was concretized through two new designs for IBM by Noyes and Associates, which perhaps constituted its most famous contributions to industrial design: the Selectric typewriter and the Execuary dictation machine, both of 1961 (Figures 2.9 and 2.10). Resurrecting and refining a disused type of typing mechanism, a rotating spherical typewriter element,[68] the Selectric revolutionized electric

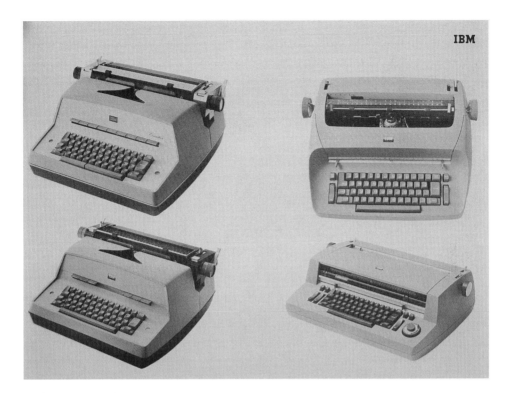

Figure 2.9 Eliot Noyes and Associates and IBM, Selectric typewriters, 1961 and after. The 1961 "golf ball" model is at upper right.

Figure 2.10 Eliot Noyes and Associates and IBM, Executary 224 dictation machine, 1961.

typewriting. The new mechanism was not only fast, it also divorced the keyboard from any strictly mechanical relation to the type. The keys now activated a small electronic computer governing the movement of the typing element, allowing the action of the keys to be lighter than ever before and reducing the complexity of the internal workings. An added advantage was that the spherical element was modular and thus easily replaceable, meaning that customers could purchase additional elements in different fonts, without having to commit to the purchase of a whole new machine. But most important to Noyes and IBM, however, was the new possibility of enclosing the mechanism almost completely, creating through its modular completeness and visual coherence a more organic continuity with its environment; a typewritten description of the design issued in a press release by the Noyes office made this explicit:

Where conventional typewriters must have large holes in the sides for the carriage to move back and forth, this device permitted the form to be very simple, and a single complete shape without any such interruptions. In design therefore, we tried to emphasize the singleness and simpleness of form by making the whole shape something like that of a stone so that you are aware of the continuity of the shape on the sides and under the machine and over the top. . . . We also were able to provide the special considerations for the user of the machine which must always be the designer's concern, and we have developed special new keys and other details which improve the usefulness of the machine to the typist.[69]

The enclosure of the Selectric ensured not only its own "continuity," but also continuity with its related products; as the release concluded, "There is also a conscious visual relationship between this typewriter and the two new IBM dictating machines, which were also designed by this office."[70] The Executary 224, which combined one of the smallest tape-recording machines then possible with a sleek casing that fit the contours of the grip of an outstretched hand, came, like the Selectric, in a range of IBM-researched colors. It could be placed flat or standing on end for table-top recording as well, and the controls—three dials sunken into the casing and a fader—were easily manipulable by a single thumb or forefinger. The speaker was conveniently placed near the condenser microphone, minimizing the complexity of the inner wiring, and concealed behind a circular series of perforations in the plastic casing. The Executary was a masterpiece of ergonomic design, and not just in terms of relating the design to the human body. The pictograms identifying the functions of each control were designed by Rand to be as simple as possible, in stark white against black,[71] and the main visual element of the machine, the counter, was laid out like a conventional radio dial that could be read easily when the machine was in either position—the farther along the tape, the higher or farther to the right the large silver indicator moved. It clearly shows the influence of the developing discipline of cognitive ergonomics, and this influence is detectable in IBM's written statements about design theory, such as the booklet titled "Industrial Design . . . So What's It All About?" assembled by the IBM Advanced System Development Division to introduce its engineers to the corporation's industrial design goals: "In essence, industrial design is the process of humanizing machine products of modern industry for

greater utility, convenience, greater pleasure and safety by expressing artistically these technical capabilities."[72]

Thus, ergonomics was a matter not only of generating isomorphisms between the human body and the machine at a technological level, but also of representation in a specific mode. The internal workings of the computer or other office machines, what Eames would later call "a landscape . . . of very little movement,"[73] were of necessity largely invisible. The external form of the computer needed to simulate the computer's activity in a (pleasing and safe) manner acceptable to the human sensory apparatus. The ergonomic logic underpinning the design of the externals of subsequent computers would thus need to be analogous to those other translational techniques that allowed the computer to function: computer languages. Without these simulations, both software manufacturers and ergonomists insisted, the computer user, forced to work in "machine language" (the bits that constituted the data manipulated by the logic circuit), would "quickly go crazy."[74]

Therefore, IBM's industrial designers concluded, the discipline of industrial design would have to ease the growing pains that would undoubtedly plague the progressive integration of human being and computer into a man–machine system. As the manager of industrial design for IBM Advanced Systems Development Division put it in 1960, repeating the by then well-established unofficial motto of the discipline of ergonomics, "the evolution of man did not adapt him for the extraordinary situations in which his technical progress has now placed him. It is not surprising, therefore, that the human sensory and response system is often inadequate for the work imposed on it."[75] The industrial designer, then, not only positions himself between the "inadequate" human being and the "extraordinary" and dangerous environment as a producer of protective counterenvironments; the industrial designer is also, by implication, a more highly evolved being. As we have seen, Noyes, modest in much else, was consistently explicit about this ambition: "for such a role [the design consultant] must be some combination of designer, philosopher, historian, educator, lecturer, and business man."[76]

The White Room: System/360 and the Spatiality of Computing

In late 1961, the vice president of IBM, T. Vincent Learson (who would later succeed Watson Jr. as president and CEO), assembled a task force—nicknamed the SPREAD committee—to provide a vision for the company's future investment in computing. In the face of rapidly growing competition, manufacturing costs, and a proliferation of varying technologies and computing standards, Learson asked the committee to present a rational plan for consolidating IBM's product line in order to reassure its dominance of the computer market in the 1960s. The committee issued a report to IBM executives, on 28 December 1961,[77] that served as the strategic manifesto for a New Product Line (NPL) that would wholly reorganize IBM's research and development efforts toward designing

and manufacturing what became the most commercially successful and technologically significant computing system to date: System/360.

While previous computing systems had relied on vacuum tubes and magnetic core memories, the NPL would, the report determined, be based on Solid Logic Technology (SLT): tiny transistor-based CPUs, which had the potential to drastically increase computational speed and complexity. In addition, "the new processor family guarantees to IBM a compatibility level not achievable by common programming languages . . . [and] capable of operat[ing] correctly all valid machine-language programs of all processors with the same or smaller I/O and memory configuration."[78] That is, the NPL would be capable of emulating all of IBM's previous computers and accessories, organizing them into a new, harmonious, and purely modular system. It would be capable, unlike the RAMAC and the hugely successful 1401 computer, of responding to "new market demands for systems capable of multiterminal, on-line, real-time, multiprogramming operation," providing customers with a single, coordinated apparatus that could be used throughout a business, even over great distances, for all of their various needs.[79] This meant that the new computer had to be equally efficient in running both scientific- and business-oriented applications; to this end, the NPL would use a new high-level programming language, called Programming Language I (PL/I), that IBM hoped would prove capable of supplanting both FORTRAN and COBOL, the two dominant computer programming languages to date.

This plan for consolidating IBM's line of computers into a single family of systems constituted an enormous risk. Previously, if any one of IBM's computer lines flopped (as they often did[80]), the financial impact was minimized by the successes of other lines. Here, "all the eggs were in one basket."[81] As a result, IBM poured nearly the entirety of its resources into the development of the NPL. By the time IBM made the decision to so consolidate their product line, Noyes was directing the design efforts of about thirty IBM industrial designers in about fifteen different locations in the United States and Europe, all of whom were diverted to work on the project.[82] IBM placed an industrial design engineer, Walter F. Kraus, at the head of the project to design the externals of the NPL. As a 1964 organizational chart for the Data Systems Division shows, the industrial design managers from the Kingston and Poughkeepsie campuses, as well as the human factors engineering manager in Kingston, and all of their staff were under his supervision. Several of Kraus's memoranda are in Noyes's office files, indicating that he was likely Noyes's single most important contact at IBM during the course of the project.[83] In 1962, Kraus and Noyes were apparently called upon to develop the "parlor and coal cellar" metaphor further, as the eventual size and function of the machines were clarified. In an undated memo (Figure 2.11) sent from Kraus's office to Noyes's,

the essence of the industrial design NPL system concept lies in the use of two elements. These elements are referred to as . . . [illus.] . . . the wall [illus.] . . . and module. The wallcan be thought of as a central communication and power corridor. It is an enclosed passageway into which the

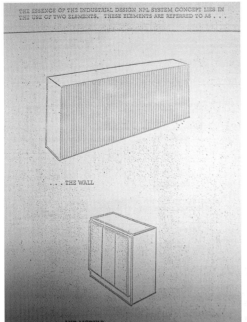

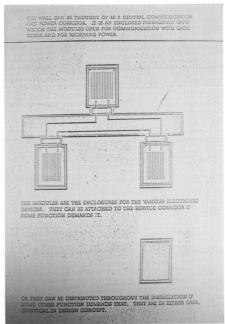

Figure 2.11 Walter F. Kraus and IBM Design Department, "Industrial Design NPL System Concept," 1962. Diagram of "wall" and "module" units. Schematic plan. Courtesy of the Eliot Noyes Archive, Norwalk, Connecticut.

modules open for communication with each other and for receiving power. [ill.] The modules are the enclosures for the various electronic devices. They can be attached to the service corridor if some function demands it. [ill.] Or they can be distributed throughout the installation if some other function demands that. They are in either case, identical in design concept.[84]

This modular approach suited the architecture of what became the System/360 perfectly. Since the computing system was to be, in today's terms, wholly "scalable"—in the sense that it was built up out of modular units that when connected to additional units became more powerful (either faster or more versatile)—a system of enclosures that could interlock with one another and provided surfaces on either side for the requisite module interfaces articulated the logical structure of the ensemble in precisely the terms of Noyes's, Kaufmann's, and the IBM engineers' late-1950s hypotheses about the future of computer design.

The main interface of the System/360 (Figure 2.12) was a module that could be operated either independently (connected to its requisite services through openings in the raised floor of computer rooms) or in conjunction with a wall unit. The wall units were a uniform black color, encased in panels of a lightweight, ridged, heat-resistant material mounted on a steel frame, inside of which various power, cooling, and storage apparatuses could be suspended. The light gray, almost white, main control panel was at the narrow end of the module and stood out dramatically against the saturated red, blue, or yellow of the module. In keeping with what had become an ergonomic standard in

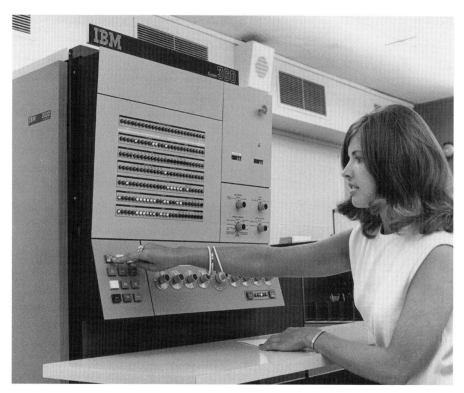

Figure 2.12 Eliot Noyes and Associates and IBM, System/360 Model 40, 1964. View of operator's control panel. Courtesy of IBM Corporate Archives, Somers, New York.

military computing systems,[85] it was divided into two sections, upper and lower, with the division at seated head level, that were tilted slightly inward toward the operator. (There was also a module with a higher control panel, for standing users.[86]) This, the designers assumed, would allow easier surveillance of the entire panel, while also allowing for an even larger surface area on which to distribute the controls. Unlike its predecessors, the System/360's control panel was divided into sections (by feature strips) according to function, in four registers. The most frequently used controls and read-outs—push-button controls and lights, the uploading controls, and run-time counter—were located in the lower register, easily seen by a seated or standing operator. Just above these were address controls, for locating specific pieces of data in relatively large programs; an added ergonomic flourish was a printed key to binary code on the left-hand side of the controls to aid in quick recall of bit-signatures for inexperienced operators. Above these was yet another register of controls that set the machine for displaying (i.e., printing or punching cards) or storing data in various formats; and at the very top, a narrow pair of panel sections containing controls for setting programming parameters (computer language, compilers), debugging checks, and an emergency stop pull. Above all of these was a nameplate designed by Rand, held aloft by two slender metal rods, reading "IBM System 360." The numbers three, six, and zero were rendered in the typeface that Rand had derived from the IBM logo, with the "IBM" in white on a blue field,

and the "SYSTEM 360" in white on black, thus carefully balancing the composition when viewed head on.[87]

All of these controls were designed in keeping with the ergonomic conventions for computer design, many of which had been established by human factors engineers at IBM.[88] All controls of a functional type were identical and set off from surrounding controls by a printed border. Controls of different types were separated starkly, and the dials and levers of the switches were detailed so as to register clearly their position with only a brief glance from the operator. For especially large configurations, which governed massive magnetic memory units, a double-width, slightly shorter version of the control panel was specially designed, meant to be manipulated by a standing operator. Taking into consideration the difference in the amount of attention required to serve as nursemaid to such a large installation, this larger panel was equipped with a push-button interface rather than the dials and switches of the smaller panel for a seated operator.

The System/360 incorporated a newly redesigned keyboard and printer (Figure 2.13) and a single panel for the entirety of the operator's control functions. The keyboard–printer was affixed to either end of a desk unit, which could be clipped onto the module in either direction, creating a space for a swivel chair on casters for the operator. The operator could then easily monitor both the control panel, with the majority of its most-used controls shifted to one side or the other, and the keyboard; however, it is important to note that without an additional key technical innovation, this design would have suffered the same drawback as the earlier RAMAC design of dividing the user's attention between too many sources of information. This problem was solved by IBM's electrical hardware engineers, who developed an additional small stored-program computer located inside the module, called the "channel," that mediated between the user at the keyboard or punch-card sorter and the CPU. As an IBM programming manual described the working of the system, "When the CPU determines that it wants an I/O operation performed, it tells the channel the core location of the first command in the desired channel program. The channel then executes the program."[89] This allowed, according to IBM's manuals, the operator to input data or read output data at her leisure, while the computers themselves governed the actual timing of computation; however, it also introduced an additional subject into the goings-on of computation, one that wholly recast the ergonomic parameters—in terms of speed, sequence, starting and stopping, and, ultimately, of attention—of the relationship between user and machine. From the System/360 on, the operating system desires and decides in tandem with its user. The impressions of comfort and control that the new ergonomic channel provides are manifestations of a hidden and powerful subjectivity—perhaps discomfiting and controlling—lurking behind the plastic and metal skin of the module.

These points of interface determined, Noyes and his fellow designers began to explore the spatial consequences of the design. In keeping with the growing sense that the computer as a design object was a matter of simulation, the industrial designers produced

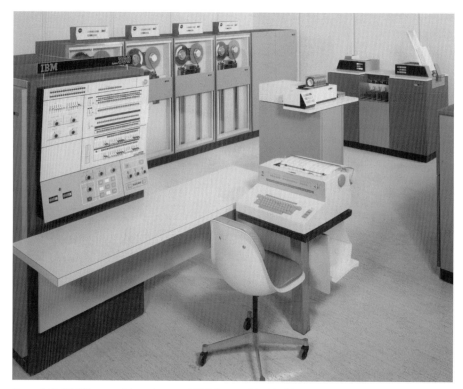

Figure 2.13 Eliot Noyes and Associates and IBM, System/360 Model 40, 1964. View of typical installation. Courtesy of IBM Corporate Archives, Somers, New York.

a seemingly endless series of 1/10-inch-scale models (Figure 2.14). Noyes deployed the walls and modules of the System/360 in a pure white space, seeking to define the environment of the man–machine system. Although there is no grid inscribed upon the white surface of the table on which these tiny simulations were conducted, the orthogonal form of the system's transistors was unrelentingly transposed to architectural scale. The walls of successive units, deployed iteratively across the white field, were invariably aligned, the right angles of the protruding modules thus suggesting the emergence of something like rooms (or at least office cubicles). Many of the photographs the Noyes office took of these models were from acute oblique, aerial angles, dramatizing the perspective recession of the massive computer installations they imagined. Yet in all of these model photographs, unlike the photographs of full-scale mock-ups they produced later in the design process, nowhere does a human figure appear. The point is clear; for all of the putative emphasis on the ergonomics—physiological and cognitive—of the man–machine system, the human subject is not the only subject necessary to the formation of the environment of data processing.

The coordination of the design to human subjects at architectural scale was accomplished by other means, a building on the Poughkeepsie campus known as "the white room." This was a one-hundred-by-fifty-foot temporary building, long since destroyed—"a shack,"

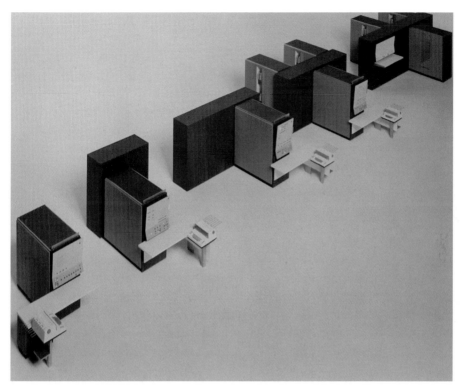

Figure 2.14 Eliot Noyes and Associates and IBM Design Department, model of System/360 installation, ca. 1964. Courtesy of Eliot Noyes Archive, Norwalk, Connecticut.

according to one of the IBM design engineers who worked there[90]—erected behind the Development Lab in 1958. However, its unremarkable, lean-to exterior disguised a striking interior: blank white walls, white plastic floor and ceiling tiles, utterly window-less. Noyes designed it and had it built as a setting for photographing all IBM products for catalogs, ads, and exhibitions. It was also the site of semiannual design critiques, when Noyes gathered together the IBM design team and his fellow consultants to evaluate work in progress on all of IBM's products. For these sessions, full-scale silk-screened plywood mock-ups of the designs in progress would be erected in the room, and hired models would be asked to "use" the machines as the designers looked on. According to the aforementioned design engineer, Jim LaDue—who, after working with Noyes on the design of the IBM 705 and the RAMAC, was promoted to head of industrial design in the IBM Europe laboratories—design critiques never took place without these human adjuncts, and the designers took a great number of photographs of these hypothetical users engaged in various common computational gestures.

Yet why was this white room necessary to the design process, and what did it have to do with the spatial separation between parlor and coal cellar so central to the design concept? There is perhaps evidence enough in the articulation of the room and its models alone, but a more compelling answer may be gleaned by turning to the spatial articula-

tion of ergonomic design logic at the historical moment that the System/360's design was being developed.

The primary source in England, Canada, and the United States for graphic and ergonomic standards remains Henry Dreyfuss's *The Measure of Man* [and Woman], originally published in 1959 and issued in updated editions ever since (Figure 2.15).[91] Noyes certainly knew and consulted Dreyfuss's work; his fellow IBM consultant George Nelson reviewed it in *Architectural Forum* on its publication.[92] Issued in its first edition as a pamphlet accompanied by a collection of large format charts and figures, then later in increasingly larger editions, it is the first and most important, comprehensive collection of human engineering or ergonomic data produced explicitly for architects and industrial designers.

The Measure of Man was long in the making. In his introduction to the first edition of the work, Dreyfuss described its genesis in an idiosyncratic collection of data from various sources: "Over the years, our pile of books, pamphlets, clippings and dog-eared index cards grew higher and more jumbled. When World War II came, the pile grew even faster." This was due to the fact that military engineers and scientists had begun to publish ever more anthropometric data; yet, Dreyfuss noted, "no one assembled these data into a single package that a designer could refer to and save spending days wading through his library and his files."[93] The spur to do so came while pursuing a typical project:

Shortly after the war, our office was working on the interior of a heavy tank for the army. We had tacked a huge life-size drawing of the tank driver's compartment on the wall. The driver's figure had been indicated with a thick black pencil line and we had been jotting odds and ends of dimensional data on him as we dug the data out of our files. Surrounded by arcs and rectangles, he looked something like one of the famous dimensional studies of Leonardo. Suddenly it dawned on us that the drawing on the wall was more than a study of the tank driver's compartment: without being aware of it, we had been putting together a dimensional chart of the average adult American male.[94]

This epiphany—that the definition average human being was the function not of some inherent set of dimensions, but rather of the "compartment" of the war machine in which it was literally inscribed in "arcs and rectangles"—gave rise to Dreyfuss's invention of a new, wholly posthumanist, model of the human being, entirely contemporaneous to the invention of ergonomics as a discipline of applied science. Dreyfuss dubbed this new male—drawn by his associate Al Tilley—"Joe" (Figure 2.15) and his female counterpart "Josephine."

The major outcome of Dreyfuss's extensive involvement with industry and the military before, during, and after World War II, Joe and Josephine became the spur for his first book on human engineering, *Designing for People* (1955). A charming and disarming book, written in layman's terms and illustrated with lighthearted cartoons, *Designing for People* offered an explanation of the expanded purview of the designer in the postwar era. On

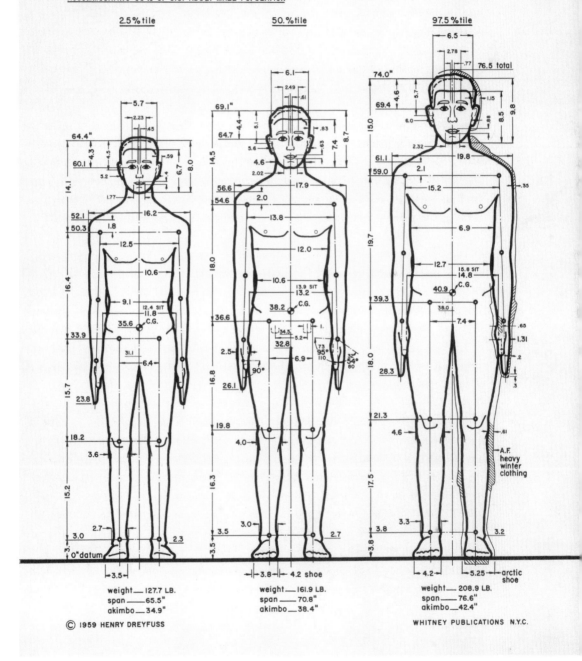

Figure 2.15 "Joe." From Henry Dreyfuss and Associates, *The Measure of Man,* 1959. Courtesy of Henry Dreyfuss Associates.

the cover, Dreyfuss printed his "creed," posted on the walls of his offices in New York and Pasadena:

We bear in mind that the object being worked on is going to be ridden in, sat upon, looked at, talked into, activated, operated, or in some other way used by people.

When the point of contact between the product and the people becomes a point of friction, then the industrial designer has failed.

On the other hand, if people are made safer, more efficient, more comfortable—or just plain happier—by contact with the product, then the designer has succeeded.[95]

Dreyfuss sought to humanize design. However, the terms of his creed are especially revealing of what this humanization of design entailed: the object is "worked on," and in so doing, "people are made." This is what Dreyfuss meant in using the term "human engineering." As he argued passionately at the outset of both *Designing for People* and the later *Measure of Man,* the "art" of design was entirely dependent upon the success of designing people themselves: their equipment, their spaces, their experiences.

The key mechanism (in both senses of the term) in this mode of design, not *for* but *of* people, was the "point of contact between the product and the people." Central to Dreyfuss's creed, everything hinged upon this "point of contact." The touching of person and product was the site of an economic exchange of activity, the embodiment of uses (riding in, sitting upon, etc.). Through this contact with the product, the qualities of the human being are literally produced; conversely, as Dreyfuss notes, if the contact between body and product resulted in "friction," the person's efficiency, comfort, happiness, and even safety were at risk.

Dreyfuss was explicit about this. "Joe and Josephine have numerous allergies, inhibitions, and obsessions. They react strongly to touch that is uncomfortable or unnatural; they are disturbed by glaring or insufficient light and by offensive coloring; they are sensitive to noise, and they shrink from a disagreeable odor."[96] Joe and Josephine are barometers registering the degree of pressure exerted upon them by the environment. (It is also worth noting here that in ergonomic discourse the designer constructs the normal human body in his self-image, as a hypersensitive aesthete. Dreyfuss is hardly alone in this; one might also think of Charles Eames's aforementioned famous prosthetic projection of the mold of his own leg onto every wounded leg in the U.S. Navy during World War II with his leg splint, another product of wartime protoergonomic design.[97])

Through such reasoning, Dreyfuss and his associates came to view all use objects as both potential threats to the body and extensions of the body. Early in his book, he related an awe-struck anecdote about the office's work for the Veterans Administration on prosthetics for amputees:

We could see how [the amputees] co-ordinated their muscles to operate the steel substitutes for what they called their "meat hands." Some of them were so expert they could select a dime or quarter from a collection of coins in their pockets. These men had trained themselves to "feel." The hook had become part of them, translating touch through cold metal.[98]

Dramatically illustrated with a tightly cropped photograph of an amputee outfitted with a hook signing his name (beginning with the letters "Jo" and likely soon to terminate in an "e"), Dreyfuss made the case for understanding Joe as just such a wounded body, healed by the application of a properly designed mechanical prosthesis. It should come as no surprise, then, that in the fully articulated charts of *The Measure of Man,* Joe and Josephine often appear clad in safety helmets and nearly always with their bodies (or at least parts of their bodies) in contact with one or another mechanical surface. Without this healthy contact with their prostheses, Joe or Josephine would be walking wounded. Not only are the qualities of life transposed from figure to ground, as it were, but the quality of the body is entirely dependent upon the interpenetration of product and body via the seemingly impenetrable surface of the interface.

Yet we would miss an essential point in Dreyfuss's reformulation of the human body as a wounded body in need of mechanical protection if we were to ignore the specific manner in which Joe and Josephine are delineated. Neither Joe nor Josephine are anatomical studies: they are not sections; no skeletal structures or internal organs are shown. Their facial features are purely schematic, and sex organs are omitted (save for Josephine's breasts, rendered as featureless lumps). They are unbroken outlines, elevations, and plans of abstract bodies rendered purely as surface.[99] Thus, the most radical intervention in the articulation of the human body by ergonomic designers is not the mechanical prosthesis sutured onto or into the body itself, but rather reimagining the body as a surface that may then be laid in contact with the interface between body and machine.

This interface or surface, one notices, begins to take on a paradoxical spatial dimension. In what is perhaps the most perplexing image in *The Measure of Man,* and one of only two in the book to address directly the character of ergonomic space, a one-page plan of a human being entitled "Environmental Comfort Zone" (Figure 2.16), Dreyfuss describes the human environment as a space defined not by any conventional measure of distance, but rather by intensities of environmental stimuli. A set of sixteen lines radiating outward from the human body at the center passes through two concentric circles, giving a range of intensities of various phenomena—temperature, humidity, atmospheric pressure, speed and acceleration, radiation, light, noise, and vibration. The area between the body and the inner circle is identified as the "environmental comfort zone," a set of intensities of these stimuli below which the human body is putatively undisturbed (although other researchers soon noted, as did Dreyfuss in subsequent editions of the book, that understimulus could also produce deleterious effects). "The band between the [two] circles demarcates the bearable zone limit. Outside this limit great discomfort or possible damage is encountered."[100] Outward beyond the outer circle, one must assume

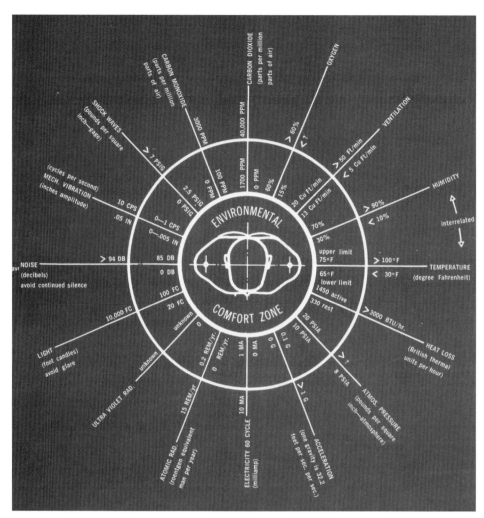

Figure 2.16 Diagram of "Environmental Comfort Zone." From Henry Dreyfuss and Associates, *The Measure of Man*. Courtesy of Henry Dreyfuss Associates.

(for Dreyfuss does not tell us), the environmental stimulus becomes fatal. "It is also necessary to consider," Dreyfuss added in this same note at the bottom of the page, "infrared radiation, ultrasonic vibration, noxious gases, dust, pollen, and heat exchange with liquids and solids,"[101] although his office did not apparently have this information on hand.

What is surprising about Dreyfuss's diagram is the way in which it replaces a conventional model of space with a topological rather than a Euclidean model: the blank space around the figure and the concentric circles and radiating lines in that space are in fact only extensions of the outer shell of the body. It is, as it were, an exploded diagram, spreading out the surface of the body to illustrate the range of the surface's durability and performance. Yet it is also inverted: the point at which some aspect of the environment would inflict physiological harm—that is, penetrate or damage the body—is rendered

farthest from the outline of the body itself. It is difficult to imagine a more radical diagram of spatial enclosure. It would appear to offer a picture of the human being's range of habitability, a broad space measured not dimensionally but in terms of temperature, light, etc.; yet this open field is only a surface pressed against the surface of the body.

The IBM Design Guidelines for computer design included, as we have seen, similar diagrams of the man–machine system: outlines of users standing and sitting at the consoles in a pure white field. Although Noyes and his fellow designers' approach was more empirical in form, eschewing the detailed diagrams and data of Dreyfuss's compendium, it nonetheless operated on identical principles. It is in this white room that the consequences of supplanting any previous architectural principles with those of ergonomics are realized. The white room reduces the problem of designing the space of interaction between humans and machines to a minimax equation: if the problem of communication was a matter of reducing interference ("noise") by smoothing out the space through which the message passed, the problem of ergonomics was a matter of eliminating any environmental stimulus. This counterenvironment, as an almost negative space, a space limited only to the play of interfaces, following the parlor and coal cellar logic of Noyes's ergonomics, placed in a grid pattern on a white field and surrounded by white walls, provides an image of a design logic taken to its limit with the utmost rigor. In an effort to support the mechanisms of control, design, conceived of as an act of creating an ideal space for the interaction of human being and machine, finds itself, under the requirements of the same logic, attempting simultaneously to eliminate and increase the space separating the two.

The broader spatial consequences of this approach are clearly revealed in the promotional imagery unleashed on the public following the announcement of System/360 in April 1964. The most famous, and wholly paradigmatic, image condenses within it the implications of the new vision engendered by this new computing system, with all of its pretentions to universality and radical enclosure (Plate 7). Taken in 1965, at the white room in Poughkeepsie, a circular photograph taken with an extreme wide-angle ("fish-eye") lens, from directly overhead, showed several IBMers, all in suits, some bustling about a massive System/360 installation supplying the machine with tape reels, others attending to a main console, and yet others standing idly by. The edges of the circular image, distorted into a distant horizon, combined with the clearly demarcated lattice of the raised white floor tiles, gave an impression of a keyhole view into an impossibly vast space. This grid, the image implies, could extend to surround the entire globe, enclosing its surfaces within the counterenvironmental space of the interface.

This was the new vision awarded to the user of System/360: immersing oneself in the radical enclosure of the white room, a carefully calibrated ergonomically designed parlor, a global view of interconnected data-processing centers became possible. What this globe looked like—inside, outside, and inside-out—from this perspective is the subject of the next chapter.

Chapter 3

IBM Architecture:
The Multinational
Counterenvironment

A typewriter sits in a room in a building. There *must* be a sense of their relationships in each of these.

Eliot Noyes

The "IBM City"

IBM had little in the way of an organized administrative strategy for its real estate and building development prior to Noyes's intervention. Under Watson Sr. factories, office buildings, and storefronts alike were often simply leased from developers on a long-term basis, and those buildings that IBM did own were limited to those that housed its central administrative apparatus, such as the skyscraper at 590 Madison Avenue in New York and a handful of buildings in Endicott. As a result, IBM's architectural appearance was eclectic, tending, if any tendency can be perceived, toward a conservative, classicizing image not unlike that of contemporary bank architecture. Pediments, marble, and decorative columns abounded in the more lavish offices, but less important facilities were often simple variations on the local vernacular.

For all of its ad hoc character, what would be viewed in hindsight as a disordered and irresponsible lack of aesthetic clarity nonetheless had a powerful uniting spatial concept that, like most other aspects of IBM culture under Watson Sr. save for the machines themselves, sprung from the mind of Watson himself. As early as 1917, when the company was still known as CTR, Watson identified the company as a permanent body, identifying it with the earth itself: "This is a business that is going on and on forever. It is going on as long as the world endures, because it is part of this world."[1] Watson's speeches from this pre-IBM era consistently deploy organic and spatial metaphors, identifying the "organization" with the "world" through a string of homologies hinging on the central figure of time.

When CTR transformed itself by consolidating additional businesses into the international concern IBM in 1924, this interest in time took on a spatial quality as well, fusing the equations or homologies organization/world and capital/time into a new corporate identity based on speed. In a written message to "the IBM Organization" in the company's house organ *Business Machines* titled "Accelerating the Progress of Business" in 1927, Watson compared IBM to

the railroad, which worked a revolutionary change in civilization. It increased the tempo of business activities. . . . The foundation on which our business is built is the saving of time for all people and all industries throughout the world, to give more time in which to do given tasks, and to make available more time for still further advancement and progress. The railroads and [IBM] . . . have a common mission—both function to increase the profits and accelerate the progress of business by conserving the most precious of all commodities—TIME.[2]

At stake in this acceleration was not just profit, but the success of a peaceful global society knitted together by an infrastructural network. In 1937, the secondary company slogan (after the ubiquitous placard "THINK"), emblazoned in the exact same form as the company logo, was wholly characteristic of American corporate paternalism: "The Workers Will Work Willingly."[3] Two years later, the slogan was changed, to great effect.

Watson was especially fond of quoting Ralph Waldo Emerson's aphorism "Trade, as all men know, is the antagonist of war. Trade brings men to look each other in the face, and gives the parties the knowledge that these enemies over sea or over the mountain are such men as we; who laugh and grieve, who love and fear, as we do."[4] Given his knack (and penchant) for condensing complex ideologies into snappy phrases, in Watson's hands Emerson's wordy description became the new IBM slogan "World Peace through World Trade." Despite the historical irony of such a statement in the face of IBM's suspected war profiteering during the ensuing global conflict,[5] it is necessary to take this slogan seriously as a representational tool that shaped not only IBM's public image, but its self-image as well, for this series of metaphors establishing IBM's spatial and temporal orientation was not just a matter of speeches. The 1924 company logo was designed as a globe, its entire surface inscribed with the name of the company, and the band circumscribing the equator of the globe bore the word "international." Again and again, Watson aggressively asserted IBM's international status; invoking one of the mottos of the British Empire, Watson declared boldly that "the sun never sets on the products of the IBM Corporation."[6]

At the 1939 World's Fair in New York, the company took this global imagery even further. The IBM exhibit, located adjacent to the twin centerpieces of the Trylon and Perisphere in the Business Systems and Insurance Building, was a "Gallery of Science and Art," featuring a breathtaking array of teletechnological and internationalist artifacts and motifs (Figure 3.1).[7] At the entrance to the exhibit was an allegorical statue representing "World Peace through World Trade," a nude male figure extending both arms and his gaze upward to a fresco of a compass painted on a dome overhead, surrounded by images of dirigibles, airplanes, and ships traversing geographical borders. The hall beyond was filled with individual exhibits that underscored this theme. At the center of the pavilion, surrounded by a dramatically lit fountain at its base, a gigantic glass globe gilt in bronze showed the location of every IBM installation across the globe, each one marked with a bronze star. Inside the globe was an IBM 405-type Electric Accounting Machine, automatically spooling out a long strand of data-covered paper. Radiating outward from this machine and its globe, the granite floor was inlaid with concentric bronze rings; in the innermost circle were displays of IBM machines. Most spectacular was a working installation of IBM's brand-new, trademarked Radio-type machine (similar to the more familiar machines produced by other contemporary firms and later known as Tele-type), demonstrating for the first time its capacity to communicate information instantaneously over great distances by sending messages back and forth between New York and another machine installed at the concurrent exposition in San Francisco. It was specially outfitted with a state-of-the-art CRT for this purpose, offering many fair-goers their first glimpse of television. On the outermost wall, providing a decidedly humanist backdrop for the stunning technology on display and maintaining the integrity of the allegorical theme of the exhibit, were hung oil paintings from IBM's own art collection—one by an artist from each of the seventy-nine countries in which IBM did business. Most of these appear to have been landscapes

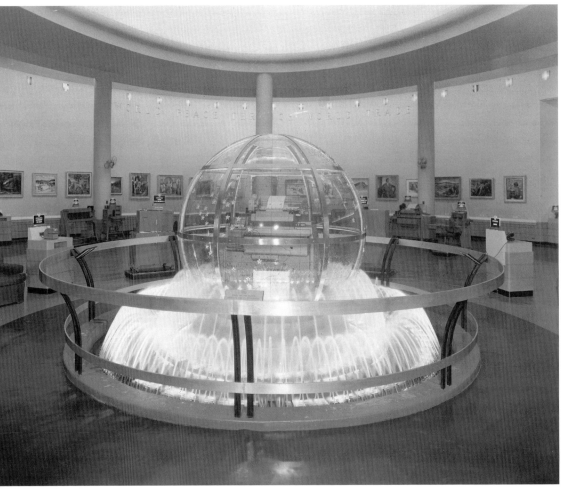

Figure 3.1 View of main exhibition space, IBM Gallery of Science and Art, Business Systems and Insurance Building, New York World's Fair, 1939. Courtesy of IBM Corporate Archives, Somers, New York.

and genre paintings; "critics said the most remarkable thing about the collection was its consistent inoffensiveness."[8] This bland display was enlivened, however, by a giant mock punch card on the same wall, its statistical capabilities literally highlighted with high-wattage bulbs.

Capping the triumphalist histrionics of the exhibit was "IBM Day," a massive festival hosted by the corporation on the main plaza of the World's Fair, on which IBM spent more than 10 percent of that year's profits.[9] Watson invited thousands of IBM employees to attend the event; the corporation paid for their train trips and hotels. In the shadow of the Trylon and Perisphere, a parade of IBM employees and visitors to the fair representing all of the nations present was followed by a Philadelphia Orchestra performance of pieces by Bach and Sibelius, and by the Italian composer Vittorio Giannini's specially commissioned "IBM Symphony." The latter was composed of three movements: the first

expressing contemporary "unrest and confusion" and the resulting "martial spirit"; the second an elaboration on the IBM company song "Ever Onward," in a call for "peace and love amongst humanity"; and the third a triumphantly orchestrated reprise, in *allegro ritmico,* of "Ever Onward."[10] The symphony's "martial call to order" was echoed in lengthy speeches by Watson, New York City mayor Fiorello La Guardia, and several foreign dignitaries, the main thrust of which was to reinvigorate two of Watson's favorite causes, the International Chamber of Commerce and the League of Nations.[11]

In comparison to the other corporations with exhibits at the World's Fair, IBM's ostentation was completely out of scale. Industrial giants such as General Electric, General Motors, and Westinghouse dwarfed IBM by every possible measure—revenue, labor power, name recognition. Today, if anything is remembered about the technological triumphalism of the fair, it is General Motors's famous exhibit "The World of Tomorrow" in the Perisphere, designed by Henry Dreyfuss, Bell's long-distance telephone exhibit, or Westinghouse's spectacular robots.[12] However, IBM's impetuous self-confidence itself— an outgrowth of both Watson's personality and the growing importance of its products in every sphere of business and government—made a claim to corporate greatness on a par with any of its larger rivals. Viewed from the vantage point of today, the IBM exhibit bordered on prophecy.[13]

It is no coincidence, given its global ambitions, that IBM chose to increase its standing in the eyes of the public through architecture as well. On one wall of the exhibition, IBM installed a diorama known as "IBM City" for short (Figure 3.2). As a pamphlet described the installation:

In the Diorama, we have brought together into a single city—from many cities all over the world—the buildings, factories, laboratories, schoolhouse, sales and service offices, and recreational facilities of the International Business Machines Corporation.

Figure 3.2 The "IBM City." Diorama of buildings of IBM Corporation and buildings in which IBM offices and service departments are located throughout the world, IBM Gallery of Science and Art, Business Systems and Insurance Building, New York World's Fair, 1939. These offices and service department buildings (along with buildings in "Factories, Research Laboratories, Schoolhouse and Recreational Facilities") are modeled as a "city" bringing together IBM's whole international architectural presence in a single, fictional place. Courtesy of IBM Corporate Archives, Somers, New York.

More than 11,500 people are employed in the "International Business Machines City." With the members of their families, they represent a population of approximately 35,000.

Based upon an average study of cities of this size, it would have a land area of 3,988 acres with a real estate value of $51,750,000. . . .

From the World Headquarters Building in the City of New York, dedicated to World Peace through World Trade, the activities of the worldwide organization are directed.

The Schoolhouse [in Endicott, NY] is the heart of an educational system which extends throughout the world. . . .

The IBM City can be truly called the capital of the Business World.[14]

The point was clear enough. Just as IBM's machines and employees served to gather disparate bits of information and organize them in space and time, IBM itself was a coherent organization, a whole, despite its far-flung and heterogeneous architectural apparatus. The powerful technologies of representation that IBM developed and deployed—whether through the literal application of information control systems such as card punches and master clocks, or through caprices such as the IBM City diorama, painting, and spectacle—functioned to hold it together, and in doing so, allow it to expand exponentially. As Watson put it in an early speech titled "Grow with the Organization," "My duty is not the building of this business; it is, rather, the building of the organization. The organization builds the business. . . . [There is] only one definition of good management; that is, good organization."[15] However, one should note the slight but significant qualification that resulted in the diorama's lengthy name; the IBM City included "buildings in which" IBM rented space, not IBM's own buildings. The organization did not have a coherent architectural appearance; IBM was as yet unaware that a systematic approach to its own architecture could not only serve to house, but also to stimulate its organizational growth.

The IBM World's Fair exhibit was ordered by two metaphorical strategies that remained essential to IBM's ability to represent and thus preserve itself throughout the ensuing decades. The first—the IBM City, the teletechnological virtuosity of Radiotype, and the synthetic internationalism of IBM Day—were an outgrowth of a topological outlook. While it is tempting to regard the IBM City as an effort to model IBM's global presence after its original, folksy but industrially developed home of Endicott, New York, the metaphorical urbanism of the IBM City was based on a more sophisticated technique: the collapse and reconfiguration of spatial relations based upon an entirely new set of ground rules. Through teletechnology, IBM reconceived geographically distant places, and its own widely spread installations, as adjacent, contiguous, and homogeneous. In this sense, the staging of the IBM City within the spatial frame of the diorama is significant; by doing so, IBM proposed that at the very center of its identity was its capacity to reorganize

information and space into new and more productive representational structures. The topological manipulation of IBM City was, in short, a metaphor for a powerful new mode of seeing that would soon become ubiquitous within and constitutive of IBM with the advent of the computer. As John von Neumann wrote in 1956—the year the IBM Design Program began—about the "fabulous future":

Of course, any technology interacts with geography, and each imposes its own geographical rules and modalities. The technology that is now developing and that will dominate the next decades seems to be in total conflict with traditional and, in the main, momentarily still valid, geographical and political units and concepts.[16]

IBM, a corporation that was built around computational technologies and soon enough organized and managed itself with its own computers, challenged precisely these conventions of spatial understanding already in 1939.

The second metaphorical stratagem of IBM's World's Fair spectacle was related to, but distinct from, the first: growth. As Watson Sr., and later his son,[17] consistently emphasized, the core of the IBM mission was to expand its purview to a global scale. Viewed in such a context, Noyes's now-familiar assessment of IBM's "corporate character"— "what IBM really does is to help man extend his control over his environment"[18]—demands a renewed exegesis. If the entropic environment was to be controlled through its technological and topological transformation, the question remains of what the formal basis of such a restructuring would be. The necessarily closed structure of the corporate body—separated from the hostile and entropic environment—required a means of delimiting itself. The emphasis in the 1939 World's Fair exhibit on punch-card technologies and the organic dominance of the entire world by a single "city"-sized company through the manipulation of time and the use of information machines was evidence of IBM's second emerging (and profoundly architectural) strategy: growth through modularity.

From its inception, Watson conceived the company as a confluence of three elements into a kind of corporate algorithm: *Men—Minutes—Money*. In one of his earliest speeches, to the International Time Recording Company (a subsidiary of CTR) Sales Convention in Endicott, New York, in January 1915, Watson explicitly acknowledged labor as modular. In a masterful bit of internal, motivational propaganda, he established a rhetorical equivalency between every member of the company by highlighting in capital letters the word "MAN": whether "MANufacturer," "MANager," or "SalesMAN," "[e]very individual member is an important cog in the wheel which all help to turn."[19] Enmeshed in the gears of the CTR machine, each individual employee was to be—whether he liked it or not—supervised by and supervising the others, and by so doing come to recognize his organic function within the company. The "Man Proposition," as Watson called it, was quintessentially ideological: the individual was immersed in the collective as an individual, but only insofar as the function he performed was one that related him to the putative whole.

The second element in Watson's algorithm was "minutes," or time, about which he developed an entire theory as early as 1916:

A minute has no negative qualities; it can be made to yield something but not nothing. . . . We spend minutes to improve ourselves physically, mentally, morally, socially and financially—they are our working capital. They are the basis of this or any business, but particularly of this business, inasmuch as we deal largely with time. When selling our products we stress the saving of time which our machines effect—the value of this time which is saved. . . . *Make time your ally and time will make you.*[20]

By exploiting time through mechanical means, Watson the archcapitalist hoped to achieve an accumulation of capital that approached permanence: timelessness.[21] The "saving of time" that his machines—punch-card machines, clock systems, scales—and his sales apparatus alike accomplished would preserve the integrity of CTR's corporate body. Such an approach was hardly new; it is that described by Lewis Mumford in *Technics and Civilization* as the very condition of modern machinic subjectivity: "The clock . . . is a piece of power-machinery whose 'product' is seconds and minutes: by its essential nature it dissociated time from human events and helped create the belief in an independent world of mathematically measurable sequences: the special world of science."[22] According to Mumford, the first organization to achieve this "special" status of accumulation and solidity in the face of the ravages of time was the monastic order: "Within the walls of the monastery was sanctuary: under the rule of the order surprise and doubt and caprice and irregularity were put at bay. Opposed to the erratic fluctuations and pulsations of the worldly life was the iron discipline of the *rule*."[23] While it is hard to understand Mumford overlooking the pride of place given to the ordering geometry and machinery of time in texts far earlier than the rule of Benedict, such as Vitruvius, the point nonetheless holds.[24] In the building type of the monastery, as before in the temple and later the factory and office, the rule is an order that proceeds from measure; measure is the form that makes possible enclosure. It is, of course, no accident that what Mumford saw as the birth of the mechanical age was both institution and building. The collective subject, the organization, that is the institution is only possible with its spatial and structural adjunct.

Watson, of course, did not read Mumford; regardless, he and his heir most certainly recognized that as the relevant module—the rule—of time shrank rapidly from the minute to the second, microsecond, nanosecond, and beyond into infinitesimal dimensions, its accumulative and ordering power increased geometrically.[25] Watson's cultic re-formation of his corporation into a state of quasi-monastic order (viz. the well-known accounts of the stereotypical IBMer: the ascetic black suits with starched white collars, the constant recitation of mottos, the singing of songs at prescribed occasions, the implementation of a standardized company time through its own master clock system geared not to Greenwich Mean but to Endicott, etc.) increasingly required fulfillment not only at the level of the individual body, but at the technological and architectural level as well.

The rule of order is always also a system of measure; the architectural module is no exception. Whether articulated in one- or two-dimensional terms, the module nonetheless always encloses a fixed amount of space—for example, five feet square, or a three-by-three-by-three triangle. It is not formed by the intersection of lines extending to infinity in orthogonal parallels and perpendiculars; it constructs that impression through the reproduction of identical enclosures.[26] The etymology of the term bears this out.[27] The English word "module" emerges from, and was originally identical to, "model" insofar as the latter word originally signified not only the measurement of objects, but also of human beings—"module" connoted one's ability to accomplish a certain task. It has since carried a string of meanings, the two most important of which are wholly opposite. On the one hand, it signified a copy, even a leftover or remainder, a shadow of what once was: a module was a "small-scale design," such as a model of a building or sculpture made after the fact, or a "mere image or counterfeit." On the other hand, a module was "a model for imitation . . . a perfect exemplar of something." In mathematics, the module is a key figure in set theory, denoting one half of a set undergoing some arithmetical operation. Generically, and in the modern senses, a module is quite simply "a component of a larger or more complex system." Being a unit of serial delimitation, a module is necessarily both part and multiple. Its multiplicity—whether by two, half, or any other positive real number—is implied in the proposition of its very delimiting.

The term is thus in each instance infused with the properties of metonymy, and even more precisely, because of the functional role that the module plays, of organicity. The module is nothing without the whole of which it is a part, yet one finds architectural theorists and practitioners again and again ascribing a generative role to it.[28] Its tautological quality, as both end and generative moment—that unstable quality bound up with the logistics of perspective and targeting—is what comes to lend modularity its appeal to those designers concerned to model design after information theory and cybernetics, in which the concepts of redundancy and feedback play such a central role.

The architecture of the laboratory and of the corporation thus begins to organize itself as the site of this monumental slippage, both as the ground plan or diagram of the transactions between scales and materials and as the wall or textile that separates the ordered world from the nonmodular chaos, the pure distance, the immeasurability of time that lies beyond. A photograph of an IBM magnetic memory core (Figure 3.3), taken by none other than Ansel Adams and set opposite an electron micrograph of a "crystal of virus" in Gyorgy Kepes's photo essay for his volume *Module Proportion Symmetry Rhythm* (1966), perfectly illustrates the basic principle of corporate space. Just as the Eames Office would, in these same years, come to describe the computer as a "landscape," and through the same technologically advanced photography render the distribution of celestial bodies in the universe isomorphic to the interior of an atom in the film *Powers of Ten* (1968), the corporate environment is an ever-expanding series of modules: CPU, I/O and storage devices, computer room, building, landscape, production network, international installations, even satellites.[29] The subject of this environment,

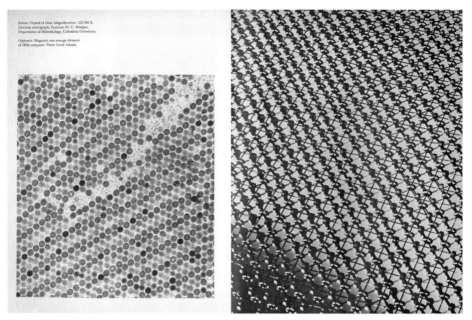

Figure 3.3 *(left)* Dr. C. Morgan (Dept. of Microbiology, Columbia University), electron micrograph, "Crystal of virus. Magnification: 122,700 X," and *(right)* Ansel Adams, photograph, "Magnetic core storage element of IBM computer," from Gyorgy Kepes, *Module Proportion Symmetry Rhythm,* 1966. Courtesy of George Braziller, Inc. Copyright 2011 The Ansel Adams Publishing Rights Trust.

however, is difficult to pinpoint. As Henri Lefebvre posed the question with admirable skepticism:

In the case of "the environment," we are confronted by a typically metonymic manoeuvre, for the term takes us from the part—a fragment of space more or less fully occupied by objects and signs, functions and structures—to the whole, which is empty, and defined as a neutral and passive "medium." If we ask, "*whose* environment?" or "the environment of *what*?," no pertinent answer is forthcoming.[30]

The ordered space of the corporation is environmental insofar as it is related to a series of subject-bodies (organisms) within it. These exist in what we may call, metaphorically and with some caution, a symbiotic relation, in which these organisms construct the environment (e.g., the buildings and tools of the monastery or corporate office building) and vice versa. However, this quasi-environmental ordered space—often understood as a composite or corporate organism in its own right—is always and everywhere situated or placed in a wider space and has a radically different relationship to that wider area than does this original ordered space to the subject-bodies within it. The environment of ordered space is perforce disordered; it is the negation of order—entropy. Therefore, considered topologically, ordered space is both the opposite of its surroundings and apposite to them. It provides an interface between inside and out through articulation of, and then inversion of, this relationship. Its relationship to the environment is one of pure

negation and assimilation: it is a counterenvironment, a space organized in contradistinc-tion to the environment by annexing part of space and defining itself negatively with respect to that space. Either that which is outside it may be ordered, and thus brought inside, or it is negated. In short, the counterenvironment is what we might describe as a homological or isomorphic engine, one that generates regularity and sameness as its very raison d'être, and in so doing becomes the true subject at the core of the corporation.

IBM was both monastery and fortress, and its consultants and commissioned architects provided the architectural apparatus of this counterenvironment. The commitment to the module and metonymy as regulating principles, to the norm itself as a powerful and expan-sive mode of identity,[31] is paramount. As Noyes wrote of his own concrete curtain walls for IBM:

Details must play their part in relation to the overall concept and character of the building, and are the means by which the architect may underline his main idea, reinforce it, echo it, intensify or dramatize it. . . . I like details . . . to be simple, practical, efficient, articulate, appropriate, neat, handsome, and contributory to the clarity of all relationships.

The converse of this is that the spectator may observe and enjoy details, and find in them an extension of his experience and understanding of the architecture. *In them he should be able to read, or at least see reflected, the character and spirit of the entire building—as to see the universe in a grain of sand.*[32]

Less important (though it is certainly not unimportant) than the appearance of the buildings is the manner in which they adhere to this metonymic imperative of modularity. The appearance of difference is precisely ideological—if by ideology we understand "logic of appearance" rather than "science of ideas"[33]—and therefore tends to conceal the fundamental identity that served to unite the architectural program (and here the conso-nance with IBM's function as a purveyor of programs should not be missed; see below). The imperative of flexibility, which was and still is so often confused with modularity, is not so much a matter of function—for everyone knows, at least after Peter Blake,[34] that modular buildings have never been truly flexible in this sense—but rather a matter of flexibility in form. Modularity is the formal condition of architecture considered as a medium in the truest sense of McLuhan's "law," that it contains or is built up out of other media and may be contained by other media in turn: its modularity may be registered and realized in wood, concrete, steel, glass, plastic; it may be made reflective or semitransparent, wholly opaque or even projected; and, perhaps most important, it may vary infinitely in scale.

The Courtyard, or Inside-Out

In 1956, anticipating further dramatic successes in the sale and leasing of its new com-puter lines, IBM began a process of rapid expansion on an international scale. As I have

already suggested, this expansion of human and finance capital, of productive capacity, and of territory within newly emerging markets required not only new facilities but also a new method of generating architectural enclosures. From 1956 to 1980, Noyes and his fellow consultants therefore fanned out across both the United States and indeed the world, commissioning literally hundreds of buildings from their colleagues: Eero Saarinen, John Bolles, Paul Rudolph, Victor Lundy, Marcel Breuer, Ludwig Mies van der Rohe, Harrison and Abramovitz, SOM, and many more architectural and engineering firms both large and small were called upon to deliver "simply the best in modern design" at an architectural scale. Although these buildings were often diverse in appearance, they were all united by a common design logic based on IBM's desire to communicate in parallel with the dictates of its management and its products. IBM's own engineers provided modules for laboratory, factory, and office buildings, demanded clear interior spans for flexibility, and set requirements for maximum and minimum lighting; however, their common logic was also the direct result of the demands that computers placed upon architecture.

In order to "extend . . . control over [the] environment," Noyes set the tone for the building campaign by developing a mode of counterenvironmental enclosure based on two different but interrelated organizational and communication logics. First, the dramatically patterned surfaces and spaces of IBM's buildings were understood as metaphorical residues or imprints left upon architecture (considered as one of many "parallel communication paths") by the passage of IBM's primary activity—data processing or "pattern recognition"— through the medium of architecture. Second, an architectural topology that facilitated the representation of the ordered, pure interiority that IBM sought to engender was required; the formal solution to this counterenvironmental problem was derived from the domestic or monastic courtyard. Noyes began to articulate this approach at architectural scale in two buildings (now demolished) designed for IBM's Poughkeepsie campus.

IBM had arrived in Poughkeepsie in 1941, purchasing a several-hundred-acre tract of land stretching up from the Hudson River to the Kenyon Estate in the hills south of the center of the city and erecting a factory facility for a subsidiary, Munitions Manufacturing Company, to manufacture Browning Automatic and Carbine rifles and supercharger impellers for high-altitude aircraft in support of the war effort. After the war, the factory was converted and expanded to produce the new, Noyes-designed electric typewriters, as well as card punches and components for the new computers. By the time Noyes turned his attention from showrooms to the Poughkeepsie campus, however, typewriter production had been moved to Kingston, New York, in order to provide more room to build computers. The central feature of the campus was its half-mile-long manufacturing building, which produced the widest variety of EDP products in the entire company and earned Poughkeepsie a worldwide reputation as the "home of the large-scale computer system."[35]

But before this reputation could be earned, in 1950 the IBM Poughkeepsie campus was sorely lacking adequate facilities; not, indeed, for manufacturing, but for the necessary

attendant services that would support the factory. Administrative offices were housed in a haphazard series of low-lying brick buildings or crammed into corners of the factory building itself; IBM had nowhere to conduct important training courses for its employees and customers in the largely unknown facts about and uses of computers; and, perhaps most alarming, its research laboratory was in fact little more than a large house: the Kenyon mansion. With no room in the main wing of the house, the industrial designers responsible for designing IBM's vastly expanded range of computing products were relegated to the stables.[36] There was no room for the Military Products Division Laboratory's massive research project on the SAGE real-time computing system for the U.S. Air Force (discussed below) and no room for anywhere near the number of mechanical, electrical, and industrial engineers needed to design IBM's forthcoming products.

Still under the regime of Watson Sr., and almost reeling from the implications of the modest success of its earliest computers, IBM quickly built an enormous Research and Development Laboratory, called Building 701 (in homage to the brand-new scientific computer the corporation had just produced), completed in 1953 (Figure 3.4). Designed by the experienced architecture-engineering firm Vorhees, Walker, Foley and Smith, the building was a relatively conservative-looking, red brick affair, complete with pitched roofs and quasi-colonial white-painted trim details.[37] Despite the building's conservative appearance, however, Vorhees et al. were in the vanguard of laboratory design at the time and included enormous clear-span interior spaces, with services supplied through

Figure 3.4 Vorhees, Walker, Foley and Smith, IBM Research and Development Laboratory (Building 701), Poughkeepsie, New York, 1952–53. Photograph of presentation model from *Poughkeepsie New Yorker,* 15 December 1952. Courtesy of IBM Corporate Archives, Somers, New York.

modular suspended ceilings and floors. In addition to housing engineers and scientists at work on IBM's advanced computer technology, the original laboratory also provided room for the engineers with whom Noyes and his fellow consultants were to work so closely in the following years. As organizational charts and photographs show, "design," "control," and "human factors" engineers worked in this building in open, drafting table–filled studios closely resembling an architectural atelier. Apparently, IBM saw the work of both researchers and designers as allied closely enough to include their facilities in the same building; and curiously, despite the more modern idiom that Noyes and his fellow consultants were to push so hard for in the ensuing years, the design studios at Poughkeepsie remained in the relatively old-fashioned 701 for some time after the beginning of the design program.

Despite the construction of this new facility, space shortages grew worse as IBM doubled in size over the following five years. To resolve the shortage of space at the geometrically expanding Poughkeepsie campus, Noyes was commissioned by Watson Jr. to design a pair of buildings that would form the programmatic basis for IBM's architectural program in the coming decade: a Research and Development Laboratory (whose two wings also bore IBM machine-related monikers, "704" and "705," Figure 3.5) immediately adjacent to the 701 building, of 1955–56, and an Education Center, of 1956–58 (Figures 3.6 and 3.7). Both projects, as Reinhold Martin has shown,[38] were clearly designed under the influence of Eero Saarinen: their extremely thin curtain walls, designed with neoprene gaskets for the windows and enameled aluminum panels, derive directly from Saarinen's designs for the General Motors Technical Center in Warren, Michigan, completed in 1956.[39] The bifurcated functional planning in evidence at GM—nearly all of the buildings organized around the central, carefully landscaped lawn there were designed as a pair of rectangular volumes connected by a passageway or atrium—clearly had an impact on Noyes's designs as well.

The Research and Development Laboratory was just such a building. Combining the functional topology of the binuclear house with up-to-date laboratory planning techniques, Noyes's laboratory was divided into two nearly identical wings, set at a right angle to one another and connected by glass-enclosed walkways. The nearly clear-span interiors were divided only by flexible partition walls, and services were brought into the laboratory spaces via conduits hidden behind suspended modular ceiling panels. The building was enclosed by curtain walls of two-tone grey, enamel-coated, extruded aluminum panels with centrally placed windows spanning the length of a two-module bay.

The second building, the IBM Education Center, was built to house training programs for up to seven hundred "customer executives, IBM salesmen and service engineers, and customer engineers" at a time, as a place to "study the application, use and maintenance of various IBM data processing machines and systems."[40] The large thirty-foot bays and light steel structure allowed for clear spans in the interior, which on the ground floor was divided into two sections on the east and west sides of the building—according

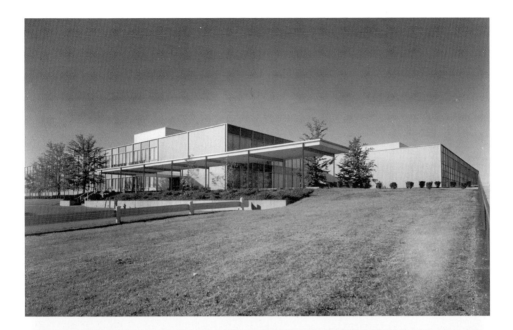

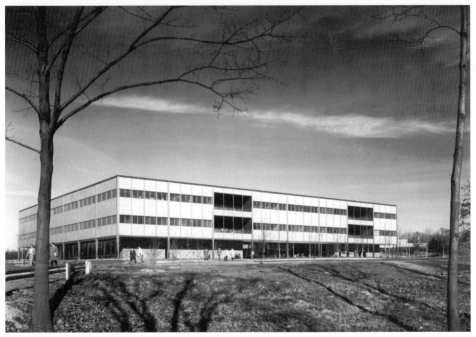

Figure 3.5 Eliot Noyes and Associates, IBM Research and Development Laboratory, Poughkeepsie, New York, 1955–56. Courtesy of IBM Corporate Archives, Somers, New York.

Figure 3.6 Eliot Noyes and Associates, IBM Education Center, Poughkeepsie, New York, 1956–58. View. Courtesy of IBM Corporate Archives, Somers, New York.

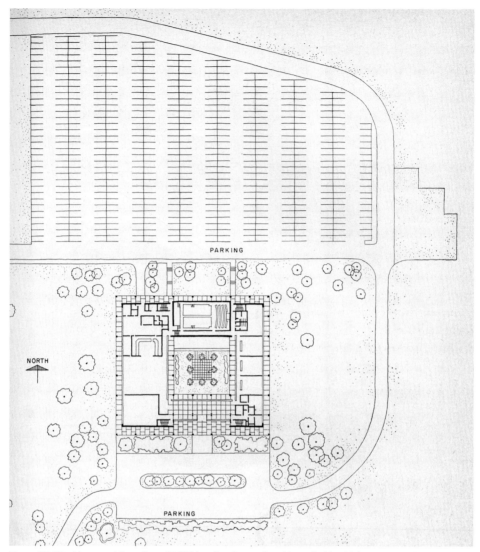

Figure 3.7 Eliot Noyes and Associates, IBM Education Center, Poughkeepsie, New York, 1956–58. Schematic site plan, as published in *Architectural Record* 126 (September 1959).

to function, the east half housing classrooms and services, the west side a cafeteria and exhibition spaces—separated by hallways and an auditorium on the south side. Recalling Noyes's own home (Figure 3.8), which was completed just as the Education Center was begun in 1956, it is essentially a two-wing program—a binuclear house—compressed into a single large volume, organized around a central courtyard.[41] The cultivated, ordered garden of the courtyard, surrounded by cloister-like glass-walled hallways at ground level, was set in stark contrast to the surrounding landscape, which was left more or less as is. Thus, the "square doughnut"[42] of the plan was focused inward. The patterned exterior—a curtain wall similar to that of the laboratory, with the same grey aluminum panels, but horizontal, ribbon-like fenestration—mediated between the disordered landscape

outside and the flexible, open interior organized around a central, ordered, and meditative landscape inside.

Noyes wrote a little-known essay on the design of his house, titled "Moods Are Not Accidents," that goes some distance toward explaining the appeal of the courtyard building to IBM.

The architectural idea was, as the plan . . . shows, to build two houses; to separate them with a court and to bind them with huge, strong, thick, stone walls, and to link these houses with covered open-air passages. . . . There are functional advantages to this split into two houses under one roof. More important, though, is that this arrangement gives visual clarity to the house, *strongly enough to dominate the family activities with their attendant clutter and paraphernalia, and so to give a kind of order to all the kinds of living that go on here.*[43]

The device of the courtyard, combined with a clear demarcation of interior and exterior, allowed the building's inhabitants, Noyes argued, to possess a clear spatial understanding of the otherwise potentially overwhelming diversity of functions. As a glance at the site plan of the Poughkeepsie building and the recessed glazed surfaces at either end of the Noyes House attest, neither the Education Center nor the Noyes House was designed with any specific view of the surrounding landscape in mind. Rather, what was necessary was a sense of what IBM called "outside awareness."[44] The compression of these diverse functions into a relation of "clarity" and "cohesiveness" created an architecture whose modular autonomy rivaled that of the monastery.

design award. House, New Canaan, Connecticut: Eliot Noyes, Architect; Richard Kelly, Lighting Consultant. Its extreme simplicity and refinement both in plan and in structure, plus the adroit handling of the open court in the middle of the house, make this architect's home distinguished among the many fine houses submitted this year.

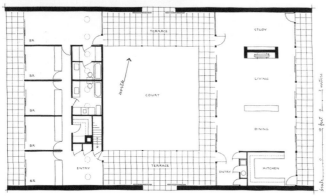

Figure 3.8 Eliot Noyes, Noyes House, New Canaan, Connecticut, 1956. View and plan.

The patterned, courtyard architecture of the Education Center was developed in parallel with a number of other IBM projects begun in the same year; although these were not Noyes's buildings, they were designed by architects he commissioned and whose plans he approved. A new manufacturing plant in Rochester, Minnesota, designed by Saarinen (Figure 3.9), was a larger and more dramatic rendition of Noyes's buildings: the curtain walls, even more spectacularly thin than Noyes's, were enameled in a two-tone blue pattern, the rectangular volumes of the building were organized around multiple courtyards, and the complex was laid out in a modular pattern that evoked a punch card superimposed on the landscape.[45]

Also in 1956, Noyes selected the California architect John S. Bolles (1905–83)[46] to design a campus for IBM's research and manufacturing facilities on the West Coast (Figure 3.10). Located within driving distance of several air force bases and Lawrence Livermore National Laboratory, the walls of the two hundred thousand–square-foot manufacturing plant were constructed using a relatively new building system using tilt-up concrete panels,[47] making the IBM campus perhaps the first of thousands of such exurban building complexes that today litter the highways in what is known as Silicon Valley. Its position as a key installation in the ongoing cold war was firmly established when it played host to Nikita Kruschev during his 1957 "thaw" visit to the United States. Amid the low-rise sprawl of the factories were courtyards of much the same form as at Saarinen's Rochester plant, although here in California they were accented by fruit trees and even an artificial lake. The central administration and laboratory building was designed to lend the complex focus, achieved through a mosaic composed entirely of massive colored squares. It was the first in a series of "pixillated" facades that would come to characterize IBM's architecture in the popular imagination and architectural press alike, evoking not only the patterned and perforated surfaces of punch cards but also the complex patterns characteristic of data processing, and even the visual structure of CRTs. Bolles's firm would eventually design thirty-three buildings on the campus (which today has over eighty) over the ensuing three decades.

Any decentralization process is really, and simply, a matter of moving one center away from the others.[48] As IBM decentralized its various divisions into quasi-autonomous entities, the central administrative apparatus of each was moved to a new location; for example, typewriter design and production (then known as the General Products Division) was moved from Poughkeepsie to Kingston, New York, to make room for Poughkeepsie's assumption of control over large-scale computer systems. Of first priority in the beginning of this program was the reorganization and resituation of IBM's increasingly critical research arm.

When the design consultancy began in 1956, IBM's research facilities were almost all housed in Poughkeepsie. While IBM's production of computers and other office machines was occurring primarily there, this sufficed; however, the other campuses strewn across upstate New York, and in places farther afield, such as Boulder, Colorado, and San

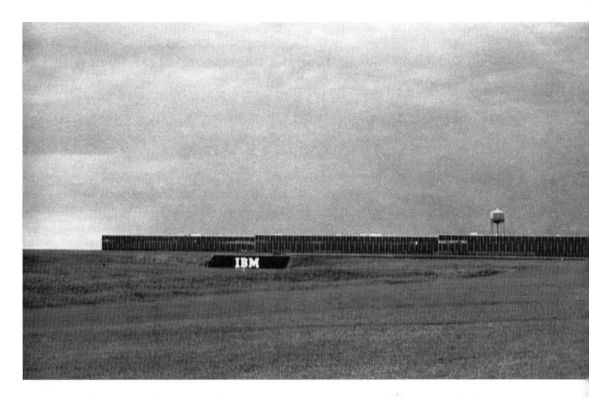

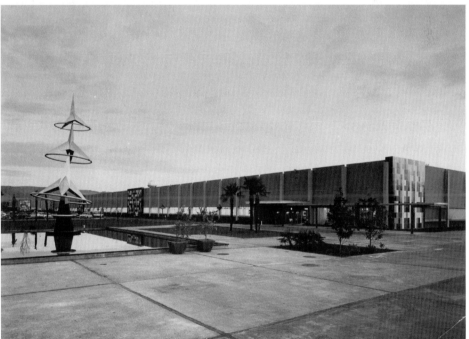

Figure 3.9 Eero Saarinen and Associates, IBM Manufacturing and Administration Building, Rochester, Minnesota, 1956–58. View. Courtesy of IBM Corporate Archives, Somers, New York.

Figure 3.10 John S. Bolles, IBM Manufacturing and Administration Building, San Jose, California, 1956–58. Courtesy of IBM Corporate Archives, Somers, New York.

Jose, Paris, and Zürich, increasingly had their own researchers in residence, working on problems related to their specific segments of development and production. Furthermore, there was no autonomous space devoted to the free scientific research that IBM and other high-technology multinationals had come to see as critical to their continued dominance of an increasingly competitive market.[49] Responding to these needs, IBM's executives elected to create a new center, which would coordinate and rationalize IBM's far-flung and wide-ranging research activities and provide a state-of-the-art facility to house and attract the top scientists IBM sought to recruit in the coming years (Figure 3.11). As a kind of geographical compromise between Poughkeepsie and the need to have some proximity to Corporate Headquarters (CHQ) in New York, the corporation selected an exurban site, in Yorktown Heights in Westchester, for this new facility; Noyes selected Eero Saarinen once again to provide the design.

The architectural history of the Yorktown Heights laboratory has already been treated very convincingly and in detail by Reinhold Martin.[50] However, because of the structure of Martin's analysis, which compares the Yorktown Heights labs to Saarinen's related projects for Bell Telephone Laboratories on the way to a different argument than that presented here, there remain to be discussed (or simply reemphasized) some small but important aspects of the design that are of note to this more IBM-centric history.

The plan of the laboratory building, formed from two concentrically arranged arcs over one thousand feet long, is clearly and strongly symbolic of the building's central status and underscores its metonymic relationship to the rest of IBM's research apparatus across the globe. The views from the building are all along the exterior, glass-covered arc, and thus oriented toward the landscape beyond and below. The building appears to be, unlike the closed courtyard counterenvironments of Poughkeepsie and Rochester, open to the world beyond. IBM certainly promoted such a reading of its building; as Watson Jr. announced to IBM's stockholders the day the laboratory opened, it would be "*an international center for unifying* the massive amount of information in the computer field and that which will be added in the years ahead."[51] Fittingly, it was dubbed the Thomas J. Watson Research Laboratory, evoking the former leader's internationalist, and even global, ambitions. However, the apparently obvious symbolism of this shape and the building's apparent orientation toward the landscape beyond is also deferred—even, seemingly, denied—in significant ways.

As Saarinen's earliest designs for the building show, the eventual design of the building emerged out of a formal exploration of the courtyard topology discussed above. Saarinen initially envisioned the university campus–like buildings having "masonry exteriors with glazed-brick facing," "normal sized windows to enhance campus atmosphere," and "masonry partitions (cinder block or formed slab) instead of movable steel partitions," which would allow for eventual "cellular" expansion.[52] The paths between buildings would be "canopy-covered or glass-enclosed," further enhancing the sense of interiority; sited upon the hill, the research complex was to become part university, part monastery, part

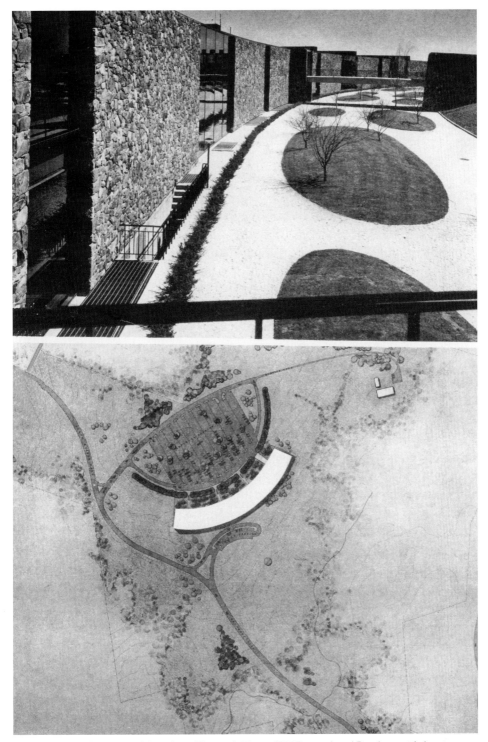

Figure 3.11 Eero Saarinen and Associates, Thomas J. Watson IBM Research and Development Laboratory, Yorktown Heights, New York, 1956–58. View and site plan.

fortress. One perspective sketch in particular, offered to IBM executives as a preview of the design, even recalls the quasi-subterranean slaves' quarters of Hadrian's villa in Tivoli: a solid brick wall lined with poplars extending to the vanishing point.

As built, the laboratory's imposing fieldstone front facade, broken only by the occasional window, greets the arriving scientist with a nearly blank wall. Entrance is only possible by crossing over a "moat"—a sunken landscaped garden of crushed white limestone and grass mounds designed by Sasaki-Walker meant to evoke water—on one of four bridges.

But whither the courtyard? The focus of the circular arcs that form the building's glass and masonry walls—that is, the imaginary central point of the implied circle—is, of course, not within the bounds of those walls and is indeed screened from view by the opaque thickness of the masonry wall along nearly its entire length. Thus the building, in comparison to Noyes's Education Center or even Saarinen's earlier campus at Rochester, is a decentered center. The partition walls of the 120-foot-long corridors housing individual laboratories on the interior, described as "radial" by contemporary architectural reviewers,[53] are not in fact radial at all, since the inclusion of wedge-shaped service areas (bathrooms, library, entrance lobby, etc.) skews these lines in multiple directions; there is thus little if any indication on the interior of any central point around which these spaces are organized. This seemingly haphazard arrangement contrasts sharply with the more consistent modularity of Saarinen's intermediary schemes for the building, in which the four-foot-by-six-foot grid is oriented without regard for the arc of the exterior walls.[54]

The scientists themselves—who, as Saarinen noted, "are like university professors—tweedy, pipe-smoking, men," and habitually faced away from windows while doing their work—were in fact oriented toward these nonradial partitions, which took the form of a "modular storage system" that mimicked the patterned curtain walls of Saarinen's and Noyes's earlier IBM buildings. Thus, in the Yorktown Heights labs, the courtyard building was turned inside-out: the module itself took the place of the courtyard, and as a result, radically extended its metonymic ordering power.[55] The laboratory figured the expansionist and organicist orientation of the corporation, reorienting the modular grid regulating the deep interiors of the lab toward the territory lying outside of its bounds. The further in one went, the further outward the patterned, modular grid grew.

The success of the Watson laboratory was immediately evident, in both architectural and technological terms. The perplexing design was published in architectural journals and featured just as widely in the company's own organs and public relations campaigns, and photographs of the facilities were used to recruit the best young scientists emerging from research universities. Similar relocations followed. For example, the IBM campus at Kingston, initially devoted to manufacturing punch cards and typewriter parts, was given over to the new Military Products Division, charged with developing the SAGE computers (see below) and the "Army Fieldata System" for managing deployed forces at a distance using computers, and designing other special-use "Military Operations

Control Computers."[56] However massive this reorganizational maneuver was, though, the reorganization and spatial redistribution of IBM's central management apparatus remained unfinished. The Williamsburg plan for reshaping IBM's management structure in late 1956 did not go into full effect until the middle of 1959, demonstrating the preparatory and structural role that the redesign of IBM's facilities played in implementing the changes.[57] By the end of 1959, Noyes had overseen or at least begun the transformation of all of IBM's major divisions save for one: CHQ (Figures 3.13, 3.15–17).

The IBM Armonk campus was originally intended to provide a new home for the growing Data Systems and General Products Divisions, and SOM designed a "square doughnut" courtyard building for the site in 1960. Construction began in 1961. However, at the same time, IBM continued the experiment—begun with the recentering of its research and production apparatus—that would profoundly alter its corporate geography in the coming years. In an effort to determine whether CHQ could, like its subordinate divisions, function better outside of Manhattan, a portion of the administrative staff at 590 Madison Avenue was temporarily moved to a yet unoccupied portion of the Yorktown Heights laboratory.[58] The experiment, closely supervised by top management, was intended to last six months; however, four months into the experiment, on extremely short notice, in December 1961, IBM purchased Standard-Vacuum's office building in White Plains, New York. Especially considering that management determined that the experiment in Yorktown Heights had been an overwhelming success, they determined that the Standard-Vacuum building would adequately house the Data Systems and General Products Divisions and require a smaller number of its employees to move or commute long distances. SOM was asked to revise its plans for the Armonk campus, already under construction, which would now house the entirety of CHQ.

While the selection of Armonk as IBM's new center was thus semiaccidental, the strategy of moving the central "brain" of IBM (as it was described often in the house organs *THINK, IBM News,* and *Business Machines*) to the exurbs was not.[59] Following the now long-standing management, geopolitical, and military imperative of decentralization, the relocation offered IBM several advantages. As a map issued to CHQ employees with Watson's announcement of the move indicates, it would now be closer to IBM's other suburban and exurban facilities; as another map made during the relocation experiment shows, it also moved the central administration of IBM away from the center, as it were; the nuclear bombs and missiles that might at any moment destroy Manhattan would still leave the corporation time to move its key functions underground, so they would be more or less unscathed (Figure 3.12).[60] More important, however, the relocation was a rational and strategic response to the practical and representational needs of the corporation itself. The Madison Avenue building, so long the center of IBM's representational apparatus vis-à-vis its consuming public, could and would remain as such. The showroom would be expanded, and services for IBM customers and employees, such as educational seminars, exhibition design, and advertising, would now occupy the skyscraper. It would be what it had always been: a combination of theater, advertising billboard,

and classroom—in short, an image factory. But the administrative apparatus it had previously housed was no longer required to be in such a traditionally conceived center; rather, it could, through the power of teletechnology, operate from a distance, and precisely by so doing, spread the infrastructure and perceptual apparatus of teletechnology more effectively.

By the early 1960s, the Radiotype system that IBM had showcased at the 1939 World's Fair had been developed into a fully computerized management system that the corporation officially launched in 1960, under the trademark "Tele-Processing." The hardware and software comprising the system—which allowed for real-time management of inventories, financial statistics, personnel assignments, and risk analysis over vast distances by linking disparate computers together into a communications network—was developed by IBM in collaboration with engineers from the U.S. Air Force, MIT, and several other technology corporations. The program, which constitutes perhaps the most significant and determining moment in the history of computing between Alan Turing's formulation of the "universal machine" theory and the development of the silicon microchip, was called Semi-Automatic Ground Environment (SAGE), begun in 1951, and fully operational by 1963.[61] It was based on the desire to defend the United States against a surprise Soviet air attack through

semi-automatic control of the basic environment in which the organization (here the Air Defense Command) does business, which every real-time system is about. . . . It does the job with a

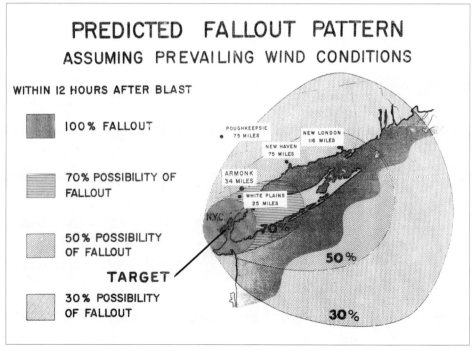

Figure 3.12 "Predicted Fallout Pattern" after an atomic attack on Manhattan. From O. M. Scott, "GPD Presentation to CMC: Armonk Fall Out Shelter," 11 January 1961. Courtesy of IBM Corporate Archives, Somers, New York.

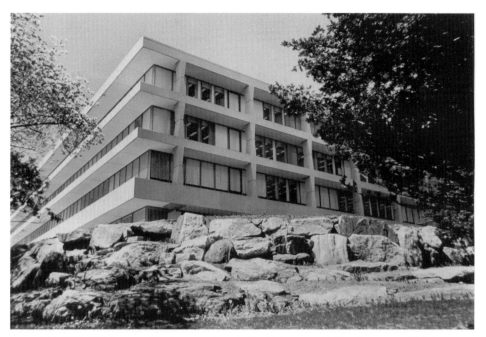

Figure 3.13 SOM, IBM Corporate Headquarters, Armonk, New York, 1962–64. View. Courtesy of IBM Corporate Archives, Somers, New York.

network of radar-fed computers that continuously analyze every cubic foot of air space around the United States, instantly track all airborne objects approaching the country, and call for appropriate action.[62]

The SAGE computers—the first to make extensive use of magnetic memory cores and parallel processing—were directly hooked up to radar installations distributed across the periphery of North America and housed in massive windowless concrete buildings (Figure 3.14). Four stories high, with a two- or four-acre footprint, these nearly identical bunker-like installations were mostly filled with hardware and its requisite services (redundant power generators and cooling plants). However, they also required operators— after all, a semiautomatic rifle is only *semi*automatic in the sense that it needs a human being to pull the trigger—who sat at the radar screens tracking the aircraft, interacting with the computers via light guns, in a space wholly blank save for the surfaces of the technology itself. Located inside the SAGE bunkers, and thus inside the computer itself, these "blue rooms," so-called because the only light emanated from the cathode-ray displays of the computer terminals, were spaces wholly defined by the logic of real-time management of airspace. Despite their locations at discrete points, these semiautomatic counterenvironments were topologically pulled together into a seamless network, both at the technological level of information flow and at the level of telescopic architectural modularity. However, the paradox of these installations is self-evident: these blue rooms, connected only to other blue rooms and their weaponized extensions (antiaircraft installations, fighter squadrons, missile systems), extend control over the ground environment—

the defensible territory—only as they segregate themselves spatially as thoroughly as possible from that environment, behind the thick and opaque concrete walls of the bunker.

Brochures that Rand designed for IBM Teleprocessing Support Services in 1960 condensed the logic of this new computerized mode of vision and organization into a single image. These depicted teleprocessing as a network of black circles against a white background connected by a complex array of thin black lines blanketing nearly the entire cover. The apparently decentralized network, composed of organizations connected to

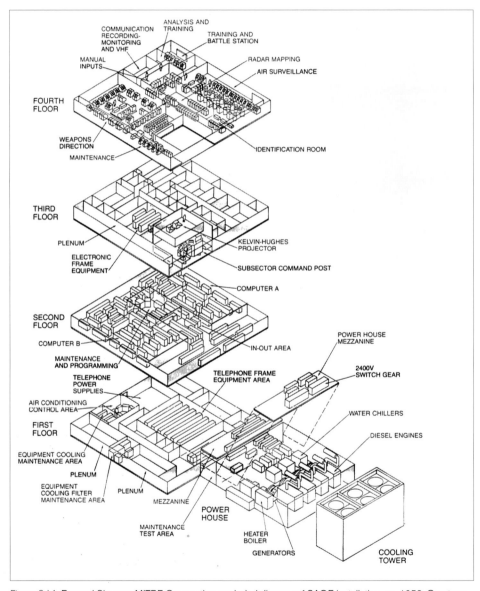

Figure 3.14 Bernard Shuman, MITRE Corporation, exploded diagram of SAGE installation, ca. 1958. Courtesy of MITRE Corporation.

other organizations, was nonetheless ordered by a single powerful oversight. At the very top right-hand corner of the design, at some remove from the tangled web of lines, the comparatively simple IBM logo hovered in white space, visually signifying IBM's privileged vantage point over the entire network through its control of the space in which this corporation was situated.

SAGE illustrated to its makers the veracity of Paul Virilio's dictum that in the constant technological advance of war, "it is no longer enough to be quickly educated about one's surroundings; *one must also educate the surroundings.* In other words, one must try to preserve, *on that very spot,* one's *head start* over the enemy."[63] It is not possible to conduct a process of extension without the outside that extension implies. The (irrefutably architectural) closing-off of the technological counterenvironment of the SAGE bunkers from its territorial surroundings thus corresponds to a desire to close off that territory from its wider surroundings; in short, it is a fortress architecture that transforms the very nature of the terrain by instrumentalizing it, turning it into both an offensive and defensive weapon—a deterrent.

Here it might be helpful to point out an often overlooked discrepancy between the meaning of the noun "real time" and the adjective "real-time" derived from it. The first is either "the actual time in which a physical process under computer study or control occurs [or] the time required for a computer to solve a problem, measured from the time data are fed in to the time a solution is received." The adjective, however, elides any such reference to a concrete, measurable, "actual time": "of or relating to computer systems that update information *at the same rate* as they receive data, enabling them to direct or control a process such as an automatic pilot."[64] That is, "real time" has to do with time, whereas "real-time" connotes a rate, speed. (As a journalist described the working of

Figure 3.15 SOM, IBM Corporate Headquarters, Armonk, New York, 1962–64. Schematic first-floor plan showing locational color scheme. Courtesy of IBM Corporate Archives, Somers, New York.

a real-time management center designed by Noyes for Westinghouse in 1964, it was a matter of "distant answers shot back in seconds.")[65] Despite the high speed of real-time management transactions, it is nonetheless critical to note that the fundamental basis of real-time computing lies within the dimension of time—in the technique of delay. Information is taken from the environment, here the corporation itself and the market within which it operates, stored in the computer's electromagnetic memory core, and only later (sometimes only a fraction of a second, but nonetheless a measurable amount of [real] time) retrieved and processed in parallel—at the same time—with other connected or relevant pieces of information. Finally, this information processed in "real time" is rendered into a visual-textual image on a screen in a dimly lit space already specifically tailored for the decision-making responses of "real-time management." That is, this delay, in which information from elsewhere is brought inside the computer, its movement stalled until it can be recombined with other discrete bits of information and then made visible on a screen, constitutes the locus of the act of organization in real time. This delay is difficult to recognize for two reasons: on the one hand, it occurs constantly, as information is updated at the same rate as it is gathered; on the other, the speed of the process during which it occurs is so fast that its gaps are literally imperceptible. The delay, the "real time" of "real-time computing" is thus rendered imperceptible to the human sensorium by the familiar techniques—and tactics—of cinematic projection.[66]

The Armonk headquarters, like the experimental installation at the Watson labs before it, was organized as just such a real-time management system: the "IBM Internal Tele-Processing System," a special purpose IBM 7750, an IBM 1405 disk storage unit, and IBM's "medium-sized" computing system 1410 were linked together with 320 IBM locations via 275 terminals across the globe.[67] This system was located directly next door to a larger-scale IBM 1460 system, which attended to corporate accounts, payroll, and personnel files around the clock. Thus, in addition to being a state-of-the-art office building—especially in terms of its heating, ventilation, and air-conditioning equipment, infrastructural autonomy, and circulation planning[68]—IBM CHQ was an experiment in the computerized management of space. As SOM had done in its design for the U.S. Air Force Academy of 1954–56, all of the office machines, furniture, and artwork for the building was organized according to a logistical system: each object was assigned a number, and its location, user, and use were tracked by the IBM 1460 computer installed on the first floor of the building.[69] IBM's growing collection of modernist art was made available to managers and executives; each individual worker could "personalize" his or her office by selecting from an approved menu of abstract paintings and matching upholstered office furniture. For those not fortunate enough to have an office to themselves, special office units, teak desk and office machine hybrids designed to correspond to the building's five-foot module,[70] were arranged in open areas alongside the corridors. Furthermore, in order to orient the building's users in the otherwise monotonously modular interior, each quarter of the building was color coded: in the northeast quadrant the walls were blue; in the northwest red; southwest green; and southeast yellow (Figure 3.15).[71]

The facade of the Armonk building seems at first to betray the initial consistency of the IBM architectural program, turning away from the thin, patterned curtain walls of Noyes's and Saarinen's buildings toward a more heavily modeled surface. The structure of the building was of reinforced concrete slabs, cantilevered at the edges, with recessed concrete piers tapered toward the middle and meeting at a joint. The deeper spatial structure of the building is registered on the facade by the thirty-foot bays—five six-foot modules apiece, just as in Noyes's Education Center. The walls were enclosed entirely in glass, lending the facade a more open appearance, but were recessed several feet behind the protruding slabs. The effect was enhanced by the use of white quartz in the concrete aggregate, causing an optical illusion that made the grey glass seem to retreat yet deeper. The brochure offered to employees and their families for IBM's open house at CHQ in 1964 showed a diagram of the building's facade superimposed over a photograph of a maple leaf (presumably taken from one of the trees near the building), clearly seeking to demonstrate that the building did "not interfere with the rural character of its setting."

The very anxiousness and hypersensitivity toward its rural neighbors' concerns that IBM demonstrated in its literature about the building highlights the speciousness of its claim. The building actually deploys the surrounding territory as a means of enclosure; not only is a third of the low-lying, 420,000-square-foot building literally buried in the terrain, but its separation (by hills, trees, and a long driveway) from any public place or thoroughfare led one journalist to declare, "Politically, architecturally, and in just about any other way you can think of, IBM-land is almost invisible in Westchester. . . . IBM's buildings, too, as well as its people, were designed to blend into the landscape. Visiting businessmen— even visiting IBMers—have driven right by the IBM headquarters in Armonk and missed it."[72] This invisibility was evidence of the radical closure and autonomy of both campus and building. In the 1970s, IBM considered eliminating lunch breaks altogether and letting employees leave early, because, as one IBM manager who spent his lunch hour walking around the parking lot put it, "what's the point of all that time if there's nothing to do with it?"[73]

As in IBM's previous courtyard counterenvironments (the Watson laboratory included), the building also interiorized its surroundings. In order to announce the central importance of the new headquarters, and to render it consistent with the representational apparatus that motivated the design program as a whole, Noyes invited the sculptor and landscape artist Isamu Noguchi to design the two courtyard spaces. For the south courtyard garden, Noguchi had enormous boulders that had been unearthed by the blasts that leveled the employee parking area and moved them into the courtyard area; the building was then built around them.[74] This garden, meant to "symbolize mankind's past" (Figure 3.16), was planted with dogwoods, magnolias, and pines in an effort to evoke "a pastoral setting . . . of the ages preceding the Industrial Revolution."[75] The northern courtyard (Figure 3.17) was meant to represent a "fantasy": "This garden is about science. It is about our future. The landscaping has been planned to give a feeling of moving into that future." In addition to a Norwegian spruce, a weeping spruce, and several Japanese cutleaf maples,

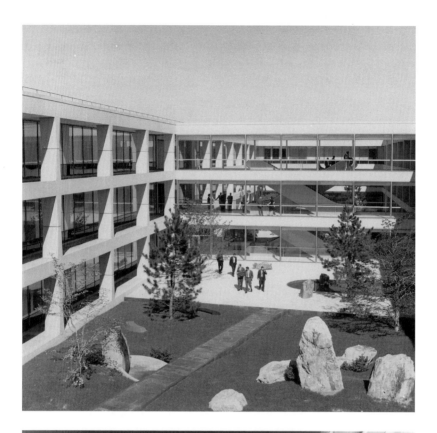

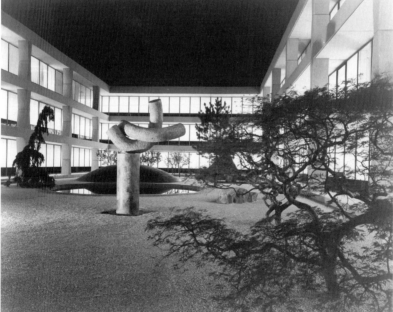

Figure 3.16 Isamu Noguchi, *Garden of the Past,* courtyard of IBM Corporate Headquarters, Armonk, New York, 1964–65. View. Courtesy of IBM Corporate Archives, Somers, New York.

Figure 3.17 Isamu Noguchi, *Garden of the Future,* courtyard of IBM Corporate Headquarters, Armonk, New York, 1964–65. View. Courtesy of IBM Corporate Archives, Somers, New York.

which were chosen "for their starkness and science fiction shapes . . . [for] an artificial and moon-like effect," Noguchi added several directly symbolic sculptural elements. A large concrete pool, painted red and illuminated with lights, was meant to give "a fantastic, shimmering effect as if it were reflecting the universes yet to be explored." Next to the pool was a black dome carved with diagrams intended to represent "man's knowledge and control of his universe"—abstractions of nuclear formations, galaxies, and computer circuitry. To find appropriate symbols, Noguchi recalled, "I even went out to Brookhaven Laboratory [a nuclear and chemical research facility on Long Island]. I wanted mathematical atomic and electronic symbols and formulas to inscribe on the black dome, much as the Egyptians inscribed their buildings and pyramids with what they conceived as the pervading truths of their time."[76] Beyond both pool and dome were a marble sundial, symbolizing "organization," and a granite pyramid, which was inspired by "an atomic fuel pile, symbolic of power to be employed in the future."

Thus, as at Yorktown Heights, the courtyard did not absorb attention inward, but rather focused it outward, to take in the surrounding territory—here it is explicit that this is not just a matter of space, but also of time—and render it equivalent to, and thus surveyed and controlled by, the modular interiors and machinic logic of IBM space-time. If the two courtyard gardens were past and future, it was clear that the present was the building, was IBM itself, reaching around to envelop both. As IBM's top employees entered the building and mounted the system of escalators in the glass-enclosed "bridge" between the courtyards, they thus performed (probably unwittingly) a daily ritual confirming the enduring presence of the corporate body.

In keeping with the building's anonymity and metonymic ubiquity in the modular space-time of "IBM-land," Watson Jr. dedicated it on 21 October 1964—just a few months after the announcement of System/360—"to IBM employees everywhere."[77] But just where Watson Jr. and IBM understood "everywhere" to be, and who would preside over this population, demands further explanation.

The Management of Space and Structure: IBM RECD

Although the selection of SOM to design IBM's CHQ was, like the choice of location, quasi-accidental, it nonetheless illustrates quite clearly Noyes's and IBM's aims in developing a new system of architectural production. By 1961, when the building began construction, SOM had already developed into an entirely new type of architectural author. In the mid-1950s, SOM won several commissions—the most notable of them the Air Force Academy in Colorado Springs—based on their willingness to approach the project as a problem of organization of information in space.[78] Flow charts and diagrams were understood as just as, if not more, significant than the plan of a building, insofar as they promised the capacity of architecture to order, and make whole, a disparate and complex range of media and practices. SOM's architecture was an architecture of management.

As a coherent architectural topology—based as it was on an increasingly codified and quantified set of programmatic criteria—emerged from the IBM buildings and their correlated real-time management systems designed between 1956 and 1964, and as the financial pressures of IBM's gamble on System/360 mounted, IBM's management pressed SOM's innovations even further, establishing an entirely new division of the corporation devoted solely to its spatiotemporal welfare: the Real Estate and Construction Division (RECD). RECD was to solve the problem of housing a doubling of IBM's workforce—it added more than seventy thousand new employees between 1964 and 1967—and a global expansion of its manufacturing facilities that included new plants in Boulder, Colorado; Raleigh, North Carolina; Montpellier, France; Vimercate, Italy; Boca Raton, Florida; and Brooklyn, New York. The expansion had proceeded so rapidly (and, apparently, unexpectedly) that at one point IBM was renting "circus tents" as ad hoc warehouses.[79] A rationalized industrial method of architectural production on a par with IBM's incredibly well-refined manufacturing apparatus was necessary.

The decision to move to an increasingly anonymous, systems-based approach also had an effect on IBM's image. As we have seen, IBM undertook the massive risk on System/360, under the duress of what was known in the business press as "The 'Assault' on Fortress IBM."[80] As it came under increased scrutiny from the judicial branch of government and several industrial giants—such as General Electric—entered the computer market, "IBM apparently decided that an image of wealth was a liability. . . . Stories abound of carpet removed or fine wood painted over."[81] While the general counterenvironmental topology remained the same, IBM nonetheless began to generate a defensive shell around its buildings that reinforced the modularity and patterning that was the essence of the curtain wall,[82] and had the added benefit of an austere and sober appearance. As the division's mission statement announced in 1964, the year that IBM CHQ opened in Armonk,

Our policy in IBM is to bring about the design and construction of our buildings at the lowest practical cost per square foot in capital investment, and at the same time insure efficient function of these facilities at the lowest possible annual operating and maintenance expense.

This in no sense means we will tolerate a "supermarket" approach to design and appearance as an alternative course to continuing the excellent building design reputation IBM has in the world today—a reputation built on good taste not lavishness.

Therefore, we will continue to build buildings whose interior and exterior design and appearance express the character of IBM in a manner appropriate to the function of the particular building or facility and its location. Where prestige is a necessary and desirable feature, then investing in the cost for prestige is clearly justified. Only that amount of prestige, however, should be paid for which serves a useful purpose in our business.[83]

Following this economic logic, a plant for producing punch cards should be "spartan"

and "utilitarian" and "have the characteristic of simplicity." Branch offices should be designed with "more prestige in mind."

The design, construction and general appearance of manufacturing buildings should strongly emphasize economy, efficiency, functionalism and utility with an uncluttered imaginative design that indicates that we are a company dealing in advanced technologies, modern and forward thinking and with a strong consideration for the welfare of the people in our company; research and development laboratories should have much the same characteristics with perhaps a more striking appearance which will be helpful in attracting to IBM research and engineering people of the highest caliber.[84]

The quality of RECD's architecture would be assured, it was hoped, by the continued involvement of IBM's consultants in the commissioning process and by a sustained education program for design engineers and architects. Luminaries from the design world—such as Reyner Banham, George Nelson, Peter Blake, Ivan Chermayeff, and of course Noyes, Kaufmann, and Eames—were brought in for yearly "mini-conferences"[85] at IBM's various design facilities. This program would eventually result in IBM possessing its own architectural expertise; as RECD president Robert H. Howe could state by 1975:

The reason we're able to function so well is due to our highly professional people. We have our own architects, designers, real estate administrators, and engineers—civil, mechanical, electrical. They are, for IBM, a unique group of professionals, and they deal with the professionals outside the company, acting as a conduit of company policy, approach, and requirements.[86]

By the mid-1970s, almost all of the architects for IBM projects were chosen from "RECD's architectural talent library," which included both IBM architects and a list of approved outside firms.[87] With a global purview, RECD managed a worldwide "land bank" both to provide sites for future IBM facilities and to generate revenue from leases.[88]

The overall regulating concept of IBM's physical growth was one of organicity. The aim of RECD was thus to reform IBM's architectural production to respond to the dynamic of organic growth. This meant, in many cases, abandoning or entirely reformulating portions of the real estate management system—if it could at that point be called a "system"—that had prevailed in the company from its inception. As *Architectural Forum* critic John Morris Dixon astutely noted of the new organic regime in a review of one of IBM's odder buildings, a Victor Lundy–designed branch office in Cranford, New Jersey,

Functionally, IBM branch offices are standardized outposts of the computer empire. Each one is programmed to start with an area of at least 25,000 square feet and expand by stages to 50,000 square feet, after which a new branch will be split off. Often, as in this case, the buildings are designed to IBM's requirements, but owned by others. The company's design manual for these branches suggests a four-story scheme, with one or two of the floors rented to others initially.[89]

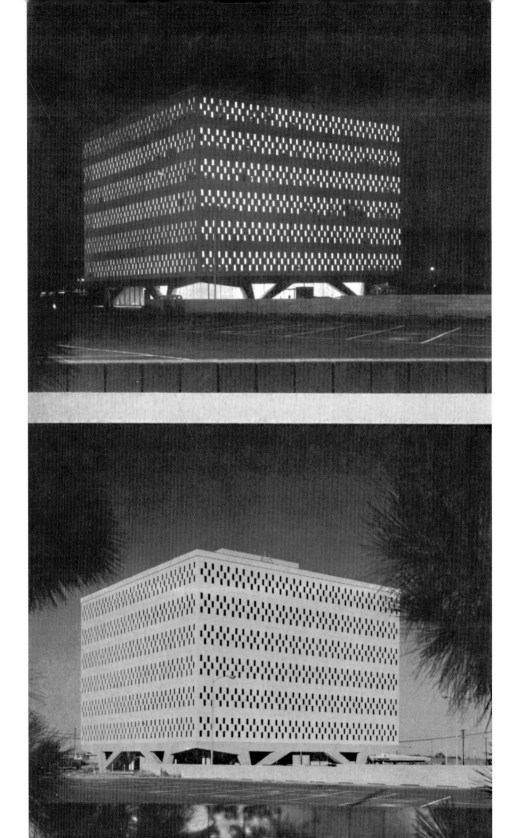

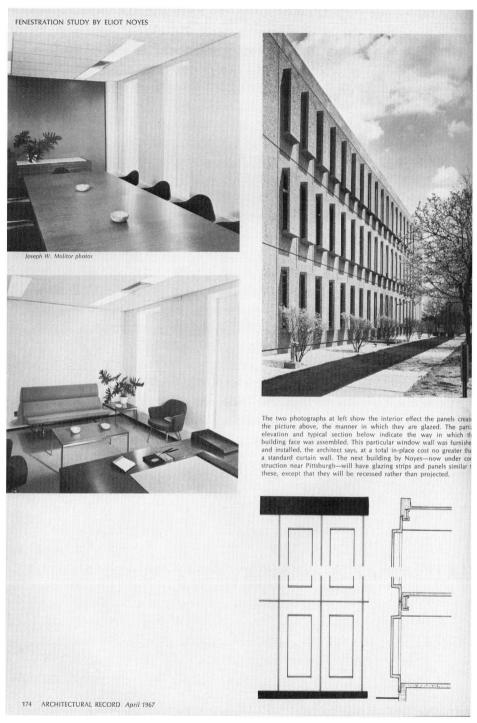

Joseph W. Molitor photos

The two photographs at left show the interior effect the panels create
the picture above, the manner in which they are glazed. The parti
elevation and typical section below indicate the way in which th
building face was assembled. This particular window wall was furnishe
and installed, the architect says, at a total in-place cost no greater tha
a standard curtain wall. The next building by Noyes—now under con
struction near Pittsburgh—will have glazing strips and panels similar t
these, except that they will be recessed rather than projected.

Figure 3.18 *(facing)* Eliot Noyes and Associates, with Quincy Jones and Frederick Emmons, IBM Aerospace
Headquarters, Los Angeles, California, 1964. View. From *Architectural Record* 141 (April 1967).

Figure 3.19 *(above)* Eliot Noyes and Associates, IBM Branch Office, Garden City, New York, 1964–65. View.
From *Architectural Record* 141 (April 1967).

The patterns of Saarinen's and Noyes's curtain walls were not gone, and the courtyards remained as well. The former had embedded themselves in the thick reinforced concrete walls of the new buildings, and the latter became, through the same topological inversion as had taken place with the Yorktown Heights laboratory, interiors by and of those patterns. For the IBM Aerospace Headquarters in Los Angeles (Figure 3.18), completed in 1964 and designed by Noyes in conjunction with the California architect–engineer duo Quincy Jones and Frederick Emmons, the courtyard as a representation of environmental control is, as at Yorktown Heights, no longer an actual landscaped courtyard but rather a courtyard turned literally inside out.[90] In the interior the representation of an ordered counterenvironment is created not by a cultivated garden but with a modular pattern, the extension of the geometry and organizational logic of the Poughkeepsie courtyard to cover and enclose the entire building. Held by a structural steel cage sitting on massive concrete "tree" columns at its base, the strongly patterned concrete "window wall" panels— which create the impression on the exterior that the building is a giant three-dimensional punch card—focus attention inward by simultaneously representing the information patterns of the work at hand and denying coherent views to the exterior. (It is worth noting that while IBM's design consultants continued to stress the importance of "outside awareness," being aware of the outside did not mean having a view of it.) The wide open interiors—with the omnipresent glass partition walls of IBM office buildings— allowed views from end to end of the square plan, wholly enveloping the IBMer in the rhythmic but disjointed patterns of the windows and the long, smooth lines of the flush fluorescent lighting fixtures overhead. That Noyes and IBM understood the panel system as an extension of the courtyard design logic is proved by the fact that Noyes tested the Aerospace Headquarters design by erecting a mock-up panel on the glass wall of the courtyard of his own house in New Canaan; according to Noyes, the patterned walls had an effect similar to that of looking into an ordered garden or cloister without it even being there.[91]

In the IBM Branch Office at Garden City, New York (Figure 3.19), designed while the Los Angeles building was going up, Noyes pushed this window wall to an almost perverse extreme by nearly eliminating the windows altogether.[92] The narrow slivers of glazing, running perpendicular to the wall surface behind projecting concrete rectangles, have the effect on the interior of transforming the window into something like a modular fluorescent light fixture (and this only on sunny days). As in the first phase of the IBM Design Program, these buildings were commissioned from leading architects and were conceived as experiments toward establishing a generative set of design criteria for a future, self-administered building program. As such, IBM took an important role in the reconsideration of skyscraper design going on in the early 1960s. The IBM office in Seattle, designed by Minoru Yamasaki in 1963, was a pathbreaking design, one of the earliest skyscrapers to eschew the curtain wall in favor of a structural wall, and served as the model for his later design for the World Trade Center in New York.[93] Curtis & Davis's IBM office building in Pittsburgh (1962–63), part of the Gateway Center developed by Equitable Life Assurance Society,[94] was also a notable experiment with its

structural steel "exterior-truss wall" in a quincunx pattern supported by only two pylons on each side of the nearly square building. These were pulled in away from the corners, giving the impression that the building hovered lightly in midair. The effect was to create an extremely strong, high-tension membrane holding the building together and up from the outside, firmly demarcating interior and exterior, and allowing for a maximally open plan on the inside.[95]

These few examples—and there are certainly many more from which one could choose—demonstrate that Noyes's organicist statement about the primacy of the detail in architecture quoted above should be taken at face value: his concrete walls, like the patterned tension-walls of Curtis & Davis, are a dramatization of the "character" of his buildings; they are "contributory to the clarity of all relationships" insofar as they clearly demarcate and separate interior from exterior and announce this fact on the very surfaces of the buildings through a manipulation of pattern in depth and radical opacity. Furthermore, these "details" are articulated so as to attest to both the irreducibility and the determining logic of the module—each modular element is articulated as a whole in and of itself, and as a part, or organ, within a greater whole made up of the iterative reproduction of said part. The imperative of flexibility that is so often stressed in the literature on the architecture of IBM, whether in professional architectural journals or in the company's own organs, is thus better understood as the amount of maneuvering room for the architect to articulate the module tectonically than it is as a matter of open plans and moveable partition systems.

Despite his apparent willingness to manage the architectural program as a system, Noyes did not, it should be noted, surrender his leading (rather than consulting) role readily. To Watson, he remained chauvinistic about the architectural program under RECD, even in the face of numerous architectural failures during the early and mid-1960s—notably the massive factory and administrative complex at East Fishkill, New York (Figure 3.20), which was designed by Paul Rudolph but was never completed to his plans due to cost overruns and long-standing conflict between RECD on one side and Rudolph and Noyes on the other. Watson wrote to Noyes in 1968:

In the last three or four years it seems to me we have been willing to settle for less than the very top people available—this, because of a bad experience in Fishkill and greater emphasis on cost. [Head of IBM RECD, H. Wisner] Wis Miller tells me that we are still employing the same quality architects that we were striving for in the period 1956 through 1962, and if this is a fact, I am delighted. If it is not, I think you, Wis and I should sit down soon and recast our thinking so that we continue to aim at the very top architects available not only in the United States but throughout the world.[96]

Noyes, who was then constantly embroiled in bureaucratic maneuvering with RECD over securing more money for what he viewed as important commissions, looked on Watson's concern as an opportunity to pressure the division. He replied:

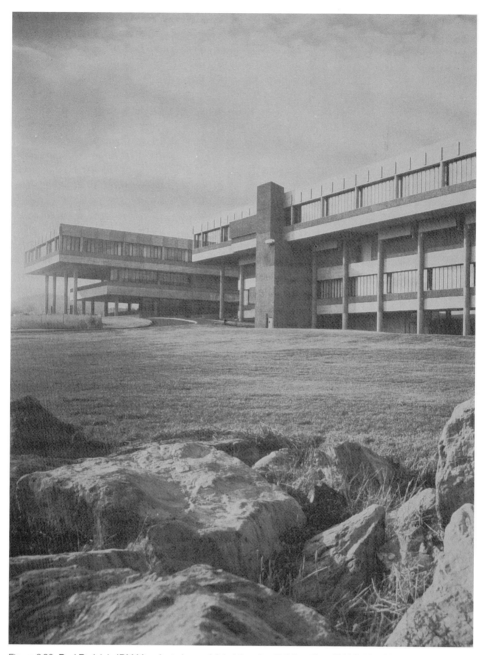

Figure 3.20 Paul Rudolph, IBM Manufacturing and Administration Building, East Fishkill, New York, 1963. View.

I think I can reassure you about the current state of IBM architecture and our selection of architects. There has never been a moment in the program when we have had so many distinguished architects at work on IBM projects. At the moment, as you know, we have work under way by Mies van der Rohe, Marcel Breuer, I.M. Pei, The Architects Collaborative (which includes Walter Gropius), Egon Eiermann in Germany, and always have in mind trying to find the best that we can for the job in hand.[97]

In his private notes and conversations about and with Miller, however, he was much less sanguine. Noyes even went so far as to declare to Eames and Kevin Roche, then at work on a museum project for IBM, that negotiating with Miller and the RECD staff was "like negotiating with North Vietnam."[98] In a letter to Miller about consecutive drafts of the RECD mission statement and architectural guidelines, he was slightly more politic, but nonetheless worried: "I am still concerned that the drive toward low costs may be nudging some IBM architecture below minimums in regard to appropriate character."[99] In short, Noyes was beginning to feel edged out by the boys at corporate; design had indeed become the means of corporate "communicating in parallel," but the process had taken on a life of its own.

His frustrations with his corporate client and collaborators aside—which ranged from the selection of architects to ensuring that RECD employed a sufficient number of designers[100]— what Noyes could not deny was that the RECD program was largely successful by its own standards. Dispatched by Noyes and Swannie to spread the word to IBM World Trade employees about the imperatives of the design program in 1973, an IBM design manager named C. C. Hollister informed his audience that "our industry is much more competitive, technological change is far more drastic, and we are subject to attack from many quarters. . . . A building provides continuity of design and form that helps to bring the company and the community together in a working relationship that is something more than window dressing."[101] This continuity was established through a sprawling network of installations across the globe, as the courtyards of IBM were transformed into a fortress that would withstand the "'Assault' on Fortress I.B.M."

Fortress IBM: The Geography of the Multinational

Before World War II, IBM's foreign subsidiaries produced their own office machines— though all were still based on IBM's patents, particularly the Hollerith patents for punch-card equipment—and some subsidiaries, such as the German Dehomag company, were publicly owned.[102] However, this seeming independence was tempered by the fact that the parent corporation maintained a monopoly on the production of the punch cards, thus retaining ultimate control over the supply of business machines to the various European markets.

After the war, however, IBM significantly changed its strategy. Due to the indispensable role that IBM played, alongside many other large corporations, in wartime production,

its top executives had unfettered access to the highest levels of U.S. military command and to the Truman administration, and thus a bird's eye view of the reconstruction and retooling of Europe's economies under the Marshall Plan. With public ownership of its subsidiaries made difficult by the profound economic collapse and long rebuilding period following the war, IBM re-created its wholly owned American subsidiary, IBM World Trade Corporation, under the leadership of Thomas Watson Jr.'s brother Arthur K. "Dick" Watson. Under the new IBM World Trade, a series of wholly owned foreign subsidiary corporations administered IBM's operations in large regions of super- or subcontinental proportions—IBM North America, IBM Europe (including northern and western Africa), IBM Far East, IBM Near East, etc. In turn, under each of these umbrella corporations were gathered wholly owned subsidiaries, each bearing the name of the country in which they operated—IBM Deutschland, IBM France, IBM Japan, IBM Senegal, etc. In 1952, IBM employed approximately 40,000 people in 86 countries; by 1969, it employed 225,000 in 106 countries. To illustrate their global reach, in 1969 they licensed Buckminster Fuller's patented geodesic globe puzzle design, which was repeatedly featured in the corporate literature.[103]

As Corinna Schlombs has argued forcefully, this dispersed, but only apparently decentralized (after all, in Fuller's world puzzle, the center triangle is occupied by North America), corporate structure in Europe was of strategic value on a number of levels.[104] In many

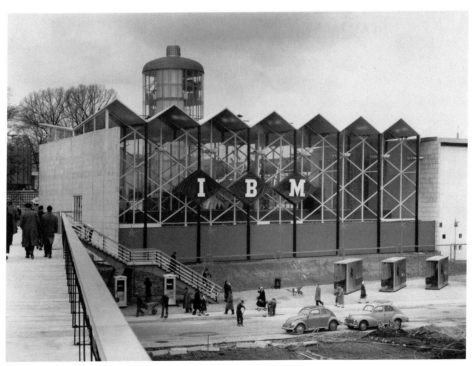

Figure 3.21 Eliot Noyes and Associates, IBM Pavilion, World's Fair, Brussels, 1958. View. Courtesy of IBM Corporate Archives, Somers, New York.

countries, such as France, where multinationals were required to employ only that country's citizens, IBM made maximal use of the limitation.[105] In each country in which it operated, IBM's subsidiaries produced only part of a given computer system; each part would then be combined with other parts produced elsewhere to produce the finished product, ensuring that each subsidiary had access to the whole of an increasingly integrated European market. By 1963, less than one percent of "World Trade IBMers" were American, and its total of 48,250 employees represented over one hundred nationalities.[106] As it had in the United States, IBM attached itself firmly to the state apparatus of each and every country in which it operated—producing the new military computers required by the exigencies of aerial and rocket warfare, coordinating the administrative nightmare of the postwar European welfare state with punch-card machines and eventually computers running sophisticated demographics programs, and managing the vastly increased information processing needs of the various national exchanges—in short, becoming a shadow bureaucracy, a double government wholly interdependent with the state.[107] At the Brussels World's Fair in 1958, Noyes's IBM Pavilion (Figure 3.21), with exhibits designed by the Eames Office, was erected not in the American section of the fairgrounds, nor even in the science and technology section, but rather in the *Belgian* section.[108] The emerging multinational corporation—for IBM was not the only corporation to run itself in this way—thus confounded traditional (and nationalist) geographies: as one set of commentators put it, "if GNP is considered in comparison to a company's annual revenues, then . . . IBM is as large as Norway and Portugal."[109]

Offices, laboratories, and factories situated in each major country would draw on the scientific and labor capital of each economy and work on the all-important task of translating achievements in technology and production and management techniques from other branches of IBM into the patois of their particular environments. On an economic level, this system offered several advantages. IBM built new facilities and reconfigured its existing plants to produce different machine parts in different countries; the parts could then be sent to the locations where they were needed for assembly into whole machines, thus evading the bulk of the heavy tariffs imposed on the import of finished products to Europe. Furthermore, the fact that all of the IBM subsidiaries were wholly owned by the parent corporation meant that the multinational's finances were less susceptible to the turbulence of a given country's stock market, and troubled subsidiaries could be quickly relieved by influxes of American capital. This arrangement, of course, produced difficulties in financing, since IBM was wholly reliant on borrowing or reinvestment for its operations abroad; however, in a business sector undergoing exponential growth, this drawback was relatively insignificant. The important achievement of the restructuring was to give IBM unprecedented flexibility and control over its diverse operations.

In 1958, Wallace K. Harrison and Max Abramovitz, who had led the planning team at the United Nations, set the tone for IBM office design abroad when they completed a new headquarters for IBM World Trade on UN Plaza in New York (Figure 3.22). In stark contrast to the gleaming glass facade of the Secretariat across the street or the open exhibition

Figure 3.22 Harrison & Abramovitz, IBM World Trade Headquarters, New York, 1958. View. Courtesy of Avery Architectural and Fine Arts Library, Columbia University, New York.

windows of its parent corporation's headquarters on Madison Avenue, it was a modest and unassuming building, with a limestone panel facade and small windows, and ornamented only by three IBM digital clocks. The ground floor, perhaps betraying the "holding company" nature of the business, contained no exhibition space, only a small, awkward series of antechambers and waiting rooms.[110] The message was clear: IBM would administer the bureaucratic functions of the reexpanding supranational economies of the West with an invisible hand.

As the French economic geographer Henry Bakis notes in his study *IBM: Une multinationale régionale,* IBM modeled its international presence on the technospatial structure of its products: a CPU, located in Armonk, with an interface in New York City, would manage input and output to and from a series of peripherals. Just as a CRT and keyboard ergonomically represent and allow for communication with the internal workings of the CPU, so the outposts of IBM's foreign subsidiaries would represent the CPU as interfaces that could feed input—in the form of information and capital—back into the system.

These peripherals, centrally managed as they were, could thus be placed discretely (and discreetly) at the very periphery of the corporation's territory without endangering the coherence of its counterenvironmental integrity. When, in 1960, IBM France was instructed to build a new laboratory for free scientific research and the development of new computing systems for IBM World Trade, the corporation had initially intended upon installing it in Paris, near the administrative offices already there on the Place des Vosges. However, the French government under De Gaulle was then pursuing a program of governmental and industrial decentralization—a process linked both to the spatial logistics of military planning and to a desire to quell political unrest through dispersed industrial development—and demanded that IBM locate its subsidiary installation in the provinces. After polling its employees, IBM determined that the Côte d'Azur was the most desirable such location and selected a site near Nice in the village of La Gaude in the foothills of the Maritime Alps. For the commission, Noyes needed an architect comfortable with practicing in France, and thus handed the commission to his former partner Marcel Breuer, who had previously worked on the UNESCO Headquarters in Paris.

IBM demanded a large six-foot module, clear-span interiors for flexible laboratory arrangements, and ample service chases for chemicals, electricity, and telecommunications. Breuer responded with a design that marked a new direction in not only his own architectural practice, but also that of IBM, expressing in particularly elegant fashion the spatial concept behind the architecture of IBM's global telepresence (Figure 3.23 and Figure 3.24). The plan responded to the uneven topography of the site: initially a "Y" shape suspended upon massive concrete columns that had emerged from his earlier UNESCO project, it was expanded to a "double Y" or "H" plan to accommodate an increased workforce and laboratory needs. Breuer, who had in previous years been experimenting with concrete structures, proposed to solve the problem of the clear-span interiors by eschewing the curtain wall and instead developing a structural window-wall

of reinforced concrete elements cast on site in molds and then craned into place. These would be supported by massive cast-in-place "tree" columns and would support the floor and roof slabs independently of those columnar supports.

These two main structural elements, window wall and tree column—which Breuer would use in numerous projects for large buildings in the following years—were derived from a pair of biological, organicist metaphors. On the one hand, the form of the tree column was based in a long familiar trope of concrete construction, perhaps best summed up by a single page from Gyorgy Kepes's *New Landscape in Art and Science,* in which a photograph of the column-and-slab structure of Nervi's Gatti Wool Mill in Rome (1951) is juxtaposed with a photograph of a sheet of glass shattered by the end of a steel rod.[111] The glass breaks in a pattern similar to that of the ribs of Nervi's structure, which prevents this shattering by reinforcing the slab at the "principal isostatic bending moments." Thus, the tree column is a particular kind of "diagram of forces,"[112] a simulation and negation of the invisible forces that would literally tear the building apart. As such, the tree columns represented the invisible continuity of the corporation in its discrete locations.

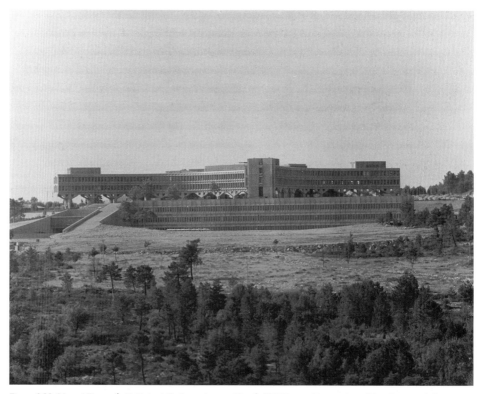

Figure 3.23 Marcel Breuer (with Robert Gatje, project architect), IBM France Research and Development Laboratory, La Gaude, Var, 1961–76. View of completed complex, ca. 1976. Courtesy of Syracuse University Archives.

Figure 3.24 *(facing)* Marcel Breuer (with Robert Gatje, project architect), IBM France Research and Development Laboratory, La Gaude, Var, 1961–76. View. Published in Gyorgy Kepes, ed., *The Man-Made Object* (New York: Braziller, 1966).

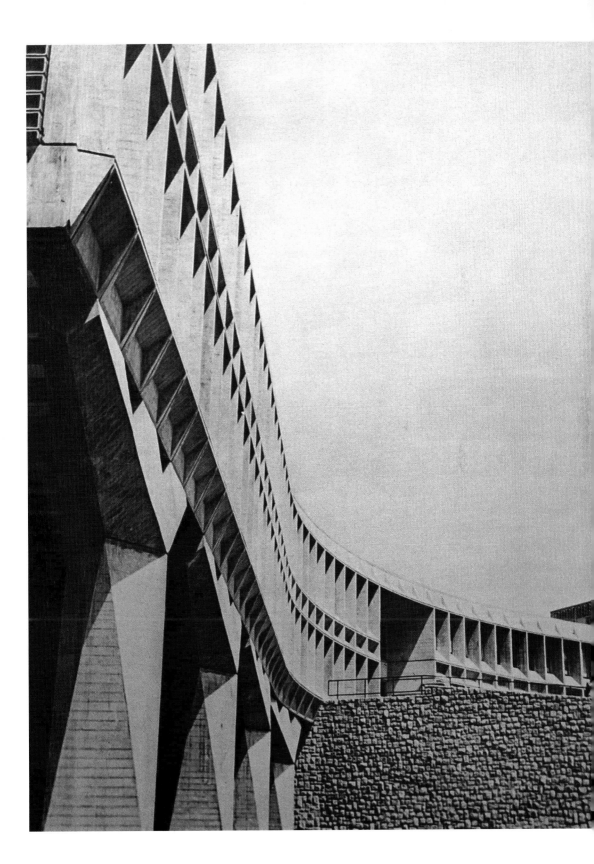

On the other hand, Breuer's description of the modular arrangement of window-wall elements, and indeed of walls in general, as the "skin" of the building reveals that he understood the curved concrete wall as an apposite membrane mediating between interior and exterior. The integration of the technical services of the building with the wall as a counterenvironmental membrane, combined with the structural function of the wall, amounts to an extension of this metaphor: the wall becomes cellular. The form of a cell—following morphologists such as D'Arcy Thompson, to whose *On Growth and Form* Breuer was probably introduced during his time at the Bauhaus, and through his ongoing association with Kepes and his circle at MIT—is created by surface tension that results from the tendency of the atoms or molecules in the cell to pull together into the smallest possible volume, as a result of both interior and exterior forces (gravity and pressure, respectively). A balance, or dynamic equilibrium, is achieved at the edge of the cell—the "bourrelet" or membrane. In the case of cells, the membrane is that point at which the dynamic exchange of energy (and chemicals) between exterior and interior occurs.

The facade of La Gaude, though not literally,[113] is designed to function in much the same way. The walls form the structural membrane of the building, and the services contained

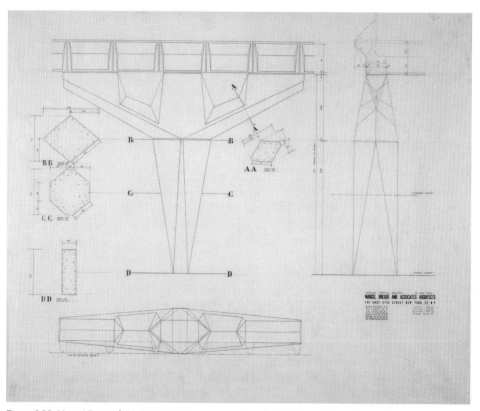

Figure 3.25 Marcel Breuer (with Robert Gatje, project architect), IBM France Research and Development Laboratory, La Gaude, Var, 1961–62. Elevations, plans, and sections of "tree" columns. Courtesy of Syracuse University Archives.

within them mediate the exchange of energy between the interior and exterior: heating and air conditioning, electricity input and output, and communications technologies are all built into the wall (though they are connected to their sources via the portions of the building directly connected to the ground). The figurative elasticity of the membrane is dramatized in the curvature of the facade.

Breuer insisted that the window-wall units gave IBM France employees plenty of light and outside awareness; however, viewed from the outside, the deep concrete facade of the building presents an impression of radical opacity. As Robert Gatje, Marcel Breuer's partner and project architect on the IBM France laboratory, attests, this resulted in a kind of "double" space, disconnected from its surroundings and connected instead to a distant central administrative space: "under French law, the management of IBM France had to be fully staffed by French citizens—even though most of them performed duties all day that had to be approved each evening with a telephone call to their counterparts in New York."[114] This double structure of IBM's corporate space is confirmed by Bakis's study of communications flows within IBM. In its "march towards totally integrated [read: decentralized] production,"[115] radical centralization over an extended space was made possible by new communications technology that eschewed the land-line technology of telegraph and telephone, instead traveling through the air to "cellular" locales. Therefore, it should hardly be surprising that the IBM France laboratory in La Gaude was in fact the site of the first transmission of data between two computers via satellite, receiving a seventeen-minute test transmission from an IBM 1401 computer in Endicott, New York, in March 1962. As the Advanced Systems Development Division assistant general manager, John M. Norton, put it at the time, "The Endicott-La Gaude test puts IBM one step nearer its goal of instantaneous, flawless global communication between computers."[116]

IBM's computers and its buildings were thus part of a rapidly growing communications and production network designed to bypass the traditional boundaries of national market economies, and instead meant to correspond solely to the topologically centralized and contiguous structure of real-time management. As if to concretize this relation, IBM later rehired Breuer's office to design a second H-shaped building complex in Boca Raton, Florida, which was but a variation and elaboration of the previous La Gaude design (Figure 3.26).[117] As Kepes made plain, including illustrations of IBM System/360 computers, designed by Noyes's team at IBM, and the La Gaude lab in his volume *The Man-Made Object* (1966), these machines and buildings were hardly passive conduits for the information economy.[118] IBM buildings such as the La Gaude laboratory were born not only of the patterns of informatics, but also of telematics: each is a fortress or bunker integrated into a broader centralized network of "emplacements" or "installations" (to appropriate Heidegger's term[119]): buildings closed in upon themselves, but only so as to extend the network's control over a wider space lying beyond its (spatially discontiguous, topologically contiguous) walls. Indeed, their integration with what Kepes and his broad network of intellectual allies saw as biological systems at the level of information—or, more specifically, at the level of pattern—was of the utmost importance to the

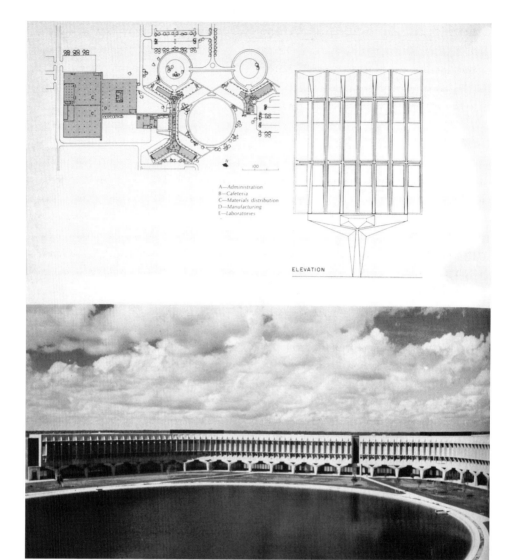

ELEVATION

A—Administration
B—Cafeteria
C—Materials distribution
D—Manufacturing
E—Laboratories

Figure 3.26 Marcel Breuer, IBM Administration Building, Boca Raton, Florida, 1968–73. Plan, elevation, and view. Published in *Architectural Record* 149 (February 1971).

emerging postindustrial economy. At La Gaude, Breuer and Gatje fulfilled IBM's demands for a clear interior span and large six-foot module with a fortress hovering above the topography with the apparent indifference of a crusader castle. These fortresses soon multiplied across Europe.

In 1967, the German architect Egon Eiermann and his employee Heinz Kuhlmann published a study, carried out from July 1965 to December 1966, that they had conducted in preparation for designing an IBM Deutschland administration complex in Sindelfingen, near IBM's campus in Böblingen and close to Stuttgart.[120] The first point stressed by the architects as they reviewed the "Raumprogramm" handed to them by the client was

the need to consider the "technological connections and liaisons."[121] In other words, both architect and client understood the new buildings' interconnectedness to other IBM installations as *the* formative principle guiding the design process. The first image in the book, acknowledged by Eiermann and Kuhlmann as the "formative" basis of the design, is a photograph of a printout from an IBM computer given to the architects by RECD, showing data for square footage requirements and costs.

Taking into account the client's stringent requirements, Eiermann and Kuhlmann's study focused on determining the best between two possible solutions (note the mathematical language) with identical programs and modules: the first, identified as the "Hochhaus-Lösung" or skyscraper solution, proposed a glass-enclosed office tower housing administrative operations and smaller low-slung buildings housing additional offices, a cafeteria, and other services; the second, "Flachbau" or low-rise solution, integrated all of the programmatic elements save the cafeteria into a single enormous four-story building pierced by two symmetrical courtyards. Although both projects show evidence of Eiermann's distinctively attenuated sense of proportion and preference for elegantly thin curtain walls suspended among boldly accented horizontals and verticals, each, in planning terms, also clearly calls to mind previous IBM projects. The skyscraper solution appears to be an emulation of the IBM Holland plant of 1962—exceptional among IBM Europe's buildings—by de Maurik and Pon, while the low-rise solution largely mimics the design of the Armonk CHQ building, albeit at smaller scale (Figure 3.27). IBM RECD, it seems, had commissioned the study to determine which, if either, solution was most compatible with both its representational and practical needs.

Eiermann and Kuhlmann produced highly articulated designs for both projects, compiling pages upon pages of data and sheaves of drawings.[122] The skyscraper solution was clearly the architects' favorite, as it promised a "bolder architectural statement" and an opportunity to experiment with new building technologies and planning techniques,

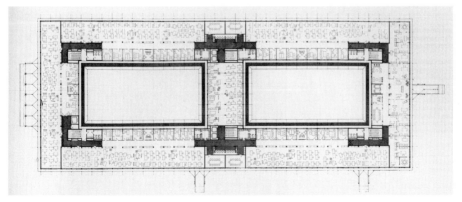

Figure 3.27 Egon Eiermann, proposed design for IBM Deutschland Research and Development Laboratory, Sindelfingen, 1965–66. Plan of the "Flachbau-Lösung" (low-rise solution). Courtesy of Karlsruher Institut für Technologie, Südwestdeutsches Archiv für Architektur und Ingenieurbau, Werkarchiv Egon Eiermann.

and it offered the rare opportunity to build a skyscraper in Germany.[123] Based on the results of the architects' and engineers' study, IBM even indulged them to undertake an additional experiment in conjunction with Siemens-Bauunion GmbH on the possibility of designing a "hanging" curtain wall that would allow the building to be built entirely by a system of cranes. From Eiermann's plans, it is clear that the purported superiority of the "short circulation spaces" provided by the skyscraper solution was due to his preference for the open, flexible *Führungszonen* planning techniques made famous by the Quickborn Team two years earlier, now commonly known as *Bürolandschaft* (office landscape).[124] Compared to the rigid compartments necessitated by the plan of the low-rise building, the free-flowing arrangements of desks appeared to answer the demand for flexibility and functionality of IBM's program. However, after taking into account cost (if the building were to be built with a reinforced concrete frame), technical aspects, speed of construction, and, above all, appropriateness to the client's demands— represented above all by the computerized program read-out—the architects were forced to conclude that the low-rise solution was indeed superior. Although the skyscraper solution appeared to offer greater initial flexibility and a certain fashionable glamour, it could not be expanded without the construction of an entirely new building, whereas the low-rise solution could be expanded easily with contiguous additions built on the same module and preserving the contiguity of the interior. Eiermann and Kuhlmann summed up the report with a statement of near frustration: "For the client [IBM] the building and maintenance costs and likewise the flexibility of the facility were decisive and not the visual effectiveness or impression of the architectonic image."[125] IBM, it seems, in keeping with its desire for a low profile, was less concerned with architectural imagery than with maintaining a topological consistency with other IBM installations around the globe.

The low-rise solution, a near copy of the plans for the Armonk campus, clearly demonstrates the doubling strategy of corporate counterenvironments. This low-rise project was never built; although it is possible that IBM intended to build at Böblingen, it is more likely that the project was what it purported to be—a study. In the year the study appeared, IBM—ostensibly on the strength of his report—gave Eiermann a commission to design and build a real administrative headquarters in the nearby suburb of Stuttgart-Veihingen (Figures 3.28 and 3.29).[126] IBM again demanded a low-rise solution. After experimenting with several possible configurations, and again reminding the client of his preference for a configuration of skyscrapers,[127] Eiermann obliged the corporation by designing a series of what he termed "pavilions," which combined some of the planning advantages of his earlier skyscraper design with the expandable low-rise courtyard buildings preferred by IBM. The pavilions, arranged on a modular grid not only within themselves, but vis-à-vis one another, in turn formed a controlled courtyard between them. The seemingly irregular pathways and landscaping between the buildings, as the plan clearly shows, are in fact thinly disguised products of the orthogonal and regular geometry of the buildings' module. Dug out and threaded through the irregular topography of the site, all the paths turn at right angles, and any deviation from the straight line is eventually corrected by the end of the path. Although only three pavilions were eventually built, with an additional free-

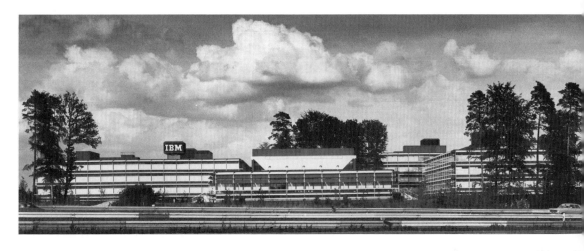

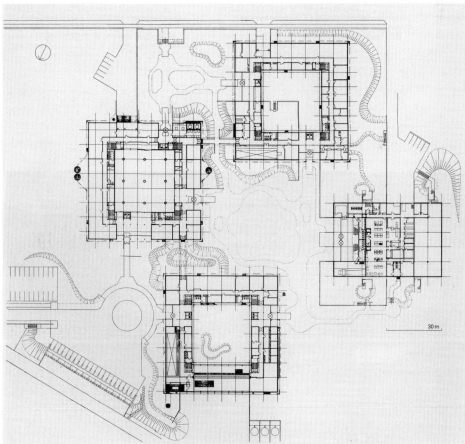

Figure 3.28 Egon Eiermann, IBM Deutschland Research and Development Laboratory, Stuttgart-Veihingen, 1967–72. View. Photograph Horstheinz Neuendorff, Baden-Baden. Courtesy of Karlsruher Institut für Technologie, Südwestdeutsches Archiv für Architektur und Ingenieurbau, Werkarchiv Egon Eiermann.

Figure 3.29 Egon Eiermann, IBM Deutschland Research and Development Laboratory, Stuttgart-Veihingen, 1967–72. Site plan. Courtesy of Karlsruher Institut für Technologie, Südwestdeutsches Archiv für Architektur und Ingenieurbau, Werkarchiv Egon Eiermann.

standing cafeteria arranged on the same module, Eiermann and IBM planned for future expansion, to be accommodated by dotting the landscape with additional pavilions, in a potentially infinite process of rationalizing the surroundings.

Perhaps most strikingly, rather than the hanging sun-shades of his earlier skyscraper design, or the concrete and steel shades of his low-rise design, Eiermann developed a system of movable external blinds—"according to the wishes of the client"[128]—that could entirely close off the interior from the visual stimulus of the world outside. As Eiermann had stressed, it was the connections that mattered, and these connections over distance were built out of a pure interiority, not of any conventional view.

This courtyard-fortress architecture, this discrete but contiguous space, became the rule for IBM's emerging and now truly global presence. For example, an IBM building in Havant, UK, commissioned from Arup Associates in 1966 (Figure 3.30), was originally intended as a computer manufacturing facility, planned as a response to the overwhelming need for production capacity in the wake of System/360's early success. The following year, however, the commission changed; IBM concluded that it needed not additional factories, but rather a rational system of managing its far-flung manufacturing apparatus. The commission was thus transformed into a "building to house a computer": the RESPOND (Retrieval, Entry, Storage, and Processing of On-Line Network

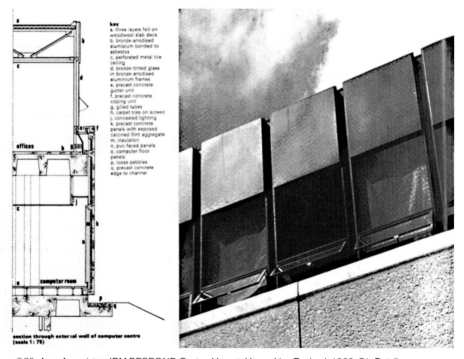

Figure 3.30 Arup Associates, IBM RESPOND Centre, Havant, Hampshire, England, 1966–71. Details and section of concrete panel wall.

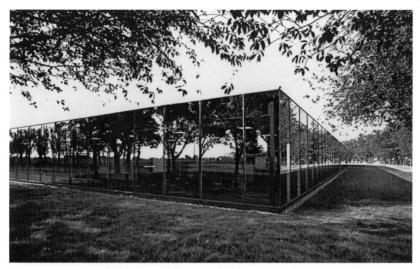

Figure 3.31 Foster Associates, IBM Pilot Head Offices, Cosham, Hampshire, 1973. View.

Data) Centre, which was to be operated by a wholly owned subsidiary—IBM Information Services Ltd.—that would coordinate "the information needs of all the IBM plants throughout the world."[129] Later, similar-looking warehouse facilities were added, but the centerpiece of the complex was the building to house the computer administering a real-time management of IBM products and facilities. Given the proximity of the building's program to that for a standard Noyes-designed IBM computer, only its scale is surprising. Wholly blank on the exterior, it is clad in gigantic concrete panels, which conceal the structure behind and are held in place with recessed black steel joints (analogues of the feature strips of the System/360); the only windows are of heavily tinted glass at the very top of the building. These provide no views, only a diffuse "natural" light falling on the computer's attendants from above.

The building, one begins to suspect, is little more than a large-scale realization of the computer, and the suspicion is confirmed by a second building designed for IBM by Foster Associates in Cosham, near Portsmouth, of 1972–73 (Figure 3.31). This office building was intended as a temporary installation, and IBM had originally intended to simply commission a builder to produce a tilt-up shed for a computer and approximately one hundred employees. However, it appears that Noyes and Foster approached IBM with a promise that Foster's design would deliver a superior product at lower cost and prevailed upon RECD to experiment.

The mirrored bronze glass facade of the Cosham building, affixed to the structure at the highest and lowest possible points with composite gaskets, caused the building to vanish into the landscape in a play of reflections to the extent that the Italian journal *Domus* referred to it as an "I.S.O. (Invisible Standing Object)."[130] All that remained was a lattice of thin lines of black steel, left as register of the delineation of a modular enclosure. On the

interior, the building was an entirely open plan, with temporary and moveable partitions segmenting managers' office spaces. Electricity and telephone lines ran from boxes suspended around the slender steel columns, and telephones and office appliances were often simply laid on the floor. The computer room was given the only permanently installed division, a glass wall surrounding a raised one-foot plinth or dais that barely concealed the cooling and electrical systems below. One critic, comparing the purist and technocratic rigor of the building's detailing on the exterior to the relatively lackadaisical layout of the building's interior, labeled it "not an architectural setting, but an 'environment' . . . a tent."[131]

The two IBM buildings in the English exurbs demonstrate the catastrophic slippage between building and object that is engendered by their reductivist modular logic. The relation that Noyes sought to solidify between the "typewriter with ideas above its station" and its "environment" becomes concretized as homology—and this to the point that the baffled architectural critics writing of both buildings seem to lack either a proper taxonomy or vocabulary appropriate to their task of evaluating both building and industrial design. Writing of the Cosham building, *Architecture Plus* proclaimed in wonderment:

How unlike a building this is! It has no top and no bottom and nothing very much in between. . . . It is much more like a super-refined piece of very sleek industrial design. . . . It is, in short, just about the finest piece of industrial design to be found, this year, in IBM's inventory of exceedingly well-designed products—and that is high praise indeed. . . . It is . . . a non-building—a scientifically accomplished enclosure of great serenity, in which those who work here count for more than the man-made container.[132]

If the IBM building is always already an IBM computer—which, as we have seen, is an apparatus composed of both machines and operators—and vice versa, this is only possible by virtue of their shared property: IBM. Just as the Bombes and Colossi of Bletchley Park could decode German signals only because those signals too had been made by (Enigma and Siemens) machines, the discursive machine (corporation) that is IBM precipitates the collapse of both computer and architecture into like discursive machines. The paradoxical statements of which IBM is constituted—knowledge is modular; number is order; the future is the past simulated in the present; etc.—drive the already unstable distinction between types of objects into a field of topological equivalence for which architectural and industrial design theory seem to have no answer. Rather than the Miesian "almost nothing,"[133] we are here confronted with an "almost everything." In Noyes's hands, however, this universal modularity began to take on a precisely articulated form.

The Black Box in the White Room

In 1978, Simon Nora and Alain Minc published their shocking report to the French president titled *L'informatisation de la société,* in which they asserted that French

sovereignty was severely threatened by its dependence on foreign multinationals for that most precious of commodities, information.

Telematics ... changes the stakes of sovereignty. The first large French computers were the result of a desire for military independence. Seeking autonomy, the public powers have gone on promoting the computer industry. . . . Today, the game is no longer played exclusively in that arena.

[We have] to take into account the renewal of the IBM challenge. Once a manufacturer of machines, soon to become a telecommunications administrator, IBM is following a strategy that will enable it to set up a communications network and to control it. When it does, it will encroach upon a traditional sphere of government power, communications. In the absence of a suitable policy, alliances will develop that involve the administrator of the network and the American data banks, to which it will facilitate access.[134]

But of what did the "IBM challenge" consist? How did telematics threaten—or at least "change the stakes of"—sovereignty? Certainly previous information or teletechnologies (railway, telegraph, telephone, television, etc.), controlled—even in France—by private firms, had previously impinged upon any putative state monopoly on communication. Nora and Minc are anything but clear on this point; their report continues to outline a series of policy proposals for reinstating public control over information technology through the use of public–private partnerships, the passage of new laws forbidding monopolies, and so on.

In the following year, however, Jean-François Lyotard published his equally shocking meditation on *The Postmodern Condition* for the Quebecois government, asking questions regarding the implications of the computer and the new levels of abstraction achieved by corporate capital. Not coincidentally, he concluded his opening barrage with the following example:

Suppose, for example, that a firm such as IBM is authorized to occupy a belt in the earth's orbital field and launch communications satellites or satellites housing data banks. Who will have access to them? Who will determine which channels or data are forbidden? The State? Or will the State simply be one user among others? New legal issues will be raised, and with them the question: "who will know?"[135]

Here Lyotard, with characteristic acumen, points out clearly that it is not just the invisibility of the mechanisms controlling information and its deployment in space that is at issue; rather, it is also a question of "who will know." The abstract subjectivity of the computerized corporation—a subject not localizable (thus Lyotard's example of a satellite in orbit, rather than an installation on the ground) in conventional terms—may appear in numerous places at once, interpellating each state independently.

Despite the fact that both the Nora/Minc and Lyotard reports make note, if only in passing, of the fact that IBM was now occupying not only international territories and economies

but, as we have already seen, outer space as well, neither is willing to dwell for very long on the specifics of the technologies, how they are used, how they occupy and control space, or even the fact that, for all intents and purposes, the futuristic scenarios that they most sought to foreclose had already come to pass. They are both content to acknowledge that the question of who or what IBM is lies well beyond the capacity of descriptive language. Therefore, missing from both reports, despite their many merits, and missing, by and large, from architectural history are serious efforts to understand the spatial realities of the multinational.

The consequences for architecture of investing a diffuse system of industrially produced objects with knowledge—more precisely, a specific and constructive form of knowledge designated by the term logic—are thus profound. The semiautonomous and semiautomatic subject called the computer, by reducing all aspects of space to an environmental relationship between territory and counterenvironment, forces the architect (or designer) to reconceive architecture as a set of purely technological occlusions. Yet that this becoming-technical of architecture, as we have seen already and will further explore in the next chapter, cannot escape its representational status or function—as a figure of knowledge, as an ordering system, as a metonym—becomes increasingly evident.

To understand the significance of this representational status, we must return again to the experimental site of Noyes's and IBM's struggle to define the spatiality of computing: the white room. That the blankness of the white room was not abstract, but rather precisely and radically confronted the limits of representation, is illustrated again and again in company literature. Indeed, the white room became the icon of informational space, and therefore of IBM space. Perhaps most striking in this regard is the IBM Military Products Division's traveling exhibition—first mounted at the first World Congress of Flight in Las Vegas in 1959—on "Systems of Tomorrow." The centerpiece—the "focal point," as a description of the exhibit in *IBM Business Machines* put it—was

an eight foot "space ball." The huge white ball presented viewers with a free "trip" through the vast reaches of outer space. Peering through the aperture of the sphere, observers witnessed a finely detailed space ship on an interplanetary mission. As the ship sped among the celestial bodies, clouds of meteoroids, wisps of cosmic dust and flurries of natural satellites hurtled by. All of the cosmic phenomena were reflected in various hues of violet and ultraviolet light. Weird space sounds added to the illusion of flight.

The impression of flight through space inside the sphere was attained by special effects, rotating mirrors and hidden light sources.[136]

A perspectival and aesthetic inversion takes place with computing technology that transforms environment into counterenvironment, even as it seeks to confound the two by erasing the fact of their difference. One peers into the "space ball" in order to look further outward than one could possibly see—the simulation inside is a visionary prosthesis.

The gridded screen of IBM's architectures—whether CRT or window wall—bars access to the visual every bit as much as it replaces it with new organs of vision. Space, whether rendered by the traditional mechanics of perspective or through the pseudo-Archimedean point of teletechnology, becomes "special effect."

This is precisely why the white room is not an a priori entity; it cannot be mistaken for a simple boiling down of architecture to an original state, a diagram, a blank lattice. Though it is indeed reductive, it is reductive only in the conceptual sense of an ideal space of pure occlusion—that is, that it excludes all that is external to the space inscribed by or absorbed by the lattice. It is important to recognize that the white room was built up—it was placed in and around territory, rather than carved out of it. One only has to jux-tapose early photographs of less rigorously modular computers—for example, Noyes's own RAMAC—with the later modularity of a System/360 white room to witness the absence of the grid, and the semitransparency of both computer and spatial relations that pre-vailed before the white room came into existence. The RAMAC, despite its significant advances in abstraction and ergonomics, still has a definite spatial orientation, wrap-ping around the user and clearly revealing its insides. Just a glance at the System/360 white room, let alone a SAGE blue room, reveals a completely different state of affairs. Many of the modules seem to have neither front nor back, and the singular surfaces with which the human components of the man–machine system work may be oriented in any direction—360 degrees, as it were.

As a result of its mass-reproduced ubiquity, through ads and literal white rooms built in office buildings to house computers, the white room became the popular image of computerized space. As early as 1957, a Hollywood film—Desk Set, starring Spencer Tracy and Katharine Hepburn—exploited (and mildly satirized) fears about automation by using actual IBM machines (an 858 Cardatype, a wooden model of a 407 Account-ing Machine, and an 026 Card Punch) and the expertise of its engineers.[137] Later films, such as Sidney Lumet's cold war drama Fail-Safe (1964), George Lucas's THX-1138 (1971), and more recently, the Wachowski brothers' The Matrix (1999), all figure the space of information technology as a white room, wholly enclosed and unbound by the rules of traditional perspective.

The white room has remained an icon, an imaginary ideal. It is only recently that IBM finally realized its original dream of entirely reorganizing itself around the logic of teletechnology; in 2005 it jettisoned its personal computer manufacturing and retail concerns in order to redesign itself yet again as a truly postindustrial entity, engaged only in research and the management of other businesses through teletechnological administration and consulting. It should hardly be a surprise, then, that its public image is that of the white room. In the corporation's recent television advertising, it figured itself as a friendly person at a (now old-fashioned) office desk, the "Help Desk," that alternately appears suddenly in a blank white room or at random in any place in real time—for example, a sheep ranch, a highway shoulder, a bank vault—wherever information technology, via logistics, helps

to control what it repeatedly labels "the business environment." The commercials, each devoted to a single theme (but many customers), treat "security," "inventory control," "networking," etc., and illustrate in allegorical fashion how IBM and its technology is utterly unbounded by place, unrestricted by distance or remoteness, and empowered to animate even inanimate objects. (One ad shows the Help Desk obstructing a highway, stopping a semitruck and redirecting it because the modular boxes in the cargo container, tracked by satellite, can tell the driver that they are headed in the wrong direction.)

It is more than evident, then, that these geographies and computer architectures—both von Neumann's concept and the physical architectural artifacts discussed here—did not emerge as a product of computer-aided design (CAD); on the contrary, they produced CAD as a kind of symptom, a result, an ergonomic solution.[138] The closure of the module, transposed from computer to architecture and back again, is both logical and spatial, and the destruction of perspective through the radical extension that results is of the utmost consequence for assessing the disciplinary assumptions of computerized multinational architecture. Nowhere is this more evident than in the white room itself. The blank space defined by the lines of the grid appear irreducible, but a closer look reveals yet a smaller grid in the structure of the computers themselves; look yet closer, and we see this image pixelate yet again into a field of ordered electrons. In the white room, modular architectural space suddenly reveals itself as both metonymy and synecdoche—scale has become immanent and essential to the point where size and distance no longer matter, only pure enclosure. The pattern of the electrons, arranged as they are in their Boolean way, reach outward and inward, determining the structure of enclosure after enclosure.

Only twelve years after the inception of the IBM Design Program, Noyes developed yet another set of architectural images of counterenvironments that could withstand and expand into an even more hostile environment when his office was hired as design consultant to Stanley Kubrick's *2001: A Space Odyssey* (1968).[139] The film is a rather ham-fisted but nonetheless deeply ambiguous parable about the confrontation of "Man" with technology, from the first deadly club to the contemporary crisis of thinking machines, moving from the desolate primordial wasteland to the utter void and abstraction of outer space.

Read as such a parable, Kubrick's film is essentially a document of a perceived environmental crisis. From the film's space shuttle, equipped with a modified version of Noyes's executive plane service to allow efficient eating in zero gravity, to the space station, decked out with Herman Miller furniture hand-picked by the Noyes office, to the computers and space suits designed by IBM engineers and their ever-present architectural consultants, *2001* presents, even fetishizes—with all of the paranoia implicit in the fetish—counterenvironmental technology. The plot of the film is quite simply the acceleration of technology to the point at which its nature as pure war is made explicit. In the film's concluding sequence, the astronaut Dave Bowman (the juxtaposition of weapon and man in his name should not be missed) emerges from the self-preserving environment of a spaceship that has been rendered uninhabitable by the hostile subjectivity of the

thinking machine HAL (a computer-actor named by transposing the letters of IBM one alphabetical place). With the rest of his crew (including HAL) now dead and protected only by a pod—or what the National Aeronautics and Space Administration (NASA) would call a module—Dave proceeds regardless to the destination of the mission, a massive monolith left behind by an alien intelligence on one of Jupiter's moons. Arriving at the monolith, he shoots through psychedelic space at several times the speed of light. But where does he end up? Isolated in a white room, fitted with a minimal and surreal Louis XVI décor, aging rapidly, and haunted by specters of human technology that can be seen only as extensions of himself.

In Arthur C. Clarke's paranoiac novelization of the film script (originally coauthored with Kubrick), Dave's encounter with the alien perception of time and space thus allows him to leave behind the limits of the human body, "evolving" into a more "abstract" intelligence, a great logical "lattice" that is one with space and matter itself. In this last great evolutionary step, the representational aspect of human thought literally becomes presence itself. This "Star-Child" returns back to earth just as thousands of nuclear ICBMs are halfway to their intended targets.

A thousand miles below, he became aware that a slumbering cargo of death had awoken, and was stirring sluggishly in its orbit. The feeble energies it contained were no possible menace to him; but he preferred a cleaner sky. He put forth his will, and the circling megatons flowered in a silent detonation that brought a brief, false dawn to half the sleeping globe.

Then he waited, marshaling his thoughts and brooding over his still untested powers. For though he was master of the world, he was not quite sure what to do next.

But he would think of something.[140]

The Star-Child's moment of indecision and ambiguous behavior—surely the warheads detonated in the atmosphere kill millions?—in the face of the technology that had sent it on its journey in the first place, at the very height of its evolutionary-technological development, might be read as analogous to IBM's own incredulity at finding itself so besieged when it had built the siege engines itself. We might say, with Samuel Weber, that IBM should have known better: "The more technics seeks to *place* the subject into safety, the less safe its *places* become. The more it seeks to place its orders, the less orderly are its emplacements. The more representational thinking and acting strive to present their subject matter, the less the subject matters."[141] As we shall see, IBM's humanistic self-image—embodied in such slogans as "Mathematics Serving Man"[142] —could hardly withstand the rapidly multiplying contradictions that its very own mathematics had unleashed on such quaint notions as "man." Resolving these contradictions—or, at least, holding them in a productive tension—fell to the final components of the IBM Design Program: exhibitions, films, and spectacles.

Chapter 4

Naturalizing the Computer:
IBM Spectacles

Everything in the circus is pushing the possible beyond the limit—bears do not really ride on bicycles, people do not really execute three and a half turn somersaults in the air from a board to a ball, and until recently no one dressed the way fliers do. . . . Yet within this apparent freewheeling license, we find a discipline which is almost unbelievable. . . . The circus may look like the epitome of pleasure, but the person flying on a high wire, or executing a balancing act, or being shot from a cannon must take his pleasure very, very seriously. In the same vein, the scientist, in his laboratory, is pushing the possible beyond the limit and he too must take his pleasure very seriously.

Charles Eames

Human and Machine in Tension

The strategic deployment of architectural installations discussed in the last chapter had a number of consequences for life and knowledge outside of IBM. As early as the beginning of the design consultancy in 1956, Noyes and his fellow advisors (Nelson and Eames in particular) began to work systematically toward a solution to the problem of how to design the interface between the architectural presence of the corporation and the various governmental, corporate, and individual consumers of its products and services. Noyes's redesign of the showroom on Madison Avenue in 1954 had set at least some of the initial ground rules. The old lacquer and gold curlicues of Watson Sr.'s IBM were swept away, replaced with sleeker, modern forms; however, more important was Noyes's overall restructuring of the exhibition space around a particular form of spectacle. Replacing the stuffy atmosphere of the ocean liner with an open, modular gridded space visible from the street through large plate-glass windows, Noyes set the computers on a stage. The room was brightly lit and painted, and the computer technicians uniformly and crisply dressed to match the iterative and modular design of the computers themselves, dramatizing the reciprocity between, and indeed unity of, both in a productive system. Though visible, the drama of the computerized space of the showroom was further rarified by the actual separation of the viewer on the street and the customer in the lobby from the action taking place inside. Of a piece with IBM's business model, following which customers could rent time on the company's computer to run their own programs but could not actually use the computers themselves, the showroom window operated as a selective membrane mediating between the potential consumer and the consumed process (as opposed to a consumed object).

This trope of staging IBM's corporate identity—that is, this method of placing IBM's products and activities within a rarefied but visually accessible space—became one of the conceptual bases for IBM's subsequent, systematic attempt to address itself to a broader public. On a certain abstract level, it was an extension of the logic of ergonomics that Noyes and Eames had deployed in their earlier designs and would later extend to the design of the computers themselves, as we have already seen. However, it could only serve as a conceptual base, since the specific modes and techniques of design would, of necessity, vary according to the context (and available capital).

As the design consultancy gained momentum following Noyes's initial efforts in 1956—with the design of the Poughkeepsie, Rochester, and San Jose campuses, in particular—several pressing problems arose that demanded further research into the problem of improving IBM's ability to communicate its function to a broader audience. Facing increased scrutiny from the judiciary branch concerning its monopolistic practices and the growing fear among the general public that the computer constituted a challenge to the sovereignty of the human individual, IBM required a set of tools with which to communicate a message—importantly, a message yet to be determined—about the unquestionable moral, technological, economic, and social good that the computer represented.

This last was a serious problem, since the public understanding of the computer was anything but universally genial. Since Edmund C. Berkeley published his heady exposé *Giant Brains, or Machines That Think,* in 1949, and in scientific writing (whether fact or fiction) well before then, the specter of a machine that could mimic the activity of the human mind had haunted experts and laypersons alike.[1] Fear and doubt reigned supreme: of unbridled technocracy, of "depersonalization," and, above all, of the possible threat that the computer presented to a received humanist tradition (i.e., can a machine be said to "think"? And if so, does it think "better" than a human being?). In short, the world once wondered: What would a computerized world look like?[2]

As we have seen, IBM recognized early that its problem of creating a mass market for computers was thus also one of visuality, space, and experience. To solve the problem, it turned to the experts: architects, industrial designers, and graphic artists. However, both the public image of the computer and even the way it was understood by experts were anything but certain. Watson and his team of designers were directly involved in what one IBM engineer, Homer Sarasohn, called "the design battle": a constant struggle to establish control over the public image of the computer.[3] We have seen how IBM's early efforts in graphics, machine design, and some exhibition designs walked a tight-rope, carefully balancing a desire to appear futuristic and exciting with a simultaneous attempt to naturalize both the concept and practice of data processing. This balancing act continued throughout the 1960s, as IBM gambled everything on its ability to integrate the computer with the most basic aspects of business, government, military planning and practice, and even everyday life.[4] As late as 1970, Noyes hosted an IBM Design Conference at his family's summer homes on Martha's Vineyard, at which they discussed how to overcome the public perception that computers were being employed to negative ends. In a memo to the attendees, Noyes attached a photostat of a clipping from the *New York Times* describing Ralph Nader's speech at the twenty-fifth annual Association of Computing Machinery conference, in which he demanded an "Information Bill of Rights" because the computer was "exclusively in the domain of corporate and governmental control" and was "leading to a significant kind of tyranny."[5] During the antiwar demonstrations at American universities in 1968 and 1969, students had publicly burned the IBM punch cards containing their registration information in protest against "the Machine."[6]

In the same year as Noyes's anxious conference, Lewis Mumford published the second volume of his erudite and exquisitely paranoid book *The Myth of the Machine,* which attempted to historicize and prophesy an ongoing technocultural crisis of epic proportions. The chapter of the book diagnosing the evils of "Mass Production and Human Automation"—the first section of which lends the volume its title *The Pentagon of Power*—comes to its climax by identifying IBM as the contemporary symbol, par excellence, of the encroaching opacity of military-industrial technocracy. A "recalcitrant IBM employee," it seems, had forwarded Mumford a technocratic manifesto by the management guru Leslie Matthies titled the "Systemation Letter," which aggressively applied the logic of

information processing to human organization.[7] It's slogan was "Deviation from the System can destroy control."[8] As if this was not terrifying enough, Mumford noted that the IBMer had included with the letter "an IBM punch card on which a single word was written—'Help!'"[9]

Mumford concludes the chapter with a perhaps too ingenuous reference to that great turn-of-the-century satire of the machine age, Samuel Butler's *Erewhon* (a favored text of both Mumford and IBM); however, since even Mumford, in his wide-ranging rants, never strayed too far from his home turf, the ultimate stakes of his critique were in the end made powerfully clear. Quoting the prophet Isaiah on "perversity and blindness," he scolded the technocrats and his readers alike by reminding them of the primacy of aesthetics in such matters: "Ye turn things upside down! Shall the potter be counted as clay? That the thing made should say of him that made it, He made me not; or the thing framed of him that framed it, he hath no understanding?"[10] Mumford illustrated his damning analysis of the inversion of subjectivity and objectivity within what he called "Computerdom" (Figure 4.1) with a provocative comparison of two images: a photograph of an exhibition of "post-painterly abstraction" at the Lawrence Rubin Gallery in New York directly above an IBM photo of a System/360 installation. In the caption he wrote:

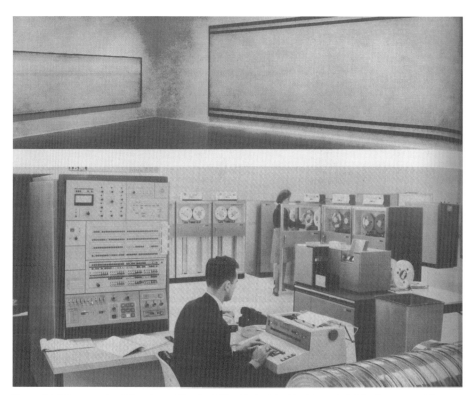

Figure 4.1 "Computerdom," from Lewis Mumford, *The Myth of the Machine,* vol. 2, *The Pentagon of Power* (New York: Harcourt Brace Jovanovich, 1970).

The utter absence of innate subjective potentialities in the computer makes the contemporary art exhibition shown here (top), in all its pervasive blankness and artful nullity, an ideal representation of its missing dimensions. Those who are so fascinated by the computer's lifelike feats—it plays chess! it writes "poetry"!—that they would turn it into the voice of omniscience, betray how little understanding they have of either themselves, their mechanical-electronic agents, or the potentialities of life.[11]

Of course, Mumford's dismissal of abstract painting is as irresponsible as his prophetic claim to "understanding . . . the potentialities of life" is condescending; moreover, his declaration of the computer's total lack of subjectivity reads as a hyperbolic and anxious refusal. However, by making the comparison he nonetheless intuitively grasps at (even if he misses) a key point—the very same point that Noyes and Eames would stress as a solution to the problem of the public's refusal to embrace the computer (both literally and figuratively). The successful integration of the human being with the computer—that is, the naturalization of the computer—hinges on experience. While, as he writes, "the computer is limited to handling only so much experience as can be abstracted in symbolic or numerical form, it is incapable of dealing directly, *as organisms must,* with the steady influx of concrete, unprogrammable experience."[12] The converse of this statement, one might assume, would also hold true for Mumford: The "organism" or human being is incapable of dissolving its experience entirely into abstractions. The "pervasive blankness" of the white rooms, enclosing both painting and computing, thus makes possible a paradoxical operation on both human and computer subjectivities, transforming them into a productive apparatus in which both human and computer deny and affirm their status as objects and subjects. The fundamental uncanniness of this new aesthetics is therefore unavoidably central to IBM's own aesthetic project, regardless of how many comforting affirmations issued forth from its Public Relations offices.

Following Eames's lead, IBM and its consultants insisted over and over again that overcoming the pervasive fear of the aesthetic inversion performed by the computer was a matter of communication; but what, exactly, was being communicated? On this point, surprisingly, IBM itself was anything but clear.

The lack of clarity was not for a lack of effort. In 1965, IBM appointed two new managers to its Promotional Services arm, I. J. "Zeke" Seligsohn and Lynn Stoller, and gave them the task of developing a seminar that would reintroduce the computer to its customers in industry and to "the opinion leaders of the U.S."[13] The daylong course, which became known within IBM as the "NYC Seminar," was held in the corporate offices at 590 Madison Avenue. As outlines preserved in the Eames Collection at the Library of Congress attest, the seminar aimed to begin from scratch.

Three presenters—the director of education at IBM, Charles De Carlo, an IBM salesman named John Worthington, and Joseph Weizenbaum, a computer researcher from MIT—guided the audience through a multimedia presentation that began with two films

(Charles and Ray Eames's *The Information Machine: Creative Man and the Data Processor*, discussed later in this chapter, and part of an IBM program produced for television explaining the relevance of the ideas of José Ortega y Gasset to understanding modern information technology)[14] "that demonstrate our deep involvement in the environment of technique, and [try] to understand how we got there from the environment of nature. The answer is man's ability to name and classify and reason, and employ a kind of *scientific inner vision* which has enabled him to impose a chain of order through his world."[15] In short, De Carlo argued that the means to knowledge about nature was to turn one's attention away from the natural world and toward the artificial structure of technology. Just as it was more effective to hunt German U-boats by decoding Enigma machines in the laboratory than to chase them around the Atlantic, the scientist and layperson alike would need to circumscribe their attention within the confines of the computer interface if they aimed to understand what lay beyond.

Then, using a slide show on the cathedral at Chartres, De Carlo delivered a five-minute lecture on Western epistemology, ranging from "the fixed, ordered, purposeful world of Aristotle/Aquinas . . . to the fission plants of the 20th Century." As the notion of a "divinely arranged universe" came under assault from the relativizing discoveries of Copernicus, Kepler, and Galileo, "old values were dissolving in a sea of swarming figure facts, and the world needed a new architect of the universal." This figure, De Carlo announced, was Newton, who "put the world back together again. It was now a vast machine, knowable and predictable." Newton's discoveries and laws, he continued, made possible new theories of "politics (Locke and Hobbes), economics (Smith and Marx), and in the emerging life-sciences (Darwin and Freud)."[16]

The summary, if schematic, was reasonable and unremarkable enough as a stock narrative of the history of scientific knowledge. However, its purpose was to introduce a profoundly disquieting problem. At the end of his sweeping talk, De Carlo surrendered the floor to Weizenbaum, who offered a demonstration on his activities at MIT, which included "a seemingly ultimate outpost of Newtonian progress—a psycho-therapeutic interview of a troubled young girl by a computer."[17] This psychotherapist was in fact a "Turing Test" program named ELIZA, capable of asking and answering selected questions by reversing the syntax of text entered into it by a human subject.[18] With this radical gesture, the stakes, if not the outcome, of beginning the seminar with Aristotelian epistemology and its Newtonian reformulation thus become clear. The computer, and the attendant theories and instrumental needs that it made possible, again placed the human being at the edge of a new frontier, in which the stable epistemological structures of the Newtonian era would be again dismantled and in need of reconstruction. The remainder of the seminar, devoted to a description of the computer in terms meant to restore said stable structure, therefore posited IBM as the agent of this reconstruction—the viewers, once shocked, could now relax; everything was well in hand. Or was it?

The computer, the presenters explained, is "a machine that can't be explained by any simple comparisons with our own muscles. It seems instead to imitate certain processes of the human mind. Thus we begin to describe the computer, not as a giant mathematical calculator, but as a *language and logic* machine. Indeed it has become a machine that even seems to be able to sense the world around it [via transduction]. . . . We note that all this information is public, as opposed to private human perception. We underline the point by amassing public data concerning roses (vitamin symbols, genetic charts, production data) on several big screens, and observing that all the data put together can't make a rose."[19] (In short, De Carlo appeared to be arguing against Turing, who would have aggressively and consistently asserted that the data *is* the rose, unless one can see the difference.) Then, in a completely counterintuitive and contradictory move, the presenters assured the visitors that the opposite was true: reality was a mathematical "construction of the creative scientific mind"; "facts," like the rose data, simply needed to be assembled more completely—via the "power" of mathematics—in order to viably predict and produce realities worthy of the name. From here, the presenters took "a few minutes to show that the scientific process actually works," by showing examples of how modeling has allowed the creation of various useful technologies. "At the same time," however, they were careful to "caution against blind faith in the scientific process, recalling the collapse of the Tacoma bridge. It's time for lunch."[20]

In the afternoon, such rapid equivocations multiplied. As slides of the medical simulation computer SIM-ONE flashed across the screen behind them, the presenters asked the seemingly rhetorical question:

Can man really be regarded as a machine[?] We ask Dr. Weizenbaum. . . . He reduces the computer to a bundle of wires and germanium dust, and pretty well proves that any life-like qualities ascribed to the machine are purely an illusion. . . . The point is clear: The noblest machine in all of nature is the human brain with its trillion neurons, and we don't even have a *theory* as to how it's wired.[21]

This final equivocation is astounding. After defining thought at the outset as a logical process utterly reproducible by the computer, and providing numerous examples that sought to blur the difference between human being and machine to the extent that computers were shown even mimicking specific organic life processes, and just moments after a demonstration meant to "pretty well" prove that "man" is not a "machine," the presenters explicitly identify the human brain as a "machine." However noble that machine may be, this habitual metaphor renders the conclusion of the entire daylong seminar hollow: "The computer is a tool that has become quite convenient and useful in the process [of extending our organizations], but it is only a tool. And so the real danger is not that computers will exercise control over organizations, but that men may begin to act like computers."[22] One imagines that IBM's seminar participants left the seminar just as, if not more, perplexed than they had been before lunch.

IBM executives and their valued consultant, Charles Eames, identified the source of the problem at once; however, the two parties had quite different responses. In a memo to Seligsohn, written after he attended the seminar, Stoller lamented the sheer number of open-ended questions presented and then left unanswered and noted that "IBM appears to protest too much." He concluded that "Hand-wringing . . . has no place here"; the presenters should "take out the references to concern about the psychological effects of technology."[23] Eames, on the other hand, seemed to understand the ingenuousness of the initial presentation. In the margins of a revised outline of the script, which aimed to remove the philosophical uncertainty of the initial version by insisting that any public apprehension of the computer was unfounded, Eames scrawled angrily: "B.S.: Progress at this scale changes the game."[24] Eames, it seems, found this uncertainty regarding the ontology of the computer not damning, but rather productive; his extensive work for IBM, discussed in what follows, sought to hold concepts of human being and machine in tension through an aggressive design strategy that would, it was hoped, displace the matter onto a discursive field in which both mutually contradictory techno-ontological approaches to thinking about the computer could be sustained. This project, however, was long in developing and arose from relatively humble beginnings.

"Gaining Attention": IBM Exhibitions and Films

As with Rand's efforts to redesign the graphic component of IBM's corporate character and image, the communication imperative issued by Watson Jr. at the outset of IBM's Design Program necessarily operated on two levels: inside and outside. First, on the inside of the corporation, it was only logical to assume that if IBM's army of salesmen and engineers were going to spread the good word about the computer, they themselves needed to understand the company line. The design consultants, in league with Watson Jr. and the newly appointed IBM vice president for communications, Gordon Smith, thus determined that the company should establish a permanent program of traveling exhibitions that would serve to educate both IBM employees and clients about the corporation's activities. Notably, the first such exhibition was dedicated to documenting and explicating IBM's new graphics design guidelines,[25] and other exhibits to follow were dedicated to topics like new programming languages, data-processing systems and their maintenance, and computing applications (from accounting to military logistics).

It was primarily for this reason that Noyes brought George Nelson into the consultancy. Nelson had recently become a widely respected expert in the field of exhibition design, marked by the appearance of his book *Display* in 1953 (Figure 4.2). The book had cataloged and critiqued progressive exhibition techniques, mounting systems, and wall text graphics dating from the 1920s onward in an attempt to codify basic principles of communication through display techniques and point the way toward new, more effective ones. In the end, the book champions the work of the former Bauhaus master and designer Herbert Bayer, who demonstrated that by multiplying lines of sight "more can

be seen *simultaneously* and with greater ease," and it gives "to the exhibition a new three-dimensional device which *changed its entire character and offered new opportunities for gaining attention.*"[26]

Yet for all their finesse, the exhibits at 590 Madison Avenue, and even the traveling exhibits, reached only a relatively limited audience: New York pedestrians, science and technology buffs, and a select segment of the business community to whom computing was just emerging as a viable management tool. In order to push their soothing but as yet uncertain view of the computer upon a wider audience, Noyes and IBM would need to send out their message through additional venues and media—additional "pipelines," to use Watson's phrase. IBM's Department of Arts and Sciences oversaw the design of numerous traveling exhibitions based upon IBM's products and collections. Notable among these were renewing already long-established traveling exhibits available to institutions free of charge, launching a specially designed truck known as "RAMACADE" that toured the country with a portable multimedia exhibit on the RAMAC, and a rugged, flexible aluminum framing system designed by the Noyes office (largely based on systems designed by Nelson) for sales demonstrations of new products.[27]

Despite the success of these capital-intensive exhibit efforts, Noyes also advised that IBM take advantage of the portable, inexpensive medium of film. To produce new exemplars for the design program and IBM's public relations arms, IBM turned to the multimedia designer who had so impressed both architects and business managers with his layperson's explication of information theory: Charles Eames.

Figure 4.2 Herbert Bayer's design for a panel display system (1939), from George Nelson, *Display* (New York: Whitney, 1953).

As Rand had done for IBM's graphics and advertising, Eames immediately diagnosed the multiple problems behind IBM's efforts to promote a positive image of itself through films. IBM's early films, such as *Piercing the Unknown* and *Direct Line to Decision,* both of 1955, addressed their viewers in an almost threatening manner, as if they were under siege, whether by nuclear missiles or piles of paperwork. More important, perhaps, neither effectively explained the fundamental principles on which the computer operated, leaping directly from sophisticated problems to a promise of an almost magical solution that is never adequately shown, and neither offered much visual excitement. In response Eames offered the perfect antidote.

IBM initially commissioned the Eames Office to create a sequel to *A Communications Primer* that would do for the emerging science of cybernetics what it had already done for information theory. It was called *An Introduction to Feedback;* however, this project was temporarily shelved so that the office could begin work on another film for IBM's pavilion at the Brussels World's Fair of 1958. The pavilion was designed by Eliot Noyes and included a screening room at its center to display the film. The new film, titled *The Information Machine: Creative Man and the Data Processor* (Figure 4.3),[28] was a relatively short, animated piece, extending the tenets of *A Communications Primer* to encompass a grand historical narrative about the ever-greater need for knowledge of the future. It begins with a humorous sight gag involving a caricature of a rather crude looking, axe-wielding man dressed in an animal skin chopping down a tree that promptly falls on him. Over this scene, the narrator intoned, "Ever since the time when Man began to control his environment, he has been plagued by his limited ability to speculate, his failure to

Figure 4.3 The Office of Charles and Ray Eames, *The Information Machine: Creative Man and the Data Processor,* 1957. Sketches by Dolores Cannata. Copyright 2011 Eames Office, LLC (eamesoffice.com).

accurately predict the effects and the consequences of his proposed actions."[29] The film goes on to explain that throughout history, "artists" stored information "in active memory banks" and used it to "predict" events. This process was illustrated by punch card–shaped fields emerging from the head of the "artist"—a smiling "Man" dressed in a toga (on occasion looking suspiciously like a Greek architect, as when he holds a T-square) each bearing ideograms of natural forms: for example, a spider's web, a tree, mountains, starfish, and seashells. These cards then begin to move around, rearranging themselves and overlapping; numbers and other mathematical symbols appear; a curtain falls, then rises, and behind it—Voilà!—the artist has created "architecture," in the form of a palace, a modern skyscraper, and a vast hall covered with what appears to be a geodesic dome.

From this epistemological foundation in the act of design, and via the figuration of thought in terms of the abstraction of punch cards, the film then makes a leap to describing the "data processor" or "calculator." (Eames did not describe the machine in question as a "computer" until after his trip with Ray to India in 1957, and it appears in the office's work for the first time in *The Information Machine*.) This, we are told, is a "tool" that can be used in three overlapping ways: (1) "as a control or balance," in the cybernetic sense of governing mechanical or production processes (automation); (2) "as a function of design"; and (3) "as a simulation or model." It is in these last two uses that Eames establishes a strict—if fundamentally equivocal—homology between the action of the "calculator" and thought itself; however, it is important to note that the mode of thought that Eames describes is that of design.

The computer, *The Information Machine* argues, is a manifestation of the thought process itself, which arranges a given set of elements in order to supply a need created by the disorder of those elements. According to Eames, this arose from the aforementioned trip to India. Among other significant results (perhaps the most famous being the essay and photo essay on the lota, in which Eames lays out his theory of the evolutionary/eugenic development of the tool, and consolidated his worshipful following in England[30]), the trip yielded what would become one of Eames's favorite anecdotes. While visiting a group of bureaucrats in New Delhi, and in visits with Jawaharlal Nehru and Indira Gandi, the Eameses learned that the Indian government wanted to buy an IBM 704 to solve "logistics and distribution" problems, but did not have sufficient money.

We sort of looked around and said, look, you know, with all this talent in the making of devices and the building of things, with talent you have, why couldn't you do the following, in a sense: why couldn't you, out of cardboard, gesso, and whatnot, build a 704, and with the skills that you have . . . build it and refine it so that, for all intents and purposes, that it really is a 704?[31]

With this machine on hand, Eames suggested, the Indian government could set about preparing problems for it to solve. As he concluded, "in preparing a . . . logistics problem one solves 60%–66% of the problem. . . . What it does is give into the system a kind of organization that it needs."[32]

Leaving aside the condescending tone of the proposal, the significance of this anecdote for understanding the stakes of *The Information Machine* should be perfectly clear. For Eames and IBM, everything was always already a system, with a need for order, an order that could only be provided through the science of modeling or simulation; however, in order to engage in this process of ordering, an object was necessary. The process could not be solely internal, qua thought, but rather needed a kind of quasi-subjective, technological foil—even if the object was only a heap of cardboard and gesso. (Later, and embarrassingly, Eames would suggest filling the box representing the computer with fireflies, to simulate the blinking lights of a real computer console.) Coming around to this state of preparedness required an aesthetic operation, the construction of an inter-face that would prompt a certain form of thought conducive to solving a systems-based problem. This was the role that the Eames films were intended to play. They were a kind of second order model, simulating the ideal encounter of human being and machine engaged in an act of simulation (the architect combining elements to model and thus control an otherwise entropic nature). This tautological strategy of simulating simulation aimed to naturalize a certain form of thought as basic to human beings by declaring it to be universal, to the exclusion of other forms of thought. The logic of simulation, in the Eames films, provided a common ground on which the subjectivities of human being and computer could interact in a safe and friendly manner.

The Eames Office's collection of literature on simulation was particularly rich; its archives are stuffed with abstracts and articles on the subject from IBM and Rand Corporation scientists and engineers.[33] Despite the fact that the key members of the Eames Office—especially Glen Fleck and Parke Meeke, who worked on all of Eames's films and exhibitions for IBM—continued to consume this literature, Eames had formulated his fundamental approach to the matter quite early. He composed a sort of free verse poem in 1957, which condensed his ideas into a series of curious but exceedingly important aphorisms:

A model is
An interim report on a possible way of organizing a bunch of (putatively) related material.
It invites feedback.
In the best case, it's an agent of negative entropy; it slows down the decay of usable information.
It captures form/order, in a way that can be built on.
A good model is to the general information soup as a new protein/enzyme molecule is to the general chemical repertoire.
There's no argument as to what works. What works at a given level is what survives and gets built on.
"Cogency"
tenacity
elegance
this-is-as-it-should-be-ness
Responsibility as model-fosterers: to *enrich* and *refine* and *make more rigorous* one's capacity to recognize these qualities. Like the architect, one can afford to include nothing out.[34]

The peculiar phrasing of this last statement—"include nothing out"—seems at first to be an awkward slip of the pen. How can one "include" something (let alone "nothing") "out"? Yet Eames's frequent use of the phrase throughout his storied lecturing career is evidence enough that he did not mean by the phrase "leave nothing out." Rather, to Eames, models (and, by extension, tools for modeling) are positioned as order itself, which must be placed in opposition to "entropy." "Nothing" is precisely not "as-it-should-be." The including-out of "nothing" is the very condition of there being a something; "form," understood as "order," must be "capture[d]" and set aside from the chaos or "soup" that constantly threatens its "cogency," that it may all the more tenaciously defend its being. The debt of this line of thought to a particular branch of evolutionary biology is obvious: that which "works . . . survives and gets built on." In Eames's thought, the model thus becomes the basis of a peculiar system of production and reproduction; peculiar, because it is in every way (en)closed.

Eames, the designer who had logically progressed through the finite set of design possibilities for a simple chair with something resembling the computational technique of "brute force," thus found himself, despite himself, looking into a peculiar kind of mirror when he gazed upon the computer. By sharply circumscribing design, defining it as an act of modeling, Eames participated in the redesign of design; design was (at least in theory) reduced to a self-consistent set of rules, a logic, identical to that undergirding the operations of information technology. This radical form of technological determinism— present as well in the work of Noyes, Nelson, and the rest of the IBM design team— motivates the apparent whimsical humanism of the Eames Office's designs.

An Introduction to Feedback (1961), the delayed sequel to *A Communications Primer,* followed up on the themes sketched out by *Information Machine* and the modeling discussions as well. Based on the work of Norbert Wiener, in particular his self-popularizing volume *The Human Use of Human Beings* (1950),[35] every bit as much as the *Primer* had explicated Shannon and Weaver, *An Introduction to Feedback* continued the project of producing uncanny homologies between human being and computer. Footage of a young girl playing jacks was intercut with macrophotographs of a governor on a steam engine, demonstrating the dynamics of biological and mechanical adaptation processes and positing the possibility of their self-conscious redesign and control.

The Eames Office took up this theme repeatedly in the ensuing years, and perhaps the best introduction to the themes explored in this body of work is a late example. *A Computer Glossary; or, Coming to Terms with the Data Processing Machine* (Figure 4.4), made for the Noyes-designed IBM pavilion at the San Antonio Hemisfair of 1968, was more explicit about the computer than the more general *Introduction* had been. Building on the pun of the title, "coming to terms," the later film attempted to explain (and thus naturalize) computer jargon by moving between macrophotographs of computer interiors and whimsical animated sequences. Sticking to their primary strategy, IBM and the Eames Office acknowledged the opacity of computer jargon—the film began with a

A program for

INFORMATION RETRIEVAL

Locating and displaying specific material
from a description of its content.

**defines a pattern of
words and values...**

**that the machine can
seek out.**

**The care with which a pattern
is defined is important.**

The problem is — not to get too little...

or too much.

Figure 4.4 The Office of Charles and Ray Eames, *A Computer Glossary; or, Coming to Terms with the Information Machine,* 1968. Detail of pamphlet version. Copyright 2011 Eames Office, LLC (eamesoffice.com).

two-minute montage of computer parts and a collage of audio recordings of "computer experts speaking to one another"—and then worked to explain the technical terminology of computer science to the public, and to IBM management, in terms of quotidian events and human bodies. The terms "feedback," "flowchart," and "subroutine," for example, were illustrated with a humorous cartoon depicting a man named Oscar. Just as Oscar makes various decisions—such as whether or not to wake up ("Is it 7 a.m.?"), whether or not to kiss his wife ("Married more than five years?"), or whether or not to go to work ("Car start?")—the computer "compare[s] two values, then take[s] the next step based on the result of the comparison (or repeat[s] that operation over and over until the desired condition is met)."[36] The cybernetic logic of the programming flowchart is thus naturalized through its identification with the basic logic governing human life.

The term "Boolean logic" is illustrated, in true Shannon fashion,[37] as a simple machine involving three elements: a fist-shaped piston, an accordion-like receptor, and wires connecting them. These three parts seem to represent quite clearly how a given assumption or new piece of information provides stimulus to a preexisting system and changes it. *Computer Glossary* thus again echoed the earlier *Introduction* by emphasizing the spatiality of computing technology: this had been represented in the first film by briefly showing animated teletechnological networks expanding across a flattened version of Buckminster Fuller's geodesic globe toy; in the second, the seemingly inanimate innards of the computer were animated as machine parts moving in space.

Computer Glossary was also produced as a small-format pamphlet that could be distributed at every possible event, from exhibitions to sales meetings; it proved successful and was expanded and installed as an exhibition, *Some Computer ABCs,* at 590 Madison Avenue in 1968.[38] From the early 1950s onwards, IBM produced several films and their corresponding publications per year; these were made available to schools and universities free of charge.[39]

IBM Spectacle: *Mathematica* and the 1964/65 New York World's Fair

Despite the success of the Eames Office's intervention, IBM executives understood that, if it was to overcome widespread misgivings about its technology of abstraction and communication, it would need more than films. Although the Eames films served admirably as manifestos for uniting IBM's multimedia self-realization into a single cohesive program—coordinating the efforts of traveling exhibit programs, storefronts, cartoons, and pamphlets—the need to reach an ever-expanding audience, or market, demanded further effort, at a larger scale than anything they had yet attempted.

In 1958, IBM determined to capitalize on the growing interest in science and technology in the wake of the Sputnik launch by intervening directly in the exponentially expanding

realm of children's education. The first such intervention was the Eames Office's first major museum exhibition, *Mathematica: A World of Numbers . . . and Beyond,* which opened at the California Museum of Science and Industry in Los Angeles in March 1961 (Figures 4.5–4.9). The show—which proved to be one of the longest running and most imitated temporary traveling museum exhibits ever, lasting, with only minor modifications, well into the 1980s—translated the basic tropes of *A Communications Primer* into three-dimensional form and hands-on experience. Images and models—many of them manipulable—arrayed in a loose configuration within a semiopen, cage-like space, demonstrated that the abstractions of mathematics do not just describe but are present in every imaginable thing, from art and architecture to plants and planets, even in the form of the human body itself. As the introduction to the catalog of the exhibit stated, matter-of-factly:

Mathematics has been called "the Queen of the Sciences," for its intrinsic beauty and because it has mothered a host of other sciences. . . . It forms the base of many practical sciences . . . [and] for cultural arts such as music, art and architecture. It is rapidly being adapted as a basic tool by the social sciences and humanities—for studies of population, political trends and economic theories. The progress of mathematics and devices for calculating and computing have been closely interrelated since the invention of the abacus. Today's modern computers solve in seconds problems that would have taken mathematicians months or years just two decades ago.[40]

By what one might call the transitive property of rhetoric, through an explication of the natural quality and ubiquity of mathematics, IBM simultaneously posited its own naturalness and ubiquity. This mode of presentation—what Eames called "a very special brand [of fun]"[41]—was thus also an effort to naturalize the place and operations of the computer at the most basic level of human understanding.

The central area of the exhibit featured large-scale, interactive models of mathematical concepts. Multiplication was illustrated by a cube of light bulbs (Figure 4.6); as the viewer entered values to be multiplied on a simple push-button panel, the corresponding number of bulbs would illuminate, thus illustrating the literal "power" multiplication granted its user in real space. Further, a board game surrounding the cube allowed the children to learn, piece by piece, the commutative law of multiplication, the basics of Euclidean geometry, and even, for more advanced viewers, the uncertainty of the consistency of arithmetic and the potential of set theory as a more basic foundation for mathematics. Sophisticated concepts in applied mathematics such as the celestial mechanics of Kepler and Newton were illustrated by allowing the visitor to launch a marble into a funnel; the marble thus rolled around and around the center point in a metaphorical "orbit," maintaining its position vis-à-vis the central point until it lost its momentum and rolled down into a hole placed at the center. The basic concepts of topology were represented by a gigantic Möbius strip suspended from the ceiling, along which a toy train shaped like an arrow ran, demonstrating that the strip had only a single side and a single edge. Children were invited to construct their own Möbius strips out of pieces of construction paper and tape, and a series of instructions allowed them to manipulate them into new topologies using safety

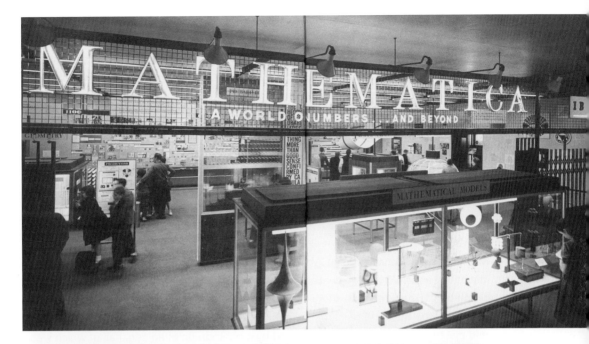

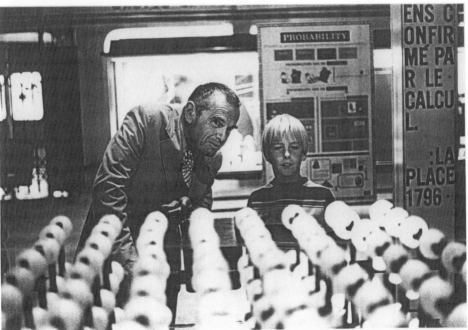

Figure 4.5 The Office of Charles and Ray Eames, *Mathematica: A World of Numbers . . . and Beyond,* California Museum of Science and Industry, 1961. View. Courtesy of IBM Corporate Archives, Somers, New York.

Figure 4.6 Charles Eames shows a young visitor to *Mathematica* the Multiplication Cube, 1961. Copyright 2011 Eames Office, LLC (eamesoffice.com).

scissors. An enclosed glass case reproduced a classic experiment in the psychology of perception. The case, when viewed from one side, seemed to be filled with randomly placed objects, but when viewed through an eyesight at one end, revealed a "neat and ordered" geometric pattern. Such experiments were usually used to demonstrate, through several such examples, the importance of point of view, subjective vision, and the tendency of the human brain to order different sense impressions into similar and familiar forms. However, in the Eameses' show, only one example was offered, thus placing emphasis on the overarching narrative of the exhibit: that if one viewed the world properly, that is, from the proper vantage point, things that at first seemed disorderly had in fact an underlying structure susceptible to description, or even definition, by simple arithmetic.

Other exhibits were less interactive, instead bridging the gap between the abstraction of mathematics and concrete reality through analogy and metaphor. On one side of the exhibition space was the Image Wall (Figure 4.7), a gallery of photographs and drawings illustrating additional mathematical concepts. There, infinity was represented by a photograph of a boy standing next to a mirror in front of a mirror, demonstrating infinite recession to the vanishing point; the difference between analog and digital, and continuous and discrete mathematics was illustrated by a photograph of an egg, half of which was rendered through white dots of varying and exaggerated sizes on a black field. (Other examples of this difference abounded, from a trombone player juxtaposed with the rotary disc from a music box, to the difference in matter states illustrated by honey and sugar cubes.) At the entrance, glass cases showing important mathematical models—for example, the rotation of straight line segments to form circles, spheres, tori, and helices—demonstrated the concrete form that mathematical concepts could take on in space.

The most spectacular exhibit of the entire show, perhaps, was that on the laws of probability and the normal distribution or bell curve, which were illustrated by the Probability Machine, a device that has since become a requisite of children's science museums everywhere. It dropped several hundred metal balls through a series of regularly distributed pegs, illustrating that while "a ball can land in any box" below, "yet any given box fills to nearly the same height every time the experiment is repeated." The Probability Machine became a favorite IBM exhibition tool, since it demonstrated the role that computers could play in the futurological enterprises of "genetics, thermodynamics, games of chance and strategy, traffic control, insurance and queuing theory,"[42] not to mention meteorology and aerodynamics. It was later a key component in the IBM pavilion at the 1964/65 New York World's Fair.

In a similar vein, a History Wall (Figure 4.8) opposite the Image Wall represented the history of modern mathematics from the twelfth century to the (then) present, focusing primarily on the "world's greatest creative mathematicians." Each received a panel with a portrait, a list of important achievements, and a set of carefully selected notes emphasizing the mathematician's personality traits.[43] In an effort to provide some context, however, additional panels included items of "active influence" on the mathemati-

Figure 4.7 The Office of Charles and Ray Eames, Image Wall, *Mathematica: A World of Numbers . . . and Beyond,* California Museum of Science and Industry, 1961. Courtesy of IBM Corporate Archives, Somers, New York.

cians in question, as well as "important accomplishments of the period." Architecture—in particular the dense geometries of gothic cathedrals, but also John Wood's Royal Crescent in Bath, and Étienne-Louis Boullée's project for Newton's cenotaph, which likewise displayed the power of simple geometric figures in defining wider surrounding spaces (in the case of Boullée, the cosmos itself)—was here included alongside photographs of slide rules, codices, and telescopes. The wall began with gothic cathedrals, and the last mathematician in the long parallel series, unsurprisingly, was John von Neumann, thus positing the burgeoning field of computer science as the culmination of the entire history of mathematical and scientific endeavor.

Another segment of the exhibition featured "peep shows," individual viewing machines showing two-minute animated films on continuous loops (Figure 4.9). Each film explicated a sophisticated mathematical concept—the inference of the circumference of the earth by Eratosthenes; Camille Jordan's curve theorem (topology); various kinds of symmetry; the idea of "functions"; and exponents—through children's storybook–like narratives. These machines were typical of the Eames strategy: serious, high-stakes concepts were blended seamlessly with humor, and, just as important, the narratives were addressed directly to the individual viewer. Eames narrated four of the five films himself (the other, *Eratosthenes,* was narrated by Vic Perrin), and the language is quite telling. In the films, Eames often begins sentences with common phrases in the second person, like "You already know that . . ." or "You are familiar with . . . ," and the conclusions of the films are littered with such statements as "Now you understand functions." The interpellative mode of the narrative, combined with the isolating viewfinder mechanism of the peep show machines themselves, all contribute to the naturalizing effect by immersing the viewer in a totalizing environment in which the machine (or mathematical process) seems to address itself directly to that viewer.

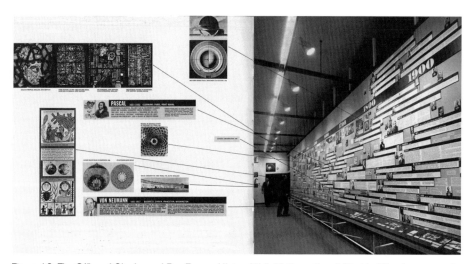

Figure 4.8 The Office of Charles and Ray Eames, History Wall, *Mathematica: A World of Numbers . . . and Beyond,* California Museum of Science and Industry, 1961. Courtesy of IBM Corporate Archives, Somers, New York.

Figure 4.9 The Office of Charles and Ray Eames, "peep show" apparatus, *Mathematica: A World of Numbers . . . and Beyond,* California Museum of Science and Industry, 1961. Copyright 2011 Eames Office, LLC (eamesoffice.com).

Notably, *Mathematica* also included a small section on "The Man/Machine Interface," which featured such droll quotations as the following:

Overheard in a recent conversation about computers: "It's merely a matter of understanding what's taking place. I remember when we got our first TV set, my wife wouldn't undress in front of the screen."

And:

The mathematician [and computer scientist] John von Neumann had amazing powers of rapid mental calculation. One of his associates said: "von Neumann was, of course, not human, but he had so carefully mastered the impersonation that most people believed him to be a member of the race."

Such jokes served a double and contradictory function that proved essential to Eames's and IBM's strategy for naturalizing the computer. The former affirms the computer's status as a mere tool; the latter implies the computer's basic humanity by playfully identifying the human being as a computer. (And, lest we forget—and Eames most certainly did not—the "computer" was originally a human actuary.)

Eames's gift for juxtaposing such seemingly contradictory statements was in evidence throughout this section of the exhibit, and beyond. As a caption to a pair of flowcharts comparing human and machine decision making, a further pair of quotations from a single source, the Rand Corporation computer scientist and operations research expert J. D. Williams, is a case in point:

To define thinking in a way that excludes the machine achievement, and then claim, on that basis, that machines can't think, "would be like saying that airplanes can't fly because they can't land gracefully in trees."

Machines compute with the speed of light and with the intelligence of earthworms.[44]

Surprisingly, Eames appeared to conclude that machines do indeed "think," albeit only in tandem with human beings. In this sense, it seems, Eames could consider the computer a mere tool; however, a certain uncanniness creeps into his formulation, despite all efforts to the contrary. In his own words, "The computer has significantly altered the man/machine interface, at least in degree. It is a tool man can communicate with. He asks it questions and gets back answers he could not himself have provided, nor does he always understand how the computer got them."[45] As we have seen time and again, this lack of understanding—that is, the user's inability to comprehend the inner workings of the black box lurking behind the newly friendly exteriors of computers—can only be resolved at a discursive level by positing a total homology between computer and mind, then immediately denaturing that homology through an appeal to an ill-defined, extrinsic vocabulary (e.g., "intelligence").

At about the time that the Eames Office completed work on *Mathematica* in August 1960,[46] IBM began to consider a project that would develop the ontological tension between human and computer into a grounds for architecture: a pavilion for the corporation at the New York World's Fair of 1964 (Figures 4.10–18). According to internal memos and subsequent press releases, the IBM pavilion at the fair would make the case that computers, and the sophisticated scientific and business functions they could perform, were an increasingly integral and necessary part of human life. As a profile of IBM in a 1963 press release about the fair put it: "If one had to come up with a single descriptive term that would characterize the business of [IBM], then one would probably decide on 'problem solving.'"[47] A committee consisting of Noyes, Rand, Eames, and a number of IBM engineers and managers, including the IBM manager for promotions and exhibits G. G. Ahlborn, assembled in autumn 1960 to begin the process of selecting an architect.

IBM seems to have kept the selection process wide open: it even considered commissioning Walt Disney to design the exhibit, which could be installed in Disneyland after the fair;[48] the committee also considered the possibility of handing the commission to Buckminster Fuller.[49] In the end, however, it seems that Noyes had the final say,[50] and he chose the architects who had the most intimate understanding of the problems facing IBM. Charles Eames would work together with his longtime friend and collaborator (and architect of the Watson Research Laboratory) Eero Saarinen on the design of the pavilion, and the Eames Office would design the exhibits.

Early in the conceptual stages of the design, from January to September 1961, Eames and Saarinen agreed that the pavilion should be what they termed "un-architecture"—in other words, an architecture that did not compete for attention as a spectacle in and of itself, but rather operated as part of the spectacle, taking on its logic and augmenting it.

Sketches preserved in the Eames Office, by an unknown hand, dated September 1961, demonstrate that the fundamental topology of the project was set from the beginning. These show numerous variations on a single theme: a set of centrally located bleachers that would rise up into a theater volume above. Most of the initial sketches of the theater show a sharp, angular volume; this was later refined into an ovoid form (which, apparently, evoked associations with the spinning typing element, the famous "golf ball," of the Selectric typewriter, though this seems to be little more than an accidental coincidence). The basic *parti* was drawn from the idea of an informal garden or forest, in which plantings at ground level would almost seamlessly blend into naturalistic tree columns, whose branches would meet at the top forming a translucent plastic-roofed canopy. The central and most spectacular display was from the first elevated up above this canopy, providing a symmetry and even monumentality when viewed from the outside but, as a perspective drawing shows, leaving the floor plan wide open. This

Figure 4.10 The Office of Charles and Ray Eames and Eero Saarinen Associates (Kevin Roche, lead architect), IBM Pavilion, New York World's Fair, 1964. View on IBM promotional postcard. Collection of the author.

open plan (Figure 4.11), the architects claimed, would allow visitors to move freely in, out, and through the multiple exhibits; and the absence of walls multiplied lines of sight, attracting visitors to the pavilion's carefully planned attractions and distractions.

Saarinen died in 1961, before the planning process was complete; along with the rest of the office, Kevin Roche and John Dinkeloo saw the project through to the end. However, shortly after Saarinen's death the firm did assemble an architects' book for the project, including a brief description of the project, costs, and a series of early drawings.[51] The early drawings for the canopy, including a reflected ceiling plan, show it as a literal forest, built from trees, albeit simplified into a more buildable arrangement. The plan was set relatively early as well, excepting one major revision—the labyrinth leading to the bleachers, initially a long and sinuous set of ramps, was, like the "trees," confined to a more geometrically rigid set of right angles, thus gaining a significant amount of additional open space within the pavilion.

Despite the fact that Eames consistently referred to the pavilion as "un-architecture" because of its open-air, grove-like quality and its integration into the overall spectacle, Roche was eager to point out that "we have out there a Pavilion which belongs very much to serious architecture, the role of which is not only to provide shelter and solve functional needs but also to create environments."[52] Roche based his claims on the long tradition of "borrowing" of natural forms throughout the history of architecture, from the temple of Ammon in Egypt to the use of more detailed plant forms in the work of Louis Sullivan and in Art Nouveau, all of which served, as he put it in a lecture on the

Figure 4.11 The Office of Charles and Ray Eames and Eero Saarinen Associates (Kevin Roche, lead architect), IBM Pavilion, New York World's Fair, 1964. Plan. Courtesy of IBM Corporate Archives, Somers, New York.

Plate 1 IBM, advertisement for IBM electronic systems, ca. 1950. Collection of the author.

No matter what the weather, speed or altitude, an IBM navigational computer system now being developed will let the pilot see his position on a moving map. His air speed is 1,500 mph, his altimeter 50,000 feet. Below him lies the earth totally obscured by cloud cover, and above, the darkness of outer space. Yet the pilot can see where he is and where he's going. How? ■ A small glass hemisphere carries a detailed map of half the earth and is tied into the plane's computer. A beam of light illuminates a small section of this hemisphere and projects it onto a screen in front of the pilot. In flight, the computer rotates the hemisphere, correlating it exactly with the plane's supersonic progress and the rotating earth. ■ To develop this system, IBM engineers came up with a new technique for depositing the map image on glass. In discovering it, they established principles that may be followed in space navigation as well—using a star map instead of an earth map. By exploring new methods of collection, processing and communication of data, IBM is uncovering many new solutions to problems of business and science.

IBM

new electronic map will show the pilot where in the world he is

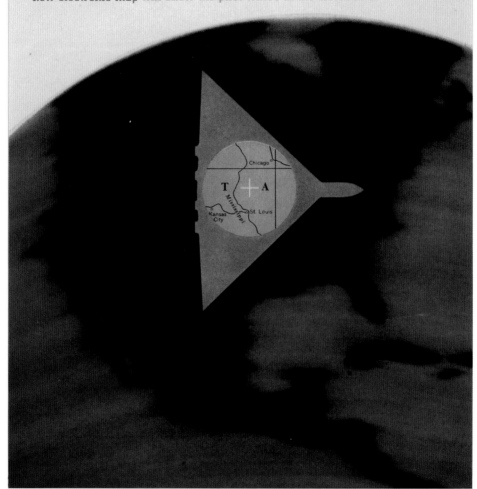

Plate 2 IBM, advertisement for IBM navigation systems, ca. 1960. Collection of the author.

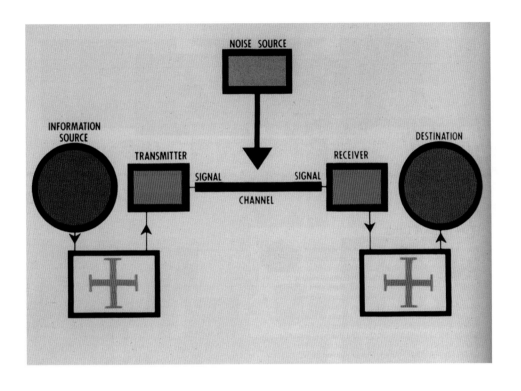

Plate 3 Diagram of communication (after Claude Shannon and Warren Weaver), from Charles and Ray Eames, *A Communications Primer,* 1953. Copyright 2011 Eames Office, LLC (eamesoffice.com).

Plate 4 Still from Charles and Ray Eames, *A Communications Primer,* 1953. Copyright 2011 Eames Office, LLC (eamesoffice.com).

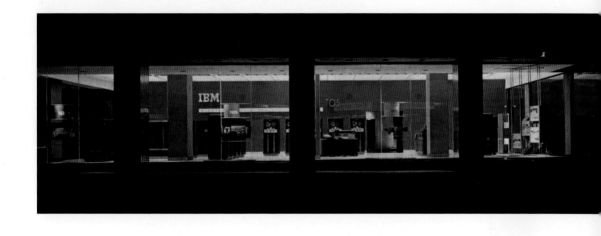

Plate 5 Eliot Noyes, IBM showroom, 590 Madison Avenue, New York, 1954. View from 1955 with IBM 705 display. Courtesy of IBM Corporate Archives, Somers, New York.

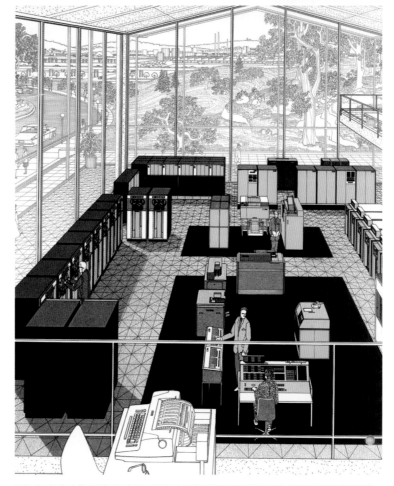

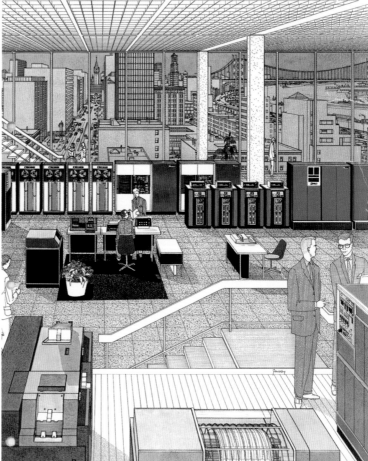

Plate 6 Illustrations
of IBM 1401 instal-
lations, from *IBM
Color for Comput-
ers Quick Refer-
ence Guide,* 1959.
Courtesy of IBM
Corporate Archives,
Somers, New York.

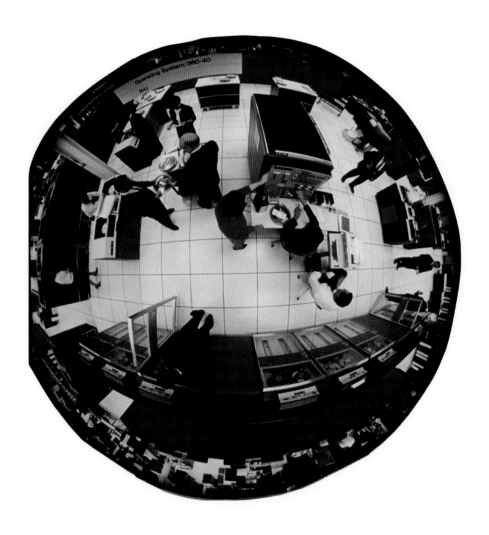

Plate 7 Promotional photograph for IBM System/360 Model 40, taken in the Computer Room ("white room") in Poughkeepsie, New York, 1965. Courtesy of IBM Corporate Archives, Somers, New York.

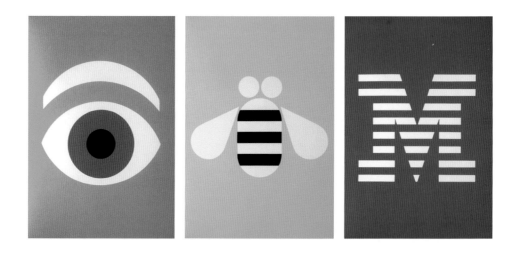

Plate 8 Paul Rand, "Eye Bee M" IBM logo, 1981. Courtesy of IBM Corporate Archives, Somers, New York.

design of the pavilion in 1964, to "create an environment." Gothic fan vaults, in particular those of the Lady Chapel of Lincoln Cathedral (which were also illustrated in his talk), formed the conceptual basis of the "tree" structure of the IBM "environment." The rolled Cor-Ten columns of the "trees" were, as IBM claimed in its promotional materials, following Roche, a new technological development in the long historical development of steel construction and would prove useful in producing inexpensive office buildings in the future. The plaster-covered, steel-framed ovoid theater atop the canopy of trees had its own representational pretensions. According to Roche, as the embodiment of a "simple geometrical equation . . . $(x^2/a^2 + y^2/b^2 + z^2/c^2 = 1)$," the ovoid was meant to suggest, metonymically, "the form of the earth, even the universe."[53] Keeping in mind IBM's global imagery at the New York World's Fair twenty-five years earlier, the significance of this can hardly be missed. IBM's self-image had changed from the global to the universal: the simultaneously shrinking and expanding universe had been embossed in its entirety with the letters "IBM" (Figure 4.12).

This appeal to universality was also evident in the overlapping of various architectural typologies. In addition to the temple, the Gothic cathedral (evident also in the inclusion of a labyrinth in the floor pavement at the entrance), the landscape garden, exhibition and garden pavilions, the hypostyle, the bank, and the theater were chopped up, reformulated, and/or fused into a thoroughly original and modern building type. Although the selection of certain aspects of each of the source building types appears at first haphazard, on closer inspection it becomes clear that their inclusion was based on a distillation of their most spectacular aspects.

In this respect the design of the pavilion, and of the exhibitions inside, was based on Eames's famous and rigorous interpretation of the synthetic and synesthetic visual and informational structure of the traditional circus. If not carefully coordinated and disciplined, IBM's bid to sell a skeptical public on the possibilities of computing would be disastrous indeed. Conversely, if the pleasure of the pavilion was not sufficiently intense, saturated, and freewheeling, the results would be the same. The central message—that computers were both technological and natural extensions of human beings—could not be lost: "Leaving the exhibit the visitor should feel that the aims of IBM are not foreign to his own."[54] Yet the "un-architecture" of the pavilion seems at first glance to have no such discipline. The exhibits seem to be autonomous entities, more or less randomly inserted between the tree columns in an open-plan arrangement.

The Computer Court featured exhibits on automatic language translation and character recognition, the former proudly announcing that "with the help of computers, man today is beginning to overcome the ancient and baffling language barriers that have been plaguing the world since the days of the biblical tower of Babel."[55] The exhibit demonstrated to the audience how a plastic optical dictionary disk—a precursor of the modern compact disc, jointly developed by the U.S. Air Force and IBM—could store and retrieve up to two hundred thousand foreign words and their English equivalents. In the pavilion,

Figure 4.12 The Office of Charles and Ray Eames and Eero Saarinen Associates (Kevin Roche, lead architect), IBM Pavilion, New York World's Fair, 1964. View of ovoid theater and "tree canopy." Courtesy of IBM Corporate Archives, Somers, New York.

a typist (who did not read Russian, but had been trained to recognize letters of the Cyrillic alphabet) at an input keyboard of an IBM 1601 computer terminal copied sentences from a Russian technical journal. The input was transmitted via IBM's patented Tele-Processing equipment to a remote computer in the development lab in Kingston, New York. There, another computer translated the text and transmitted the English version back, which was printed out on an automatic typewriter (printer). The entire process took only about eight seconds per sentence. Below the marquee, a woman attendant answered questions, carefully pointing out how each step in the process was equivalent to the steps that a human translator would make. Analogies to "memory" and "reading" abounded, and cases in which the computer had to make seemingly difficult contextual decisions between homonyms were emphasized.

In the character recognition section of the Computer Court, fairgoers were invited to write their date of birth on a card, which was then inserted into an optical scanner. The computer, an IBM 1410, then "read" each person's individual handwriting and offered back a newspaper headline from that day on an LED marquee, drawing on a memory disk containing forty thousand such headlines.

The Typewriter Bar, originally designed by Eliot Noyes and Associates in 1957 for the IBM pavilion at the World's Fair in Brussels of 1958, was a particularly ingenious marketing tool and had long been a fixture at IBM exhibits. The New York version offered visitors a chance to try out the Selectric themselves: each entrant received an IBM postcard on which to type and send a message to friends or family. In addition, the typewriters were arranged in a circle, on a decagonal bar, so that part of the fun was to watch one's fellow visitors using their machines. In the center, two geared-down automatic versions of the Selectric demonstrated the spinning and tilting motion of the spherical typing element in slow motion. Thus, not only did the exhibit expose a mass audience to the typewriter in a fun hands-on way, it also served as a direct-mail advertisement generator, in which images of IBM and its products were associated directly with the warm or amusing sentiments of loved ones.

The pavilion also included holdovers from the *Mathematica* exhibition. The Probability Machine was given pride of place, near the entrance, perhaps because of its striking scale and appearance. Farther back in the pavilion, the Scholar's Walk offered a quiet retreat from the commotion of the pavilion, a small labyrinth of display cases and panels holding selected elements from the History Wall.

Finally, at the center of the pavilion, in the suggestively named Pentagon Theater (the name was changed in the final promotional materials to Little Theaters), IBM presented several short "puppet shows." The "puppets" were in fact automatons synchronized to audio recordings, controlled by a computer in the nearby IBM administrative building. Two of the most successful comic educational skits were written by Glen Fleck, each one serving a single end in the two-pronged naturalizing narrative. In *Computer Day at*

Midvale, the bloviating mayor of an everytown, Midvale, presides over a ribbon-cutting ceremony for a new civic building housing the government's new computer. After trumpet fanfares, the mayor announces that the computer will solve all of the town's problems, thereby eliminating the need for any further worry. At this point, a tweedy computer expert—who clearly represents IBM—steps in and gently corrects the mayor, explaining that computers will not solve problems on their own; rather, they are but tools with which people solve problems. In the comic back-and-forth that ensues, the mayor makes many more such silly mistakes, and each time the computer expert gently corrects him to the applause of the unseen audience.

A second show, *The Singular Case of the Plural Green Moustache* (Figure 4.13), does not make mention of the computer as such, but rather demonstrates the power of Boolean logic to solve mysterious problems through a simple series of yes/no questions and deduction. After a train robbery, Sherlock Holmes is called in to apprehend the criminal. Without leaving the train station, using only a small set of facts (the fact that the criminal in question has a green moustache, the layout of the train tracks, and two reports of the criminal's passage through other stations) and with his perennial companion Dr. Watson as a straight man, Holmes is able to deduce who stole the train, where the criminal is, and how to switch the tracks in order to force the criminal's train back into the original station. The punch line, of course, is that deductive reasoning, that most human of abilities, is replicated perfectly in the digital computer. It was underscored by the finale, in which the Holmes puppet opens his coat to reveal his true identity as a computer, complete with circuits and blinking lights.[56]

Despite their delirious diversity, in each of these exhibits, and especially in the puppet shows, we recognize the ubiquity of the already familiar strategy of holding two opposed propositions in a dynamic tension. In each, the computer and the human being are simultaneously posited as identical and, paradoxically, fundamentally different. Eames's claim, then, that the pavilion was based on the disciplinary structure of the circus, finds its validation at least at a conceptual level; but what about at a formal level? How are these disparate elements brought into any kind of unity?

Any circus, of course, has multiple events occurring in parallel; however, these are all strictly coordinated from the center ring by a central and all-powerful figure, the ringmaster. In the IBM pavilion, the center ring, around which all else swirled in an all-too-ordered chaos, was a kind of rigidly determined *promenade architecturale*—or, perhaps more accurately, a *promenade du spectacle technologique.* Despite the open plan of the pavilion, which could ostensibly be entered from any direction, visitors were herded (through simple tricks of landscaping and ticketing) toward a single entrance marked with the words "IBM Information Machine," rendered in twinkling lights (Figure 4.14). At the entrance, the visitors found themselves standing on a pavement marked with a curious labyrinth (visible at the bottom of Figure 4.11). This labyrinth, which the Cameses had used prominently in *Mathematica,* while seemingly a trivial decorative detail, is in

fact of the utmost importance to understanding the spectacular and architectural unity of the building as a whole. It was in fact a topological puzzle—one that "you can solve in the dark." As Eames wrote for the topological lesson in *Mathematica,* "Just walk along, touching one finger to the wall all the time. Your finger will trace a curve that completely surrounds the wall [thus leading you to the finish]. The wall is inside that curve, and so, part of the time, you will be in the open air."[57] That is, the maze was another way of figuring the topological mystery of the Möbius strip: with only a single point of contact or view, the topologically closed curve has only one side, and neither "inside" nor "outside" (unlike, say, a sphere, box, torus, etc.). While the viewers may be, at the entrance or elsewhere in the pavilion, "in the open air," by crossing the quasi-sacral symbol of the labyrinth, they enter into a perpetually closed system. This state of being both inside and out—and, indeed, inside-out—constitutes the basis of the spectacular and architectural logic of the pavilion.[58] Each element along the closed-curve journey through the Information Machine rigorously operates to uphold this tension.

From the entrance, a bewildering set of winding staircases provided a three-dimensional realization of this topological labyrinth: though individual spectators could take any number of entrances into the maze, each was topologically separate from the others, leading to a separate row in the bleachers at the center of the pavilion called the People Wall. According to Eames, the paths of the maze of stairs "follow these rules which are well known in circus and carnival circles: It takes a crowd to attract a crowd; People want to be seen as much as to see; *There is enjoyment in being disoriented and the very special world it creates changes the sense of time;* People like to see people being

Figure 4.13 The Office of Charles and Ray Eames (Glen Fleck and Parke Meeke, lead designers), Pentagon Theater or Little Theaters, IBM Pavilion, New York World's Fair, 1964. Courtesy of IBM Corporate Archives, Somers, New York.

Figure 4.14 The Office of Charles and Ray Eames and Eero Saarinen Associates (Kevin Roche, lead architect), IBM Pavilion, New York World's Fair, 1964. View of entrance to the "labyrinth" of the IBM Information Machine. Courtesy of IBM Corporate Archives, Somers, New York.

entertained."[59] The disorientation of which Eames speaks is indeed of a "very special" kind; while the individual spectators would indeed be unsure of the orientation, they were never in any danger of actually becoming lost. With their figurative "finger on the wall," they meandered through the labyrinthine sensual overload of the staircase with an unconscious purposiveness. As they progressed through the maze, visitors were entertained by strolling minstrels and jugglers and could watch their fellow visitors traveling along their own separate paths, in a kind of bizarre spatial reformulation of the outdoor balcony of the eighteenth- and nineteenth-century bourgeois theater. Unsure of the distance of the end point from the entrance due to the winding twists and turns, any sense of speed was destroyed, creating the change in the perception of time of which Eames spoke.

After the audience had been funneled through the labyrinthine ramps, they took their seats on the People Wall (Figure 4.15). Set in the middle of an artificial lagoon, the People Wall was a peculiar bleacher seating apparatus. The spectators did not quite sit, but rather propped themselves between a foot rest and an upper thigh or seat rest and clutched a railing in front of them at nearly shoulder level in a pose of heightened attention and readiness. Yet once they took their positions as part of the People Wall, it must have been anything but clear what the visitors believed they were supposed to be looking at. Below them were the smaller exhibits but no central spectacle.

Then without warning the host appeared, a coy male actor wearing a tuxedo lowered on a small circular platform from the ovoid above, and gave a brief introduction. Then the hydraulic lift was powered up, and the People Wall slowly rose—fifty-three feet up—into the darkened interior of the Information Machine.

You rise into the darkness of the theater, the huge bay through which you entered is drawn up, the world is closed out, and the show begins. You adjust quickly to the dim light inside . . . and soon you make out the multi-faceted interior, the fifteen screens of various shapes and sizes that line the curved wall.[60]

The host, who had disappeared into the blackness, suddenly reappeared—like the Cheshire Cat—spotlighted on a balcony between the screens on the right-hand side of the theater.

At the bidding of the host, information leaps at you from all directions. Just to show what the machine can do, he fills the screens with miscellaneous information about himself—his credit card, the change in his pocket, what he had for breakfast, what's inside his closet, even a little chat with his mother up in Schenectady.

Another example, he announces—and suddenly you are in the roaring midst of a road race. *With all screens filled with action, you see far more than if you were actually on the spot: you are in*

many places at once, on the curves, in the pits, with the onlookers, in the driver's seat, inches from the ground next to the front wheel.[61]

The Information Machine thus displaced the spectator, several times over. First, deprived of any sense of direction by the labyrinth stairs, then set in bleachers without a point of reference, then lifted into the ovoid, and at last fragmenting and multiplying her points of view in a rapid succession of film segments and slides, the spectator has embarked on a kind of pilgrimage. She has quite clearly transcended three-dimensional (or even four-dimensional) space and has come to inhabit, however briefly, an entirely new medium. At this point, before even summarizing the actual message of the Information Machine, one may begin to understand what is at stake in the agglomerations of architectural fragments compiled by Eames, Saarinen, and Roche into a spectacular "un-architecture."

A first glance at a section drawing of the ovoid theater, with its multiple screens angled toward the People Wall, would seem to suggest that the design owed something to Bayer's exhibition designs (visible in Figure 4.2). Indeed, a purely formal comparison might

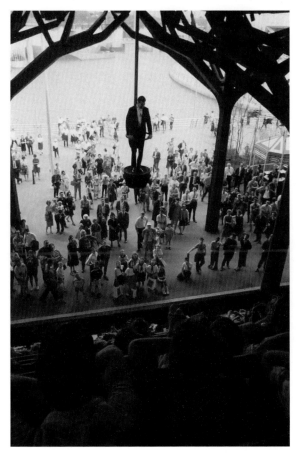

Figure 4.15 The Office of Charles and Ray Eames and Eero Saarinen Associates (Kevin Roche, lead architect), People Wall, IBM Pavilion, New York World's Fair, 1964. View showing host lowered on platform to greet visitors. Courtesy of IBM Corporate Archives, Somers, New York.

relate the design directly to Herbert Bayer's design—with Walter Gropius, Marcel Breuer, and Laszló Moholy-Nagy—for the Werkbund Exhibition in Paris, of 1930.[62] And, on a spatioconceptual level, the audience's trajectory through the exhibit toward the theater would seem to bear comparison to Bayer's well-known emphasis on determining precisely the viewer's movement and attention throughout the exhibit. However, as a study plan by Glen Fleck of the lines of sight on the interior of the ovoid theater shows (Figure 4.17), the Information Machine utilizes a fundamentally different underlying conception of visuality and its relation to content. While Bayer's conceptual drawing of his panel display system—done for *PM* magazine in 1939—relates all of the planes to a single embodied eye, more or less free to take in the entirety of the show at its leisure, the Information Machine addresses itself to multiple, disembodied points of view.[63] By fragmenting the traditional one-point perspective of the theater (and of the cinema), and presenting the individual subject with a view of the spectacle seemingly wholly created through the exigencies of attention and distraction amid an overflow of images, the Information Machine allegorizes abstraction and displacement in its very form.

Contemporary reviews of the Information Machine were quick to grasp this. As Mina Hamilton wrote in *Industrial Design* in 1964,

The IBM film is more than a film. It is a show, a ride, a happening.... Often one's eyes are drawn in opposite directions simultaneously. Eames did not expect everybody to see everything. Quite the contrary, he expected each person to come away with separate sets of information and experience. The pace of the show ... is so fast that a person does not have enough time ... to weed out what he wants to see or not see so the different sets of information are completely haphazard. In a sense, what Eames has done to the film in the IBM show is to present it as a symphony or ballet: a succession of images and sounds move so rapidly across time and space

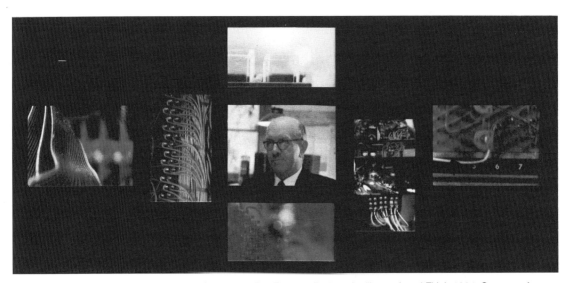

Figure 4.16 The Office of Charles and Ray Eames, stills from the film version of *Think,* 1964. Courtesy of IBM Corporate Archives, Somers, New York.

that they cannot be isolated, recognized, or remembered as individual events but they are interwoven to form a total impression. The kaleidoscope-like result is overwhelming and "spectacular" but too fragmented to be entirely successful.[64]

The "spectacular" nature of the Information Machine, then, lies in its investment in the organic (and organizational) tautology: no whole without the parts, "fragmented" but "total." Hamilton's criticism, particularly her claim that Eames's technique overwhelms the film, making it "occasionally confusing, more often frustrating—particularly because of the beauty and precision of each individual still or take," directly underscores Eames's deliberate aim to engender confusion between naturalization and mystification.[65] As a machine that enables one set of media to approach an apparent and spectacular total representation of another medium only by breaking down the whole into innumerable bits, its every act lays waste to humanist assumptions: perspective is shattered; the intellect

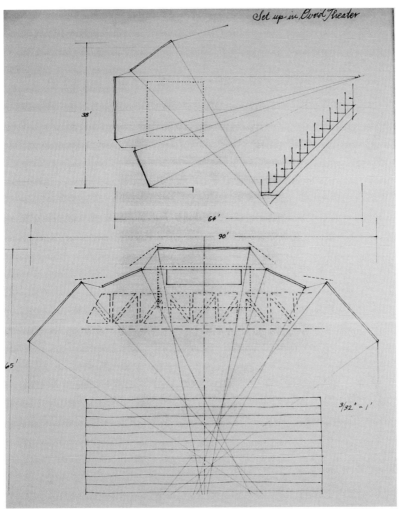

Figure 4.17 Glen Fleck (Eames Office), diagrammatic plan of projections in the Information Machine, ca. 1964. Copyright 2011 Eames Office, LLC (eamesoffice.com).

is mechanized even as it asserts its sacred aspect; design is transformed into a pure deterrent. There is no difference between the formation of subjectivity in the face of the computer and the regime of power/knowledge known as the war room.[66]

In a slew of examples ranging from planning a dinner party, a football play, designing a chemical compound, or determining a missile trajectory, the host and the hyperactive images comprising the Information Machine demonstrated that "computer problems, philosophical problems, homely ones—the steps for solving each are essentially the same, some methods being but formal elaboration of others."[67] Behind all such problems was a more basic equation, which everyone from housewife to ballistics engineer could understand: human endeavor = rational planning. Essential to this process of planning was a process the host identified as abstraction, paradoxically identified also as representation, which lay at the foundation of thought itself (Figure 4.18). Through quantification, IBM—and by implication, the computer—simply helped people "THINK" easier, faster, cheaper. Fifteen minutes after the show began, the spectator was cast back into the glaring light of the earthly circus below, armed with the new knowledge that the "aims of IBM are not foreign to his own"; perhaps they were, by then, his or her own.

The Information Machine, as a naturalizing machine, thus reiterates the duplicitous logic we have already seen motivating the design of Eames's other films and exhibits for IBM, simultaneously positing the computer as wholly new and shocking, and as a completely natural extension of everyday life. However, as we have seen throughout our discussion

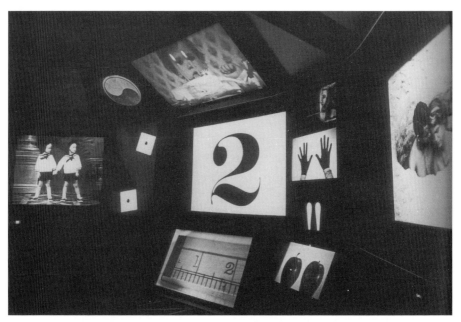

Figure 4.18 The Office of Charles and Ray Eames and Eero Saarinen Associates (Kevin Roche, lead architect), IBM Pavilion, New York World's Fair, 1964. Interior of the Information Machine. Courtesy IBM Corporate Archives, Somers, New York.

of Eames's efforts to communicate clearly about the relevance, importance, and harmless-
ness of the computer to the human being, no effort was made to resolve this contradic-
tion. Rather, the tension between these concepts was preserved, through remarkably
elaborate means. The task of naturalizing the computer did not involve a true effort
at ontology, of either human being or computer; rather, it involved a design logic of
displacement and enclosure. In pursuing this goal, the work of the Eames Office was
remarkably consistent and, in a manner of speaking, particularly honest with regard to
the nature of the problem of nature.

By 1973, IBM estimated that approximately ten million people visited its exhibits annually,
either at IBM facilities or at permanent IBM installations at various science centers
or museums (including the Chicago and California Museums of Science and Industry;
the Pacific Science Center in Seattle; the Cranbrook Institute of Science in Bloomfield
Hills, Michigan; the Hayden Planetarium in New York; the Morehead Planetarium in Raleigh;
and the Smithsonian). As an IBM memo from that year regarding expanding the IBM
Exhibit Program in 1974 and 1975 stated, "It is in IBM's best interests to assemble a
selection of portable, interactive computer terminal exhibits . . . in an effort to bring exhibits
to the people rather than relying on the general public to visit a few science centers or
museums. . . . Most of IBM exhibits have dealt with the history of technology, mathematics
and historical concepts and their inventors. Few exhibits have been developed that
make use of computer equipment or describe the computer."[68] While its stated ambition
was to render the computer exhibit more ubiquitous by using computers themselves,
IBM required a firm strategy for this distribution and specific form of the computer to
accomplish its aims.

The Heuristic Environment: The "IBM Museum"

We do not seem to have yet the appropriate view of how the computer is changing the world.
It is perhaps the great mass of the prosaic, day to day computer jobs that will have the most
far-reaching effect on our society, and our new views of philosophy. The exciting and exotic
computer applications are periferal [sic] manifestations. Each day one billion calculations per
second for each man, woman and child.
Charles Eames[69]

IBM had in fact recognized the imperative to create exhibits that would introduce the visitor
directly to the computer as early as 1960. As Mathematica was nearing completion
and at the same time as he offered the Eames Office the commission for the World's Fair
pavilion, IBM vice president Dean R. McKay approached Eames with a second ambitious
project: to create what was initially formulated as an IBM Information Center (Figures
4.20–22). The Information Center—referred to by Eames, Noyes, and IBM staff as the
"IBM Museum and Exhibition Center," or "the museum" for short—was to be a part of

the Armonk campus, as an accompaniment to the projected Corporate Headquarters building. The Noyes office did a site study for the museum in late 1962 and 1963;[70] though little documentation survives, it is clear from correspondence and extant reproductions of design drawings that the Eames, Noyes, and Roche-Dinkeloo offices, in addition to IBM staffers, worked on the project up until 1970, when funding for the project was pulled due to financing difficulties.[71] At that point, the research on the history of the computer and design work that the Eames Office had done—over the course of ten years—was truly massive, amounting to boxes upon boxes of materials, notes, slides, and models,[72] and IBM still maintained the goal of presenting its customers and the public in general with a historical narrative about the sources, development, and nature of the computer. A compromise was, evidently, reached: first, the Eames Office was commissioned to design a permanent installation on the history and basic concepts of computing called the IBM Presentation Center in the IBM branch office in Washington, D.C., a temporary version of which Noyes had already designed; second, the Eames Office designed a smaller scale (but no less ambitious in concept) temporary exhibition, called *A Computer Perspective,* which opened at 590 Madison Avenue in 1971.

That IBM sought to posit its activities as the culmination of scientific and technological history was not new in 1960; indeed, it had been the policy of the corporation since its earliest days under Watson Sr. Watson was no intellectual, but he did have what one might call an intuitive understanding that placing IBM at the vanguard of scientific progress was a good sales pitch. Furthermore, his quintessentially bourgeois anxiety about having culture provoked him, as we have also already seen, into collecting art. By the early 1950s, this hobbyism as advertising had coalesced into a formidable (if not entirely remarkable) collection, most of which was owned by IBM itself and administered by its own Department of Arts and Sciences. Although most of the works were landscape paintings—ironically for a corporate manager, Watson seems to have had a terror of abstraction—and benignly decorative works of sculpture, Watson had also encouraged the corporation to create one of the largest collections of reproductions of the writings and works of Leonardo da Vinci. The purpose of the collection, which was arranged in 1951 into a traveling exhibit available to any museum willing to pay the costs of moving the pieces, was, like Watson's frequent pronouncements about IBM's control over time and space, to position the company at the end of a great narrative of scientific and artistic achievement. The Leonardo show—which featured codices, paintings, technical drawings, and even models built by IBM engineers from those drawings—drew on the public reverence for that great humanist and both served as an exemplar of corporate cultural generosity and helped to humanize IBM through association.[73]

The museum project was originally undertaken with a similarly propagandistic mindset; as with *Mathematica* and the World's Fair pavilion, the aim was to simply focus the Eames Office's popularizing talents toward a (suitably whimsical but undeniably factual) explication of the computer. However, as the project progressed—parallel to IBM's growing concern with and investment in System/360—it became evident that the stakes were in fact much higher.

This identity crisis is crystallized almost perfectly in a 1964 memo from the IBM behavioral psychologist and ergonomist Serge Boutourline to IBM's director of communications research Robert S. Lee, in which Boutourline outlined the emerging contours of a crucial problem for IBM: the eventual use of computers by "non-specialist users." Boutourline began the memo with a tripartite assumption: that in the future computer "users will not become computer experts but will simply use computer services in their everyday work schedules"; that "IBM has always had an interest in concern for the efficiency and well-being of individual users of its equipment and equipment services"; and that "if these users found their use-patterns unpleasant or inefficient eventually the client companies would be affected and IBM's business would suffer."[74] In sum, "the non-specialist computer user will expect and want IBM to have a responsibility to him personally, regardless of mediating agents between IBM and this user. . . . IBM could profitably develop an 'individual-centered' identity with the non-specialist user group that would be 'IBM relevant' and 'IBM-beneficial.'"[75]

Boutourline insisted that "the more personally and (in a temporal sense) immediately involved a person tends to be, the more he tends to blame something or someone else for his troubles."[76] He illustrated the point by a peculiar analogy of the difference between a nonspecialist and a highway engineer both stuck in the same traffic jam. While, argues Boutourline, the nonspecialist would tend to "blame 'New York City,' 'Los Angeles' or some other large agency that presumably has overall responsibility," the highway engineer, "in understanding the discretions which *were* available to him and the great constraints which make it unlikely that one agency is responsible for *this* situation is more likely to start focusing on *himself* as the cause of the blame."[77] From this parable of the highway, Boutourline concludes that "the new non-specialist users *are* amateurs . . . [and] a deficiency in service to a particular individual is likely to be very complex (including, as it does, various mediating agents between the user and the machine, the work load on the system, etc.). Clearly this is a situation where it is probable, if not inevitable, that IBM will be 'blamed' for various service deficiencies by non-specialist users."[78] Though his recommendations do not extend to any specific changes in the way in which computers themselves would be designed, he did insist that IBM change the way in which computers should be described. Addressing the Corporate Communications Department in Armonk, Boutourline stressed that

the central credibility which IBM must establish with the new user group is that IBM *in principle* cares about the individual user. . . . Users must believe that if they (for any reason), have difficulties that they have someone to go to. . . . It is my suggestion that IBM develop a line of argument which demonstrates that, in fact, its business depends today in large part on good individual user experiences, and that *many things in IBM's future point to the same conclusion. This kind of demonstration . . . is absolutely necessary because of IBM's present association with large-scale devices where no single human is benefited very directly by the operation of the device and no human is required as part of the direct operation of the device itself.*[79]

Boutourline repeatedly stressed the importance of successfully navigating the historical juncture he posited between the inhuman and the human eras in computing. The concluding section of the memo, and the longest, is thus titled "Legal and Moral Problems of Man–Computer Relationship." Citing "Bell Telephone's early insistence on the individual's rights of privacy" and their "broader understanding of *what the telephone would have to become in people's lives* if it were really to be widely accepted," Boutourline insisted that IBM must likewise arrive at "an understanding about *what the computer will have to become in future users' lives* . . . for only then can IBM know the *general kind of company* it will have to become to successfully deal (and be recognized as trustworthy) in the broader public domain."[80] Finally, by way of illustrating the sheer magnitude of the problem, Boutourline cited a series of ethical and legal dilemmas, concluding with the Turingesque question of the "'deception of the individual' at a [computer] terminal. Should an information retrieval device inform an individual that the information available to him is being modified based on the questions he asks? Should a patient in a mental hospital be told that he is 'talking' (via a typewriter terminal) to a computer program?"[81] Boutourline considered it imperative that IBM conduct "a full investigation of the moral and legal problems of man–machine computer usage" and to "begin building an IBM competence in this important aspect of the new computer environment."[82]

Eames responded directly to these concerns; however, he argued, Boutourline's concerns about ethics and blame were in the end wholly "superficial." What really mattered was the user's experience. According to Eames, there were two "strands" of "disturbingness" about the computer:

One is a (superstitious?) repugnance to machines getting too clever, because the distinction between machines and people seems to be threatened. . . . The other strand is in a sense more realistic; this is *fear of the computer as an instrument of centralised power,* and as instrumental in the making of decisions that can affect the lives of people—decisions against which they have little or no redress, because no human individual can be called to account for them. If a computer can assemble, store, and keep available for the use of the authorities, personal data from different sources about employees of a company, students in a university—ultimately, citizens of a nation—this is clearly a great administrative convenience; *but it is hardly conducive to the individual's feeling that he is being treated as an individual.* And this situation is compounded, first by the use of computers to predict the behaviour of people and groups (behaviour they would prefer to think was free and thus unpredictable) and further by the use of computers to calculate optimal strategies—in marketing, in management in general, and even in diplomatic and military contexts.[83]

On a page of notes written in preparing a report on the museum project Eames explained the goal of emphasizing the historical "development of computers and brains that shaped them."[84] The problem was one of emphasizing the "fact of visibility, [that] completely answers some questions . . . obviates many of the superficial questions in [the] public's mind." Glen Fleck later clarified the idea, scrawling on the same page, below Eames's

notes, "Chartres vs. pictures—reality of stuff—closeness through authenticity—etc." The reference was to a point Eames made frequently in his lectures, both to public and corporate audiences, and in the promotional imagery for the Eameses' various exhibitions, such as *Mathematica*. In short, the Eames Office saw the resolution of the problem of the computer's "disturbingness" as a simple matter of placing the "non-specialist user" in front of a computer specially designed to address her concerns: once one was familiar with the computer, any remaining epistemological crises would be swept away by what Eames called the "excitement of the computer world." The point would be made that "the human memory man (storage) and the human mathematical calculator (reckoner) do not function in the same way as formal mechanical devises *[sic]*."[85]

This line of thinking led to the office's first systematic presentation of the project to IBM in the form of the aforementioned report, titled "Overall Museum Philosophy & Goals," in 1967. To confront IBM's "most significant P.R. problem," the Eames Office provided a "suggested theme" for the museum: The "promise of the computer as a tool to enrich the individual. *Computer based interaction devices—through which [the] individual will directly / immediately experience a new sense of mastery and freedom.* [The] computer can increase his creativity and freedom of choice—in concrete situations by making enormous amounts of information available, *adapted to an individual's needs.*"[86] Rather than relying on a strategy that too often appeared defensive and self-incriminating—for example, "The computer is just a tool. Man is necessary to give it meaning. Symbolism is not true essence—only physical reality is"[87]—IBM would create an architectural counterenvironment from which visitors would "leave . . . feeling a little more at home with the computer—and sufficiently at ease with the idea that they can position the computer in relation to their own daily decisions."[88]

Thus, what had originally appeared to IBM as a technological and ideological problem was at once transformed into an aesthetic problem. This is not to say that the technological and ideological aspects would be ignored; rather, with the architects' intervention these were sublimated into a new discipline of the experiential, the ergonomic. In this respect, Eames's approach to naturalizing the computer reminds one of Pascal's dictum that "All our reasoning ends in surrender to sensation"—or, as Louis Althusser once paraphrased the sentiment with respect to his "inversion" of the theory of ideology with regard to matter and form: "Kneel down, move your lips in prayer, and you will believe."[89] This inversion—that is, of beginning the process of naturalization not with an abstract concept that lies underneath or before the act of making, but rather allowing an abstract concept to develop out of the interaction between subject and object, thus masking an a priori contradiction or conceptual indeterminacy—is of crucial importance in understanding Eames's and IBM's project. The aesthetic experience of the computer is neither purely functional—that is, a matter of pure efficiency, as measured by any of various psychological, biometric, or productive techniques—nor in any sense a matter of revealing hidden truth. Following Eames, the design of the interface between human being and machine that will naturalize the latter and supplant its uncanniness with an unquestioned

and unquestionable experience of usefulness was and is, rather, a heuristic process. That is, both the process of educating the individual to perceive the computer properly and the process of designing the computer to address the individual so as to efface any questions concerning the computer's ontological instability vis-à-vis the human being are a matter of "placing a pupil, as far as possible, in the position of a discoverer," in which "the pupil is trained to find out things for himself."[90]

The modern terms "heurism" and "heuristic," which derive from the Greek for "invention" or "discovery," emerge as the name of a particular branch of the logic of organization.[91] Despite numerous shifts in definition and application, one might say that the concept retains two primary axes of significance. The first axis, mentioned already, is that pertaining to pedagogy. A heuristic process is one in which learning something is always already at stake, and moreover, one that is structured as a kind of game. In this game, the learner is placed in a controlled environment—bounded by strict rules of engagement—and allowed to explore that environment; it is, one might say, the converse of the Socratic method. As such, the power of irony (consisting in his false profession of innocence or lack of knowledge with respect to the object in question) that the Socratic examiner possesses over the student is transformed into quite another but equally powerful phenomenon, and it is this aspect of heurism or heuristics that forms its second axis of signification: the logic of doubt and the bypassing of doubt.

In its most common contemporary sense, the adjective "heuristic" refers to a particular mode of combinatory logic that has reached its highest development in the realm of computer science: according to *Webster's,* "relating to or using a problem-solving technique in which the most appropriate solution of several found by alternative methods is selected at successive stages of a program for use in the next step of the program."[92] At first glance, this appears to be a constructive form of logic, in which fundamental logical assumptions (e.g., A = B, B = C) are used to deduce more sophisticated logical conclusions (e.g., A = C). However, the actual character of heuristic logic is anything but constructive; it is, in fact, precisely the reverse. If we pay close attention to the logical structure of the definition itself, we find that the criterion for the selection of "the most appropriate solution of several" is not the rationale behind the initial assumptions, but instead their compatibility or lack thereof with regard to the requirements of "the next step of the program." In heuristics it is the program that assumes an a priori status, not the assumptions; said assumptions are bypassed or excluded on the basis of their indeterminacy vis-à-vis the logic of the program.

However, this heuristic method, although it appears to be a game, in which the student plays in order to gain knowledge experientially, must not be confused with the type of situation confronted in game theory—the "n-player game." The heuristic environment does not allow the human player to possess a crucial component of the game: the ability to choose strategically. The heuristic game is played by two players, but only one player matters. As the most critical and discerning popularizer of game theory, the mathematical

biologist Anatol Rapaport, makes clear, in the heuristic environment the game is played by only one participant, and the conventional agency of the players is reversed. He illustrates this with a simple and commonplace example:

Curiously, the slot machine can be considered a bona fide player. It makes choices (to be sure at random, but this does not matter) and receives payoffs. But the person who plays the slot machine only receives payoffs. He makes no choices, because the only thing he can do in each play of the game is insert a coin and pull the lever. Therefore he is not a bona fide player. He is only a dummy player.[93]

Thus we may see that the heuristic environment is better described as a "one-person game," and therefore falls outside of the scope of conventional game theory as defined by its inventors, von Neumann and Morgenstern, because the putative "player" is not in possession of the ability to choose a strategy and because said player lacks knowledge about the potential outcomes of a given play. Instead, the applied-mathematical discipline of operations research—the branch of applied mathematics that aims to maximize positive outcomes and minimize negative ones—constitutes the conceptual foundation of the heuristic environment, a fact that should hardly surprise us given that the Eames Office was often working elbow-to-elbow with prominent researchers from IBM and the Rand Corporation in their Santa Monica studio on their projects for IBM. Pedagogically speaking, the one-person game (but also one-player game, with the player being the machine or environment) is a matter of occluding the workings of the game itself (for the person cannot have the knowledge of a player), focusing attention elsewhere, upon some principle, fact, or concept that bears only a loose relationship to the environment doing the teaching.

The play occurring in the heuristic environment is thus not the ludic activity of the child-at-play, but rather that of a semantic play between homology and ontological difference. As Jean Baudrillard has noted of the performance of the automaton,

When the illusionist [acting as a robot], at the pinnacle of his artistry, renders his own gestures mechanical and subtly changes his own appearance, his intention is to bring out his performance's true *raison d'être,* which is the pleasure to be derived from the difference between the automaton and the man. His audience would be far too alarmed if they were really unable to tell which figure was "real," and he knows full well that creating a perfect automaton, and hence a perfect identity, is far less important than giving play to difference—and, indeed, that the very best outcome is that the spectators should take the machine for the man and the man for the machine.[94]

Thus the heuristic in its instrumental sense is circumscribed by a fundamental doubt, a limit of indeterminacy, as its other axis of meaning indicates: "Serving to guide, discover, or reveal; *specif. valuable for stimulating or conducting empirical research, but unproved or incapable of proof—often used of arguments, methods, or constructs that assume or postulate what remains to be proven* or that lead a person to find out for himself."[95] As

an IBM scientist described the concept in a relatively early article in the *IBM Journal of Research and Development* on the value of heuristics in computer science (in which the term today retains its instrumental significance, but not its characteristic aporia), "For the moment . . . we shall consider that a *heuristic method* (or a heuristic, to use the noun form) *is a procedure that may lead us by a short cut to the goal we seek or it may lead us down a blind alley.*"[96] This statement is particularly apt because it highlights the radical closure of heuristic logic due to the assumption of process that must be risked in order to perform it. The heuristic aesthetics Eames had developed into a full-fledged design logic from his very earliest work with Saarinen and Noyes—and central to the work of numerous other designers, including (but not limited to) Nelson and Rand—because of its very structure, had precisely such stakes attached. Either architecture, understood in Eames's all-encompassing sense, would become everything, or it would become nothing at all, cut off from its previously sustaining traditions and left with no basis not self-same with some other phenomenon: the goal or the blind alley, in a double-or-nothing throw. In their work on the IBM museum project, and in the immediate aftermath of it, the designers in the Eames Office and their collaborators approached this limit, at which point the consequences would become clear, with alarming speed.

In the early conceptual designs for the museum, Glen Fleck figured this new relationship between the individual user and the computer by taking up a suggestion floated in an internal IBM memo from 1962, forwarded to the Eames Office by Lee, titled "A museum of computer science run by a computer."[97] Written in response to a series of discussions Lee had had with another IBM researcher, D. L. Holzman, on the successes and failures of pedagogical experiments he had conducted with Boutourline at the IBM exhibit at the Seattle World's Fair,[98] the memo stressed "that we are on the threshold of revolutionary developments in the museum and exhibit field, and that IBM should be the first to exploit the possibilities that have opened up as a result of our own efforts."[99] The IBM exhibit at the Seattle World's Fair, with the theme "New Paths to Knowledge," had confirmed, at least partially, Lee's working hypothesis:

I suspect that the reason for "museum fatigue" on the part of visitors is that there is an oversaturation of environmental demand. . . . Despite the limited amount of learning that takes place at the cognitive level, exhibits can have strong *experiential* impact as they can exploit the fact that the visitor is physically present and that all his sense modalities are available for communication.[100]

None of the exhibits at the Seattle fair was in fact run by a computer; however, the "number maze" served as a powerful illustration of the value of such "experiential impact" (Figure 4.19). The maze, designed along with the rest of the pavilion by the Philadelphia-based firm Carreiro Sklaroff Design Associates with the architect Charles Broudy and landscape architect Karl Linn consulting, immersed visiting children in an environment made up solely of "number walls" painted on four-foot enameled panels and mirrors. Walking toward the painted numbers and away from their reflections in the mirrors would guide them through the maze by the shortest possible route. This discovery could only be

made, however, by thoroughly exploring the maze and engaging both sight and touch, as the spatial illusions created by the mirrors were found to be dead ends. Moreover, the students of this heuristic environment were led away from recognizing their position in space by mirrored, perspectival self-images and encouraged to replace these with a new, abstract system. The "basic message" of the ubiquity of Boolean logic was thus demonstrated in the form of "simple and dramatic," if counterintuitive, spatial relationships, and not only for the children. Parents watching from the surrounding raised garden would thus see the normal task of minding their children transformed into demonstrations of the "yes-no decisions . . . involved in computer decision making."[101]

The promise of such exhibits lay, to Lee's mind as much as to Eames's, in just such environmental immersion, and the influence of this line of thinking is clear in the design of the pavilion for the New York World's Fair two years later. However, while the Information Machine was a more elaborate version of the simple maze, it still fell far short of the ideal degree of interaction between human being and machine that this design logic required. All of the IBM exhibits, from *Mathematica* to the "Information Machine," for all of their visual, aural, and even haptic intensity, remained purely metaphorical. What was needed was a truly computerized space. As Lee speculated,

it may be technologically feasible to have an entire hall or museum of programmed interaction exhibits run by a computer in conjunction with portable input-output boxes by which visitors would get instructions from and respond to the computer. Furthermore, each visitor could be given a number and could then be carried through an integrated sequence of programmed interaction exhibits especially geared for his own level. . . . In addition, it may even be practicable to have the computer adapt the museum experience of each particular individual depending on his reactions to various test questions at different periods in the sequence. It is probably also possible for the computer to keep an individual record so that the visitor could briefly review and then pick-up where he left off when he returns to the hall at a later date.[102]

Figure 4.19 Carreiro Sklaroff Design Associates with Charles Broudy and Karl Linn, Number Maze, IBM Pavilion, Seattle World's Fair, 1962. Courtesy of IBM Corporate Archives, Somers, New York.

The museum would thus need to be what Fleck came to call a "computer arena" (Figure 4.20) in which the user's contact with the computer and its attendant concepts would be a series of interactions with any number of interfaces; these would guide the visitor through a heuristic "programmed interaction." The "parlor and coal cellar" division would thus be upheld in precisely the same manner as it had been in designing IBM's commercial computers, except that rather than the stark geometry of a System/360 installation, here the museum exhibits/interfaces would be of the whimsical sort: toy soldiers representing binary code, automated board games, and models, all taking up the circus aesthetic that had prevailed in the office's work throughout the 1960s, particularly in the design of the New York World's Fair pavilion.

Sometime after Noyes finished his site study and work on the pavilion had concluded, the Eames Office set to work on articulating precisely how the computer would be able to sustain such "programmed interaction." According to Fleck, the main goal of the exhibits, as they were designed in the early developmental stages, developed alongside those eventually installed in the IBM pavilion at the New York World's Fair, was to create "environments which have a built-in feeling of interest."[103] In the museum, this could be achieved through a play on the word "interest" (Figure 4.21): each museum visitor would receive a token, which could then be spent on or invested in a particular exhibit. Upon the completion of the lesson, the machine would dispense another token or perhaps several, which could then be spent on yet other exhibits. The principles (if not the techniques!) of Monte Carlo mathematics were to be taught in a "casino," in which the "suspense" and "familiar but exotic" qualities of gambling would be "exploited" in an effort to provide an introduction to the computer.[104]

Although it would certainly be an attraction for the education and entertainment of the public, the museum was thus also intended as "a research laboratory in the field of communicating ideas."[105] The initial experiment followed from the operative premise of the museum: that the computer needed to be related to the human body. A "binary counter" would register the five-digit binary code passing through the computer's processing unit with automaton toy soldiers, who could indicate "one" or "zero" by raising their arms; another exhibit, a "binary fountain" would allow visitors to insert their fingers into one or more of five streams of water, changing the stream's state from "one" to "zero" and then witnessing the change in the overall complex flow of water through the fountain. A further development of the "peep show" concept explored in *Mathematica*—this time using sturdier 16mm film, fiber-optic displays, and even 5″ Sony color television screens—was proposed, and Fleck designed various new configurations, including one model in which the screen and audio apparatus is lowered over the visitor's head "like a hairdryer,"[106] thus immersing the experimental human subject in a computerized multimedia counterenvironment at the scale of an individual human body. Other exhibits included "a collection of terminals where the visitor will experience direct contact with the computer" in a series of "short but not trivial . . . man–machine games."[107] One such game would ask the visitor to press a button as quickly as possible after he saw

Computer Arena

c Real computer hooked to a group of sattelite displays...

A search to find aspects to demonstrate which an IBM computer guy would agree are significant in relation to the problems at hand — in effect... not-trivial, unembarassing... an invitation to an interesting larger problem.

Figure 4.20 Glen Fleck, conceptual sketch of "Computer Arena" for IBM Information Center, ca. 1965–69. Copyright 2011 Eames Office, LLC (eamesoffice.com).

Figure 4.21 Glen Fleck, design sketches of "computer casino" and "peep show" interfaces for IBM Information Center, ca. 1965–69. Copyright 2011 Eames Office, LLC (eamesoffice.com).

a light on the interface go on, measuring his reaction time against that of the computer; another was a literal version of the Turing Test, in which the visitor would ask questions via a computer terminal of two respondents, one the computer and another a concealed fellow visitor, and would be invited to guess which was which.

Also included in most of the projects by Roche and Fleck was an "experimental theater," which would allow IBM not only to screen its previously commissioned Eames films—from the relatively mundane *Information Machine* and *An Introduction to Feedback* to their more ambitious multiscreen reprises of the mid-1960s—but also to provide a "laboratory" for producing additional experimental educational cinema, and even theatrical presentations. One sketch section by Fleck even shows a fly house over a stage, with space behind for stage sets. These experiments could then be practiced upon the visitors, further helping IBM articulate a properly aesthetic interface between human being and machine. While there is no indication that this theater was directly controlled by the computer ostensibly running the museum, this was in all probability one of the Eames Office's ambitions.

All things considered, Eames rightly argued from the beginning, the usual architectural typologies associated with the traditional museum could hardly apply to the IBM museum; another architectural form would be needed that could accommodate a "climate in which new techniques can be tried before using in Exhibitions, fairs, etc." Eames suggested to the architects Noyes selected for the project, Roche-Dinkeloo, that the design should "reflect the experimental laboratory in its adaptibility—easy access to air, water, electricity throughout—hanging and plug-in hardware, etc."[108]

Architectural drawings from the office of Roche-Dinkeloo[109] indicate that at least two separate schemes for the museum emerged from this core idea, while plan sketches by Glen Fleck suggest the existence of at least two more, although each fittingly preserves the courtyard topology endemic to IBM office and laboratory architecture after 1956. However, there are significant differences between the designs, which seem to correspond to the development of the museum exhibits over the course of the decadelong design process, as well as the varying amount of money earmarked for the project at different junctures. Unfortunately, none of them can be accurately dated, though it is likely that all were made sometime between 1965 and 1969.[110]

While identical in program, the two earliest schemes, represented by Fleck's sketches, differ in the extreme: one shows a freestanding building arranged on a nearly nine-square plan, while the other proposes integrating the museum into the Armonk headquarters building directly beyond the main lobby. The former scheme is organized around a central gallery area in the form of a Greek cross, beveled at the corners, with attendant service spaces at the corners. The latter scheme (Figure 4.22)—nearly a building within a building—has its own lobby and massive exhibition hall at the center, with offices and service spaces on the left and right. The main exhibit hall at center

opens out onto a terrace overlooking a formal garden. These designs clearly reflect a program requiring approximately fourteen thousand to seventeen thousand square feet; as the design process progressed, however, the program eventually more than doubled in size, reaching forty thousand square feet by February 1969.[111]

This larger project does not differ greatly in program from the earlier ones, with the exception of an additional "computer showroom" near the lobby and provision for a greater amount of storage and potential expansion space.[112] A computer-drawn perspective rendering of the interior, probably made by IBM for the Roche-Dinkeloo office, was produced of this scheme and included in the Eames Office's film presentation of the project in 1969.[113]

Despite these significant differences in scale, all of the schemes preserve a definite continuity of concept. The exhibition spaces, which housed the interfaces and laboratory spaces, were segregated spatially from the actual CPU, which was either buried below ground in a basement space or installed in a second-story room overlooking the exhibitions. Thus, the museum was a kind of parlor of an even more radical kind than the white computer rooms of System/360 and its predecessors; here, computerized space was like something out of *The Wizard of Oz:* as the unwitting visitors moved about inside the computer's interiorized interfaces, they would "pay no attention to the man behind the curtain." As Eames described the museum in a filmed pitch to Watson and his fellow executives at a retreat in Vail that year, the space was designed as a perfect heuristic illusion:

The visitor's first impressions of the museum are of spaciousness . . . and of the activity and excitement that await him in the "see-through" interior. The transparent glass walls, which provide sound barriers but not visual barriers, allow glimpses of the many things to see and do in the different areas of the museum.[114]

Figure 4.22 The Office of Charles and Ray Eames (Glen Fleck, lead designer) and Roche-Dinkeloo, project for an IBM Information Center, Armonk, New York, 1960–70. Plan for third and final project, ca. 1969. Copyright 2011 Eames Office, LLC (eamesoffice.com).

Computer-generated perspectives of the interior of the museum that flashed across the screen, intercut with photographs of exhibit models, heightened the effect—to the extent that one could almost miss the main point, which was that the visitor was wholly immersed in a building that was in fact a computer.

Along with McKay, Eames and Noyes clearly lobbied Watson and his fellow executives intensely over the development of the project.[115] However, the final presentation in Vail failed to convince IBM of the necessity to spend several million dollars on a high-tech building in the suburbs, when the company already had a sustained program of exhibitions in its existing, high-profile, showroom in Manhattan. More than fifteen years after Noyes began the IBM Design Program with his redesign of the 702 showroom, the center of IBM's self-representational apparatus would once again return to Madison Avenue. The new project, given the working title *The Computer Idea in the 20th Century,* was to be headed by Fleck, with the Harvard University historian of science I. Bernard Cohen as "consultant and critical conscience."[116] It was to include an Eames film and several exhibits based on the Eames Office's decade of research and design. (The film, *A Computer Landscape,* which depicted computers being dismantled and reassembled and their various uses by computer specialists, dramatically violated both the "parlor and coal cellar" and naturalizing principles that had guided IBM's Design Program almost from the start, and it was excluded from the exhibit.)

Computerized Perspective

The exhibit, eventually renamed *A Computer Perspective* (Figures 4.23–26), opened on 17 February 1971 at the IBM building on Madison Avenue in New York and closed more than four years later, in mid-1975. The exhibition reiterated many of the themes and techniques already discussed, incorporating aspects of the *Computer Glossary* and *A Communications Primer* and reusing several of the interactive exhibits from *Mathematica* and the World's Fair pavilion. Although the exhibition fell somewhat short of the ambitious plan for the IBM Museum, the Eames Office was nevertheless able to develop new and more sophisticated spatiotemporal idioms in its effort to communicate the natural/ magical essence of computing. While at the World's Fairs visitors were strategically and perspectivally displaced in an effort to figure a specific process (homology through numerical abstraction), in *A Computer Perspective* multiple narratives and multiscreen technologies were deployed in a more direct way, positioning the viewer in a reciprocal visual, spatial, and temporal relationship to the ontological uncertainty of the computer. Rather than establishing metaphorical relationships between everyday events and computational processes (as in the early films and in the Information Machine), the Eames Office designed a new "information machine" called the Communications Rack (Figures 4.24–26).[117]

Whereas the Information Machine had been primarily theatrical in its structure, the Communications Rack was intended to be a fuller, more synesthetic simulation of the

computer counterenvironment. The rack itself was really a system of Formica and polished chrome panels suspended in space on an aluminum frame. Vaguely I-shaped in plan, the rack had two ends: the "TV-end," on which three CRTs showed a multiscreen film of images of computer parts and people poached from *A Computer Landscape,* and a "shelf-end," which held a scale model of an IBM System/360 computer and several computer controls such as buttons and dials attached to the panel above. Between the two ends were two bays, one housing a system of six slide projectors and three additional CRT screens (Figure 4.25), which displayed live feed from three video cameras taping six other slide projectors arranged so as to project overlapping images in a remote room, and the other a series of macrophotographs of the internal parts of various IBM computers.

The projectors in the former bay projected images through a translucent panel, directly at the viewer. The CRT screens, covered with green and blue colored filters, showed overlapping images—created by pointing two slide projectors at one another and inserting a clear piece of plastic between them at a 45-degree angle. The two sets of images were thus set up in stark contrast to one another, the former projected outward first onto the translucent panel and then onto the viewer herself, the latter rendering otherwise illusionistically three-dimensional images into abstract images of utter flatness on the CRT screens. Over this structured chaos of images, a stereo audio system overhead played a looped original score composed by Elmer Bernstein with improvised jazz percussion by Shelley Manne.

Figure 4.23 The Office of Charles and Ray Eames, *A Computer Perspective,* 1971. Aerial perspective of design of exhibit, ca. 1970. Copyright 2011 Eames Office, LLC (eamesoffice.com).

Underfoot, the viewer moved over a grid of tiles designed by the Eames Office, each one displaying a striking white-on-black diagram of a computer component.[118] Depicting various wiring matrices, chip metalization patterns, assembly sections, analog to digital converters, and connectors, each tile was a simplified technical drawing; all of the diagrams were either plans or sections of computer parts, blown up to the scale of the floor tile, imparting an architectural quality to their tiny referents. Viewed in close juxtaposition to the models, projections, and photographs, the tiles created a sense of slippage between very different spatial scales, concretely connecting the microtechnological to the haptic. One walked on, around, and through these representations of computers, identifying human and machine spaces with one another. The tiles were clearly meant to evoke the tiled flooring of computing rooms—which had appeared in Computer Landscape—that concealed the "coal cellar" components of the computer. The floor, with its plans and sections of computer parts, thus served as a heuristic device, allowing a seemingly free discovery of the interiority of the computer that was in fact simply yet another patterned surface.

The second bay was identified by the Eames Office as the "House of Cards Bay" (Figure 4.26) because it redeployed the macrophotography technique they had used in their original House of Cards toy of 1952, and in a subsequent set of cards produced a year earlier for IBM's exhibition at the Osaka World's Fair of 1970.[119] It similarly played with scale, flatness, and depth of field, albeit in other media: instead of geometric patterns and photographs of toys, the images here were of transistors, wiring, chips, and other computer parts. The photos, without captions, were arranged in an orthogonal fashion on a central white Formica panel, and additional photos were mounted on two chrome panels set at ninety degrees to the central panel on either side. On the white panel, off center, was an inset text (the only text in the Communications Rack besides one vaguely describing the overlapping TV images) that read as follows:

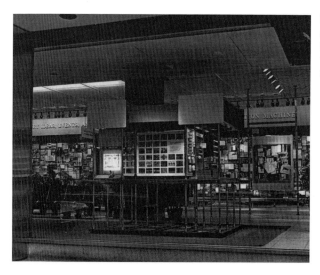

Figure 4.24 The Office of Charles and Ray Eames, Communications Rack, *A Computer Perspective*, 1971. View. Copyright 2011 Eames Office, LLC (eamesoffice.com).

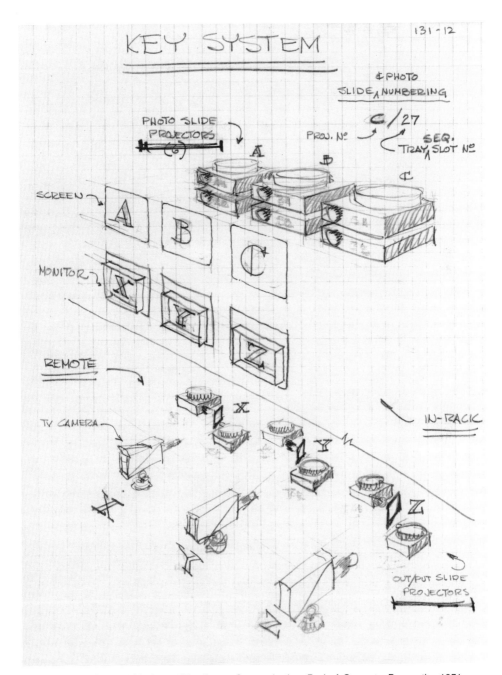

Figure 4.25 The Office of Charles and Ray Eames, Communications Rack, *A Computer Perspective,* 1971. Sketch diagrams of CRT and slide projector displays. Copyright 2011 Eames Office, LLC (eamesoffice.com).

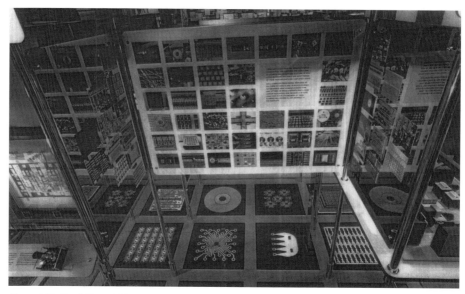

Figure 4.26 The Office of Charles and Ray Eames, Communications Rack, *A Computer Perspective,* 1971. View of "House of Cards Bay." Copyright 2011 Eames Office, LLC (eamesoffice.com).

These are images from the intimate internal landscape of the computer. The view is one of richness and variety and also one of very little movement. The finest and most precise of these working parts are completely static.

Had a computer professional been able to see these pictures in 1950, he would probably not recognize what is shown in more than half of them. We should perhaps take a good look at such images now, because it is quite likely that in our lifetime many of these elements will become all but invisible to the human eye.[120]

The purported intimacy of the computer's "internal landscape" was underlined by the play of reflections between the chrome panels. A viewer, stepping into the bay, would find the photos of wires and circuit boards, switches and knobs superimposed over multiple reflections of her body receding toward a vanishing point in a virtual space of infinite extension. The motionlessness of the computer parts, however, was set in sharp contrast to the viewer moving—with both eye and body—through this virtual space, lending a sense of agency to the subject in the face of the seemingly solid objectivity of the computer.

The aim of the Communications Rack was thus quite clear, even in its strategy of deliberate confusion: to create a highly paradoxical spatial experience that mimicked precisely the spatial dynamic of the computer itself. The visitor's perspective is simultaneously radically extended, through macrophotography and the overhead view provided by the model, and dramatically destroyed, through the play of overlapping reflections and hypermediation of the television screens and polished chrome mirrors. The Communications Rack reproduces the spatial logic of the white or war room, in which a telescopic

dominance over space (and a certain illusion of omniscience) is only achieved through the creation of a space dedicated first and foremost to absence and enclosure from the environment observed and controlled. The coming invisibility of the "internal landscape" of the computer is represented through a trope of transcendence: it disappears from space only so as to become immanent to it. The Communications Rack figures the happening of this transcendence at the level of the individual human perceiving subject by translating computerized perspective into human terms: through the miniature architecture of this disorienting and titillating pavilion, the Eames Office offers a glimpse into the future mediation of perception through computers.

Regarding this last point, it is essential to notice that there is also a temporal dynamic at work in the Communications Rack and in the exhibition as a whole. Eames's warning that the viewer had best observe the inanimate, intimate space of the computer before it disappears alerts us to the presence of a peculiar historical narrative about the computer that was posited in various forms throughout the exhibition. The most direct and didactic example of this narrative was the History Wall, a dense quasi-linear timeline of overlapping images and texts that traced the history of the development of the modern computer from 1890 to 1950.

The History Wall drew upon the pedagogical and display techniques that the Eames Office had developed in conjunction with Alexander Girard and George Nelson in the 1950s.[121] While the images and texts were laid out below a cornice marked at even intervals by the six numbers indicating the beginning of each decade, below any sense of order was less immediately legible. Here photographs, film stills, facsimiles of book and magazine covers, invoices, patents and other documents, machine parts, and text panels all protruded from the wall at various depths in six eight-foot-wide cases each three feet deep, overlapping and competing with one another for the attention of the viewer. An additional set of caption texts, screened directly onto the glass enclosing each case, provided yet another layer of information.

Based on a massive amount of research by Glen Fleck and a large cast of IBMers[122] and the contributions of numerous experts in the history of science and technology, the History Wall drew the seemingly disparate events and artifacts leading to the development of the modern digital computer into a kind of historical tapestry. As Eames stressed in his subsequent lectures, the wall's narrative did "*not* [represent] a coherent planned development; if one gets any impression from the Wall it's that; no single line."[123] Rather, the wall interwove three chronological threads: the emergence of the modern computer out of calculating machines, statistical machines, and logical automata.

Wide at the beginning, the scope of the History Wall steadily narrowed as it approached the development of the concept underlying the design of the modern computer: the von Neumann architecture. As the Eameses' primary consultant, the historian of science I. Bernard Cohen, wrote of this historical threshold:

Almost all at once an unanticipated flexibility of operations and power was disclosed, with the result that the computer became transformed from a machine for calculating numerical results to the multipurpose machines that have become so dominant an element in almost every aspect of our society—government, industry, commerce, science, social science, education, any kind of short- and long-term planning, and even writing.[124]

However, at that point, at the moment von Neumann achieved his radical extension of the heuristic concept to provide computers with the capacity to "think," which was illustrated with various early computers of World War II and the late 1940s, the wall simply stopped (just short of the hydrogen bomb, it is hard not to notice), almost as if in mid-sentence. The viewer, who had been viewing the wall with her back turned on the rest of the exhibit, then turned around to face a display opposite the wall. Running the full length of the room was a row of actual IBM machines arranged in roughly chronological order, beginning with Hollerith punch-card machines, early scales and typewriters, and ending with a functioning IBM 2250 graphics display unit running data from the 1970 U.S. Census. An "epilogue panel" stood some distance from the History Wall, offering a sketch of the "beginning of the first commercial electronic computers" from 1950 onward. The point was clear enough (and common enough, in corporate exhibitions touting the historical significance of their product): IBM was the point to which this complex history had arrived and through which it must pass.

As if to figure this very passage, an opening in the History Wall allowed the visitor to reenter the present (which, as we have seen in the world of computing, is always also the future): a functioning IBM System/360 Model 40 installation humming away in a storefront room beyond, just as the Noyes-designed 702 installation had nearly twenty years earlier. Numerous addenda to the exhibit expanded its historical scope over the four years it was installed in New York—on Newton, Babbage, Copernicus, and Kepler, and on biology and astronomy, all designed by the Eames Office.[125]

In sum, the Eames Office's exhibitions and films manufactured a multivalent series of interfaces with the public at large, holding in tension the contradictory essentialisms regarding human being and computer that had previously so perplexed IBM's public relations arms. Charles Eames in particular—with the crucial technical help of Parke Meeke and Glen Fleck—developed a theory for naturalizing the computer that not only relieved fears of a nascent posthumanism, but also loudly proclaimed that future's arrival. Thus, it could only be due to Eames's savvy intervention that IBM could sponsor, in 1967, a television series on the technological and social impact of the computer, titled *The Computer and the Mind of Man.*

This series compared the two entities named in the title from a variety of perspectives, inviting philosophers, sociologists, and engineers to comment on the changed nature of the human mind in the face of computing technology. The final episode asked the question, "Will machines ever run man?" It concluded with an evocative image of a "man looking

out over the ocean," as the narrator intoned, "The situation of man and the computer has been described as 'man's first encounter outside himself with something that is exactly like some inside part of himself.'" As the man on the beach stared into tide pools, and then again out to the horizon as the screen faded to black, the episode ended with the following reflection by De Carlo:

I view technology as at once a crushing weight on the individual, but on the other hand an enormous opportunity to understand himself and to reflect and assess where he wants to go, [and] at the same time realize that he has to fight the battle within himself to remain a biological mechanism.[126]

Just as Michel Foucault famously observed, only a year earlier, that the human sciences had developed a wholly contingent view of the human being as susceptible to being washed away as a figure traced in the sand at the edge of the sea,[127] De Carlo acknowledged the passing of humanist notions of "man" and the "individual" even as he confirmed that its status as a "biological mechanism" offered no way back to a putative humanistic past.

The Eames Office understood this problem well—perhaps better than De Carlo and his scientific colleagues at IBM. In what was probably its most honest film to date on the computer, *A Computer Perspective*,[128] the office replaced the apparent failure of *A Computer Landscape* with a kind of quiet manifesto (it was never widely shown) summarizing the consequences of the computer in the twentieth century and pointing the way forward. Toward the end of the ten-minute film, a quasi-hallucinogenic swirl of computer graphics—some of them animated and sped up dramatically—is intercut with aerial photographs of SAGE, NORAD at Luke Air Force Base, the Rand Corporation building in Santa Monica, and the Urban Laboratory at UCLA. Over this dramatic montage depicting the computerization of both space and perspective, the narrator (none other than Gregory Peck) proposed that this "new world" demanded that "we develop new languages." The "languages" of the past, we are meant to understand, have already been superseded—the future of both design and everyday life will be narrated in FORTRAN, COBOL, and Coursewriter II.

Conclusion

Virtual Paradoxes

The age of media (not just since Turing's game of imitation) renders indistinguishable what is human and what is machine, who is mad and who is faking it.

Friedrich Kittler

The End of the IBM Design Consultancy and Its Simulacra

Now, with an overview, if not of the entirety, then at least of a reasonable cross-section of the IBM Design Program, several questions arise. First, and most generally: to what extent was Noyes's and IBM's attempt to redesign design—to reformulate design, previously conceived as an authorial act in one or another medium, into a systematic and anonymous logical process carried out simultaneously in various media—successful? In a televised interview with Noyes in 1966, just as RECD was gaining momentum and taking over the reins from Noyes in governing IBM's architectural endeavors, the architecture critic and historian Reyner Banham asked him, "how will you hand on your power? Is there enough momentum inside the company or have you got to find and train another person?" In an obvious bid at continuing his quest to find the source of what he called an "Other Architecture,"[1] Banham grinned and answered his own question before Noyes could respond: "You see the sneaky conclusion I'm working 'round to. This man might not be a designer." Noyes, for his part, answered tellingly,

It could happen of course. Adriano Olivetti was such a man. I haven't seen it happen much. One of the things that I've been able to do, and really needed to do, I think, was direct the programme also by example setting. [Pointing to a slide of the IBM Development Laboratory.] You see the first modern building that IBM built, I built for them. I said, you see, that you can do it this way, and I got in there and started designing typewriters, and I then had to fight for my foothold in those areas. But I've insisted with all the companies that I work for that I'm really an architect and industrial designer, and that as a third profession or activity I'm willing to consult rather intensively, but I'm not willing to consult *only;* and if they're not going to give me these jobs to do, I'm not going to accept the assignment; so my mix as a guy who performs, as well as talks, is very important to me, and I don't know if I could run the programme without both.[2]

At this critical juncture in the design program, in the wake of the release of System/360, Noyes ultimately felt that he had, despite his collaboration and leadership in creating a collective and autogenerative mode of design—whether through the *Design Guidelines* or through RECD—preserved his autonomy as an author, but only by retaining control over individual architectural projects. The role of the traditional architectural author remained, to be sure, but only (in the best scenario) as an exemplar, to set a standard to which the automated and autonomous production of corporate architecture could then aspire. The architect of the corporation had already become a diffuse set of relations.

Eames acknowledged this state of affairs in a response to a questionnaire circulated to various designers by the curators of a 1969 exhibition at the Louvre, provocatively titled *Qu'est-ce que le design?* (What Is Design?). The exhibition put this provocative question, among others, to the participating designers, in response to a perceived crisis in the identity of design. No longer associated with the humanist tradition of *disegno,* or with the modernist discipline of the Industrial Revolution and its aftermath, the definition of design was undergoing rapid change. As the Belgian art historian Henri Van Lier wrote in the

introduction to the catalog for the exhibition, what had changed was the introduction of an "information explosion":

In the aftermath of the Second World War, and concurrently with the information explosion, design reformulated its problems in the terms of communication theory. It is at this moment that the industrial object, just as all other objects, appeared as a bundle of messages, according to its forms, its handling, its functions. These different messages, denoted (direct) and connoted (indirect), evidently assume codes, i.e. conventions ... and consist of redundancies, in other words repetitions and insistence, the better to understand them.[3]

In the face of this new status for the industrial object, all aspects of the ontology of design were, in the minds of the curators, called into question.

Eames responded to the questionnaire not only with pithy and coy answers (e.g., "Q: What are the boundaries of design? A: What are the boundaries of problems?") but also by drawing a pair of diagrams. The second, more famous diagram, which eventually appeared as the Eameses' manifesto-like statement in the exhibition, was abstracted from the first. In the earlier sketch (Figure C.1), "R & C" (Ray and Charles) appear at the center of a sprawling web of individuals, corporations, institutions, and events, in what is at once a topological analysis and a historical description of their practice. ("EERO," appearing in one of the circles nearest their own, had been dead for eight years, and "Moscow," referring to their multiscreen projection *Glimpses of the U.S.A.* for USIA in 1958, was

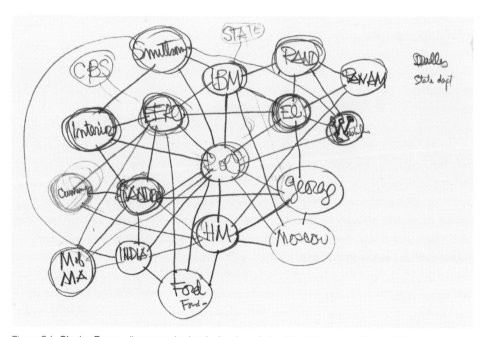

Figure C.1 Charles Eames, diagrammatic sketch showing relationships between the Eames Office and other designers, corporations, and projects, from the exhibition *Qu'est-ce que le design?* Musée du Louvre, Paris, 1969. Copyright 2011 Eames Office, LLC (eamesoffice.com).

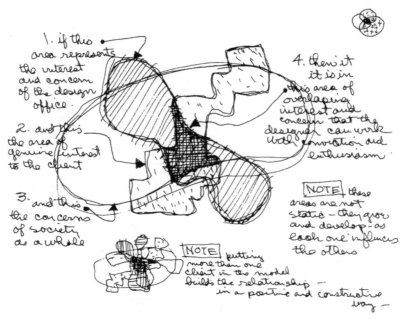

Figure C.2 Charles Eames, diagrammatic sketch showing overlapping "areas of interest," from the exhibition *Qu'est-ce que le design?* Musée du Louvre, Paris, 1969. Copyright 2011 Eames Office, LLC (eamesoffice.com).

then a decade gone.) "El"—Eliot Noyes—is depicted as a nearby element in the flowchart, in turn connected to IBM, Westinghouse (depicted by a sketch of Rand's "W" logo), and many of the other corporations for which he consulted. The work of the Office of Charles and Ray Eames, in short, was implicated in a network of individuals and institutions—both producing it and produced by it.

The second diagram (Figure C.2) went through numerous drafts before it was finalized for publication,[4] but the idea behind it remained the same throughout. Essentially a topological diagram translated into an if–then statement, it is composed of three overlapping, amorphous, and shaded enclosed areas—the first representing "the interest and concern of the design office," the second "the area of genuine interest to the client," and the third "the concerns of society as a whole." The area where all of these overlap (following the "and" rule of set theory) is heavily shaded. If this is the case, Eames wrote, in step four of his logical deduction, "then it is in this area of overlaping interest and concern that the designer can work with conviction and enthusiasm." This shaded area indicated the bounds of the first, the "area" in which Eames had worked "with conviction and enthusiasm" for over two decades.

Although Eames, Noyes, and their fellow consultants had indeed worked to construct these overlaps and to occupy them over the course of their careers, they had—as Banham hinted—also labored to design themselves out of corporate design. When Noyes died unexpectedly of a heart attack in 1977, and when Eames passed away the following year, IBM did not deign to replace either of its leading consultants. A design system was

in place, and it only required consultants in minor areas. Rand stayed on, eventually design-ing a playful new logotype—the "Eye Bee M" pictogram (Plate 8)[5]—in 1981, although he soon moved on to other corporate clients (including Steve Jobs, who commissioned Rand to design the logo for his line of NeXT computers). Richard Sapper was given responsibility for overseeing graphic and industrial design in the European laboratories, but the rest of Noyes's and Eames's responsibilities were distributed to a cadre of thir-teen design managers.[6] The Noyes office's last building for IBM, fittingly a management training campus in Armonk, was finished four years after his death—in the same year that the IBM 5150 personal computer was announced. The consultancy was over, its goal of rendering itself obsolete achieved.

This achievement noted, however, the coherence of the postconsultancy design program at IBM was greatly weakened in Noyes's absence. The IBM PC, with its greyish boxy exterior, was hardly a great achievement of industrial design, despite its excellent sales; and Rand's pictogram logo was a violation of every rule he had established in the pre-ceding years regarding the sanctity of IBM graphics.[7]

Second, if the rather brash claim at the outset of this book that the IBM Design Program constitutes a determining case in the mutual imbrication of architecture, corporations, and information technology, what impact did it have upon these fields as wholes? This is a question that lies well beyond the scope of this book to answer, the argument here being to establish both the rough outline and fine points of the design program itself, in the hopes that other scholars of this period may find in it resonances, parallels, and even direct relationships. That said, however, the IBM program produced any number of immedi-ate heirs, simulacra of Noyes's and IBM's effort to redesign design, that deserve mention.

The first such program was at Westinghouse Electric Corporation, for which Noyes served in a nearly identical capacity as consultant director of design, beginning in 1960.[8] At the time, Westinghouse was known primarily for its consumer products, although after an involved tour, Noyes discovered to his surprise that it was a company with twice as many employees as IBM (albeit half the profits), involved in technologically sophisti-cated and far-flung research and development projects in areas ranging from military vehicles to nuclear power. He described this revelation to the industrial design press several years later:

Westinghouse is easy to think of as a maker of household appliances. But three-quarters of their business is in a vastly more important and exciting area—the development and distribution of power. What they are doing has implications for the safety of the country, possibly even the survival of the planet. So if you start looking at Westinghouse in those terms . . . you get a quite different notion about how it ought to look.[9]

Despite these important differences, just as he had at IBM, Noyes immediately turned to Rand, who redesigned their corporate logo (Figure C.3), and Eames—who, among

many other projects, created the film *Westinghouse from A to Z,* which created a taxon-omy for the individual consumer of Westinghouse's activities, showing that Westing-house's production methods for household appliances and nuclear reactors alike were intimately related activities. For his part, Noyes designed several buildings for Westing-house, including the Tele-Computer Center near Pittsburgh, of 1964.[10] This building was designed for the real-time management of Westinghouse's global resources, and the reader will hardly find it surprising that it resembles in almost every particular the courtyard/fortress buildings that Noyes and others had designed for IBM. While the Westing-house building used UNIVAC computers (the effective real-time management software for the IBM System/360 was still a year or two off), it was a courtyard building much akin to the buildings he had designed for IBM.

In some respects, Noyes's approach to the Westinghouse consultancy benefited from his earlier and current experiences at IBM. As he had at IBM, he preserved his professional and authorial autonomy to a certain extent, directing numerous projects for Westinghouse in his own office; these ranged from product redesign to an ambitious scheme for a new public transit system for Pittsburgh, and the office also produced prototype designs for an electric car.[11] In 1964 Noyes designed the Westinghouse pavilion for the New York World's Fair, a strange, flying-saucer-like affair. However, Noyes also changed his approach to better systematize Westinghouse's entire design process. Although he com-missioned special architectural projects from numerous architects (such as a molecular electronics plant designed by Vincent Kling in Baltimore, of 1966–68), he also created a generic prototype for Westinghouse's WESCO distribution warehouse buildings; at least thirty of these were built across the country in collaboration with local architectural firms throughout the 1960s. The company commissioned Knoll Associates (now the Knoll Design Company) to design office interiors across the country as well, creating a streamlined building-production scheme and standardizing the appearances of the corporation's offices. And unlike IBM's Design Program, in 1966 Westinghouse eventu-ally built a centralized Design Center, with interiors by Noyes, in the company's research campus in Pittsburgh, housing thirty-one designers and managers, organized into three

Figure C.3 Paul Rand, Westinghouse logo, 1960.

departments, tasked with overseeing "every visible manifestation of Westinghouse."[12] To help supervise this center, Westinghouse hired away the IBM industrial designer C. F. Graser (who had played a crucial role in the design of System/360) in 1964. Thus, in many aspects, the systematization of the Westinghouse program, though younger than IBM's, advanced quickly, achieving the sophistication of IBM RECD's apparatus within less than a decade.

Several other Noyes consultancies followed, of which the most thorough-going was for Mobil Oil, begun in 1964.[13] Here, with a corporation less far-flung in its activities than either IBM or Westinghouse, Noyes was able to move quickly. Rather than look to the overstretched Rand, Noyes turned to the graphic designers Ivan Chermayeff and Tom Geismar to redesign the logo and signage for the corporation's vehicles and buildings, famously separating the company's Pegasus mascot from the logotype and changing the color of the "o" in the company's name to red. Noyes pursued the redesign of Mobil's vast network of filling stations within his own office. The result, the ubiquitous, flexible yet iconic circular gas pumps under circular canopies, tied together the company's publicly accessible architectural presence with its logo through the shared circular motif.

Noyes repeated his successes with multiple other corporations, as either a consultant or designer, and often as both: Pan American Airlines, redesigning plane interiors and commissioning a new graphic design regime; Xerox, redesigning the company's New York showroom in 1963 (although a conflict of interest with IBM forced him to stop work for Xerox soon after); Cummins Engine, for whom the Noyes office redesigned engines and the interior of CEO Irwin Miller's private jet; and North American Rockwell, for whom the Noyes office produced (alongside other firms, such as Loewy/Snaith and Teague Associates) habitability studies for NASA's first space station, Skylab.[14]

Although the designs that Noyes and his fellow consultants produced for all of these varying corporations were markedly different in character and appearance than the IBM projects and products discussed in the preceding chapters, this is wholly consonant both with the core of Noyes's theoretical approach and with the thesis pursued in this book. On the one hand, Noyes, as "curator of corporate character," took care to express in his and his collaborators' designs a unified and systematic set of statements regarding both the look and the organizational structure of the corporation in question. On the other hand, the nature of Noyes's approach to corporate design—as communication, as logistical, as managerial—teaches us to look at the designs not for any repetitive stylistic quality, but for each object's status as a component of a larger communicative and functional apparatus.

When it comes to assessing the impact of the IBM Design Program on architectural culture beyond the immediate design consultancy, the matter is slightly more difficult. Although it eventually became a corporate exemplar of the school of thought known as design methods, the design program itself did not always contribute directly to the integration of computational techniques—ranging from software for determining building

programs to computer-aided drafting suites—into the everyday practice of architecture. These, as was argued in chapter 2, were primarily the province of engineers and computer scientists (although the efforts of architects such as Christopher Alexander, Nicholas Negroponte, and Yona Friedman also resulted in significant contributions). The effects we may detect are more subtle and indirect. Only part of the legacy of the IBM Design Program is in such technical feats and the program's reproducibility in formal terms at other corporations; its significance extends rather to determining essential aspects of the technical and aesthetic integration of computers into everyday life, from professional ambits to the most basic elements of our personal lives. The IBM Design Program shaped, through various media, the contemporary image of computation for a vast public well outside of the computer lab.

Information Art?

This point is important, since emphasis on the aesthetic outcomes of the design program can all too easily be misunderstood as an emphasis on the beauty of its products, as a matter of imagism. I have argued throughout that the outward appearance of objects is only of secondary importance when considering how these objects (and indeed systems of objects, processes, and concepts) came to be. Even considered as a surface, the interface is anything but superficial. As we have seen, the graphics, machine casings and I/O devices, curtain and cellular walls, and exhibition techniques that related the human being to the computer and corporation alike all played a determining role in the way these machines interact. However, art and architectural history all too often remain mired in the institutional imperatives toward aestheticization, fixing machines as objects rather than as apparatuses, as images rather than as interfaces.

A clear, if perhaps unfair, example of this stagnating trend may be seen in the trajectory of MoMA's three explicit efforts to come to terms with the machine. Alfred H. Barr and Philip Johnson's *Machine Art* exhibit, of 1934, famously posed the question—subject to heated contemporary debate[15]—of whether or not a machine may be considered "beautiful" and in so doing achieve the status of "art." How could a design be "the unconscious result of the efficiency compelled by mass production"?[16]

More than two decades later, Arthur Drexler concluded his review of the museum's design collection with a description of "The New Machine Art," illustrated with a color photograph of an IBM RAMAC control panel (Figure C.4). Drexler begins promisingly:

Most often the design of machines is not consciously guided by aesthetic considerations. But in technology as a science, the more limited aesthetic decisions may be, the more significant are their effects. For this reason Machine Art still offers important clues to emerging concepts of design, the word design being understood not only in its conventional sense but also as a broad approach to the making and organizing of objects.

Figure C.4 IBM RAMAC control panel, 1958. From Arthur Drexler and Greta Daniel, *Introduction to Twentieth Century Design from the Collection of the Museum of Modern Art* (Garden City, N.Y.: Doubleday, 1959). Courtesy of the Museum of Modern Art, New York.

Since the end of World War II electronics has altered our conception of how things need to be shaped in order to work, and of how they may be related to each other. . . . The new machines are incomprehensible unless one knows about the existence of invisible forces.

So far, so good; however, addressing the circuit board as an image, he quickly loses his way.

Perhaps the most striking characteristic of the new machine aesthetic is its dematerialization of finite shapes into diagrammatic relationships. Examples are the printed electrical circuits, which replace separate three-dimensional objects with groups of patterns printed on a flat surface. Such patterns can hardly be said to have precise boundaries, or to be complete in themselves. This is also evident in a three-dimensional design such as the control panel from a RAMAC computer, with its clusters of colored wires arranged on a panel according to the requirements of computer operations. . . .

Dematerialization and pattern relationships recall similar ideas in painting, most notably in the work of Jackson Pollock.[17]

Now the significance of the "invisible forces" that animate the RAMAC, that relate it to other objects, is lost, and Drexler is left with a vague, embarrassing formal comparison to a painting. Drexler leaves us with no real sense of what is "new" about "New Machine Art."

Cara McCarty's *Information Art* exhibition, of 1990, was another self-conscious attempt at returning to the provocation of *Machine Art* with a more technologically sophisticated set of objects, hoping to gain new insight into spectral images of information technology and their significance for modern culture. Yet the exhibit consisted solely of photographs of logic circuits, framed and mounted on the walls as pictures. As McCarty admitted, unwittingly anticipating a point that the media theorist Friedrich Kittler would make several years later, there was no making sense of these images from a technical point of view. All that could be done by the art historian in the face of the sheer complexity and opacity of these images was to appreciate them as images. McCarty suggests as much by making use of an early draft of Drexler's confounding description of the RAMAC as an epigraph, but then goes on to make the point much more explicit: "But even if we never understand them, we can delight in their marvelously complex and variegated designs."[18]

The diagrams are indeed delightful as patterns; however, one in particular, a particular kind of "neural net" called a "foveated retina-like sensor" (Figure C.5) developed by IMEC and the University of Pennsylvania in order to give robots "active vision," interrupts our pleasure. Surely a diagram that is capable of staring right back at us demands a more critical art historical method.

It is plain from even this very cursory overview that when considered as an image, the problem is not the consideration of the computer or any other technology as art. Instead it is the fact that the interface produces the virtual; that is, it produces a misleading

Figure C.5 IMEC and the University of Pennsylvania, "Foveated retina-like sensor," ca. 1989. Courtesy of the Museum of Modern Art, New York.

and seductive surface that is "almost or nearly [the apparatus] as described, but not completely or according to strict definition."[19] The most successful interfaces present images of connection and interrelatedness, power, and ubiquity, even as they interpellate individuals, producing what we might call a paranoid sense of well-being. That the interface performs this work does not herald the emergence of a radically new kind of image—after all, the *ikon* and other forms of religious imagery have been doing the same for centuries—but rather of yet another technical reconfiguration and remediation of the image with vast political implications.[20]

It is my hope that an expanding critical art history of the computerization of art, design, and architecture—one that is the product of multiple historians and theorists in dialogue, one that sheds light on the ideologies inherent to the vague metaphorics of systems, networks, and interfaces even as it seeks to describe these phenomena—may help to avoid our being held hostage in the whimsical oxymoron and epistemological trap of "virtual reality."

Acknowledgments

I am extremely grateful to Paul Lascewicz, Dawn Stanford, and the staff at the IBM Corporate Archives in Somers, New York. Without their efforts in opening up the rich collections there to me, and without their generous help at each stage in my research and preparation of the manuscript, this book would never have been written.

Gordon Bruce has my sincere thanks for granting me time in the Noyes Archive well before his own monograph on Eliot Noyes had been published. My thanks also to Eames Demetrios for allowing me to study the archival collections of the Eames Office in Santa Monica, California, which proved an invaluable aid when I turned my attention to the Eameses' papers at the Library of Congress. Peter Papademetriou shared his sources on Saarinen's IBM laboratory in Yorktown Heights, which was very helpful. My original dissertation benefited greatly from my interviews with Nina Bremer, Gordon Bruce, Mary Brust, Sandy Garsson, Robert Gatje, Lee D. Green, James LaDue, John Black Lee, and Frederick Noyes; I am grateful to all of them for sharing their time and expertise. Alexandra Lange generously shared both the results of her archival research and her expertise on post–World War II architecture and design, and Kevin Stumpf gave very generous and constructive criticism of the second chapter, for which I am very thankful.

This book is based on my dissertation, and I was fortunate to have the support of both the Department of Art History and Archaeology at Columbia University and the Center for Advanced Study in the Visual Arts at the National Gallery of Art, which funded my research and writing for two years with a Chester Dale Pre-Doctoral Fellowship. I thank everyone at the Center, especially Dean Elizabeth Cropper and Associate Deans Therese O'Malley and Peter Lukehart; Professors Jean-Philippe Antoine, Stephen Bann, Stephen Campbell, and Alexander Nagel; and the other predoctoral fellows.

My graduate advisors, mentors, and friends Barry Bergdoll and Reinhold Martin have been tireless and wholly unselfish in support of my work. In the embarrassment of riches that was (and, when I have the opportunity to return there for research, still is) studying architectural history and theory at Columbia University, I continue to owe debts of gratitude to Mary McLeod, Robin Middleton, Joan Ockman, Kenneth Frampton, Jonathan Crary, Felicity Scott, Branden Joseph, and Janet Parks. My undergraduate advisor, Dietrich Neumann, has been a wonderfully generous critic, mentor, and referee.

Colleagues and friends from near and far contributed so much to the development of my thinking that it would be criminal not to list at least some of them here. In particular, Jesse LeCavalier is one of my dearest friends, collaborators, and a constant source of inspiration. My opportunity to work with the Aggregate group (Danny Abramson, Lucia Allais, Arindam Dutta, Timothy Hyde, Pamela Karimi, Jonathan Massey, Ijlal Muzaffar, Michael Osman, and Meredith TenHoor) not only let me participate in a vital process of experiment in architectural writing from which I gained much, but also provided a group of friends and colleagues who continually surprise me with the originality of their thought. I am likewise grateful to my friends and architectural historians Richard Anderson,

Cesare Birignani, James Graham, Teresa Harris, Hyun Tae Jung, Andrew Leach, Andrew Manson, Albert Narath, and many others who gave me much advice, criticism, and knowledge.

My colleagues at Oberlin College are very supportive, and I particularly note my gratitude to DeSales Harrison, Laura Baudot, Erik Inglis, Bonnie Cheng, Christina Neilson, Pawan Dinghra, Drew Wilburn, Sean Decatur, Kathryn Stuart, and David Breitman for their willingness to discuss my concerns and ideas at almost any hour.

Pieter Martin, Kristian Tvedten, the crack staff and board of advisors at the University of Minnesota Press, and the Quadrant program have also earned my profound gratitude for their support, courtesy, professionalism, and patience as this project developed. As always, I am eternally grateful to my family for their love and patience—my parents Brian and Janice, my brothers Michael and Scott, and my in-laws Stephen, Madeleine, and Julia Green.

Lastly, I could never have finished this book without the patience, love, and support of my wife, Jessica Green. I dedicate this work, as I do all else, to her.

Notes

Introduction

The Interface

The epigraph is from Reyner Banham, "(Thinks): Think!" *New Statesman,* 11 October 1965, 109–18; reprinted in Banham, *Design by Choice,* ed. Penny Sparks (New York: Rizzoli, 1981), 115–16.

1 Thomas Watson Jr. and Peter Petre, *Father, Son & Co.: My Life at IBM and Beyond* (New York: Bantam, 1994), 260.

2 On Behrens, see Stanford Anderson, *Peter Behrens and a New Architecture for the Twentieth Century* (Cambridge, Mass.: MIT Press, 2000), which, in addition to being the most thorough single account of Behrens's career, includes an exhaustive bibliography.

3 Walter Gropius, "Die Entwicklung moderner In-dustriebaukunst," in *Form and Function: A Source-book for the History of Architecture and Design, 1890–1939,* ed. Tim Benton, Charlotte Benton, and Dennis Sharp (London: Crosby Lockwood Staples, 1975), 53.

4 Ibid.

5 On Bayer and Container Corporation of America, see James Sloan Allen, *The Romance of Commerce and Culture: Capitalism, Modernism and the Chicago-Aspen Crusade for Cultural Reform* (Chicago: University of Chicago Press, 1983), and *Herbert Bayer, Collection and Archive at the Denver Art Museum* (Denver: Denver Art Museum, 1988). Other important recent efforts to assess the history of corporate architecture and design are Janet Y. Abrams, "Constructing the Corporate Image: Architecture, Mass Media and the Early Multinational Corporation" (PhD diss., Princeton University, 1989); Alexandra Lange, "Tower, Typewriter and Trademark: Architects, Designers and Corporate Utopia, 1956–64" (PhD diss., New York University Institute of Fine Arts, 2005); Hyun Tae Jung, "Organization and Abstraction: The Architecture of SOM from 1936 to 1956" (PhD diss. in progress, Columbia University).

The most common monographs on corporate design are those on Olivetti, which, it is well known, provided an initial spur to IBM's own design program. Yet despite cosmetic similarities between IBM and Olivetti (their business in office machines, the strong paternalism of their early leading figures), the two corporations hardly bear comparison in terms of their corporate structures and practices, economic importance, or even the means by which their designs were authored. Unlike IBM, Olivetti remained committed to the end to a patronage model of architectural and design production, and to a paternalistic corporate culture characteristic of the Italian context—in this regard, it is instructive to recall that Olivetti's headquarters in Ivrea is called the Open-Air Museum. If more evidence is needed to convince the reader of the fundamental difference between Olivetti and IBM in terms of design culture and production, and the lack of direct influence of Olivetti on IBM in anything but the impulse to organize a design program at all, it should suffice to cite chronology. Marcello Nizzoli's famous "spiral" logo for Olivetti was not designed until 1956, the same year in which Rand originally redesigned the IBM logo; Olivetti did not produce its first computer, the Elea 9000, until 1959, at which point Noyes and the industrial design firm of Sundberg-Ferar had already developed a modular ergonomic system for computers similar to that used in the Olivetti computer. The Elea 9000 was in fact designed just down the road from the Noyes and Associates Office in New Canaan, Connecticut, suggesting, if any connection can be made, that the formal relationship between Olivetti and IBM business machines is not a question of direct influence in a single direction.

On Olivetti, see Bernard Huet and Georges Teyssot, eds., "Politique industrielle et architecture: Le cas Olivetti," special issue, *Architecture d'aujourd'hui,* no. 188 (December 1976); Manfredo Tafuri, *History of Italian Architecture, 1944–1985,* trans. Jessica Levine (Cambridge, Mass.: MIT Press, 1988), chap. 2, "*Aufklärung* I: Adriano Olivetti and the Communitas of the Intellect"; Daniele Boltri et al., *Architetture olivettiane a Ivrea: I luoghi del lavoro e i servizi socio-assistenziali di fabricca* (Rome: Gangemi, 1998); Patrizia Bonifazio and Paolo Scrivano, *Olivetti Builds: Modern Architecture in Ivrea; A Guide to the Open Air Museum* (Milan: Skira, 2001); Rosano Astarita, *Gli architetti di Olivetti: Una storia di committenza industriale* (Milan: F. Angeli, 2000). Many more

articles on Olivetti, and the work of Nizzoli and Ettore Sottsass, could be listed here, but most are to be found in the most complete source of citations on the history of Olivetti, Eugenio Pacchioli's *L'Archivo storico Olivetti* (Ivrea: Associazione Archivio storico Olivetti, 1998).

See also Manfredo Tafuri's damning analysis of the "backward" industrial culture of Italy in his essay "Design and Technological Utopia," in *Italy: The New Domestic Landscape; Achievements and Problems of Italian Design,* ed. Emilio Ambasz (New York: Museum of Modern Art; Florence: Centro Di, 1972), 388–404.

6 Thomas J. Watson Jr., "Good Design Is Good Business," in *The Art of Design Management: Design in American Business* (New York: Tiffany, 1975).

7 For a very insightful architectural historical analysis of this question, see Michael Osman, "Regulation, Architecture and Modernism in the United States, 1890–1920" (PhD diss., MIT, 2008).

8 Eliot Noyes, speech at Yale University, 8 December 1976, quoted in Gordon Bruce, *Eliot Noyes: A Pioneer of Design and Architecture in the Age of American Modernism* (London: Phaidon, 2006), 146.

9 Ibid.

10 Quoted in Scott Kelly, "Curator of Corporate Character . . . Eliot Noyes and Associates," *Industrial Design* 13 (June 1966): 43. My emphasis.

11 *The Oxford English Dictionary,* online edition, "management."

12 Alfred D. Chandler Jr., *The Visible Hand: The Managerial Revolution in American Business* (Cambridge, Mass.: Belknap Press, 1977), 1. See also Richard Coase, "The Nature of the Firm," *Economica* 4 (1937): 386–405, which offers the first economic analysis of the integration of numerous "operating units" of business into a single enterprise; James Burnham, *Managerial Revolution* (New York: John Day, 1941), a book that describes this transformation as it was taking place; Oliver Williamson, *Corporate Control and Business Behavior* (Englewood Cliffs, N.J.: Prentice-Hall, 1970), based in large part on Williamson's study of Burnham; and journals that emerged around the

middle of the twentieth century such as *Management Science,* which sought to codify such consolidated business practices by elevating them to academic disciplinary or subdisciplinary status.

13 See Adolf A. Berle and Gardiner C. Means, *The Modern Corporation & Private Property* (New Brunswick, N.J.: Transaction, 2007), esp. chaps. 5–6, "The Evolution of Control" and "The Divergence of Interest between Ownership and Control," 66–116.

14 Chandler, *Visible Hand,* 3.

15 Steven W. Usselman, "IBM and Its Imitators: Organizational Capabilities and the Emergence of the International Computer Industry," *Business and Economic History* 22, no. 2 (1993): 1–35; David Stebenne, "Thomas J. Watson and the Business–Government Relationship, 1933–1956," *Enterprise & Society* 6, no. 1 (March 2005): 45–75.

16 William H. Whyte, *The Organization Man* (New York: Simon and Schuster, 1956).

17 The most crucial documents in this list of theories are summarized and cited in David Millon, "Theories of the Corporation," *Duke Law Journal,* no. 2 (April 1990): 201–62. See also Morton J. Horwitz, *The Transformation of American Law, 1870–1960: The Crisis of Legal Orthodoxy* (New York: Oxford University Press, 1992), chap. 3. The most important example of organicist corporate theory is Ernst Freund, *The Legal Nature of Corporations* (Kitchener, Ont.: Batche, 2000). The "nexus of contracts" theory is predominantly attributable to Coase, "Nature of the Firm," and developed as a historical theory by Richard R. Nelson and Sidney G. Winter, *An Evolutionary Theory of Economic Change* (Cambridge, Mass.: Belknap Press, 1982).

18 John Dewey, "The Historic Background of Corporate Personality," *Yale Law Journal* 35, no. 6 (April 1926): 655–73. Dewey borrows the term from A. N. Whitehead and C. S. Peirce.

19 Karl Marx, *Capital,* trans. Ben Brewster (London: Penguin, 1972), 1:932.

20 *Oxford English Dictionary,* online ed.

21 For a detailed and excellent description of just such a system, see Martin Campbell-Kelly, "The Railway Clearing House and Victorian Data Processing," in *Information Acumen: The Understanding and Use of Knowledge in Modern Business,*

ed. Lisa Bud-Feiermann (New York: Routledge, 1994), 51–74.

22 On the origins and theory of ergonomics, see John Harwood, "The Space of the Wound: Ergonomics and the Aesthetics of Survival," in *Aggregate I—Governing by Design: Modern Architecture and Crisis from Modernization to Sustainability,* ed. Arindam Dutta and Timothy Hyde (Pittsburgh: University of Pittsburgh Press, forthcoming). Numerous foundational texts of ergonomics are cited throughout this book.

23 For an exceptionally insightful critique of this insidious tendency of systems theories to produce tautologies and catachreses, see Lily E. Kay, *Who Wrote the Book of Life? A History of the Genetic Code* (Stanford, Calif.: Stanford University Press, 2000), chaps. 1–2.

24 Hubert Damisch, *The Origin of Perspective,* trans. John Goodman (Cambridge, Mass.: MIT Press, 1994), 151; my emphasis. Such a troubled approach often emerges in media theoretical accounts of sophisticated technological phenomena; see Anne Friedberg, *The Virtual Window: From Albert to Microsoft* (Cambridge, Mass.: MIT Press, 2006).

25 Jean Baudrillard, *The System of Objects,* trans. James Benedict (London: Verso, 1996), 67.

26 For an excellent, if only partial, investigation of the significance of the term "organic," see Joseph Rykwert, "Organic and Mechanical," *Res* 22 (Autumn 1992): 11–18.

27 Here I would include as exemplars, despite these works' many significant merits and the great extent to which I have relied on their insights, Roland Marchand, *Creating the Corporate Soul: The Rise of Public Relations and Corporate Imagery in American Big Business* (Berkeley: University of California Press, 1998); Pamela Laird, *Advertising Progress: American Business and the Rise of Consumer Marketing* (Baltimore: Johns Hopkins University Press, 1998); and Beatriz Colomina, *Domesticity at War* (Cambridge, Mass.: MIT Press, 2007).

28 I am hardly alone in attempting to give architectural history this agency. A few recent compelling examples of architectural historical critiques of institutions, deploying very different methods,

include Daniel Abramson, *Building the Bank of England: Money, Architecture, Society, 1694–1942* (New Haven, Conn.: Yale University Press, 2005); Carla Yanni, *The Architecture of Madness: Insane Asylums in the United States* (Minneapolis: University of Minnesota Press, 2007); and Lucia Allais, "Will to War, Will to Art: Cultural Internationalism and the Modernist Aesthetics of Monuments 1932–1964" (PhD diss., MIT, 2008).

29 Quoted in Herbert H. Swinburne, "Organization for Efficient Practice: 8. Eliot Noyes & Associates," *Architectural Record* 133 (March 1963): 164.

30 See, for example, Nicholas Negroponte, *The Architecture Machine* (Cambridge, Mass.: MIT Press, 1970); Negroponte, *Soft Architecture Machines* (Cambridge, Mass.: MIT Press, 1976); and William J. Mitchell, *The Logic of Architecture: Design, Computation, and Cognition* (Cambridge, Mass.: MIT Press, 1989).

31 An excellent, detailed history of this movement, with an expansive bibliography, is given in Alise Upitis, "Natural Normative: The Design Methods Movement, 1952–1967" (PhD diss., MIT, 2006).

Chapter One
Eliot Noyes, Paul Rand, and the Beginnings of the IBM Design Program

The epigraph is from Eames's handwritten notes in Box 217, Folder 9, "Burns . . . Lecture Tour, 1970," Charles and Ray Eames Collection, Library of Congress.

1 The following biographical information on Eliot Noyes is compiled from my interviews with Noyes's daughter Mary Brust (25 February 2002), his son Frederick Noyes (28 February 2002), and his former secretary Sandy Garsson (27 February 2002). See also Bruce, *Eliot Noyes.*

2 See Walter Gropius, *The New Architecture and the Bauhaus,* trans. P. Morton Shand, with an introduction by Joseph Hudnut (New York: Museum of Modern Art, 1936).

3 Barry Bergdoll, "Encountering America: Marcel Breuer and the Discourses of the Vernacular from Budapest to Boston," in *Marcel Breuer: Design and Architecture,* ed. Alexander von Vegesack and

Mathias Remmele (Weil am Rhein: Vitra Design Stiftung, 2003), 258–307.

4 On the Jackson House, see "They Extended Their House for the Children," *House and Garden* 25 (October 1948). I am grateful to Deborah Jackson for giving me this citation and a copy of the article.

5 See Siegfried Giedion, *Space, Time and Architecture: The Growth of a New Tradition* (Cambridge, Mass.: MIT Press, 1941), 233–45.

6 Noyes, quoted in Edward R. Pierce, "The Brick and Mortar of IBM," *THINK,* November/December 1975, 30–35. Box F46, IBM Corporate Archives, Somers, New York.

7 See Anderson, *Peter Behrens and a New Architecture,* and Tilmann Buddensieg and Henning Rogge, eds., *Industriekultur: Peter Behrens and the AEG, 1907–1914,* trans. Iain Boyd White (Cambridge, Mass.: MIT Press, 1984).

8 Peter Behrens, "Art and Technology" (1910), reprinted in Buddensieg and Rogge, *Industriekultur,* 214. My emphasis.

9 Reprinted in Hans Maria Wingler, *Bauhaus* (Cambridge, Mass.: MIT Press, 1969).

10 Buddensieg and Rogge, *Industriekultur,* 48.

11 See Horatio Greenough, *Form and Function: Remarks on Art, Design, and Architecture,* ed. Harold A. Small (Berkeley: University of California Press, 1947).

12 Sheldon Cheney and Martha Chandler Cheney, *Art and the Machine: An Account of Industrial Design in 20th-Century America* (New York: Whittlesey House, 1936), 55.

13 See Jeffrey L. Meikle, *Twentieth Century Limited: Industrial Design in America, 1925–1939* (Philadelphia: Temple University Press, 1979), chap. 2.

14 See Roy Sheldon, *Consumer Engineering: A New Technique for Prosperity* (New York: Harper and Brothers, 1932); Henry Dreyfuss, *10 Years of Industrial Design, 1929–1939* (New York: Pynson, 1939); Walter Dorwin Teague, *Design This Day* (New York: Harcourt, Brace, 1940); Harold Van Doren, *Industrial Design: A Practical Guide* (New York: McGraw-Hill, 1940); Raymond Loewy, *Never Leave Well Enough Alone* (New York: Simon and Schuster, 1951); Henry Dreyfuss, *Designing for People* (New York: Simon and Schuster, 1955); and Christina Cogdell, *Eugenic Design: Streamlining America in the 1930s* (Philadelphia: University of Pennsylvania Press, 2004).

15 John Dewey, *Art as Experience* (London: Penguin Perigee, 2005), 2–3, 12–13, 353.

16 Alfred H. Barr Jr., "Forward," in *Machine Art* (New York: Museum of Modern Art, 1934), unpaginated.

17 Walter Gropius, "Gropius Appraises Today's Architect," *Architectural Forum* 44, no. 5 (May 1952), reprinted as "The Architect within Our Industrial Society," in Gropius, *Scope of Total Architecture* (New York: Collier, 1952), 76.

18 Walter Gropius, "Architecture at Harvard University," statement on assuming role as professor of architecture at Harvard University, published in *Architectural Record* 81 (May 1937): 8–11, republished in Gropius, *Scope of Total Architecture,* 18. Gropius's understanding of the concept of "vision," however, was hardly constricted to the planning of the future; rather, he was increasingly interested in the management both of the literal design and of perception itself. Already something of an amateur psychologist, once in the United States he continued his investigation into Gestalt psychology and the physiology of vision. See also his essay "Is There a Science of Design?" *Architecture: Journal of the Royal Australian Institute of Architects* 42 (July–September 1952): 132, 136–37, 140 (or the republished version in *Scope of Total Architecture),* which features extensive diagrams of perceptual experiments and physiology.

19 Noyes was officially appointed by the Board of Trustees of MoMA and by the museum's director, Alfred H. Barr Jr.; however, the masterminds behind the creation of the Industrial Design Department were Philip Johnson, who had long been curating exhibitions out of the Architecture and Design Department on industrial and applied arts, and Edgar Kaufmann Jr., the design editor of *New Directions* and scion of the Kaufmann family of department store entrepreneurs. Both were close allies and friends of Gropius and Breuer. It was Kaufmann who played the largest role in shaping the program of the new department, laying out, in letters to Barr (25 January 1940) and to Nelson

Rockefeller (3 March 1940), a program for a yearly design competition and exhibition. Even though Kaufmann sprinkled disclaimers throughout his report suggesting that the business aspect was secondary (e.g., to Rockefeller: "I hope it is clear that we believe the only basis for this comparison should be good design, completely divorced from immediate sales possibilities"), the program of the department was clearly to further the development of commercial and artistic relations between MoMA, manufacturers, and retailers that had been fostered so carefully by Johnson from the late 1920s onward. As Kaufmann concluded his letter to Rockefeller, "Let me assure you once more of our very active desire to cooperate in the work of the Industrial Design department and to encourage it in any way that we can as an active business organisation." In writing to Barr, Kaufmann used slightly more high-minded language, but nonetheless invoked the potential of creating a new commercial market for modern design, when he wrote that the jury for the competitions "be partly composed of the previous year's competitors along with other interested people, thus building up the general public acceptance and personal moral responsibility of the leading designers in the country."

After the opening of the exhibition, there was considerable confusion about the relationship between retail corporations and MoMA. An article in *PM* magazine (12 October 1941) only mentioned the display in a shop window at Bloomingdale's and omitted any reference to the exhibition, prompting an angry letter to the editor from the museum's publicity department (Letter to the Editor, 17 November 1941). The museum was clearly at pains to preserve the furniture's status as high art, despite John Hay Whitney's admission in a speech in honor of the winners of the competition (transcript of "Remarks by John Hay Whitney, at luncheon—Museum of Modern Art, June 16, 1941," A&D Exh. #148, The Museum of Modern Art Archives, New York), in which he stated: "By definition, 'a Museum piece' is something worthy of exhibition in a Museum. By inference, it is something too rare and too precious, for common use." This put MoMA, he claimed, in

"the paradoxical position" of "launching so-called 'Museum pieces' for common use." A memo from Sarah Newmeyer of the MoMA publicity department to Noyes (19 August 1941) stresses over the course of several pages the need for keeping MoMA separate in the public eye from commercial interests, especially the nearby Bloomingdale's (A&D Exh. #148, MoMA Archives).

The outbreak of World War II prevented further competitions from taking place, but when Noyes returned to MoMA after the war, his last exhibition before leaving to establish his practice with Marcel Breuer, *Printed Textiles* (11 March–15 June 1947), was a competition organized along similar lines; once again, Kaufmann was directly involved both as juror and as a representative of his family's manufacturing and retail interests. On this exhibition, see A&D Exh. #375, MoMA Archives.

On the commercial and ideological aspects of MoMA's collaborations with industry in its later "Good Design" program under Kaufmann, see Terence Riley and Edward Eigen, "Between the Museum and the Marketplace," in *The Museum of Modern Art at Mid-Century: At Home and Abroad,* ed. John Elderfield, Studies in Modern Art 4 (New York: Museum of Modern Art, 1995), 150–79; and Greg Castillo, *Cold War on the Home Front: The Soft Power of Midcentury Design* (Minneapolis: University of Minnesota Press, 2010), 38–39.

20 The jury for the competition, which met in late January 1941, was Alvar Aalto, Alfred Barr, Catherine Bauer, Kaufmann, and Edward Durell Stone. "A committee of technical advisers from manufacturers of each main type of furniture, a lighting expert, and an authority in the field of textile manufacturing" were also present, although they had no vote. "Industrial Design Competition for the 21 American Republics," A&D Exh. #148, MoMA Archives.

21 Eliot F. Noyes, *Organic Design in Home Furnishings* (New York: Museum of Modern Art, 1941), inside front cover. The emphases of Noyes's architectural education at Harvard under Gropius and Breuer is evident throughout the book, particularly in the history of modern furniture design offered at the beginning. Noyes in fact wrote to Breuer on several occasions during the

planning of the exhibition, including two letters (15 and 24 July 1940) in which he announced plans to visit Gropius and Breuer at the "professor patch" in Cambridge with Kaufmann to ask for advice. A&D Exh. #148, MoMA Archives.

22 The New York department store Bloomingdale's collaborated in the production of the exhibit with a $15,000 donation to MoMA, in an arrangement stipulating that the store would receive exclusive rights to sell certain products included in the exhibition. The other department stores who entered into similar arrangements with the museum were L. S. Ayres & Company, Indianapolis; Barker Bros., Los Angeles; Famous-Barr Co., St. Louis; Marshall Field & Company, Chicago; Gimbel Brothers, Philadelphia; Jordan Marsh Company, Boston; The Halle Bros. Co., Cleveland; The J. L. Hudson Company, Detroit; Kaufmann Department Stores, Pittsburgh; The F. & R. Lazarus & Co., Columbus; and Wolf & Dessauer, Fort Wayne. The manufacturers were Cyrus Clark Co., Inc., New York; Ficks Reed Co., Cincinnati; Haskelite Manufacturing Corp., Chicago; Heywood-Wakefield Co., Gardner, Massachusetts; Moss Rose Manufacturing Co., Philadelphia; Mutual-Sunset Lamp Manufacturing Co., New York; Red Lion Furniture Co. and Red Lion Table Co., Red Lion, Pennsylvania; Valley Upholstery Corp., New York.

23 Transcript of "Remarks by John Hay Whitney, at luncheon—Museum of Modern Art, June 16, 1941." A&D Exh. #148, MoMA Archives.

24 Noyes, *Organic Design in Home Furnishings*. Both quotes are taken from chap. 7, "The Assimilation of the Machine," of Lewis Mumford, *Technics and Civilization* (New York: Harcourt, Brace, 1934), 363 and 356, respectively.

25 Mumford, *Technics and Civilization,* 357.

26 Besides Saarinen and Eames, the winning teams were Oscar Stonorov and Willo von Moltke, Martin Craig and Ann Hatfield, and Harry Weese and Benjamin Baldwin. Other teams were given honorable mentions. For the entire list of categories and awards, see the inside cover, facing page, of Noyes, *Organic Design in Home Furnishings*.

27 Eliot Noyes, "Charles Eames," *Arts & Architecture* 63 (September 1949): 43.

28 "Preliminary Report of the Jury—Industrial Design Competition," 27 January 1941, A&D Exh. #148, MoMA Archives.

29 The Bloomingdale's catalog is included in A&D Exh. #148, MoMA Archives. Before Noyes went to the Baltimore Museum of Art to lecture on "The Philosophy of Modern Furniture" in May 1942 on the occasion of the installation of a traveling version of *Organic Design* there, the exhibition's Baltimore curator, Leslie Cheek Jr., wrote to Noyes (24 April 1942) and attached a clipping from a local paper attacking the idea that a "chair . . . molded to an average human backside will be the ultimate in human comfort . . . consider: the human form is not static; it changes. The chair into which your svelte youth fits may be less comfortable in your fleshy forties and a rack of torture in your old age" (A&D Exh. #148, MoMA Archives). The critique made in the article presages post–World War II efforts at rendering ergonomic chairs more flexible; see, for example, Bengt Åkerblom, *Standing and Sitting Posture,* trans. Ann Synge (Stockholm: A.-B. Nordiska Bokhandeln, 1948), and Joseph Rykwert, "The Sitting Position: A Question of Method" (1958), republished in Rykwert, *The Necessity of Artifice* (New York: Rizzoli, 1982), 23–31.

30 "Museum to Show Prize Furniture," *New York Times,* 22 September 1941, quoted in Eames Demetrios, *An Eames Primer* (New York: Rizzoli/ Universe, 2001), 40.

31 Noyes, *Organic Design in Home Furnishings,* 11.

32 See Noyes, "Charles Eames," 43.

33 Interestingly, it was this drawing, and not the chair itself, that convinced the jury of the superiority of Eames and Saarinen's design, since prizes and inclusion in the exhibition were decided on the basis of drawings alone. The production of the actual pieces of furniture, especially in the case of the Eames-Saarinen pieces, was only achieved with some difficulty and at great expense, after the competition was already over. See ibid.

34 Noyes, *Organic Design in Home Furnishings,* 13–15. Noyes concludes his essay on "Chair Construction" with a caveat regarding the current difficulty of mass-producing such designs (12): "While these chairs as first produced must be expensive, the principle involved is sound and it

is reasonable to expect that with further develop-
ment the chairs shown on the following pages will
come into moderate price brackets."

35 Noyes, "Charles Eames," 44.

36 Charles Eames, "Organic Design," *California
Arts and Architecture* 58 (December 1941): 16.

37 In the course of their work on IBM exhibitions,
the Eameses later befriended several scientists at
the Rand Corporation, the main offices of which
were located just down the street from their own
in Santa Monica. Correspondence from Rand
employees, copies of their reports and articles,
and notes of their visits to the Eames Office are
preserved in the Charles and Ray Eames Collec-
tion, Library of Congress (hereafter cited as "CRE
LOC").

38 Noyes, "Charles Eames," 44.

39 Quoted in Ralph Caplan, "Doing Quality: A
Modest Proposal for Honoring Charles Eames,"
undated manuscript, Box 14, Folder 1, CRE LOC.

40 See Charles Eames, "Architecture in Min-
iature," *San Francisco Examiner,* 10 November
1958, Pictorial Living Section, Box 218, Folder 3,
CRE LOC: "The need to reinvestigate, restudy, and
restate old problems, is of course as much a part
of architecture and planning as it is of furniture.
We hope that architects will continue to use the
field of furniture as a human-scale proving ground
for directions in which they have faith."

41 Hannah Arendt, *The Human Condition* (Chi-
cago: University of Chicago Press, 1998), 153.

42 See the multiple letters to and from Noyes,
dating from late 1940 to December 1942, A&D
Exh. #375, MoMA Archives.

43 See Barry Katz, "The Arts of War: 'Visual
Presentation' and National Intelligence," *Design
Issues* 12, no. 2 (Summer 1996): 3–21.

44 On some of the problems generated by the
necessary normativity of ergonomics, see K. F. H.
Murrell, *Ergonomics: Man in His Working Environ-
ment* (London: Chapman and Hall, 1965), xix.

45 As many as 150,000 of the splints were
produced under contract with the U.S. Army, and
their success led to more work for the military
producing molded-plywood products. Probably
due to their valuable contacts either in the military
or working as military contractors, including Eliot

Noyes, who was then working on gliders for the
Pentagon as a test pilot and designer for the U.S.
Army Air Force glider research program, they
designed a nose cone for the CG-16 glider (also
known as the Flying Flatcar) and ergonomically
sound pilots' seats in 1943. The Eameses got the
capital necessary to start the project through a
partnership with John Entenza, with whom they
would later collaborate extensively on the design
magazine *Arts & Architecture* and the Case Study
House Program, and Colonel Edward S. Evans of
the manufacturing company Evans Products. See
Demetrios, *Eames Primer,* 43–44.

46 From his first experience flying gliders on
an archaeological dig in Iran in 1935–36, Noyes
maintained a lifelong fascination with flight. This
and the following information about Noyes's early
career and initial encounter with Watson were
obtained in interviews with Noyes's daughter
Mary Brust (25 February 2002), his son Frederick
Noyes (28 February 2002), and his former sec-
retary Sandy Garsson (27 February 2002). See
also Thomas J. Watson Jr. to Eliot Noyes, 20 April
1971, Box 66, Folder "IBM Project, 1967–72,"
Eliot Noyes Archive, Norwalk, Connecticut, and
Bruce, *Eliot Noyes,* 78–79.

47 Noyes collaborated closely on the design with
Ronald Dodge, Henry Beiderbecke, and Henry
Kleckler, all of whom remained design engineers
in the IBM Electric Typewriter Division throughout
the development of the IBM Selectric typewriter
as well. Eliot Noyes, "IBM Typewriter Design—
Models 'A' and 'B,'" TS, [1961], Box 7, unlabeled
folder, Eliot Noyes Archive.

48 Promotional pamphlet, "The New IBM Electric
Typewriter," Box 7, unlabeled folder, Eliot Noyes
Archive.

49 See note 47.

50 Eliot Noyes to Thomas J. Watson Jr., 19 Sep-
tember 1947, Box 52, Folder "Thomas J. Watson's
office," Eliot Noyes Archive.

51 See note 47.

52 M. Henris [IBM Patent Department] to Eliot
Noyes, 24 January 1949, Box 7, unlabeled folder,
Eliot Noyes Archive.

53 Letters in the Archives of American Art
(Breuer 5711/0256), dating from 22 July to 16

October 1947, document the Noyes-Breuer partnership in architecture and industrial design. The pair collaborated with each other on projects of both sorts, e.g., on the design of the Kniffin House on Long Island, New York (1949), and, according to Noyes's former partners John Black Lee (interviewed 27 January 2003) and Gordon Bruce (interviewed 2 April 2002), Noyes consulted with Breuer frequently on the redesign of the IBM 562 typewriter. I am grateful to Barry Bergdoll for sharing copies of the Breuer-Noyes letters with me.

54 Eliot Noyes to Charles Love [IBM Corporate Headquarters (CHQ)], 22 December 1948, Box 7, unlabeled folder, Eliot Noyes Archive.

55 Eliot Noyes, "The Shape of Things," *Consumer Reports,* April 1947, February 1948, July 1949. Noyes continued to write articles for *Consumer Reports* until the mid-1950s.

56 Noyes, "The Shape of Things," *Consumer Reports,* April and June 1947.

57 "Design Too Often a Sales Trick Noyes Tells New Haven Symposium," *Retailing Daily,* 21 April 1949, 31.

58 Eliot Noyes, "The Shape of Things," *Consumer Reports,* July 1949, 312–14.

59 Ibid., 312.

60 Thomas J. Watson Jr. to Eliot Noyes, 30 January 1952, Box 7, unlabeled folder, Eliot Noyes Archive.

61 Hugh B. Johnston, "From Old IBM to New IBM," *Industrial Design* 4 (March 1957): 50.

62 The following account of Watson's reorganization and redirection of IBM is summarized from Emerson W. Pugh, *Building IBM: Shaping an Industry and Its Technology* (Cambridge, Mass.: MIT Press, 1995), and Robert Sobel, *I.B.M.: Colossus in Transition* (New York: Times Books, 1981), Part II: "The Computer Wars."

63 Watson and Petre, *Father, Son & Co.,* 285.

64 On the transition, see ibid., chap. 23; William Rodgers, *THINK: A Biography of the Watsons and IBM* (New York: Stein and Day, 1969), chap. 14.

65 Watson and Petre, *Father, Son & Co.,* 285. The emphasis is Watson's.

66 Ibid: "named the previous year. Under his plan we took product divisions that we'd already established, tightened them up so that each executive had clearly defined tasks, and then turned the units loose to operate with considerable flexibility."

67 See *IBM Business Machines* 39, no. 19 (28 December 1956), the "Special Issue on Williamsburg Conference," which provides a detailed series of organizational charts and much decentralization rhetoric.

68 Watson and Petre, *Father, Son & Co.,* 286.

69 Ibid., 258.

70 On the design of the Olivetti showroom in Manhattan, see "What's Going on Here? Upper Case Showmanship and Lower Case Selling Win a Quick Reputation for Italian Business Machines," *Industrial Design* 1 (October 1954): 52–57, which quotes Dino Olivetti (Adriano's son) as saying, "The architects were planning to put some sculpture in front of the showroom window. I said, our typewriter is sculpture, why not put it there, like a merchant's symbol of what we are selling?"

71 Watson and Petre, *Father, Son & Co.,* 258. In all likelihood Watson is referring to the numerous advertisements and catalogs produced by the modernist graphic and industrial designer Marcello Nizzoli, who worked at Olivetti from 1938 onward. On Olivetti's comprehensive design program, directed by its owner and patriarch Adriano Olivetti, see Tafuri, *History of Italian Architecture, 1944–1985,* chap. 2, "*Aufklärung* I: Adriano Olivetti and the *Communitas* of the Intellect"; Huet and Teyssot, "Politique industrielle et architecture"; Bonifazio and Scrivano, *Olivetti Builds;* "Olivetti: Design in Industry," *Museum of Modern Art Bulletin* 20, no. 1 (Fall 1952); "Olivetti," *Architectural Forum* 97 (November 1952): 116–21; and Georgina Masson, "Olivetti: The Creation of a House Style," *Architectural Review* 121 (June 1957): 431–39.

As Reinhold Martin rightly points out, Huet and Teyssot identified the stakes of the strategic alignment of art with commerce in Olivetti's project as a matter of life and death for architecture. As they conclude the first page of their special issue of *Architecture d'aujourd'hui:* "A. Olivetti probably did not suspect himself that he was thus repositioning architecture in a new art market. The large American firms (IBM, Lever, Johnson, Seagram) had quickly understood the lesson: Henceforth, architects serve to fashion the 'corporate image.'

For architecture, this is without a doubt one of the last chances for survival in the capitalist system" (translation quoted is Martin's, *The Organizational Complex: Architecture, Media and Corporate Space* [Cambridge, Mass.: MIT Press, 2003], 274). Despite the insight contained in this dramatic remark, I hope to show that the architectural project at IBM, every bit as much as at Olivetti, was concerned not just with "image," but with space conceptions and function—even if, in many cases, this was a matter of creating what one might call operational images, or ideology.

72 Paul Rand, "IBM Presentation . . . 1955," ACCN 1745/200-M-133, Box 22, Folder "IBM 1962–66 (1 of 2)," p. 1, Paul Rand Collection, Yale University Archives. My emphasis.

73 Ibid., 2.

74 Ibid.

75 Ibid., 12.

76 Ibid.

77 Ibid.

78 Ibid.

79 Paul Rand and IBM, *The IBM Logo: Its Use in Company Identification* (Armonk, N.Y.: International Business Machines, 1982), unpaginated.

80 The legal basis for establishing the value of the trademark is set out in the 1883 Paris Convention for the Protection of Industrial Property. The principles therein are summarized in World Intellectual Property Organisation, *Understanding Copyright and Related Rights* (Geneva: WIPO, 1992).

81 *IBM Trademark Manual,* [1960], Box F47, p. 1, IBM Corporate Archives.

82 As related by Christine Quain [IBM Armonk] to Reinhold Martin, 22 April 1998. I am grateful to Reinhold for supplying a copy of this letter.

83 *IBM Trademark Manual,* 7. My emphasis.

84 Paul Rand, *Some Thoughts . . . and Some Logos* (self-published pamphlet, 1991), 5. This pamphlet reproduces many of the corporate logos that he designed from 1954 to the 1990s.

85 On the uncanny status of money as an object possessing both intrinsic and extrinsic value, see Georg Simmel's discussion of "The Value of Money as a Substance" and "Money in the Sequence of Purposes," chaps. 2–3 in *The Philosophy of Money,* ed. David Frisby, trans. Tom Bottomore and David Frisby, 2nd ed. (London: Routledge, 1990).

86 Paul Rand (1950), quoted in Stephen Heller, *Paul Rand* (London: Phaidon, 1999), 154.

87 Rand, "IBM Presentation . . . 1955," 13.

88 Ibid.

89 Ibid., 14.

90 Almost as an afterthought, on the last page of his report Rand included a final proposal. In order to get the new graphics program started, he suggested "a full page institutional ad in newspapers" that would "make people newly aware of the IBM initials and what they stand for." Rand proposed including a rebus: "the eye ["I"] standing for beauty, vision, insight, etc., and the B ["bee"], of course, for industry and efficiency" (Ibid., 15). Although nothing was done with the idea at the time, Rand remained fond of the idea for decades, and eventually convinced IBM to use the rebus logo in advertisements and packaging for IBM personal computers in 1980.

91 The Eameses' account of information and communications theory, while in the main quite accurate, consistently elided important indeterminacies and problems in the theory in favor of simplicity and authority. A case in point is the utter absence, in *A Communications Primer* or in any of Charles Eames's numerous subsequent lectures on the topic, of discussion regarding what Weaver called "the semantic problem." This thorny issue, which centers on the ability of the "sender" of a message to confirm that the "receiver" has actually received the message accurately, was also a key—if often underemphasized by its popularizers—component of the related, entropy-based mathematical discipline of cybernetics, which the Eameses later addressed in their film for IBM, *An Introduction to Feedback* (1961). The later film also avoided any discussion of semantics, implicitly positing what would become a paradoxical but basic underlying assumption and limit in informational theories of aesthetics: the noiseless channel.

The problem of the noiseless channel has received numerous treatments, varying widely in their degree of criticality. For a credulous account see a text, extremely important to the French

avant-garde in the 1960s as well as to the Venice School of architectural history, by the engineer and musician Abraham Moles, *Information Theory and Esthetic Perception,* trans. Joel E. Cohen (Urbana: University of Illinois Press, 1969); Moles's impact on contemporary designers and artists is nicely summarized in Larry Busbea, *Topologies: The Urban Utopia in France, 1960–1970* (Cambridge, Mass.: MIT Press, 2007).

For a more provocative and critical account application of media theory to the problem of the noiseless channel, albeit addressing literature and philosophy rather than architecture per se, see Friedrich Kittler, *Discourse Networks 1800/1900,* trans. Michael Metteer with Chris Cullens (Stanford, Calif.: Stanford University Press, 1990), esp. 70–123 and 265–72.

92 Warren Weaver, "Recent Contributions to the Mathematical Theory of Communication," in Warren Weaver and Claude Shannon, *The Mathematical Theory of Communication* (Urbana: University of Illinois Press, 1963), 7–8.

93 Norbert Wiener, *The Human Use of Human Beings* (Boston: Houghton Mifflin, 1967), 239, 254.

94 Charles Eames and Jehane Burns, Box 218, Folder 1, "Lectures, Unidentified, 1968–76, n.d.," p. 8A , CRE LOC: "If you try to apply the same biological image to the world in which artefacts are designed, made and used today—it might look rather as if an enormous dipper were taking ladlefuls of the North Sea, with its organisms, and pouring them into the Pacific; and ladlefuls of the Pacific into the Mediterranean; and so on—causing a massive ecological trauma, and completely outpacing the slow process of adjustment by selection."

95 Watson, like his father, heavily endorsed the welfare-state liberalism of Keynes, Roosevelt, and Truman; after all, for a company that owed its initial formation and continued success to a series of lucrative government contracts, this was quite simply a matter of looking out for its self-interest. At one time Watson Jr. even considered running for governor of New York on the Democratic ticket. See, for example, the recent biography of Watson Sr.: Kevin Maney, *The Maverick and His Machine: Thomas Watson, Sr. and the Making of IBM* (Hoboken, N.J.: John Wiley and Sons, 2003), esp. 169–74 on Watson's friendship with Roosevelt and his alliance of IBM with state stewardship of the national economy.

96 An illustration of this room appears in a calendar with images of important milestones in IBM's history, produced at IBM Poughkeepsie in 1971. There is no identification there of Noyes's authorship, but the clean lines and interior glass windows are suggestive. Location Files, Poughkeepsie, IBM Corporate Archives.

97 The 702, along with the 650 model, helped IBM to overcome the initial lead in the business computing market built by Remington Rand (later Sperry Rand) in the early 1950s with its UNIVAC. For an account of this story that treats both its business and technical aspects, see Pugh, *Building IBM,* esp. 145–82.

98 Watson and Petre, *Father, Son & Co.,* 259.

99 Ibid., 260.

100 "Brain Center: A New Machine, a New Showroom Dramatize IBM Design Policy," *Industrial Design* 2 (July 1955): 36–41.

101 Watson and Petre, *Father, Son & Co.,* 260.

102 See D. R. McKay to Eliot Noyes, 8 May and 18 June 1964, Box 62, Folder "IBM Project '64: ID Design Programs '64, Report, correspondence," Eliot Noyes Archive, and Watson Jr., "Good Design Is Good Business."

Charles Eames worked out a more informal arrangement with IBM, insisting on agreements in letter form rather than in legal contracts. See Marion Swannie to Charles Eames, 2 March 1961, Box 156, Folder 2, "Billings, 1959–61," CRE LOC, in which a purchase order is granted to Eames "to cover the time we know you spend in IBM's behalf, but which is not related to any specific project. This would include experimental work, visits to your studio, informal telephone consultation, etc." The suggested compensation for this informal work was $300 per day, fifteen days per year, plus an additional $1,500 for travel expenditures. In 1970, IBM tried to press Eames into a formal contract, but he refused, appealing to Watson Jr. (then retired as president, but still chairman of the board) for yet another letter agreement;

IBM eventually consented. Multiple letters are preserved in Box 48, Folder 3, "IBM Corporation General Correspondence, 1970," CRE LOC.

103 Eliot Noyes, speech to the IBM Design Seminar, March 1957, quoted in Bruce, *Eliot Noyes,* 157.

104 Thomas J. Watson Jr., "The New Environment," in *A Business and Its Beliefs: The Ideas That Helped Build IBM* (New York: McGraw-Hill, 1963), 59–60.

105 Johnston, "From Old IBM to New IBM," 50–51. My emphasis.

106 Bernard Michael Boyle, "Architectural Practice in America, 1865–1965: Ideal and Reality," in *The Architect: Chapters in the History of the Profession,* ed. Spiro Kostof (Oxford: Oxford University Press, 1977), 309–44. See also Mary N. Woods, *From Craft to Profession: The Practice of Architecture in the Nineteenth Century* (Berkeley: University of California Press, 1999), esp. "Conclusion," 167–80.

107 See Avigail Sachs, "Marketing through Research: William Caudill and Caudill Rowlett Scott (CRS)," *Journal of Architecture* 14, no. 1 (2009): 737–52; and Sachs, "Research and Environmental Design: Building a Discipline and Modernizing the Discipline" (PhD diss., University of California at Berkeley, 2009).

108 Van Doren, *Industrial Design,* 26–27.

109 Ibid.

110 Noyes interviewed by Reyner Banham, transcript of "New Thinking About Industrial Design: 5. The Consultant Designer in Industry—Eliot Noyes in Conversation with Reyner Banham," Producer: Leonie Cohn, Recorded: Tuesday, 11 October 1966, 14.30–16.30, Transmission: Saturday, 15 October 1966, 22.00–22.20; Box 24, Folder "Lectures," Eliot Noyes Archive.

111 Heller, *Paul Rand,* 153.

112 Swannie remained the lead coordinator of the design consultancy from 1956 to 1975, when she married Rand and retired from the company. On Swannie, see Franc Nunoo-Quarcoo, *Paul Rand: Modernist Design* (Baltimore: Center for Art and Visual Culture, University of Maryland Baltimore County, 2003), 186–97.

113 Heller, *Paul Rand,* 153.

114 Swannie remembers in particular that the designers in Stuttgart and Paris were particularly accomplished, even if their organizational apparatus was underwhelming. Interview with the author, 11 March 2006.

115 *IBM Design Guide,* July 1960, Box 60, Folder "IBM Project," Eliot Noyes Archive.

116 Paul Rand and IBM Corporate Brand Management, *The Spirit and the Letter* (Armonk, N.Y.: IBM, 1994), 21.

117 Ibid., 16–17.

118 Paul Rand, *IBM Design Guide* (Armonk, N.Y.: IBM, 1971), 4, Box F47, IBM Corporate Archives. See also Rand, "City Medium Type," [1961], Box 22, Folder "IBM 1961– (2 of 2)," Paul Rand Collection, Yale University Archives. In this report, Rand claimed a savings of $1,400 per year based on standardizing graphic design.

119 Marion Swannie to Dean R. McKay [IBM Communications], report, 21 September 1960, Box 22, Folder "IBM 1961–," p. 3, Paul Rand Collection, Yale University Archives.

120 Rand, *IBM Design Guide.*

121 Paul Rand, "Colors," [1961], Box 22, Folder "IBM 1961– (2 of 2)," Paul Rand Collection, Yale University Archives.

122 Ibid.

123 Quoted in Heller, *Paul Rand,* 153.

124 American corporations have, since the mid-nineteenth century, been widely recognized as "fictional persons," "legal persons," or "moral persons." *The Oxford English Dictionary,* online edition, gives the definition as "a group of people authorized to act as an individual." In most countries, corporations possess many but not all of the rights and obligations attributed to individual citizens, including the right to property and the obligation to pay taxes, but not the right to vote.

125 Quoted in Heller, *Paul Rand,* 158.

126 Paul Rand, *Thoughts on Design* (New York: Wittenborn, 1947), 90.

127 Rand and IBM Corporate Brand Management, *The Spirit and the Letter,* 24.

128 Heller, *Paul Rand,* 155.

129 According to a memorandum by R. L. Monahon, corporate design manager, to Eliot Noyes and Paul Rand, "Subject: Corporate Design Program

Record," 26 January 1960, monthly reports detailing "the activities on the specific project" on which each engineering group or design firm was at work would be submitted to McKay's office. Box 22, Folder "IBM 1961–," p. 3, Paul Rand Collection, Yale University Archives. This memorandum also includes a breakdown of the various projects overseen by Noyes, Rand, and various IBM design managers during 1960, along with mission statements for each project.

130 Rand, undated memorandum, "Plant Educational Program," [1961], Box 22, Folder "IBM 1961–," Paul Rand Collection, Yale University Archives; Heller, *Paul Rand,* states that Alvin Eisenman, a book designer and head of the graphic design program at Yale University, was hired to lecture to several of the design departments (153).

131 Ibid.

132 W. J. van Hoek to Marion Swannie, R. J. Currie [IBM World Trade Headquarters (WTHQ) New York], J. A. Healion [IBM WTHQ New York], B. McKenzie [IBM World Trade Europe (WTEC) Paris], Eliot Noyes, Paul Rand, C. D. Hunter [IBM WTHQ New York], E. van der Kruk [IBM Netherlands], L. de Jong [IBM Netherlands], "Memorandum, Subject: Study Communications Design in Europe," Box 22, Folder "IBM 1962–1966 (1 of 2)," p. 5, Paul Rand Collection, Yale University Archives. Eventually, in 1966, IBM appointed Josef Müller-Brockmann, a Swiss graphic designer and proponent of the *Neue Grafik* to the post of European design consultant.

133 See, for example, C. F. Graser [manager, ID DSD Poughkeepsie] to B. O. Evans et al., memorandum, "Subject: Industrial Design Policy; Reference: Your memo to R.B. Bevier, dated 1–15–64," 31 January 1964, Box 62, Folder "IBM Project 1964: ID Design Programs '64, Report, correspondence," Eliot Noyes Archive: "Although I agree with the somewhat belated statement of some local channels for recourse in the event Industrial Design differences with Engineering require resolution by higher management, I believe your choice of words that 'Industrial Design feels *subservient* to Engineering' gives the unfortunate connotation that D.S.D. Industrial Design management has not asserted itself in the past. To help rectify this possible impression I should like to point out that despite attempts to *subjugate* Industrial Design effort, by virtue of the financial control by Engineering, the record can be shown, more often than not, that Industrial Design *has* taken a strong voice when the issues are important to the Corporate Design Program and good design. . . . I don't think Eliot Noyes is worried 'that Industrial Design has to *take* a stronger voice' but rather that local top level management be prepared to listen to the voice that is already there and to be more enlightened about the Industrial Design disciplines as a function of the Corporate Design Program."

134 See R. B. Wheeler to C. F. Graser, Eliot Noyes, Walter Furlani, James LaDue, et al., memorandum, "Industrial Design and Human Factors," 11 March 1964, Box 62, Folder "IBM Project '64, Report, correspondence," Eliot Noyes Archive.

135 Pugh, *Building IBM,* 289.

136 See ibid., esp. chapters on System/360, System/370, and Future System (FS) projects.

137 J. J. Troy, Laboratory Memorandum 9–161 to All Laboratory Managers, "Subject: Design Center for 'Aesthetics,'" 28 May 1964, Box 62, Folder "IBM Project '64, Report, correspondence," Eliot Noyes Archive.

138 *IBM Industrial Design Practices—General Design Guidelines* (updated 15 May 1974), 1. I received this copy from James LaDue.

139 See, for example, "IBM Corporate Facilities Practice: Facilities—Acquisition of Art Objects, CFP 8–5001–012," May 1966, Box 62, Folder "IBM RECD," Eliot Noyes Archive.

Chapter Two
The Architecture of the Computer

The epigraphs are from Banham, "(Thinks): Think!" 501; and Martin Heidegger, *Parmenides,* trans. André Schuwer and Richard Rojcewicz (Bloomington: University of Indiana Press, 1992), 85–86.

1 Progressive models for narrating the history of science and technology that have informed my approach here may be found in Beniger, *Control Revolution;* Peter Galison, *Image and Logic: A Material Culture of Microphysics* (Chicago: University of Chicago Press, 1997); Peter Galison, *Einstein's*

Clocks, Poincaré's Maps: Empires of Time (New York: W. W. Norton, 2004); Peter Galison and Bruce Hevly, *Big Science: The Growth of Large-Scale Research* (Stanford, Calif.: Stanford University Press, 1992); Peter Galison and Emily Thompson, eds., *The Architecture of Science* (Cambridge, Mass.: MIT Press, 1999); Bruno Latour and Steve Woolgar, *Laboratory Life: The Construction of Scientific Facts* (Princeton, N.J.: Princeton University Press, 1986); and Bruno Latour, *We Have Never Been Modern,* trans. Catherine Porter (Cambridge, Mass.: Harvard University Press, 1993).

2 Numerous histories of computing are cited throughout the notes. Three of the histories that have been used here, and from which relevant historical developments have been summarized, are Martin Campbell-Kelly, *Computer: A History of the Information Machine* (Boulder, Colo.: Westview Press, 2004); Pugh, *Building IBM;* and Office of Charles and Ray Eames, *A Computer Perspective* (Cambridge, Mass.: Harvard University Press, 1973).

3 The primary source material on the industrial design of the computer is mainly to be found in industrial design trade journals of the period under consideration, e.g., *Industrial Design,* and in corporate archives. Reyner Banham made some small contributions to the design history of the computer in his essays (see the first epigraph). The only book to treat the landmark developments in the design of computer interfaces in any detail is M. Mitchell Waldrop's biography *The Dream Machine: J. C. R. Licklider and the Revolution That Made Computing Personal* (London: Penguin, 2002), which chronicles Licklider's and others' contributions to the design of graphic interfaces, the computer mouse, and text-based telecomputing interfaces.

4 See my discussion of the "channel" I/O apparatus for System/360 in this chapter. Another set of amusing exceptions are the video games that the Eames Office designed for IBM in the late 1970s and early 1980s; documentation of these designs can be found in Boxes 47–57, CRE LOC.

5 D. B. Miller to H. T. Marcy et al., memorandum, "Subject: Industrial Design—SDD" [attached: "Industrial Design—Issues for Discussion and Decision," 4 November 1965], Box 62, Folder "IBM Poughkeepsie—ID Reviews '65 Report, correspondence," Eliot Noyes Archive.

6 Transcript of "New Thinking About Industrial Design: 5. The Consultant Designer in Industry—Eliot Noyes in Conversation with Reyner Banham."

7 Recall Harold Van Doren's description of the industrial designer as immanent to the corporation; see chapter 1, n. 108.

8 The interpenetration of ostensibly different modes of value within Marx's description of the commodity is most readily visible in *Grundrisse,* ed. and trans. David McLellan (New York: Harper & Row, 1972), chap. 1. The rigorously sustained dialectical reasoning—and the sheer mass of verbiage—necessary to distinguish between such concepts as production and consumption, Marx is careful to point out repeatedly, is a characteristic of his analysis, not of the commodity itself. So too, a distinction between use value and exchange value is artificial—in a sense, likewise produced and consumed in the play of language—and provides the grounds for the descriptive system as eventually laid out in *Das Kapital,* with its various economic and ethical diagnoses, implications, and prescriptions.

9 Marx, *Capital,* 1:163–64.

10 See Michel Foucault, *The Order of Things* (New York: Random House, 1970), xxiv: "I am concerned here with observing how a culture experiences the propinquity of things, how it establishes the *tabula* of their relationships and the order by which they must be considered. I am concerned, in short, with a history of resemblance: on what conditions was Classical thought able to reflect relations of similarity or equivalence between things, relations that would provide foundation and a justification for their words, their classifications, their systems of exchange? What historical *a priori* provided the starting-point from which it was possible to define the great checkerboard of distinct identities established against the confused, undefined, faceless, and, as it were, indifferent background of differences?"

See also Gilles Deleuze, *Foucault,* trans. Séan Hand (Minneapolis: University of Minnesota Press, 1988), esp. the section on "A New Archivist," in

which Deleuze clarifies the potential of Foucault's notion of discourse analysis.

11 Here I would like to be clear that I am not making reference to or relying upon psychological and psychoanalytical interpretations of the computer's effect on human identity, social relations, and so forth, such as those offered by Sherry Turkle. Besides lying well beyond the scope of the arguments offered here, in my view such approaches to understanding the impact of computing on culture are simultaneously based upon anecdotal evidence and upon theories of mind that bear little relationship to the material underpinnings of computing technology. Nevertheless, such investigations are apropos to the discussion here in that they critique the theory of the computer as a subjective entity with some degree of nuance and identify it as a key medium of contemporary social relations. See Turkle, *The Second Self: Computers and the Human Spirit* (New York: Simon and Schuster, 1984); Turkle, *Life on the Screen: Identity in the Age of the Internet* (New York: Simon and Schuster, 1997); and Turkle, ed., *The Inner History of Devices* (Cambridge, Mass.: MIT Press, 2008).

12 See, e.g., Beniger, *Control Revolution;* Campbell-Kelly, "Railway Clearing House"; and David Alan Grier, *When Computers Were Human* (Princeton, N.J.: Princeton University Press, 2005).

13 Human thought is, in the tradition of modern analytical philosophy, often referred to as "mind"; thus the subdiscipline of philosophy examining the ontology of thought is often identified by the moniker "philosophy of mind." This tradition, however, remains confined to repeating the usual tautologies (only one of which is discussed here), due to its refusal to recognize its uncritical acceptance of the ontology of technology presented by mathematician-philosophers such as Bertrand Russell and A. N. Whitehead.

14 Alan Turing, "On Computable Numbers, with an Application to the *Entscheidungsproblem,"* *Proceedings of the London Mathematical Society* 42 (1937): 251. The paper was originally written in 1935.

15 See the excellent biography by the mathematician Andrew Hodges, *Alan Turing: The Enigma*

(New York: Simon & Schuster, 1983), which describes these experiments in lively detail.

16 Alan Turing, "Computing Machinery and Intelligence," *Mind* 59, no. 236 (1950): 433–60.

17 The most important and oft-cited challenge to Turing's thesis is presented in John Searle's article "Minds, Brains, and Programs," *Behavioral and Brain Sciences* 3 (1980): 417–24, which describes his famous thought experiment of the "Chinese Room." Leaving aside the specifics of the argument, it is interesting to note that Searle resorts to architectural metaphor in order to construct his argument.

18 Mortimer Taube, *Computers and Common Sense: The Myth of Thinking Machines* (New York: Columbia University Press, 1961), 69. Regarding Taube's damning analysis, it is suggestive that in order to see this tautology for what it is, it is necessary to note the presence of the designer of the machine. While Taube likely refers to the scientist or engineer in this case, the implications are no different when considering the case of the industrial designer's role in creating the machine, since simply to indicate the presence of a designing subject is enough to introduce the fundamental contingency of the machine's "architecture," to borrow von Neumann's term.

See also Joseph Weizenbaum, *Computing Power and Human Reason: From Judgment to Calculation* (San Francisco: W. H. Freeman, 1976).

19 Konrad Zuse, *Der Computer: Mein Lebenswerk,* 2nd ed. (Berlin: Springer, 1984), 77; quoted and translated in Friedrich Kittler, *Gramophone, Film, Typewriter,* trans. Geoffrey-Winthrop Young and Michael Wutz (Stanford, Calif.: Stanford University Press, 1999), 258. Zuse's machine was used only minimally in the war effort, primarily in calculating handwritten mathematical simulations for scientists working on the V-2 rocket, and for a long time was written out of the early history of computing. His biography, written years after the war, is thus tinged with a certain unavoidable regret; however, his grasp of the ontological implications of feedback is firm and his deontological nervousness thus well grounded. See my discussion of IBM's own misgivings as to this

issue in chapter 4.

20 See John Johnston, *The Allure of Machinic Life: Cybernetics, Artificial Life, and the New AI* (Cambridge, Mass.: MIT Press, 2008). Presented as a theoretical critique and not a strictly historical account, his review of the literature of the "computational assemblage" is similar in some ways to the views presented here; however, while his account is object-oriented, he does not offer a critique of the material design of these apparatuses in anything other than a purely technical sense.

21 See the fractious discussion at http://en.wikipedia.org/wiki/Talk:Mainframe_computer#POV.

22 Henry S. Tropp, "SAGE at North Bay," *Annals of the History of Computing* 5, no. 4 (October 1983): 402.

23 See John Markoff and Saul Hansell, "Hiding in Plain Sight, Google Seeks More Power," *New York Times,* 14 June 2006; and Ginger Strand, "Keyword: Evil," *Harper's Magazine,* July 2008, which provides statistics on Google's installation in The Dalles.

24 On modern cryptography as it pertains to military use, in particular on its use during World War II, see Laurence Dwight Smith, *Cryptography: The Science of Secret Writing* (New York: Dover, 1955).

25 Gilbert Burck and the editors of *Fortune* magazine, *The Computer Age and Its Potential for Management* (New York: Harper & Row, 1965), 26. See also "The Computer Center: New Building Type?" *Architectural Record* 136 (November 1964): 153–58.

26 On the subsequent development of cybernetic theory, see, e.g., W. Ross Ashby, *An Introduction to Cybernetics* (London: Chapman & Hall, 1956); and Heinz von Foerster, ed., *Principles of Self-Organization: Transactions* (New York: Symposium and Pergamon, 1962).

27 Norbert Wiener, *The Human Use of Human Beings,* 2nd ed. (New York: Dover, 1954).

28 A recent study in design history points out the long history and ideological consequences of this homological engine; see Arindam Dutta, *The Bureaucracy of Beauty: Design in the Age of Its Global Reproducibility* (New York: Routledge,

2007), chap. 5: "Cyborg/Artisan: On a Certain Asymmetry Deriving from the Binary System; or, Notes on a Moment in the Development of a Taylorist Feudalism."

29 This patent became the grounds for the antitrust proceedings that plagued IBM throughout the second half of the twentieth century and resulted early on in IBM being barred from using its characteristic sales strategy of only leasing computers. See Franklin M. Fisher, James W. McKie, and Richard B. Mancke, *I.B.M. and the U.S. Data Processing Industry: An Economic History* (New York: Praeger, 1983), which documents the entire history of IBM's legal entanglements up through the late 1970s in lucid detail.

30 Quoted in Office of Charles and Ray Eames, *A Computer Perspective: Background to the Computer Age,* 2nd ed. (Cambridge, Mass.: Harvard University Press, 1990), 153.

31 On Hurd, and the tremendous impact he had upon both the design of early digital computers and IBM's decision to make these machines useful to businesses, see Cuthbert Hurd, "Early Computers at IBM: Edited Testimony," *Annals of the History of Computing* 3, no. 2 (April 1981): 163–86.

32 Paul N. Edwards, *The Closed World: Computers and the Politics of Discourse in Cold War America* (Cambridge, Mass.: MIT Press, 1996), 102: "More than half of IBM's income in the 1950s came from military sources." On additional benefits for IBM of working on government projects, particularly in reference to the air-defense system SAGE, see ibid., chap. 3: "SAGE."

33 Quoted in Fisher, McKie, and Mancke, *I.B.M. and the U.S. Data Processing Industry,* 14.

34 Thomas J. Watson Jr., quoted in ibid., 15.

35 Cuthbert C. Hurd, legal testimony, quoted in ibid., 15.

36 Hurd, "Early IBM Computers"; see esp. section 15, 180–86, which treats "IBM Innovations" in the physical design of computers and IBM's exceptional customer education and service capacity.

37 Fisher, McKie, and Mancke, *I.B.M. and the U.S. Data Processing Industry,* 16.

38 Quoted in ibid., 16.

39 Quoted in Bruce, *Eliot Noyes,* 146.

40 "Brain Center," 36. The only other firm in the running was that of Norman Bel Geddes, who lost out to Kress and Sundberg-Ferar. On Sundberg-Ferar, see "Sundberg-Ferar," *Industrial Design* 2 (October 1955): 86–89, and Arthur J. Pulos, *The American Design Adventure, 1940–1975* (Cambridge, Mass.: MIT Press, 1988), 23–24.

41 Quoted in "Brain Center," 37.

42 Ibid.

43 Ibid., 36.

44 Ralph Caplan quoting Eliot Noyes, transcription of speeches at Noyes's funeral, "A Celebration for Eliot Noyes, 1910–1977," 10 September 1977, Box 23, Folder "Noyes, Eliot," Paul Rand Collection, Yale University Archives. My emphasis.

45 On the design of the RAMAC, see Arthur Gregor, "Ramac: An IBM Case Study; IBM Develops Its Random-Access Memory Accounting Machine," *Industrial Design* 4 (March 1957): 54–57.

46 See my discussion of the problematic term "real time" in chapter 3.

47 Johnston, "From Old IBM to New IBM," 51.

48 See my discussion of this house and Noyes's architectural designs for IBM in chapter 3.

49 A list of "Design Awards by the Industrial Designers Institute (IDI)" is made available by the Industrial Designers Society of America, at http://www.idsa.org/whatsnew/sections/dh/IDI_Awards_1951–1965.pdf. My emphasis.

50 Fisher, McKie, and Mancke, *I.B.M. and the U.S. Data Processing Industry,* 36.

51 On SABRE, see Martin Campbell-Kelly, *From Airline Reservations to Sonic the Hedgehog: A History of the Software Industry* (Cambridge, Mass.: MIT Press, 2003), 41–45.

52 The last reference that I have found in the Noyes Archive pertaining to Nelson's involvement is George Nelson to Eliot Noyes, 7 October 1957, Box 66, Folder "George Nelson," Eliot Noyes Archive, a letter informing Noyes of his impending departure for Japan and contractual obligations that prevented him from working for IBM. While the contractual dispute was still unresolved, Noyes ensured that IBM reimbursed Nelson for his expenses indirectly, the money passing first through Noyes's office (Eliot Noyes to George Nelson, 5 June 1957, Box 66, Folder "George Nelson," Eliot Noyes Archive).

Although nothing seems to have come of the SABRE project, Nelson did lecture to IBM industrial designers on 20 August 1957 (Eliot Noyes to George Nelson, 25 July 1957, Box 66, Folder "George Nelson," Eliot Noyes Archive), and before that carried on a sustained interaction with IBM managers and designers about the possibility of IBM designing new product lines. Following a visit to the IBM designers and managers at Poughkeepsie, Nelson wrote to Noyes regarding the possibility of IBM pursuing products designed for home use (George Nelson to Eliot Noyes, 28 May 1957, Box 66, Folder "George Nelson," Eliot Noyes Archive).

It is hard to imagine that Nelson's ideas had much of an influence on the practical design of machines; rather, his appeal to IBM probably arose from the way in which he convincingly talked about the impact of new technologies on everyday life. In any case, Nelson probably continued to exert at least an indirect influence on the IBM Design Program through his friendship and collaborative projects with the Eameses and his lasting friendship with Noyes. On Nelson's career, see Stanley Abercrombie, *George Nelson: The Design of Modern Design* (Cambridge, Mass.: MIT Press, 1995); John Harwood, "The Wound Man: George Nelson and the 'End of Architecture,'" *Grey Room* 31 (Spring 2008): 90–115; Enzo Fratelli, "The World of George Nelson," *Zodiac* 8 (1961): 96–101; and George Nelson, *Building a New Europe: Portraits of Modern Architects, Essays by George Nelson, 1935–36* (New Haven, Conn.: Yale University Press, 2007). The latter book includes a useful essay on Nelson's early years by Kurt W. Forster, "An American in Rome: George Nelson Talks with European Architects," which places Nelson in the intellectual clime of Italy in the 1930s but is not based upon archival research.

53 On *Glimpses of the U.S.A.,* see Hélène Lipstadt, "'Natural Overlap': Charles and Ray Eames and Federal Government," in *The Work of Charles and Ray Eames: A Legacy of Invention* (New York: Harry N. Abrams, 1997), 150–77; and Beatriz Colomina, "Enclosed by Images: The Eameses'

Multimedia Architecture," *Grey Room* 2 (Winter 2001): 6–29. The India trip and *Mathematica* are discussed in chapter 4.

54 Edgar Kaufmann Jr. to Eliot Noyes, 13 June 1957, Box 66, Folder "Edgar Kaufmann," Eliot Noyes Archive.

55 As Noyes stated in an interview with John Peter in 1957, the same year as his exchange with Kaufmann over the design for the RAMAC, "I like the idea of putting color into architecture, but every time I've tried to do it I've suddenly backed away again. I did a laboratory for IBM where I was all set to put in colored porcelain enamel panels in the spandrels. Then I thought, five years from now I'm going to come and look at that color and think, oh brother, I'm sick of that color. So I backed off and did two shades of alternating grays" (John Peter, *The Oral History of Modern Architecture* [New York: Harry N. Abrams, 1994], 72).

56 My emphasis.

57 On the IBM Washington Presentation Center, see John Neuhart, Marilyn Neuhart, and Ray Eames, *Eames Design: The Work of the Office of Charles and Ray Eames* (New York: Harry N. Abrams, 1989), 335.

58 Eliot Noyes, "Memorandum to: Gordon Smith, R. Monahon, R. Wadsten, W. Furlani, L. Albrecht," 17 June 1957, Box 66, Folder "Edgar Kaufmann," Eliot Noyes Archive: "I am enclosing copies of some notes which Edgar Kaufmann, Jr. has sent [in a letter to Noyes dated 13 June 1957] in following our review and discussion at Pough-keepsie recently. For clarification the 'parlor–coal cellar' idea which he refers to is what we have called the furnace approach to the design of a computer in which only components used by the staff are exposed on a main floor and all others are buried in the cellar or in a back room."

59 Ibid.

60 Both Noyes and Kaufmann appear to have been well aware of industrial design's role in this double movement; one almost wonders if they can have read Heidegger, who in *Holzwege* (Frankfurt am Main: V. Klostermann, 1957), among many other places, insisted that "technology itself prevents any experience of its essence" (272).

61 See Waldrop, *Dream Machine*.

62 Marion Swannie to Edgar Kaufmann Jr., 26 January 1965, Box 66, Folder "Edgar Kaufmann," Eliot Noyes Archive.

63 IBM Industrial Design Department, Endicott, N.Y., "Appearance Design Guide for IBM Machines & Systems," 10 November 1959, Box 53, Folder "Design Program: ID—IBM Design Program '59 Correspondence and outlines," Eliot Noyes Archive.

64 No trace of an *IBM Design Guidelines* manual published between 1959 and 1966 exists in the Eliot Noyes Archive, despite references in corre-spondence to common standards of design devel-oped for System/360. A mock-up version of the guidelines was produced in 1962 (Box 53, Folder "IBM-ID Design Practices I—Mock-up of design guidelines, '62 booklet," Eliot Noyes Archive). It appears that these standards were only fully codified after the first series of System/360 com-puters were delivered in 1965; later System/360 models and their successors, the System/370 series, were designed with nearly identical casings and interfaces. The only changes appeared to be slight adjustments in dimension and the integra-tion of various I/O equipment not manufactured by IBM, such as CRTs.

65 Bob O. Evans, "System/360: A Retrospective View," *Annals of the History of Computing* 8, no. 2 (April 1986): 159.

66 Box F48, IBM Corporate Archives. My em-phasis.

67 *IBM Industrial Design Practices—General Design Guidelines* (15 May 1974), 2. Author's col-lection, gift of James LaDue. The color system for the 1401 was eventually used in almost identical form in the design of System/360 and was thus integrated eventually into the guidelines.

68 The rotating type-head was last used in the Blickensderfer portable typewriter, which went out of production around 1922. George C. Blickens-derfer continued to hold the patent on the rotating element, but IBM's electric system was an innova-tion and earned it patent rights for the Selectric design. See "Design Review: IBM 72 Typewriter," *Architectural Review* 131 (March 1962): 202.

69 "IBM Selectric Typewriter," TS, Box 7, unla-

40 "Brain Center," 36. The only other firm in the running was that of Norman Bel Geddes, who lost out to Kress and Sundberg-Ferar. On Sundberg-Ferar, see "Sundberg-Ferar," *Industrial Design* 2 (October 1955): 86–89, and Arthur J. Pulos, *The American Design Adventure, 1940–1975* (Cambridge, Mass.: MIT Press, 1988), 23–24.

41 Quoted in "Brain Center," 37.

42 Ibid.

43 Ibid., 36.

44 Ralph Caplan quoting Eliot Noyes, transcription of speeches at Noyes's funeral, "A Celebration for Eliot Noyes, 1910–1977," 10 September 1977, Box 23, Folder "Noyes, Eliot," Paul Rand Collection, Yale University Archives. My emphasis.

45 On the design of the RAMAC, see Arthur Gregor, "Ramac: An IBM Case Study; IBM Develops Its Random-Access Memory Accounting Machine," *Industrial Design* 4 (March 1957): 54–57.

46 See my discussion of the problematic term "real time" in chapter 3.

47 Johnston, "From Old IBM to New IBM," 51.

48 See my discussion of this house and Noyes's architectural designs for IBM in chapter 3.

49 A list of "Design Awards by the Industrial Designers Institute (IDI)" is made available by the Industrial Designers Society of America, at http://www.idsa.org/whatsnew/sections/dh/IDI_Awards_1951–1965.pdf. My emphasis.

50 Fisher, McKie, and Mancke, *I.B.M. and the U.S. Data Processing Industry,* 36.

51 On SABRE, see Martin Campbell-Kelly, *From Airline Reservations to Sonic the Hedgehog: A History of the Software Industry* (Cambridge, Mass.: MIT Press, 2003), 41–45.

52 The last reference that I have found in the Noyes Archive pertaining to Nelson's involvement is George Nelson to Eliot Noyes, 7 October 1957, Box 66, Folder "George Nelson," Eliot Noyes Archive, a letter informing Noyes of his impending departure for Japan and contractual obligations that prevented him from working for IBM. While the contractual dispute was still unresolved, Noyes ensured that IBM reimbursed Nelson for his expenses indirectly, the money passing first through Noyes's office (Eliot Noyes to George Nelson, 5 June 1957, Box 66, Folder "George Nelson," Eliot Noyes Archive).

Although nothing seems to have come of the SABRE project, Nelson did lecture to IBM industrial designers on 20 August 1957 (Eliot Noyes to George Nelson, 25 July 1957, Box 66, Folder "George Nelson," Eliot Noyes Archive), and before that carried on a sustained interaction with IBM managers and designers about the possibility of IBM designing new product lines. Following a visit to the IBM designers and managers at Poughkeepsie, Nelson wrote to Noyes regarding the possibility of IBM pursuing products designed for home use (George Nelson to Eliot Noyes, 28 May 1957, Box 66, Folder "George Nelson," Eliot Noyes Archive).

It is hard to imagine that Nelson's ideas had much of an influence on the practical design of machines; rather, his appeal to IBM probably arose from the way in which he convincingly talked about the impact of new technologies on everyday life. In any case, Nelson probably continued to exert at least an indirect influence on the IBM Design Program through his friendship and collaborative projects with the Eameses and his lasting friendship with Noyes. On Nelson's career, see Stanley Abercrombie, *George Nelson: The Design of Modern Design* (Cambridge, Mass.: MIT Press, 1995); John Harwood, "The Wound Man: George Nelson and the 'End of Architecture,'" *Grey Room* 31 (Spring 2008): 90–115; Enzo Fratelli, "The World of George Nelson," *Zodiac* 8 (1961): 96–101; and George Nelson, *Building a New Europe: Portraits of Modern Architects, Essays by George Nelson, 1935–36* (New Haven, Conn.: Yale University Press, 2007). The latter book includes a useful essay on Nelson's early years by Kurt W. Forster, "An American in Rome: George Nelson Talks with European Architects," which places Nelson in the intellectual clime of Italy in the 1930s but is not based upon archival research.

53 On *Glimpses of the U.S.A.,* see Hélène Lipstadt, "'Natural Overlap': Charles and Ray Eames and Federal Government," in *The Work of Charles and Ray Eames: A Legacy of Invention* (New York: Harry N. Abrams, 1997), 150–77; and Beatriz Colomina, "Enclosed by Images: The Eameses'

Multimedia Architecture," *Grey Room* 2 (Winter 2001): 6–29. The India trip and *Mathematica* are discussed in chapter 4.

54 Edgar Kaufmann Jr. to Eliot Noyes, 13 June 1957, Box 66, Folder "Edgar Kaufmann," Eliot Noyes Archive.

55 As Noyes stated in an interview with John Peter in 1957, the same year as his exchange with Kaufmann over the design for the RAMAC, "I like the idea of putting color into architecture, but every time I've tried to do it I've suddenly backed away again. I did a laboratory for IBM where I was all set to put in colored porcelain enamel panels in the spandrels. Then I thought, five years from now I'm going to come and look at that color and think, oh brother, I'm sick of that color. So I backed off and did two shades of alternating grays" (John Peter, *The Oral History of Modern Architecture* [New York: Harry N. Abrams, 1994], 72).

56 My emphasis.

57 On the IBM Washington Presentation Center, see John Neuhart, Marilyn Neuhart, and Ray Eames, *Eames Design: The Work of the Office of Charles and Ray Eames* (New York: Harry N. Abrams, 1989), 335.

58 Eliot Noyes, "Memorandum to: Gordon Smith, R. Monahon, R. Wadsten, W. Furlani, L. Albrecht," 17 June 1957, Box 66, Folder "Edgar Kaufmann," Eliot Noyes Archive: "I am enclosing copies of some notes which Edgar Kaufmann, Jr. has sent [in a letter to Noyes dated 13 June 1957] in following our review and discussion at Pough-keepsie recently. For clarification the 'parlor–coal cellar' idea which he refers to is what we have called the furnace approach to the design of a computer in which only components used by the staff are exposed on a main floor and all others are buried in the cellar or in a back room."

59 Ibid.

60 Both Noyes and Kaufmann appear to have been well aware of industrial design's role in this double movement; one almost wonders if they can have read Heidegger, who in *Holzwege* (Frankfurt am Main: V. Klostermann, 1957), among many other places, insisted that "technology itself prevents any experience of its essence" (272).

61 See Waldrop, *Dream Machine*.

62 Marion Swannie to Edgar Kaufmann Jr., 26 January 1965, Box 66, Folder "Edgar Kaufmann," Eliot Noyes Archive.

63 IBM Industrial Design Department, Endicott, N.Y., "Appearance Design Guide for IBM Machines & Systems," 10 November 1959, Box 53, Folder "Design Program: ID—IBM Design Program '59 Correspondence and outlines," Eliot Noyes Archive.

64 No trace of an *IBM Design Guidelines* manual published between 1959 and 1966 exists in the Eliot Noyes Archive, despite references in corre-spondence to common standards of design devel-oped for System/360. A mock-up version of the guidelines was produced in 1962 (Box 53, Folder "IBM-ID Design Practices I—Mock-up of design guidelines, '62 booklet," Eliot Noyes Archive). It appears that these standards were only fully codified after the first series of System/360 com-puters were delivered in 1965; later System/360 models and their successors, the System/370 series, were designed with nearly identical casings and interfaces. The only changes appeared to be slight adjustments in dimension and the integra-tion of various I/O equipment not manufactured by IBM, such as CRTs.

65 Bob O. Evans, "System/360: A Retrospective View," *Annals of the History of Computing* 8, no. 2 (April 1986): 159.

66 Box F48, IBM Corporate Archives. My em-phasis.

67 *IBM Industrial Design Practices—General Design Guidelines* (15 May 1974), 2. Author's col-lection, gift of James LaDue. The color system for the 1401 was eventually used in almost identical form in the design of System/360 and was thus integrated eventually into the guidelines.

68 The rotating type-head was last used in the Blickensderfer portable typewriter, which went out of production around 1922. George C. Blickens-derfer continued to hold the patent on the rotating element, but IBM's electric system was an innova-tion and earned it patent rights for the Selectric design. See "Design Review: IBM 72 Typewriter," *Architectural Review* 131 (March 1962): 202.

69 "IBM Selectric Typewriter," TS, Box 7, unla-

beled folder, Eliot Noyes Archive.

70 Ibid.

71 Allan McCroskery to Sam Kolow, 20 September 1963, Box 62, "IBM Architecture & ID 1964–66," Folder "IBM," Eliot Noyes Archive. Photographs of Rand's designs for the symbols are enclosed.

72 Rudolf H. Koepf [manager of industrial design, IBM Advanced System Development Division], "Industrial Design . . . So What's It All About?" [ca. 1960], Eliot Noyes Archive, p. 15.

73 Wall text from the Communications Rack, photograph of *A Computer Perspective,* CRE LOC, Box 136, Folder 7.

74 TOOL Praxis, *Assembler — Programming auf dem PC,* Ausgabe 1 (Wurzburg: TOOL Praxis, 1989), 9; quoted and translated in Friedrich Kittler, "Protected Mode," in *Literature, Media, Information Systems,* ed. John Johnston (Amsterdam: G+B Arts International, 1997), 157.

75 Koepf, "Industrial Design . . . So What's It All About?" 4.

76 Ibid.

77 John W. Haanstra, chairman, and Bob O. Evans, vice chairman, Joel D. Aron, Frederick P. Brooks Jr., John W. Fairclough, William P. Heising, Herbert Hellerman, Walter H. Johnson, Michael J. Kelly, Douglas V. Newton, Bruce G. Oldfied, Seymour A. Rosen, and Jerrold Svigals, "Processor Products—Final Report of SPREAD Task Group, December 28, 1961," republished in *Annals of the History of Computing* 5, no. 1 (January 1983): 6–26. The republication of the report also includes confidential memos concerning the new line of processors.

78 Ibid., 7.

79 Ibid., 6. This ambition was not, in fact, realized in the System/360 except in special circumstances—such as IBM's own use of the machine. A panel of scientists at MIT determined that the system's architecture was not immediately up to the task of real-time telecomputing of any great complexity; this problem was later resolved by the System/370, which became a workhorse of real-time computing throughout the 1970s. See Evans, "System/360," 171–79; for an account of MIT's alternative systems designs for real-time comput-

ing, see Waldrop, *Dream Machine,* chaps. 5–6.

80 IBM's STRETCH computer project, of 1956–60, which in fact prompted Learson to push for System/360, was one such failure, as was IBM UK-Hursley's SCAMP line of computers.

81 Supposedly said by an executive from the IBM Strategic Planning Group, in charge of financial projections, quoted in Evans, "System/360," 170.

82 Eliot Noyes, speech to "Design and Marketing at Home and Abroad" Panel, International Design Conference at Aspen, 1966, Box 62, Folder "IBM Poughkeepsie—ID Reviews '66," Eliot Noyes Archive.

83 W. F. Kraus, "Industrial Design Organization Chart, I.B.M. Data Systems Division, Poughkeepsie/Kingston, N.Y.," 9 September 1964, Box 62, Folder "IBM Project 1964: ID Design Program '64 Report, correspondence," Eliot Noyes Archive.

84 Eliot Noyes and Associates, "IBM Confidential: Industrial Design for System 360" [ca. 1962], Box 66, Folder "System/360," Eliot Noyes Archive.

85 This standard was established early; see Deborah Allen, "Men and Machines," *Industrial Design* 1 (October 1954): 58–67, and Allen, "Men and Machines, Part 2," *Industrial Design* 2 (April 1955): 44–49; *Industrial Design,* under the editorship of Noyes and Eames's friend Ralph Caplan, continued to publish extensively on the establishment of new ergonomic standards throughout the late 1950s and early 1960s.

86 C. F. Graser and Walter F. Kraus, "Developing the Product 6: International Business Machine's System/360," *Industrial Design* 11 (August 1964): 37–38.

87 As the collections of System/360 control panels in numerous museums show, there were many variations on this signage, leading one to assume that although Rand had a hand in the original design for Models 30 and 40, subsequent models were given signage based upon the original but designed by IBM's in-house designers.

88 In an internal IBM memo on attempting to better integrate the last stages of industrial design into the overall design process (Miller to Marcy et al., "Subject: Industrial Design—SDD"), IBM managers emphasized the need to improve communication between "E. Noyes and ID and

Human Factors" and that the consultants and industrial design engineers needed to improve their knowledge of the data and techniques already assembled by human factors engineers. The accusation was that "many laboratories working on related units of a total system with local I.D. responsibilities and rivalries do not provide for divisional consistency with a design theme. This results in standardization late in the design cycle almost wholly as a result of Eliot Noyes application of energy"—clearly indicating that the innovations made by human factors were being progressively integrated into the design process, if slowly, in these years.

89 Clarence B. Germain, *Programming the IBM 360* (Englewood Cliffs, N.J.: Prentice-Hall, 1967), 41. This complex relation, in which we can already see a dialogue between computers taking place almost unbeknownst to the user, was reduced on the main interface to a single knob, "Channel Select," that allowed the operator to select between up to four different stored programs in the channel that were designed to suit general types of application.

90 Author's interview with Jim LaDue (Poughkeepsie, N.Y., 19 June 2002).

91 Henry Dreyfuss, *The Measure of Man: Human Factors in Design,* 2nd ed. (New York: Whitney, 1960), 4.

92 George Nelson, review of the paperback edition of Henry Dreyfuss's *Designing for People* and the second edition of Dreyfuss, *The Measure of Man: Human Factors in Design* in *Architectural Forum* 128 (June 1968): 80–81.

93 Dreyfuss, *Measure of Man,* 4.

94 Ibid.

95 Dreyfuss, *Designing for People,* cover; reprinted in Dreyfuss, *Measure of Man,* 3.

96 Dreyfuss, *Designing for People,* 27.

97 On the Eames splint, see Neuhart, Neuhart, and Eames, *Eames Design,* 27–29.

98 Dreyfuss, *Designing for People,* 29. On the substitutional logic of prosthetics, see Vivian Sobchack, "A Leg to Stand On: Prosthetics, Metaphor and Materiality," in *The Prosthetic Impulse: From a Posthuman Present to a Biocultural Future,* ed. Marquard Smith and Joanne Morra (Cambridge,

Mass.: MIT Press, 2006); and Sobchack, "Beating the Meat / Surviving the Text, or How to Get Out of This Century Alive," *Body & Society* 1, no. 3 (November 1995): 205–14.

99 These drawings form the basis of an entire genre of diagrammatic representations of the body in ergonomic literature. For other examples, see Ernest J. McCormick, *Human Factors Engineering,* 2nd ed. (New York: McGraw-Hill, 1964); and Étienne Grandjean, *Fitting the Task to the Man: An Ergonomic Approach,* trans. Harold Oldroyd, 3rd ed. (London: Taylor & Francis, 1980).

100 Henry Dreyfuss and Associates, *The Measure of Man: Human Factors in Design,* 2nd ed. (New York: Whitney, 1960), insert R.

101 Ibid.

Chapter Three
IBM Architecture

The epigraph is quoted in Swinburne, "Organization for Efficient Practice: 8," 164.

1 Thomas J. Watson Sr., "Grow with the Organization," speech at TMC Convention, January 1917, in Watson Sr., *Men—Minutes—Money* (New York: IBM Corporation, 1934), 35.

2 Watson Sr., "Accelerating the Progress of Business," 5 November 1927, in ibid., 138.

3 "IBM Highlights, 1914 through 1984," promotional pamphlet for IBM Poughkeepsie, [1984], Box F47, p. 1, IBM Corporate Archives.

4 Quoted in "IBM Day Special Exercises in the Interest of World Peace," 4 May 1939, RG8 World's Fairs, Box 2, Folder "N.Y. 1939 Ephemera," IBM Corporate Archives.

5 See the overheated and problematic exposé by Edwin Black, *IBM and the Holocaust: The Strategic Alliance between Nazi Germany and America's Most Powerful Corporation* (New York: Crown, 2001); for a measured (and negative) review that confirms the general lack of quality scholarship on American multinational corporations operating in Germany during World War II, see Michael Allen, "Stranger than Science Fiction: Edwin Black, IBM, and the Holocaust," *Technology and Culture* 43, no. 1 (January 2002): 150–54. It is also important to point out that IBM, like many other American and European multinationals accused of colluding

with the Nazi regime, also produced munitions and more advanced statistical and computational technologies for the Allies during these years, often at a significant net fiscal loss. However, much of this ingratiating behavior was aimed at securing later lucrative contracts from various states in the promised (and actualized) period of economic growth following the war. The cold war, not World War II, proved to be the making of IBM as a major multinational, as government programs such as SAGE integrated it with the American and foreign university research apparatus and thus fueled its innovations in computing technology.

6 "Men Make the Business," talk at 2nd Quarter Century Club, Atlantic City, 25–29 September 1925, in Watson Sr., *Men—Minutes—Money,* 74.

7 International Business Machines, Gallery of Science and Art, Business Systems and Insurance Building, New York World's Fair, exhibition catalog, Box 2, Folder 3, "N.Y. 1939 IBM Gallery," IBM Corporate Archives.

8 Maney, *The Maverick and His Machine,* 234.

9 Ibid., 236.

10 "IBM Day Special Exercises in the Interest of World Peace."

11 After World War II, Watson Sr. was a leading apologist for the United Nations. In a file of materials from his desk that he saved for the IBM Corporate Archives in 1954, he left notes for a speech defending the UN, and clearly considered his support of the League of Nations and the UN as absolving him from the sin of his admiration for fascism. He accepted a Nazi medal from Hitler in 1937 while attending a meeting of the International Chamber of Commerce in Berlin, which became a perpetual source of embarrassment.

12 On the more spectacular exhibits at the 1939 New York World's Fair, see, for example, David Gelernter, *1939, the Lost World of the Fair* (New York: Free Press, 1995); David E. Nye, *The American Technological Sublime* (Cambridge, Mass.: MIT Press, 1994); and Adnan Morshed, "The Aesthetics of Aerial Vision: The Futurama of Norman Bel Geddes" (PhD diss., MIT, 2003), which provides a remarkably thorough bibliography.

13 A chart prepared by IBM for promotional uses, titled "1939 World's Fair Attendance/Size of Pavilion," showed clearly that IBM outdrew many of its larger competitors—3 million visitors in ten thousand square feet—rating a "Smash Hit." It also projected already IBM's goals for the 1964 World's Fair, with a pavilion of fifty to sixty thousand square feet and an audience of 7.5 million (RG8 World's Fairs, Box 2, Folder "1939 N.Y.," IBM Corporate Archives). The actual attendance at IBM's pavilion at the second New York World's Fair was closer to 6 million, but it was nonetheless the most popular exhibit by far.

14 "International Business Machines City" pamphlet (New York: IBM, 1940), World's Fairs Box 12, "Ephemera," IBM Corporate Archives.

15 Watson Sr., "Grow with the Organization," 34.

16 John von Neumann, "Can We Survive Technology?" in Editors of *Fortune, The Fabulous Future: America in 1980* (New York: E. P. Dutton, 1956): 43.

17 See Watson Jr.'s first two lectures given at the Columbia University School of Business, reprinted in Thomas J. Watson Jr., *A Business and Its Beliefs: The Ideas That Helped Build IBM* (New York: McGraw-Hill, 1963), chaps. 1–2.

18 Quoted in Kelly, "Curator of Corporate Character," 43.

19 Thomas J. Watson Sr., "The Man Proposition" (1915), in *Men—Minutes—Money,* 15, 18.

20 Thomas J. Watson Sr., "Men—Minutes—Money" (1916), in *Men—Minutes—Money,* 32–33. The emphasis is Watson's.

21 This goal remained unchanged after IBM identified itself with the computer; as an IBM manager put it in a talk nearly sixty years after Watson's speech, "The IBM Design Program does not indulge in planned obsolescence. . . . We seek a classic timelessness" (C. C. Hollister, "The IBM Design Program," lecture delivered to IBM employees in Paris, June 1973, Box F48, IBM Corporate Archives).

22 Mumford, *Technics and Civilization,* 15.

23 Ibid., 13.

24 Mumford later corrected this oversight in his two-volume rant *The Myth of the Machine* (New York: Harcourt Brace Jovanovich, 1967–70), there beginning his account of the encroaching autocracy of the machine with Egyptian culture.

25 This reduction in the scale of the module

corresponds to our contemporary notion of "resolution," which is a measure of the clarity of the television image. On the role of the module in computer graphics and television, see Friedrich Kittler, "Computer Graphics: A Semi-Technical Introduction," *Grey Room* 2 (Winter 2001): 30–45.

26 The grid—as distinct from the finite grille constructed from like forms, such as squares—only emerges in post-Cartesian mathematical thought. Perspectival technique, as outlined in treatises such as Alberti's *De aedificatoria* and *De pictura,* only *seems* to construct an image of infinite extension through the device of the vanishing point; however, as Erwin Panofsky and Hubert Damisch both demonstrate (in very different terms), mathematical perspective is always already established through the imposition of a frame. See Panofsky, *Perspective as Symbolic Form,* trans. Christopher S. Wood (New York: Zone, 1993), 27–72; and Damisch, *Origin of Perspective.* Also useful on the nature of the grid is "Hubert Damisch and Stephen Bann: A Conversation," *Oxford Art Journal* 28, no. 2 (2005): 172. I thank Stephen Bann for bringing this discussion to my attention.

27 See entries for "module" and "model," *Oxford English Dictionary,* online edition.

28 This is perhaps most dramatically demonstrated by the French "rationalist" tradition in architectural design (see, for example, J.-N.-L. Durand, *Précis des leçons d'architecture données à l'École polytechnique* [Paris, 1809] and subsequent design textbooks by figures such as Auguste Choisy); certainly Le Corbusier's dictum that "the plan is the generator" and his eventual articulation of the *Modulor* proportional system are also derived from this tradition.

29 See Martin, *Organizational Complex,* esp. chap. 2.

30 Henri Lefebvre, *The Production of Space,* trans. Donald Nicholson-Smith (Oxford: Basil Blackwell, 1991), 326.

31 See Georges Canguilhem, *The Normal and the Pathological,* 3rd expanded ed., trans. Carolyn Fawcett (Dordrecht: D. Reidel, 1978), 146: "In any case the property of an object or fact, called normal in reference to an external or immanent norm, is the ability to be considered, in its turn, as

the reference for objects or facts which have yet to be in a position to be called such. The normal is then at once the extension and the exhibition of the norm. It increases the rule at the same time that it points it out. It asks for everything outside, beside, and against it that still escapes it. A norm draws its meaning, function, and value from the fact of the existence, outside itself, of what does not meet the requirement it serves. The normal is not a static or peaceful, but a dynamic and polemical concept."

32 Eliot Noyes, "Architectural Details [7]," *Architectural Record* 139 (January 1966): 121. My emphasis.

33 See Terry Eagleton, *The Ideology of the Aesthetic* (Oxford: Basil Blackwell, 1990), chaps. 1–3, and esp. 87–88; and Louis Althusser, "Ideology and Ideological State Apparatuses (Notes towards an Investigation)" (January–April 1969) and "Postscript," trans. Ben Brewster, in Althusser, *Lenin and Philosophy and Other Essays* (New York: Monthly Review Press, 1971), 127–86.

34 Peter Blake, *Form Follows Fiasco: Why Modern Architecture Hasn't Worked* (New York: Little, Brown, 1977), "The Fantasy of the Open Plan," 33.

35 "IBM . . . Only Yesterday—Now Tomorrow," promotional pamphlet, [1966], Poughkeepsie Box 49, Folder "Divisions," IBM Corporate Archives.

36 After Noyes's additions to the campus, the Kenyon mansion was eventually converted into the "IBM Homestead," where both visiting IBMers and clients would be greeted by a specially trained Guest Services Staff and could embark on a tour of the facilities. The Guest Services Staff developed tours designed to address visitors' specific questions; it also hosted frequent luncheons for visitors with IBM managers ("IBM Poughkeepsie Guest Services," [1966], Poughkeepsie Box 49, Folder "Guest Services," p. 4, IBM Corporate Archives).

37 On the laboratory designs of Vorhees, Walker, Foley and Smith, see Charles Haines, "Planning the Scientific Laboratory," in *Buildings for Research,* ed. Herbert L. Smith Jr. (New York: F. W. Dodge, 1958), 3–19.

38 See Martin, *Organizational Complex,* chaps. 4 and 5.

39 On Saarinen, see the recent monographs Jayne Merkel, *Eero Saarinen* (London: Phaidon, 2005); Antonio Román, *Eero Saarinen: An Architecture of Multiplicity* (New York: Princeton Architectural Press, 2003); and the scholarly exhibition catalog edited by Eeva-Liisa Pelkonen and Donald Albrecht, *Eero Saarinen: Shaping the Future* (New Haven, Conn.: Yale University Press, 2006).

40 "Clarity, Cohesiveness, Good Detail; IBM Education Center, Poughkeepsie, New York," *Architectural Record* 126 (September 1959): 199–204. See booklet "IBM Poughkeepsie Guest Services."

41 Noyes's second house in New Canaan is probably his most famous architectural work. It was published repeatedly in the architectural and popular press as an exemplar of modern design, winning praise for its powerfully simple integration of a binuclear plan into a single, enclosed volume; see, for example: "House, New Canaan, Connecticut," *Progressive Architecture* 35 (January 1954): 122; "House: New Canaan, Connecticut," *Progressive Architecture* 37 (December 1956): 98–105; John Peter, "The New Early American Look in Home Living," *Look* 20, no. 8 (17 April 1956): 72–73; and John Peter, "For Women Only," *Look* 20, no. 8 (17 April 1956): 76.

42 "Clarity, Cohesiveness, Good Detail," 200.

43 Eliot Noyes, "Moods Are Not Accidents," *Life,* 15 February 1965, unpaginated. Noyes continues, "You know where you are and to a large extent you can see every other part of the house and through it to the woods beyond on every side. . . . Because of the separation of the spaces, special devices for communication are obviously necessary; there is an intercom system which links the kitchen and study with all bedrooms."

44 See note 31.

45 Saarinen's design is treated in greater detail by Martin, *Organizational Complex,* chap. 4.

46 On Bolles, best known for his design of Candlestick Park in San Francisco, see David Parry, "Bolles, John S(avage)," in *Encyclopedia of San Francisco,* http://www.sfhistoryencyclopedia.com/articles/b/bollesJohn.html.

47 "How IBM Constructs Low-Cost, Handsome Buildings," *Engineering News-Record,* 6 September 1962, unpaginated, reprint in Box F46, IBM Corporate Archives.

48 See Peter Galison, "War against the Center," *Grey Room* 4 (Summer 2001): 6–33.

49 The first director of IBM's research activities at Yorktown Heights, Emmanuel R. Piore, has written of this change in approach in *Science and Academic Life in Transition,* ed. Eli Ginsberg (New Brunswick, N.J.: Transaction, 1990); on the shift toward free research, see also Vannevar Bush, *Science: The Endless Frontier,* report to the President (Washington, D.C.: U.S. Government Printing Office, 1945), and Edwards, *Closed World,* esp. 58–60.

50 See Martin, *Organizational Complex,* chap. 6: "The Topologies of Knowledge," 183–211.

51 Thomas J. Watson Jr., in "Proceedings: Annual Meeting of Stockholders of the International Business Machines Corporation," at the Thomas J. Watson Research Center, Yorktown, New York, 25 April 1961, p. 4, Location Files, Folder "Yorktown Heights," IBM Corporate Archives. See also Martin, *Organizational Complex,* 206.

52 See Saarinen's statements on the building in *Eero Saarinen on His Work: A Selection of Buildings Dating from 1947 to 1964,* ed. Aline B. Saarinen (New Haven, Conn.: Yale University Press, 1962).

53 "Unique Cross-Curve Plan for IBM Research Center," *Architectural Record* 129 (June 1961): 140.

54 "Possible Space Layout," in *The New IBM Research Center in Yorktown,* IBM Report (1959), Collection of Peter Papademetriou, Eero Saarinen Archive Project. I am grateful to Peter Papademetriou for sharing copies of this report with me.

55 A productive comparison for understanding how this topological inversion is achieved is Le Corbusier and Iannis Xenakis's La Tourette monastery in Eveux-sur-l'Arbresle, France, of 1957, in which the traditional monastic cloister is turned inside out, into a pair of hallways meeting at the center. The concrete mullions of these glass-enclosed walkways, whose spacing is determined by an algorithm similar to that used by Xenakis in composing his music, replace the cloister as an image of order in a gesture of grand-scale ab-

straction and autonomous enclosure: rather than being applied to the landscape, the order (of these hallways suspended over the landscape) pertains only to itself. See Iannis Xenakis, "The Monastery of La Tourette," in *Le Corbusier,* ed. Albert Brooks (Princeton, N.J.: Princeton Architectural Press, 1987), 143–62.

56 "What We Make and Where," *IBM Business Machines* 42, no. 2 (February 1959): 6–7.

57 "Special Organization Issue," *IBM Business Machines* 42, no. 6 (June 1959).

58 P. M. Freeman to IBM Corporate Headquarters employees, memorandum, 21 December 1961, and Thomas J. Watson Jr. to "Fellow IBMers," 10 May 1961, Location Files, Folder "Armonk/Old Bldg./Relocation from NYC," IBM Corporate Archives.

59 The decision to relocate to the suburbs and exurbs of Westchester County was part of a general exodus of corporations from Manhattan. General Foods began the trend in 1954, and tens of major companies followed throughout the 1950s, 1960s, and 1970s. On this relocation, see Hank Whittemore, "IBM in Westchester: The Low Profile of the True Believers," *New York Magazine* 5, no. 21 (22 May 1972): 51–63.

60 See also O. M. Scott, "GPD Presentation to CMC: Armonk Fall Out Shelter," 11 January 1961, and R. W. Brown to IBM CMC staff and IBM division managers, memorandum, "Subject: Shelters at IBM Locations," n.d., Location Files, "Armonk/Old Bldg/Fallout Shelter," IBM Corporate Archives.

61 On SAGE, see Edwards, *Closed World,* chap. 3; and "SAGE (Semi-Automatic Ground Environment)," special issue, *Annals of the History of Computing* 5, no. 4 (October–December 1983).

62 Burck and the editors of *Fortune, The Computer Age and Its Potential for Management,* 31.

63 Paul Virilio, *Popular Defense and Ecological Struggles* (New York: Semiotext(e), 1990), 15. Emphasis in original.

64 *Webster's II New Riverside University Dictionary* (Boston: Houghton-Mifflin, 1988). My emphasis.

65 Burck and the editors of *Fortune, The Computer Age and Its Potential for Management,* 26.

On Noyes's projects for Westinghouse, see the brief discussion in the Conclusion.

66 The SAGE interfaces were designed by a spin-off of the Rand Corporation, the Systems Development Corporation (SDC), to be a wholly enclosed and self-consuming cinematic economy, in which filmic projection recorded and reprojected itself: "The center also has IBM equipment hooked up to an SDC-designed electronic unit for automatic production of training films. These training films are an essential element in a unique training technique developed by SDC—*the packaged air raid. Electronic spots from the tape automatically produce tiny blips of light on the film. These, in turn, can be projected on a radar scope to simulate an enemy attack"* ("Relationship of Man and Computers," *IBM Business Machines* 43, no. 9 [September 1960]: 11; my emphasis). Compare with Paul Virilio, *War and Cinema: The Logistics of Perception,* trans. Patrick Camiller (London: Verso, 1989), 6: "There is no war, then, without representation, no sophisticated weaponry without psychological mystification. Weapons are tools not just of destruction but also of perception—that is to say, stimulants that make themselves felt through chemical, neurological processes in the sense organs and the central nervous system, affecting human reactions and even the perceptual identification and differentiation of objects."

67 "Highlights: IBM Corporate Headquarters, Armonk, New York," IBM press release, 18 March 1964, Location Files, "Armonk/Old Bldg/About Our New HQ," 3, item B, IBM Corporate Archives.

68 On the numerous innovations that SOM made in the design of the Armonk building, see the lengthy brochure "About Our New Corporate Headquarters, Armonk, N.Y.," 18 March 1964, Location Files, "Armonk/Old Bldg/About Our New HQ," IBM Corporate Archives.

69 "Highlights: IBM Corporate Headquarters." SOM's experience in the rationalized and computerized control of space at the Air Force Academy and at Armonk evidently had a profound impact; in the late 1960s, SOM engineers designed a computer program called BOP ("Building Optimization Program") that applied minimax logic to data such as zoning regulations, building codes,

required area, and mechanical systems in order to generate a full-fledged building design. The firm ran the program on an IBM 2250 graphic interface attached to an IBM System/360 Model 91 computer in its Chicago office. On the early use of computer design programs and graphic interfaces, see, for example, Murray Milne, "From Pencil Points to Computer Graphics," *Progressive Architecture* 51 (June 1970): 168–77; Yona Friedman, "The Flatwriter: Choice by Computer," *Progressive Architecture* 52 (March 1971); David Campion, *Computers in Architectural Design* (London: Elsevier, 1968).

70 "About Our New Corporate Headquarters," unpaginated.

71 This technique was also used at the IBM France Research Laboratory at La Gaude in the same years, and later at the IBM Administrative Building at Boca Raton, Florida; both buildings were designed by Marcel Breuer and Associates. The project architect on both buildings, Robert F. Gatje, designed supergraphics in the same four colors to distinguish the various wings of the building (interview with author, 28 February 2002).

72 Whittemore, "IBM in Westchester."

73 Ibid.

74 In the end, Noguchi included one rock too many, and in order to remove the outstanding boulder, the contractor was forced to break down one of the building's rear walls in order to be able to bring in equipment required to crush it ("Secrets of a Japanese Garden," *North Castle News,* 28 October 1964, 6, Location Files, "Armonk/Old Armonk Bldg/Courtyards," IBM Corporate Archives).

75 "Gardens at CHQ Symbolize Man's Past and Future," *IBM Corporate Headquarters News,* 23 September 1964, 3, Location Files, "Armonk/Old Armonk Bldg/Courtyards," IBM Corporate Archives. The following quotes about the garden, unless otherwise noted, are taken from this article.

76 Isamu Noguchi, interviewed in *THINK,* November/December 1975, 32.

77 IBM Press Release, "IBM Dedicates New Headquarters," 21 October 1964, Location Files, "Armonk/Old Armonk Bldg/IBM Dedicates New HQ," IBM Corporate Archives.

78 This phenomenon is recorded multiple times in Robert Bruegmann, ed., *Modernism at Mid-Century: The Architecture of the United States Air Force Academy* (Chicago: University of Chicago Press, 1994).

79 Fisher, McKie, and Mancke, *I.B.M. and the U.S. Data Processing Industry,* 140.

80 See Burck and the editors of *Fortune,* "The 'Assault' on Fortress I.B.M.," chap. 4 of *The Computer Age and Its Potential for Management.* The authors argue that in fact IBM was in little danger of losing its position as the largest and most profitable computer corporation. See also Pugh, *Building IBM,* chap. 18.

81 John Morris Dixon, "I.B.M. Thinks Twice," *Architectural Forum* 124 (March 1966): 33.

82 The curtain wall is, of course, a wall that has been relieved of structural duty and thus performs only the function of environmental segregation and ornamental representation. See the excellent entry "Curtain Wall" by Giuseppe Giordanino, Giuseppe Varaldo, and Gian Pio Zuccotti, in *Encyclopedia of Modern Architecture,* ed. Gerd Hatje (New York: Harry N. Abrams, 1964), 78–81.

83 "Draft Memorandum to: Real Estate and Construction Division Managers; Subject: Design and Construction of IBM Buildings," 14 May 1964, Box 62, Folder "IBM Real Estate & Construction 1966," Eliot Noyes Archive.

84 Ibid.

85 E. G. Newlin-Wagner [manager, IBM Interior Design Coordination, RECD] to Eliot Noyes, 25 September 1969, Box 66, Folder "IBM Project 1968," Eliot Noyes Archive.

86 Pierce, "The Brick and Mortar of IBM," 32.

87 Ibid.

88 Ibid., 34. As of the article's publication, Howe stated that IBM currently owned parcels of land in "North Carolina, Oklahoma, Nebraska, Arizona, California, Connecticut, New Jersey and Virginia; overseas, in Denmark, Germany, Iran, Ireland, Chile, Peru, Argentina, the Netherlands, Spain, Switzerland, Australia, and the United Kingdom."

89 John Morris Dixon, "From Uxmal to IBM," *Architectural Forum* 122 (June 1965): 39. See also Victor Lundy to Frank Eliseo [IBM RECD], 28 January 1964, Box 66, Folder "IBM RECD 1968," Eliot Noyes Archive.

90 On this project, see "Offices, Los Angeles," *Architect and Building News* 232, no. 15 (11 October 1967): 619–20; and "IBM Aerospace Headquarters," *Arts & Architecture* 81 (October 1964): 15–17.

91 Eliot Noyes, "A Continuing Study of the Window Wall by Eliot Noyes," *Architectural Record* 141 (April 1967): 173–80.

92 Ibid.

93 Yamasaki probably captured Noyes's attention with his ribbed-vault design for the Science Pavilion at the Seattle World's Fair of 1962, in which IBM also participated. On the IBM Seattle building, see Sheri Olson, "Pride and Prejudice: Minoru Yamasaki's Seattle Legacy," *Arcade* 23, no. 2 (Winter 2004): 10–13; David L. Salomon, "Divided Responsibilities: Minoru Yamasaki, Architectural Authorship, and the World Trade Center," *Grey Room* 7 (Spring 2002): 86–95; "IBM Building, Seattle, Washington," *Architectural Record* 137 (February 1965): 123–28; "Structure Plays Leading Role in Latest Yamasaki Designs," *Architectural Record* 134 (December 1963): 103–10.

94 On other buildings in this technologically advanced development, especially the two by Harrison & Abramovitz, see John Harwood and Janet Parks, *The Troubled Search: The Work of Max Abramovitz,* exhibition catalog (New York: Miriam and Ira D. Wallach Art Gallery/Studley Press, 2004), 70, 107.

95 "IBM's Exterior-Truss Walls," *Progressive Architecture* 43 (September 1962): 162–67.

96 Thomas J. Watson Jr. to Eliot Noyes, 13 November 1968, Box 66, Folder "IBM Project 1968," Eliot Noyes Archive. Four years earlier, Noyes and Watson had another exchange of letters about the quality of the design program, when Watson asked Noyes to intervene in the controversy over the Fishkill plant: Eliot Noyes to Thomas J. Watson Jr., 18 November 1964, Box 66, Folder "IBM Project 1968," Eliot Noyes Archive.

97 Eliot Noyes to Thomas J. Watson Jr., 25 November 1968, Box 66, Folder "IBM Project 1968," Eliot Noyes Archive.

98. Eliot Noyes, notes on "Boca Raton" and "IBM Museum" dated 24 March 1969, Box 66, Folder "IBM Boca Raton, Florida, Breuer Project '68–'70,"

Eliot Noyes Archive.

99 Eliot Noyes to H. Wisner Miller Jr., 9 June 1964, Box 62, Folder "IBM Real Estate & Construction 1966," Eliot Noyes Archive.

100 See Eliot Noyes to Max Cardiff [RECD], 21 January 1969, Box 62, Folder "IBM RECD 1969 General," Eliot Noyes Archive.

101 Hollister, "IBM Design Program."

102 The most comprehensive study of IBM's business practices from the 1940s to the 1970s—and thus of the business history of computing as a whole—is Fisher, McKie, and Mancke, *I.B.M. and the U.S. Data Processing Industry.* The book is "closely based" on the "Historical Narrative" study that the three economists wrote as testimony in the antitrust trial *U.S. v. IBM,* of 1969. Information regarding IBM's business practices in this section is taken from this source, unless otherwise noted.

103 IBM World Trade pamphlet, "This Is IBM," 1969, Box 57, Folder 5, CRE LOC.

104 Corinna Schlombs, "Engineering International Expansion: IBM and Remington Rand in European Computer Markets," *IEEE Annals of the History of Computing* 30, no. 4 (January 2009): 42–58; see also Schlombs, "Towards International Computing History," *IEEE Annals of the History of Computing* 28, no. 1 (January 2006): 108.

105 See Henry Bakis, *I.B.M.: Une multinationale régionale* (Grenoble: Presses Universitaires de Grenoble, 1977), a detailed study, written from a critical geographic perspective, of the development of IBM France from the 1950s to the 1970s. The first part of the study analyzes "la firme et son organisation dans l'espace" (3–52), arguing that IBM was particularly aware of the exigencies of the national economies within which it operated, and he notes IBM's flexibility in adapting to new situations through restructuring its international organs as subsidiaries of a nonpresent parent corporation. Thus, it achieved "organisation intégrée" through a strategy of centralized decentralization.

106 In the special issue "Profile of IBM World Trade" of *IBM Business Machines* 45, no. 5 (May 1963), IBM proudly enumerated the ways in which its World Trade arm had integrated itself

into the state apparatus of each country in which it did business, from Sweden to Ethiopia.

107 For a history of IBM's ingratiation and integration with the French military, see Jacques Vernay, "IBM France," *Journal of Computing History* 11, no. 4 (1989): 299–311; Henri Boucher, "Informatics in the Defense Industry," *Journal of Computing History* 12, no. 4 (1990): 227–40; and Boyd France, *IBM in France* (New York: National Planning Association, 1961), esp. 13–32. Bakis, *I.B.M.,* also documents the development of this relationship, particularly in the third part of his study, "L'impact economique et social," 101–70.

108 While the U.S. theme for the fair was "America . . . the Land and the People," IBM operated under its own motto, "World Peace through World Trade." Materials on the Brussels pavilion and exhibits are preserved in World's Fairs Box 3, IBM Corporate Archives.

109 Nasrollah S. Fatemi, Gail W. Williams, and Thibaut De Saint-Phalle, eds., *Multinational Corporations: The Problems and the Prospects,* 2nd ed. (New York: A. S. Barnes; London: Thomas Yoseloff, 1976), 199; see also the remainder of chap. 7, "The Multinational Corporation and National Sovereignty." See also "Profile of IBM World Trade."

110 Working drawings for the IBM World Trade Headquarters building are preserved in the Wallace K. Harrison Collection in the Miriam and Ira D. Wallach Study Center, Avery Architectural and Fine Arts Library, Columbia University.

111 Gyorgy Kepes, *The New Landscape of Art and Science* (Chicago: Paul Theobald, 1956), 262.

112 D'Arcy Thompson, *On Growth and Form,* abridged ed., ed. J. T. Bonner (Cambridge: Cambridge University Press, 1961), 11.

113 As Christopher Alexander points out in his essay "From a Set of Forces to a Form," in *The Man-Made Object,* ed. Gyorgy Kepes (New York: Braziller, 1967), 96: "Forces generate form. In the case of certain simple natural systems, this is literally true. In the case of complex, man-made systems, it is a metaphor." However, many architectural theorists of the curtain or membrane wall during this period took this metaphor rather more literally; for instance, James Marston Fitch, in *Architecture and the Esthetics of Plenty* (New York: Columbia University Press, 1961), argued that "a technology which can achieve the thermonunclear bomb and the moon rocket should give us a wall which behaves like the epidermis of the animal body—i.e. which responds actively and automatically to changes in its external environment. It is not too difficult to imagine such a wall" (201).

114 Robert Gatje, *Marcel Breuer: A Memoir* (New York: Monacelli, 2000), 99. On the IBM France laboratory at La Gaude, see ibid., 99–108; "Centre de Recherches I.B.M. La Gaude, France," *Architecture d'aujourd'hui,* no. 106 (February 1963): 18–25; "Le Centre d'Études et de Recherches d'IBM-France," *Construction moderne* 79, no. 3 (1963): 34–44; Robert F. Gatje, "Marcel Breuer's Research Center for IBM France," *Japan Architect* 38 (March 1963): 12–22; "Centre de Recherches I.B.M. près de Nice," *Architecture d'aujourd'hui,* no. 99 (December 1961–January 1962): 28–29.

115 Bakis, *I.B.M.,* 3–4.

116 "Binary Bounce: Endicott to La Gaude, France," *IBM Business Machines* 45, no. 12 (December 1962): 4–5.

117 The difference between the commissions further draws out the "double" nature of the Boca Raton complex; while IBM indulged Breuer's desire to experiment in his design for the La Gaude lab, RECD had no patience for his insistence on including a man-made lake with an island sculpture garden in the middle. A bitter battle ensued in correspondence between Breuer, Gatje, Noyes, various RECD managers, and even Watson, much of which is preserved in Box 66, Eliot Noyes Archive.

118 Kepes, *Man-Made Object.* The photograph of the System/360 computer is printed on 21; on the facing page is another photograph, of a "Shaker room"—clearly drawing an analogy between both based upon their shared blankness, rationality, and order. The IBM France building appears, twice, as an illustration for Marcel Breuer's very short essay, "Genesis of Design," 120–25.

119 See Samuel Weber, "Upsetting the Setup: Remarks on Heidegger's 'Questing after Technics,'" in Weber, *Mass Mediauras: Form Technics Media* (Stanford, Calif.: Stanford University Press,

1996), esp. 70–75.

120 Egon Eiermann and Heinz Kuhlmann, *Planungsstudie Verwaltungsgebäude am Beispiel für die IBM-Deutschland,* Projekt 2 (Stuttgart: Karl Krämer, 1967). The designs from the study are also republished, with minimal commentary, in Wulf Schirmer, ed., *Egon Eiermann, 1904–1970: Bauten und Projekte* (Stuttgart: Deutsche Verlags-Anstalt, 1984), 219–21. IBM and Eiermann seem to have established a relationship well before the commissioned study, as evidenced by a letter from Eierman to the director of IBM in Sindelfingen, a certain Perschke, dated 9 November 1964, published in *Egon Eiermann: Briefe des Architekten, 1946–1970,* 2nd ed. (Stuttgart: Deutsche Verlags-Anstalt, 1997), 216. Four additional letters from Eiermann to various IBM managers are also published there, 217–20.

121 Eiermann and Kuhlmann, *Planungsstudie Verwaltungsgebäude,* 7.

122 Ibid. The relative cost and effectiveness of the proposed sun-shading mechanisms and communications, trash disposal, and air-conditioning systems were examined in great detail, illustrated with charts and diagrams wherever relevant. In addition, the architects estimated the different construction (and maintenance) costs if the structures were to be built with reinforced concrete or steel structural skeletons. Three engineers, G. Lewenton, Ernst Werner, and L. Schwarz, contributed a brief report to the study on the relative efficiency of concrete and steel construction. They concluded that the use of a new technique for constructing curtain walls by "hanging" them from a steel space frame on the roof that could be raised up around the building's structural core by a system of cranes would result in a significant savings if the skyscraper solution were chosen.

123 Ibid., 66: "Wenn man die aufgezeigten Vor- und Nachteile der beiden Entwürfe abwägt, ist man als Architekt geneigt, dem Vorschlag I: Hochbau den Vorrang einzuräumen. Die Klarheit in der funktionellen Lösung, die gute städtebauliche Eingliederung, die Gesichtspunkte der Werbewirksamkeit und der kurzen Verkehrswege sind eindeutig."

124 See Eberhard Schnelle and Alfons Wankum,

Architekt und Organisator (Quickborn: Verlag Schnelle, 1964); and Branden Hookway, *Pandemonium: The Rise of Predatory Locales in the Postwar World* (Princeton, N.J.: Princeton University Press, 1999).

125 Eiermann and Kuhlmann, *Planungsstudie Verwaltungsgebäude,* 66: "Für den Bauherrn [IBM] waren die Bau- und Betriebskosten sowie die Flexibilität der Anlage entscheidend und nicht die Werbewirksamkeit oder der Eindruck, den das architektonische Bild gibt." Eiermann was not completely foiled in his efforts to build his new type of skyscraper, however. In 1968 he was given the commission to design what would be his last building, the Olivetti offices in Frankfurt, that was built using the construction system that he had developed in conjunction with Siemens-Bauunion.

126 On the Stuttgart-Veihingen buildings, see Schirmer, *Egon Eiermann, 1904–1970.*

127 Eiermann made a relatively weak proposal for a skyscraper on the suburban site in his earliest plans, all from 1967. Some of the drawings are published in Schirmer, *Egon Eiermann, 1904–1970.*

128 Ibid., 315.

129 Lance Wright, "Factory and Offices, Havant, Hants," part two of a three-part article on two IBM buildings in England titled "Form in the Commercial Waste," *Architectural Record* 151 (January 1972): 13–14.

130 "I.S.O. (Invisible Standing Object)," *Domus,* no. 506 (January 1972): 11.

131 Wright, "Offices, Cosham, Hants," part three of "Form in the Commercial Waste," 23–24: "This is not an architectural setting, but an 'environment.' . . . Plinth and capping are traditional definers of the building: their disappearance, therefore, marks a stage in the move to make the building itself a non-thing. Indoors, the fact that the ceiling stops short, not only of the window itself but even of the perimeter beam, adds to the feeling of insubstantiality and un-dress. This is not so much a building that we are in, but something nearer to a tent."

132 "Least Is Most: British IBM Is the Understatement of the Year," *Architecture Plus* 1, no. 6 (July 1973): 27.

133 The office of Mies van der Rohe also

designed an IBM building—fittingly a tower in Chicago—that was completed only in 1972. See Rob Cuscaden, "The IBM Tower: 52 Stories of Glass and Steel on a Site That Seemed 'Almost Nonexistant,'" *Inland Architect* 16, no. 6 (July 1972): 9–13.

134 Simon Nora and Alain Minc, *The Computerization of Society: A Report to the President of France* (Cambridge, Mass.: MIT Press, 1980).

135 Jean-François Lyotard, *The Postmodern Condition: A Report on Knowledge,* trans. Geoff Bennington and Brian Massumi (Minneapolis: University of Minnesota Press, 1984), 6.

136 "IBM Sponsors Space 'Trip,'" IBM Business Machines 42, no. 5 (May 1959): 11.

137 See "Calculatin' Emmy," *IBM Business Machines* 40, no. 5 (May 1957): 12; for an extended analysis of this film in relation to the work of Charles and Ray Eames, see Merrill Schleier, *Skyscraper Cinema: Architecture and Gender in American Film* (Minneapolis: University of Minnesota Press, 2009).

138 See Friedrich A. Kittler, "There Is No Software," in *Literature, Media, Information Systems: Essays,* ed. and intro. John Johnston (Amsterdam: G+B Arts, 1997), 147: "The last historical act of writing may well have been the moment when, in the early seventies, the Intel engineers laid out some dozen square meters of blueprint paper (64 square meters in the case of the later 8086) in order to design the hardware architecture of their first integrated microprocessor." Compare with Cara McCarty, *Information Art: Diagramming Microchips* (New York: Museum of Modern Art, 1990), 4: The drawings "are unique in that, unlike drawings of earlier logic machines, there is little distinction between what is being represented and the representing. They are not symbolic, but are multi-layered patterns of the actual circuitry, and become the template of the chip. . . . *These designs were in fact not meant to be seen"* (my emphasis). The artistic quality of the microchip thus emerges not from a symbolic character, but rather from the representational power of pattern, which remains fundamentally opaque: "The consideration of the diagrams as art derives from their patterning. They are the most complex pat-

terns people have ever made, and because of their intricacy they can be deciphered completely only by a computer."

On the development of CAD and its growing use in the process of design from the perspective of an architectural historian, see Robert Bruegmann, "The Pencil and the Electronic Sketchboard: Architectural Representation and the Computer," in *Architecture and Its Image: Four Centuries of Representation,* ed. Eve Blau and Edward Kaufman (Montreal: Canadian Centre for Architecture; Cambridge, Mass.: MIT Press, 1989), 139–55.

139 Interview with Gordon Bruce, 2 April 2002. The on-set designer from the Noyes office was Noyes's partner Ernest Bevilacqua. Apparently the designs for 2001 were convincing enough to persuade NASA to ask the Noyes office—along with several other prominent industrial design firms, such as Raymond Loewy Associates—to design a real space station that would allow astronauts to survive in space for months on end and could generate its own rotational "gravity" via the Coreolis effect. This project eventually became known as Skylab. The Noyes office designs are lost; the only indication of their existence is on a postcard Charles Eames sent to Noyes and his wife Molly, 11 August 1969 (Box 81, Folder 10, "Noyes, Eliot, Correspondence and printed matter, 1969–1978, 1986, n.d.," CRE LOC): "Pinch me! You and Molly designing a space station—that's fantastic!" The Loewy office designs for Skylab are published in Raymond Loewy, *Industrial Design* (Woodstock, N.Y.: Overlook, 1979), 219–22 and the exhibition catalog *The Designs of Raymond Loewy* (Washington, D.C.: Renwick Gallery of the National Collection of Fine Arts/Smithsonian Institution Press, 1975), 34–36.

140 Arthur C. Clarke, *2001: A Space Odyssey,* "Millennial Edition," based on a screenplay by Stanley Kubrick and Arthur C. Clarke (New York: New American Library/Penguin, 1999), 236 (although this final page is, pointedly, not numbered).

141 Weber, "Upsetting the Setup," 74.

142 The slogan of an advertising campaign, published in *IBM Business Machines* 43, no. 12 (December 1960): back cover.

Chapter 4
Naturalizing the Computer

The epigraph is from Charles Eames, "Language of Vision: The Nuts and Bolts," *Bulletin of the American Academy of Arts and Sciences* 28, no. 1 (October 1974): 17–18.

1 The most familiar and dramatic examples of this (not altogether unreasonable) mass hysteria are post–World War II tales in which a haywire computer triggers Armageddon. Classics of the genre include Nevil Shute's *On the Beach* (New York: Morrow, 1957); Philip K. Dick's *Time Out of Joint* (Philadelphia: J. B. Lippincott, 1959); Eugene Burdick and Henry Wheeler's *Fail-Safe* (New York: Dell, 1962); Stanley Kubrick's *Dr. Strangelove: or, How I Learned to Stop Worrying and Love the Bomb* (1963); and James Cameron's film series *Terminator* (1984) and *Terminator 2: Judgment Day* (1991), to name but a few. For provocative readings of several popular films about computing technology, see Edwards, *Closed World,* chap. 10, "Minds, Machines, and Subjectivity in the Closed World."

However, the scenario is also one considered quite seriously in strictly scientific (or at least pseudo-scientific) circles as well. Herman Kahn's *On Thermonuclear War* (Princeton, N.J.: Princeton University Press; London: Oxford University Press, 1960), with its infamous chapter "Will the Survivors Envy the Dead?" is the masterpiece of this anxious and ideologically instable genre, filled with speculative "doomsday" scenarios. Earlier texts, such as Harrison S. Brown's *Must Destruction Be Our Destiny?* (New York: Simon and Schuster, 1946), established the ground rules of this genre even as the full implications of the bombings at Hiroshima and Nagasaki were yet unknown.

2 This was identified by both IBM and the Office of Charles and Ray Eames as IBM's "most significant P.R. problem" in notes for a presentation on the IBM Museum titled "Overall Museum Philosophy & Goals," [1967], Box 146, Folder 13, "Notes on Philosophy and Goals, 1962–69, n.d.," CRE LOC: *"P.R. Problem: what life would be like in a computerized world. 1. lessening individual importance, invading unique province of human mind. 2. intellectuals: impact on our culture—de-personalized society—conformity and sameness—downgrading man's importance."*

3 Homer M. Sarasohn [IBM Corporate Technology and Engineering staff] to Eliot Noyes, 9 April 1964, Box 62, Folder "IBM Project 1964: ID Design Program '64, Report, correspondence," Eliot Noyes Archive.

4 On the stakes of IBM's gamble on System/360, see Fisher, McKie, and Mancke, *I.B.M. and the U.S. Data Processing Industry;* and Emerson W. Pugh, *Memories that Shaped an Industry: Decisions Leading to IBM System/360* (Cambridge, Mass.: MIT Press, 1984).

5 Eliot Noyes, "Memorandum to: Members of the Martha's Vineyard IBM Design Conference [E. R. Piore, J. B. Wiesner, Charles Eames]," 10 September 1970, Box 48, Folder 3, "IBM Corporation General Correspondence, 1970," CRE LOC. The quoted article was an Associated Press summary, "Nader Sees Peril in Computer Use," *New York Times,* 2 September 1970.

6 During this period, Eames often lectured on the misguided attitude of the student protestors toward technology, criticizing them for idealizing nature. In his lecture notes are particularly vitriolic and mocking statements, such as "The Berkeley Guy conversation: '[Computers] are not like nature—nature is sympathetic and understanding.' 'Do you think you would have that view of nature if you were in a small craft during a storm at sea?'" (Box 146, Folder 13, "Notes on Philosophy and Goals, 1962–69, n.d.," CRE LOC).

7 Lewis Mumford, *The Pentagon of Power,* vol. 2 of *The Myth of the Machine* (New York: Harcourt Brace Jovanovich, 1970), 192–93. The fundamental theses of the Systemation Letter are described in greater detail in "System and Order," *Royal Bank of Canada Monthly Letter* 52, no. 5 (May 1971).

8 Quoted in Mumford, *Pentagon of Power,* 192.

9 Ibid., 192–93.

10 Isaiah 29:16, quoted in ibid., 196. The more modern, New American, translation reads: "Your perversity is as though the potter were taken to be the clay: As though what is made should say of its maker, 'He made me not!' Or the vessel should say of the potter, 'He does not understand.'"

11 Mumford, *Pentagon of Power,* pl. 6.

12 Ibid. My emphasis.

13 "The Seminar: A Precis," Box 57, Folder 4, "Scripts for films and slice shows, 1962, 1972–1980," p. 1, CRE LOC. According to this typescript, the precis was authored by Charles De Carlo and Dan Wright, and the production design of the seminar was by Bob Richardson.

14 This film was excerpted from the television series *The Computer and the Mind of Man,* a series of six half-hour programs aired on NET, the National Educational Television Network, in 1962 and 1963. Six episodes—"Logic by Numbers," "Universe of Numbers," "Universal Machine," "The Control Revolution," "Managers and Models," and "Engine at the Door"—explored the history and future of computing. De Carlo was featured prominently in all of them. Scripts for the entire television series are preserved in Box 57, Folder 1, CRE LOC.

15 "The Seminar: A Precis," 1. My emphasis. In a letter to Charles Eames, 23 January 1967, Ralph Caplan describes a pilot presentation of the seminar for the Federal Communications Commission that he attended in mid-January of the same year, further suggesting the Eameses' involvement, Box 57, Folder 4, "Seminar on Computer technology," CRE LOC.

16 "The Seminar: A Precis," 2.

17 Ibid.

18 Weizenbaum, despite his efforts to create a computer that could simulate conversation, has been a lifelong skeptic regarding the possibility of a "genuine" computer subjectivity, i.e., AI. He has published numerous essays warning against excessive enthusiasm in this regard, the most important of which are gathered in *Computer Power and Human Reason.*

19 "The Seminar: A Precis," 4.

20 Ibid., 5.

21 Ibid., 8.

22 Ibid., 8–9.

23 Lynn Stoller to I. J. Seligsohn, 3 July 1969, Box 146, Folder 8, "General correspondence, 1964–1970, n.d.," CRE LOC.

24 "The Seminar: New Afternoon Outline," [1969], Box 146, Folder 8, "General correspon-dence, 1964–1970, n.d.," p. 6, CRE LOC.

25 See James H. Carmel, *Exhibition Techniques: Traveling and Temporary* (New York: Reinhold, 1962), 63; the illustrations there are of the Noyes office–designed panel system erected in the lobby of Noyes's IBM Education Center in Poughkeep-sie, which opened in 1959.

26 George Nelson, *Display* (New York: Whitney, 1953), 110. My emphasis.

27 On these exhibits, see IBM Department of Arts and Sciences, *Leonardo da Vinci* (1951), and *IBM Traveling Exhibitions* (ca. 1958), promotional pamphlets, Department of Arts and Sciences, Box 5, Folder 13 and Folder 9, respectively, IBM Corporate Archives; Carmel, *Exhibition Techniques,* unpaginated checklist; "Data Processing Takes to the Road," *IBM Business Machines* 41, no. 1 (January 1958): 4–6; and "Successful in West, RAMACADE Heads East," *IBM Business Ma-chines* 41, no. 2 (February 1958), entire issue.

28 Dolores Cannata did the drawings, and Parke Meeke animated. Eames wrote the narration, which was read by Vic Perrin, and Elmer Bernstein scored.

29 This and subsequent quotes transcribed from *The Information Machine: Creative Man and the Data Processor,* IBM Corporate Archives.

30 See Charles Eames, "Designing a Lota," *Archi-tectural Design* 36 (September 1966): 431.

31 Transcript of Charles Eames lecture "The Information Machine," Box 218, Folder 1, "Burns . . . Lectures, Unidentified," CRE LOC. In 1972, Eames refined the anecdote into a free verse poem, in which a "king" sends for an "expert in the field," who gives much the same recommendation to the king that the Eameses gave to Nehru ("The Cardboard Computer," TS, dated "11/2/72," Box 222, Folder 5, CRE LOC).

32 Ibid.

33 For instance, the Eames Office maintained a friendship with Robert M. Stewart, a Rand Corporation scientist and later the director of the Artificial Biosystems Laboratory at Aerojet-General Corporation in Los Angeles. For materials kept by the Eames Office given to them by various military-industrial scientists and managers, much of which was used as source material in the

design of the IBM Museum, see Boxes 147–48, CRE LOC.

34 Typescript, with additional notes, in Box 218, Folder 1, "Burns . . . Lectures, Unidentified, 1968–1976, n.d.," CRE LOC.

35 See also Norbert Wiener's other important popular works: *Cybernetics* (New York: J. Wiley, 1948) and *Cybernetics; or, Control and Communication in the Animal and the Machine,* 2nd ed. (New York: MIT Press, 1961), both of which formed the basis of *The Human Use of Human Beings;* and his later *God and Golem, Inc.: A Comment on Certain Points Where Cybernetics Impinges on Religion* (Cambridge, Mass.: MIT Press, 1964).

36 The Eames Office also designed a brochure of the same title for IBM in 1968, from which this quotation is taken (Box 133, Folder 5, CRE LOC).

37 See Claude Shannon's doctoral dissertation, "A Symbolic Analysis of Relay and Switching Circuits," republished in *Transactions of the American Institute of Electrical Engineers* 57 (1938), in which he demonstrated that a series of telegraph relays could be used to represent and perform the functions of the whole of Boolean logic.

38 The new exhibit, *Some Computer ABCs,* was designed not by the Eames Office but by two IBMers, Robert L. Monahon Sr. and Marty Rosenzweig, with the illustration talents of the cartoonist Tomi ("Some Computer ABCs," promotional pamphlet, Box 49, Folder 1, CRE LOC).

39 Box 48, Folder 1, "International Business Machines Corp., film catalogs and lists, 1963–64," CRE LOC. In addition to the Eames films, the catalog includes *No Margin for Error* (on the Rochester, Minnesota Magnetic Tape Testing Center), 1957; *The Search at San Jose* (on RAMAC), 1958; *X-15: Man into Space,* 1959; *The Question Tree* (on computing problems in cryogenics, language translation, vapor growth, and optical lasers), 1961; *IBM Control Systems at Work,* 1962; *Inquiry* (on military computer systems), 1963; *OAO: Eye in Space* (on plans for an orbiting space telescope), 1963; and many others. By 1978–79, IBM had a catalog of films several pages long.

40 *Mathematica: A World of Numbers . . . and Beyond,* exhibition catalog (New York: IBM, 1961), unpaginated.

41 Quoted in Neuhart, Neuhart, and Eames, *Eames Design,* 255.

42 Dept. of Information, International Business Machines Corp., *"International Business Machines Corporation* Pavilion: Probability Machine" press release, 15 December 1963, World's Fair Box 20, Folder 6, IBM Corporate Archives.

43 *Mathematica,* unpaginated.

44 Both quotations are legible in the Eames family's private collection of photographs and slides of the exhibit.

45 Charles and Ray Eames Office Archive, Slide EH.MA.T206.

46 See J. T. Carty [manager, IBM Corporate Promotion Programs] to Charles Eames, 13 October 1960, Box 156, Folder 2, "Credits, n.d.," CRE LOC.

47 Dept. of Information, International Business Machines Corp., "A Profile of *International Business Machines Corporation,"* press release, 15 December 1963, World's Fair Box 20, Folder 6, p. 1, IBM Corporate Archives.

48 Eliot Noyes to Paul Rand, 15 August 1960, Box 62, Folder "IBM Project 1964," Eliot Noyes Archive.

49 IBM apparently entertained the idea of including Buckminster Fuller in the design team for the pavilion, albeit only briefly. See G. G. Ahlborn to Mr. Sigmund Goode [Paul C. Virdone, Inc.], 16 September 1960, Box 62, Folder "IBM Project 1964," Eliot Noyes Archive.

50 J. T. Carty [IBM CHQ] to Eliot Noyes, 10 January 1961, Box 62, Folder "IBM Project 1964," Eliot Noyes Archive: "I talked with Eero Saarinen on the phone and he's definitely with us for the World's Fair. He and Charlie Eames are still arguing about who is to be considered the 'Indian Chief.' I am sure it will all work out." Eames, Saarinen, and Noyes met in late February in New York to discuss the project (Eliot Noyes to Eero Saarinen, 13 February 1961, Box 62, Folder "IBM Project 1964," Eliot Noyes Archive).

51 Eero Saarinen and Associates, "New York World's Fair for 1964: IBM Building Report," 5 January 1962, World's Fairs Box 20, Folder 8, "Architect's Book," IBM Corporate Archives.

52 Kevin Roche, slide talk given to the IBM Pavilion Staff, 1964, World's Fairs Box 20, Folder 1, "NY 64/65 Training Manual Pt. 2," p. 8, IBM Corporate Archives.

53 Ibid.

54 Saarinen and Associates, "New York World's Fair for 1964," 2.

55 *IBM Automatic Language Translation: New York World's Fair 1964/65,* pamphlet, World's Fairs Box 15, Folder 11, "IBM Automatic Language Translation," IBM Corporate Archives. The design and typography were by Paul Rand.

56 The choice of Sherlock Holmes as a stand-in for the computer was an apt one, given Holmes's frequent reliance on coordinating various teletechnologies—telegrams, newspaper advertisements, and (of course) Watson and the Baker Street Boys—to complement his legendary powers of deduction. See, for example, "The Adventure of the Dying Detective," in which Holmes apprehends a criminal without leaving the confines of 221B Baker Street, in Sir Arthur Conan Doyle, *His Last Bow* (1917), republished in Doyle, *Sherlock Holmes: The Complete Novels and Stories,* vol. 2 (New York: Bantam, 1986).

57 *Mathematica,* unpaginated.

58 On the uncanny socialization of solipsism that underpins spectacle, see Guy Debord, *The Society of the Spectacle,* trans. Donald Nicholson-Smith (New York: Zone, 1995), esp. 1:28: "The reigning economic system is founded on isolation; at the same time it is a circular process designed to produce isolation. Isolation underpins technology, and technology isolates in its turn; all *goods* proposed by the spectacular system, from cars to televisions, also serve as weapons of that system as it strives to reinforce the isolation of 'the lonely crowd'"; and 1:33: "Though separated from his product, man is more and more, and ever more powerfully, the producer of every detail of his world. The closer his life comes to being his own creation, the more drastically he is cut off from that life."

59 Charles Eames, "Fact Sheet: IBM Pavilion, 1964–65 New York World's Fair," World's Fairs Box 20, Folder 1, "NY 64/65 Training Manual Pt. 2," IBM Corporate Archives. My emphasis.

60 *IBM Fair* (New York: International Business Machines Corporation, 1964), the typography and design of the booklet by Paul Rand, 21. The text is adapted from the script for *The Information Machine* by Glen Fleck, from the Eames Office.

61 Ibid. My emphasis.

62 On this exhibition, see Isabelle Ewig, Thomas W. Gaehtgens, and Matthias Noell, eds., *Das Bauhaus und Frankreich / Le Bauhaus et la France, 1919–1940* (Berlin: Akademie, 2002), esp. Joachim Driller, "Bauhäusler zwischen Berlin und Paris: Zur Planung und Einrichtung der 'Section allemande' in der Ausstellung der Société des Artistes Décorateurs Français 1930," 255–74, and Matthias Noell, "Zwischen Krankenhaus und Mönchszelle: 'Le nouveau visage de l'Allemagne': Die Werkbund-Ausstellung 1930 im Spiegel der französischen Tagespresse," 313–46.

63 See Mina Hamilton, "Films at the Fair II," *Industrial Design* 10, no. 3 (May 1964): 37–41.

64 Ibid., 41.

65 Ibid.

66 On the war room and the metaphorical understanding of the human mind that it implies, see Edwards, *Closed World,* chap. 5, "Interlude: Metaphor and the Politics of Subjectivity."

67 *IBM Fair,* 28.

68 [IBM], "1974–1975 Corporate Exhibit Program," Box 47, Folder 8, p. 2, CRE LOC.

69 Charles Eames, "IBM Notes," March 1969, Box 146, Folder 13, "Notes, On Philosophy and Goals, 1962–1969, n.d.," CRE LOC.

70 Eliot Noyes to Charles Eames, 21 December 1962, Box 62, Folder "IBM Project 1964," Eliot Noyes Archive.

71 Thomas J. Watson Jr. to Charles Eames, 16 March 1970, Box 146, Folder 9, "General correspondence, 1964–1970, n.d.," CRE LOC.

72 Most of these materials, save for the models, are preserved in the Charles and Ray Eames Collection in the Library of Congress.

73 *Leonardo da Vinci,* exhibition catalog (New York: International Business Machines Corporation, 1951), Department of Arts and Sciences, Box 5, Folder 13, "Leonardo," IBM Corporate Archives.

74 Serge Boutourline Jr. to Robert S. Lee, memorandum, Re: "IBM's business relations with nonspecialist computer users," 24 November 1964

[forwarded by Robert Lee to Charles Eames, 20 July 1965], Box 146, Folder 8, "General correspondence, 1964–1970, n.d.," pp. 1–2, CRE LOC.

75 Ibid., 1.

76 Ibid., 4.

77 Ibid., 4–5. Emphasis in original.

78 Ibid., 5.

79 Ibid., 7. The latter emphasis is mine.

80 Ibid., 9–10.

81 Ibid., 10. The latter question refers directly to the experiments of Dr. Weizenbaum at MIT, described in the IBM "NYC Seminar."

82 Ibid., 11.

83 Charles Eames, "Robin—Draft 3/1," [1966], Box 146, Folder 12, "Notes, 'Notion writing,' 1966, n.d.," pp. 1–2, CRE LOC.

84 Box 146, Folder 13, "Notes, On philosophy and goals, 1962–1969, n.d.," CRE LOC. The remainder of the unfootnoted quotations in this paragraph are from these unpaginated notes.

85 Charles Eames, unpaginated notes, Box 146, Folder 11, "Notes, General, 1966–1969, n.d.," CRE LOC.

86 "Overall Museum Philosophy & Goals." My emphasis.

87 Ibid.

88 "The IBM Museum and Exhibition Center," film script, 7 September 1967, Box 146, Folder 13, p. 1, CRE LOC.

89 Althusser, "Ideology and Ideological State Apparatuses," 168.

90 *Oxford English Dictionary,* online edition, "heurism."

91 Ibid., "heuristic," etymological entry A explicitly links "heuristic" to the Greek root *ergon,* also the root of "organ" and "work" and of the neologism "ergonomics."

92 *Webster's 3rd New International Dictionary* (Springfield, Mass.: Merriam, 1963), "heuristic, adj.," definition 3.

93 Anatol Rapaport, *Two-Person Game Theory: The Essential Ideas* (Ann Arbor: University of Michigan Press, 1966), 21. See also his discussion of "Opportunities and Limitations" of game theory in chap. 12, particularly his conclusion that "the great philosophical value of game theory is in its power to reveal its own incompleteness. Game-

theoretical analysis, if pursued to its completion, *perforce* leads us to consider other than strategic modes of thought" (emphasis in original).

Another useful and accessible text on game theory for the layperson, albeit a far less critical and perhaps even sinister one in that it emphasizes the immediate applicability of game theory to real-world conflicts, is by J. D. Williams of the Rand Corporation: *The Compleat Strategyst: Being a Primer on the Theory of Games of Strategy* (New York: McGraw-Hill, 1954). The book is written beautifully and illustrated with humorous cartoons by Charles Satterfield, making it more than likely that it was a favorite resource for Charles Eames, who knew J. D. Williams and his colleagues at Rand in Santa Monica.

94 Baudrillard, *System of Objects,* 130n.

95 *Oxford English Dictionary,* online edition, definition 1. My emphasis.

96 The description is quoted in the Oxford English Dictionary, online edition, from H. L. Gelernter and N. Rochester, "Intelligent Behavior in Problem-Solving Machines," *IBM Journal of Research and Development* 2, no. 4 (October 1958): 337.

97 Robert S. Lee to D. L. Holzman, 30 November 1962, "Subject: A Museum of Computer Science Run by a Computer," Box 146, Folder 13, "Notes, On philosophy and goals, 1962–1969, n.d.," CRE LOC.

98 The deployment of all of the rudimentary strategies of behavioral psychology was at the core of the IBM museum project; in a paper that Lee presented at the Conference on Computers and their Potential Applications in Museums at the Metropolitan Museum of Art in New York (15–17 April 1968), he outlined a rigorous theory of environmental determinism and outlined various methods of heuristic pedagogy from Montessori up through the 1960s, concluding with the following article of faith: "We have come to believe that interaction was the key—not the superficial mechanical interaction of pressing buttons—but the more engrossing interaction of cognitive and emotional engagement with a responsive environment" (Box 150, Folder 15, "Photocopies of early cartoons re computers, n.d.," pp. 11–12, CRE LOC).

99 Lee, "A Museum of Computer Science Run by a Computer," 1.

100 Ibid. The emphasis is Lee's.

101 IBM News Release, "Seattle World's Fair," [April 1962], World's Fairs Box 15, Folder 4, "Seattle 1962," IBM Corporate Archives.

102 Lee, "A Museum of Computer Science Run by a Computer," 2.

103 Glen Fleck, design notes for "IBM Museum," Box 147, Folder 7, CRE LOC.

104 Ibid.

105 Notes by Charles Eames, Glen Fleck, and Jehane Burns, Box OV-1, Folder "IBM Museum & Exhibit Center, Armonk, NY; Items: Conceptual Planning, Notes, General, 1966–69, n.d.," CRE LOC.

106 Glen Fleck, conceptual sketches, Box 146, Folder 7, CRE LOC.

107 Script of 1967 "museum film," in *Project Inventory: IBM/Office of Charles and Ray Eames* (compiled by the Office of Neuhart Donges Neuhard Designers, Inc., 1981), in Eames Office Archives, Santa Monica, Calif., p. 15.

108 Eames, Fleck, and Burns, "IBM Museum & Exhibit Center."

109 Copies of the plans are in Box 147, Folder 7, "Drawings, 1967, n.d.," CRE LOC. The attribution here is a best guess, based on the inclusion of notes—by Fleck, Eames, and Burns—referencing Roche's participation in the same folder.

110 One of the drawings (Figure 4.22) is dated by Neuhart, Neuhart, and Eames (*Eames Design,* 328–29) to 1968.

111 See Charles Eames to I. B. Cohen, 18 December 1967, and Charles Eames Office, "Statement of Requirements—Museum and Exhibition Center," February 1969, both in Box 146, Folder 9, "General correspondence, 1964–1970, n.d.," CRE LOC.

112 Glen Fleck, "Series: Research and Production; Heading: Exhibits, Invention and Innovation, Artwork and Plans, Unidentified, n.d.; Items: Misc. Unidentified Drawings and Plans," Box OV-1, no folders, CRE LOC. Three additional perspective sketches of the exhibit spaces, in Fleck's hand and preserved in the Eames Collection, seem to pertain to this project, showing a group of visitors standing, sitting, or bending over CRT screens freely distributed in an open space divided only by thin partitions featuring enormous supergraphics of binary code (Box 147, Folder 7, CRE LOC).

113 The still from the *IBM Museum* film is reproduced in Neuhart, Neuhart, and Eames, *Eames Design,* 329.

114 Eames Office, *IBM Museum* film, IBM Corporate Archives.

115 Dean R. McKay to Charles Eames and Eliot Noyes, memorandum, 3 August 1965, Box 146, Folder 8, CRE LOC.

116 Charles Eames, "Lecture 6," Box 217, Folder 10, "Burns . . . Lectures, Chas. Eliot Norton Lectures, Harvard University, 1970–71," pp. 1–2, CRE LOC.

117 The Communications Rack was designed collaboratively by members of the Eames Office; the projection and CRT schemes were designed by Bill Miner.

118 Photostat reproductions of each design ("Microprogramming Memory Matrix," "Analog to Digital Converter" and "Binary Analog to Digital Converter," "Chip Assembly Wiring Matrix," "Chip Metalization Patterns," "Chip Connecting Wiring Patterns," "Assembly Section," "Modern Cable Connector," and one unlabeled design [transistor]) are preserved in Box 131, Folder 13, "Floor panels, n.d.," CRE LOC.

119 The "Computer House of Cards" came with a descriptive insert: "On these cards are some very close views of the inside and outside of electronic digital computers. Within this world of hardware is a richness and beauty often found when machines are designed to function on the forward edge of technology." On the insert were diagrams for building "houses of cards" to represent various computer concepts, including "data processing" (with three volumes attached by thin arms to a central volume), "subroutine" (grids), "algorithm" (a staircase shape), "simulation" (a nearly formless complex), and "flowchart" (designed to look like a programming flowchart when seen from above).

120 Wall text from the Communications Rack, photograph of *A Computer Perspective,* Box 136, Folder 7, "Photographs of mounted exhibit and exhibit model, 1970–1971, 1979, n.d.," CRE LOC.

Compare with Kittler, "There Is No Software," 147: "The last historical act of writing may well have been the moment when, in the early seventies, the Intel engineers laid out some dozen square meters of blueprint paper (64 square meters in the case of the later 8086) in order to design the hardware architecture of their first integrated microprocessor." Kittler's diagnosis of this moment as the (purported) vanishing of the spatial aspect of writing could just as easily be cast as the moment of the vanishing of certain traditional aspects of spatiality from architectural design. After all, the Intel engineers working on the design of the 4004 integrated microprocessor were practicing what had been called for many years previous "computer architecture."

121 As Alexandra Lange has shown, in "Tower, Typewriter and Trademark," the technique used by the Eames Office for the History Wall in *A Computer Perspective* was first fully articulated by Girard in his design for the company history exhibition at the John Deere Headquarters in Moline.

122 The design of the exhibition materials was done by the Eames Office in conjunction with several IBMers at the Armonk campus who had previously been engaged in the museum project: Bobbi Mapstone was IBM's research coordinator; Edward J. Cullinane was the archival specialist in charge of IBM's collections of computer materials; Nan Farley of the corporate headquarters business reference library provided and edited historical texts; and Helen B. Owens and R. Ken Valley, of the corporate headquarters' Museum and Exhibit Center Department, consulted on exhibit designs. Their roles, all relatively minor with regard to the design of the exhibits themselves, are described in *IBM Corporate Headquarters Today,* 17 February 1971, Box 136, Folder 6, "Opening and announcement, 1971," CRE LOC. Hugh Smallen & Associates consulted on the architectural design; several drawings are preserved in Box 134, Folder 1, "Floor plans and design elements, 1964–71, n.d.," CRE LOC.

123 Eames, "Lecture 6," 1–2.

124 I. B. Cohen, "Introduction," in Office of Charles and Ray Eames, *A Computer Perspective,* 7.

125 Information on, and the designs for, these exhibits can be found in Boxes 146–51, CRE LOC; they are also summarized, with photographs, in Neuhart, Neuhart, and Eames, *Eames Design.*

126 Transcript of *The Computer and the Mind of Man,* episode 6, "Will Machines Ever Run Man?" (initial draft title for the final episode "Engine at the Door"), Box 146, Folder 13, "Notes, On Philosophy and Goals, 1962–1969, n.d.," p. 21, CRE LOC.

127 Foucault, *The Order of Things,* 387.

128 Charles and Ray Eames and IBM, *A Computer Perspective,* IBM Archives Storage #78–004–08. 10 min. Narrated by Gregory Peck.

Conclusion
Virtual Paradoxes

The epigraph is from Kittler, *Gramophone, Film, Typewriter,* 144.

1 See the series of articles Reyner Banham wrote and edited, "Propositions," *Architectural Review* 127 (January–June 1960).

2 Transcript of "New Thinking About Industrial Design: 5. The Consultant Designer in Industry— Eliot Noyes in Conversation with Reyner Banham."

3 Henri Van Lier, "Introduction," in *Qu'est-ce que le design?* ed. L. Amic, exhibition catalog (Paris: Musée du Louvre, 1973), unpaginated.

4 At least four different versions are preserved in the Eames Office Archives, Santa Monica, Calif., AW.CE P008–P011.

5 The design of this logo is described in Rand, *The IBM Logo.*

6 Interview with Lee D. Green, director, IBM Design Program, January 2002.

7 See Rand and IBM Corporate Brand Management, *The Spirit and the Letter,* 17: "Don't alter the IBM logo . . . even in humor."

8 See E. W. Seay, "Design and Management 2: Westinghouse," *Industrial Design* 14, no. 3 (May 1967): 52–57.

9 Quoted in Kelly, "Curator of Corporate Character," 43.

10 See "Computer Center, Pittsburgh," *Architect and Building News* 228, no, 18 (24 November 1965): 985–87; "The Computer Center," 153–58; and John Harwood, "The White Room: Eliot Noyes and the Logic of the Information Age Interior,"

Grey Room 12 (Summer 2003): 6–31. Materials pertaining to the Westinghouse consultancy are preserved in Box 116, CRE LOC and Boxes 11, 24, 39, Eliot Noyes Archive.

11 On these projects and several others, see Bruce, *Eliot Noyes,* 188–99.

12 Seay, "Design and Management 2," 52.

13 On the Mobil program, see Bruce, *Eliot Noyes,* 200–211, and Ben Rosen, *The Corporate Search for Visual Identity: A Study of Fifteen Outstanding Corporate Design Programs* (New York: Van Nostrand Reinhold, 1970).

14 On this last project, see John Harwood, "Skylab, or the Outpost," *AA Files* 61 (Fall 2010).

15 See *Machine Art,* exhibition catalog (New York: Museum of Modern Art, 1934).

16 Museum of Modern Art, press release, 17 March 1934, MoMA Archives.

17 Arthur Drexler and Greta Daniel, *Introduction to Twentieth Century Design from the Collection of the Museum of Modern Art* (Garden City, N.Y.: Doubleday, 1959), 94.

18 McCarty, *Information Art,* 4.

19 *New Oxford American Dictionary,* online edition, "virtual."

20 See Friedrich Kittler, *Optical Media: Berlin Lectures 1999,* trans. Anthony Enns (Cambridge: Polity, 2010), "Preface," 25: "I recall an American president who came out of the film industry and who governed with television interviews . . . but also formulated plans for an optical-electronic future war." See also Alexander R. Galloway and Eugene Thacker, *The Exploit: A Theory of Networks* (Minneapolis: University of Minnesota Press, 2007), which attempts to make clear the political stakes of the "real but abstract" definition of protocol-driven media networks.

Index

John Harwood is associate professor in the Department of Art at Oberlin College.